PICTURING EXPERIENCE IN

THE EARLY PRINTED BOOK

PICTURING EXPERIENCE IN THE

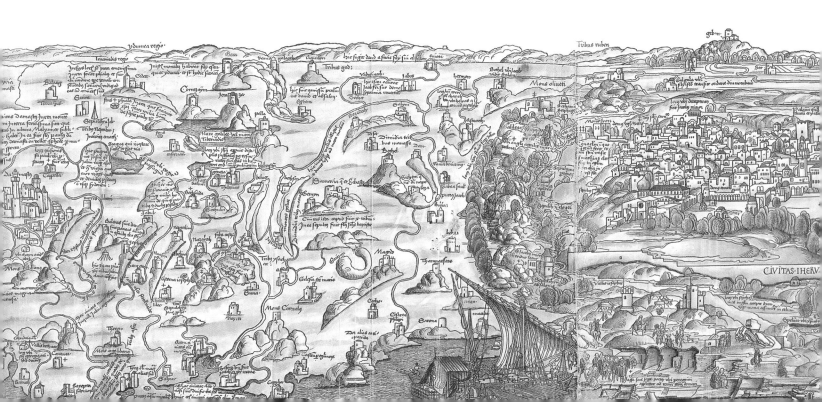

EARLY PRINTED BOOK

Breydenbach's *Peregrinatio* from Venice to Jerusalem

ELIZABETH ROSS

THE PENNSYLVANIA STATE UNIVERSITY PRESS, UNIVERSITY PARK, PENNSYLVANIA

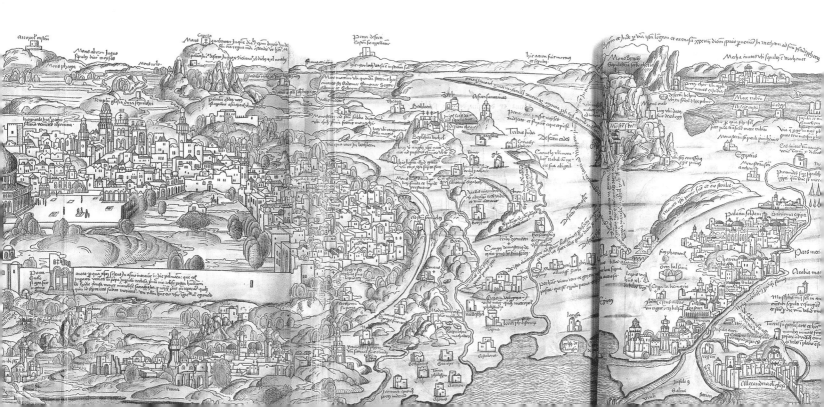

For my mom and dad,

HOLLY WEINER ROSS AND DAVID BENNET ROSS,

with love and gratitude

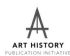

ART HISTORY
PUBLICATION INITIATIVE

THIS BOOK IS MADE POSSIBLE BY
A COLLABORATIVE GRANT FROM THE
ANDREW W. MELLON FOUNDATION.

Library of Congress Cataloging-in-Publication
Data

Ross, Elizabeth, 1973– author.
Picturing experience in the early printed book :
Breydenbach's Peregrinatio from Venice to
Jerusalem / Elizabeth Ross.
 p. cm
Summary: "Examines the creation in 1483 of
the first illustrated travelogue, Peregrinatio in
terram sanctam (Journey to the Holy Land),
by Bernhard von Breydenbach and his artist,
Erhard Reuwich of Utrecht. Focuses on the
early use of the print medium to influence public
opinion"—Provided by publisher.
Includes bibliographical references and index.

ISBN 978-0-271-06122-1 (cloth : alk. paper)
1. Breydenbach, Bernhard von, –1497.
 Peregrinatio in Terram Sanctam.
2. Breydenbach, Bernhard von, –1497—
 Travel—Palestine—Early works to 1800.
3. Christian pilgrims and pilgrimages—
 Palestine—Early works to 1800.
4. Palestine—Description and travel—Early
 works to 1800.
5. Reuwich, Erhard, active 1483–1486.
6. Illustration of books—15th century.
7. Christianity and other religions—Islam.
8. Islam—Relations—Christianity.
I. Title.

DS106.B78R67 2014
915.69404′33—dc23
2013030230

CONTENTS

ILLUSTRATIONS

Bethlehem) from *Peregrinatio* Latin, hand-colored woodcut on vellum, fols. 143v–148r. Photo © The British Library Board, C.14.c.13. All rights reserved 2014. *129*

FIGURE 76

Erhard Reuwich, *Map of the Holy Land with View of Jerusalem* (detail: Egypt) from *Peregrinatio* Latin, hand-colored woodcut on vellum, fols. 143v–148r. Photo © The British Library Board, C.14.c.13. All rights reserved 2014. *130*

FIGURE 77

Hans Memling, *Scenes from the Life of Christ and the Virgin*, c. 1480. Alte Pinakothek, Bayerische Staatsgemael-desammlungen, Munich. Photo: bpk, Berlin / Alte Pinakothek, Bayerische Staatsgemaeldesammlungen, Munich / Art Resource, New York. *133*

FIGURE 78

Fragments from *Jerusalem with Scenes of the Passion*, 1450–60, hand-colored woodcut. Hood Museum of Art, Dartmouth College, Hanover, New Hampshire; purchased through the Florence and Lansing Porter Moore 1937 Fund, the Robert J. Stasenburgh II 1942 Fund, the Julia L. Whittier Fund, the Barbara Dau Southwell '78 and David P. Southwell T'88 Fund for European Art. *134*

FIGURE 79

Hans Memling, Shrine of Saint Ursula, 1489. Musea Brugge © Lukas-Art in Flanders vzw. Photo: Hugo Maertens. *135*

FIGURE 80

Hans Memling, Shrine of Saint Ursula (detail: crossing the Alps), 1489. Musea

Brugge © Lukas-Art in Flanders vzw. Photo: Hugo Maertens. *136*

FIGURE 81

Hans Memling, *Scenes from the Life of Christ and the Virgin* (detail: Jerusalem and Magi observing star), c. 1480. Alte Pinakothek, Bayerische Staatsgemäl-desammlungen, Munich. Photo: bpk, Berlin / Alte Pinakothek, Bayerische Staatsgemäldesammlungen, Munich / Art Resource, New York. *137*

FIGURE 82

View behind the high altar of the Church of Domus Flevit, Jerusalem, built 1955. Photo: author. *142*

FIGURE 83

Official visit of Bill Clinton to Gaza, December 16, 1998. Photo © Ira Wyman / Sygma / Corbis. *143*

FIGURE 84

Diagram of monuments in Erhard Reuwich, *Map of the Holy Land with View of Jerusalem* (detail: Jerusalem) from *Peregrinatio* Latin, hand-colored woodcut on vellum, fols. 143v–148r. Photo © The British Library Board, C.14.c.13. All rights reserved 2014. *145*

FIGURE 85

Erhard Reuwich, *Map of the Holy Land with View of Jerusalem* (detail: Ghawanima and Bab al-Asbat Minarets and Via Dolorosa) from *Peregrinatio* Latin, hand-colored woodcut on vellum, fols. 143v–148r. Photo © The British Library Board, C.14.c.13. All rights reserved 2014. *146*

FIGURE 86

Ghawanima (top) and Bab al-Asbat (bottom) Minarets and Via Dolorosa (middle right), photographed near vantage for the *View of Jerusalem* in

Breydenbach's *Peregrinatio*. Photo: author. *147*

FIGURE 87

Holy Grave and Dome of the Rock, sixteenth century, pen and ink over traces of charcoal or black chalk. Staatliche Graphische Sammlung München, 1962:184 Z. *148*

FIGURE 88

Entrance Court of the Church of the Holy Sepulcher, sixteenth century, pen and ink over traces of charcoal or black chalk. Staatliche Graphische Sammlung München, 1962:183 Z. *149*

FIGURE 89

Erhard Reuwich, *Holy Grave* from *Peregrinatio* Latin, printed on reverse of *Map of the Holy Land with View of Jerusalem* (fols. 143v–148r). Beinecke Rare Book and Manuscript Library, Yale University, Zi +156, Copy 2. *150*

FIGURE 90

Erhard Reuwich, *Map of the Holy Land with View of Jerusalem* (detail: minarets framing Church of the Holy Sepulcher) from *Peregrinatio* Latin, hand-colored woodcut on vellum, fols. 143v–148r. Photo © The British Library Board, C.14.c.13. All rights reserved 2014. *151*

FIGURE 91

Minaret of the Mosque of 'Umar ibn al-Khattab (formerly Mosque of al-Malik al-Afdal) from entrance court of the Church of the Holy Sepulcher, Jerusalem, before 1465. Photo: author. *152*

FIGURE 92

Minaret of the Salahiyya Khanqah, Jerusalem, before 1417. Photo: author. *152*

ACKNOWLEDGMENTS

Breydenbach may have called the *Peregrinatio* his little book (*bůchlyn*), but it has spawned an outsized library of literature. The work of those scholars made this book possible, although the view of the *Peregrinatio* offered here, one outlook from a particular vantage, cannot presume to encompass the entirety of their contributions.

Some of the material presented in chapters 1 and 3 first appeared in articles published in *Cultural Exchange between the Netherlands and Italy, 1400–1600*, edited by Ingrid Alexander-Skipnes for Brepols in 2007, and *The Books of Venice / Il libro veneziano*, edited by Lisa Pon and Craig Kallendorf for Biblioteca Nazionale Marciana, La Musa Talìa, and Oak Knoll Press in 2008. I would like to thank Brepols and the editors of *The Books of Venice* for permission to incorporate elements of those essays in this work.

My interest in German art circa 1500 was first stirred by the intellectual charisma of two scholars in the field, Joseph Leo Koerner and Christopher S. Wood. As teachers, they both ask unexpected questions that led to better answers. Year in, year out, Henri Zerner's office was open for counsel, and David Roxburgh introduced me to the Umayyads and their successors and shaped my thinking about Jerusalem. Susan Merriam played the role of mentor before her time. Many have praised the geniuses of Scott Rothkopf, but his greatest gift may be his generosity as a friend. Graham Bader, David Drogin, Emine Fetvaci, Sean Keller, Aden Kumler, Amanda Luyster, Cammie McAtee, Christine Mehring, Benjamin Paul, Lisa Pon, and Alexis Sornin all offered

intellectual exchange that helped bring this work to better completion.

The University of Florida Office of Research Scholarship Enhancement Fund allowed me to develop the project substantially through an extended stay in Jerusalem and travel to libraries and print collections in Europe, and it has provided a subvention for acquiring and publishing images. That was augmented by a semester's stay at the Paris Research Center of the University of Florida at the invitation of its director, Gayle Zachmann. Gila Yudkin navigated my first walk around the Mount of Olives and other parts of Jerusalem with exceptional enthusiasm. Lisa DeCesare agreed to photograph the *Gart* in a pinch. And Gretchen Oberfranc provided skilled editorial services right when needed.

Melissa Hyde, Katerie Gladdys, Joyce Tsai, and Glenn Willumson have all gone well beyond the call of duty to support my work in Gainesville. The company of such colleagues is one of the pleasures of life at the University of Florida. I know I am lucky to have fallen in with such a collegial group, in particular, Barbara Barletta, Oaklianna Brown, Lea Cline, Ben Devane, Richard Heipp, Ashley Jones, Howard Louthan, Victoria Masters, Scott Nygren, Robin Poynor, Maria Rogal, Vicki Rovine, Maya Stanfield-Mazzi, and Maureen Turim. Pamela Brekka, Choi Jong Chul, and Denise Reso provided particular research and administrative assistance. The conversation that started when Rebecca Zorach visited our campus helped refine many elements of the text.

Carrie and Danielle Zublatt seem to grow fuller in empathy with each passing year, and the strength of their relationship is an inspiration. During the course of this project, my brother Matthew found Wendy, and they brought us Madison and Ethan, who helped in their own special way. My mother has waited patiently at the bottom of Mount Sinai while I climbed to the top to take in one view, and my father has tromped with me across the Mount of Olives as I searched out another. They have read drafts and continually championed art-historical life in deeds large and small. Of course, my father learned all this from his father, Papa Sol, whose memory is one of our great blessings.

NOTE ON EDITIONS AND FOLIO NUMBERS

References to the *Peregrinatio in terram sanctam* are cited in the notes or in parentheses in the body of the text. The folio and line numbers refer to the June 21, 1486, German edition, unless the text makes explicit reference to the Latin edition, published on February 11, 1486. Neither edition has printed signatures. The foldout woodcuts were assembled by gluing extra sheets onto the outside edge of one folio of an opening. Each sheet of these extensions is counted as two folios. Blank lines are not counted in the line numbering. Latin abbreviations have been expanded.

Incunabula are cited using the conventions of the *Incunabula Short Title Catalogue* (ISTC), which has an English-language interface but often uses the Latin name for authors. Each ISTC entry links to the database of the German *Gesamtkatalog der Wiegendrucke* (GW), which often contains more and different information. Both the ISTC and GW entries link directly to library websites that make incunabula available online in digital format. The Universitäts- und Landesbibliothek Darmstadt offers the Latin edition with the most easily navigable interface, and both it and the Bayerische Staatsbibliothek in Munich facilitate the download of entire volumes in PDF format. In addition, Isolde Mozer has published a modern edition of the text of the June 21, 1486 German *Peregrinatio* with folio numbers. In light of the availability of the *Peregrinatio* text and with limited printed space, full quotations from the original text of the *Peregrinatio* and other recently published or digitized works have been limited.

The online editions do not include all of the *Peregrinatio*'s foldouts, but they can be viewed together on the website of the Beinecke Library at Yale University in their digital collections. They were printed in facsimile in Elisabeth Geck's 1977 edition with abridged text in modern German.

The woodcuts of the *Peregrinatio in terram sanctam*	Figure	Folio in *Peregrinatio* Latin	Folio in *Peregrinatio* German
Frontispiece	2, 45	IV	IV
Initial R with the arms of Archbishop Berthold von Henneberg	4	2r	—
Initial H with the arms of Archbishop Berthold von Henneberg	—	—	2r (some exemplars)
Initial S	—	4v	—
View of Venice	I	13v–20r	17v–24r
View of Parens [Poreč, Italian: Parenzo]	—	21v–22r	25v–26r
View of Corfu	—	23v–24r	27v–28r
View of Modon [Methoni]	35	25v–28r	29v–32r
View of Candia [Heraklion]	—	29v–32r	33v–36r
View of Rhodes	28	33v–36r	37v–40r
Entrance Court of the Church of the Holy Sepulcher	12	41v	47r
Saracens [Muslims]	26	88r	103r
Arabic Script	26	88r	103r
Jew	32	88v	103v
Hebrew Script	—	90r	105r
Greeks	30	90v	105v
Greek Script	—	92r	107r
Syrians	34	92v	107v
Chaldean [Syriac] Script	—	93r	108r
Jacobite [Coptic] Script	—	94r	109r
Armenian Script	—	—	111r
Abyssinians or Indians [Ethiopians]	31	96v	112r
Indian [Ge'ez] Script	—	97r	112v
Map of the Holy Land with View of Jerusalem	gatefold	143v–148r	127v–132r
Holy Grave	89	reverse of Map of the Holy Land with View of Jerusalem	
Holy Land Animals	19		
Janissary Turks	8	154r	172r
Printer's Mark	3	163v	180r

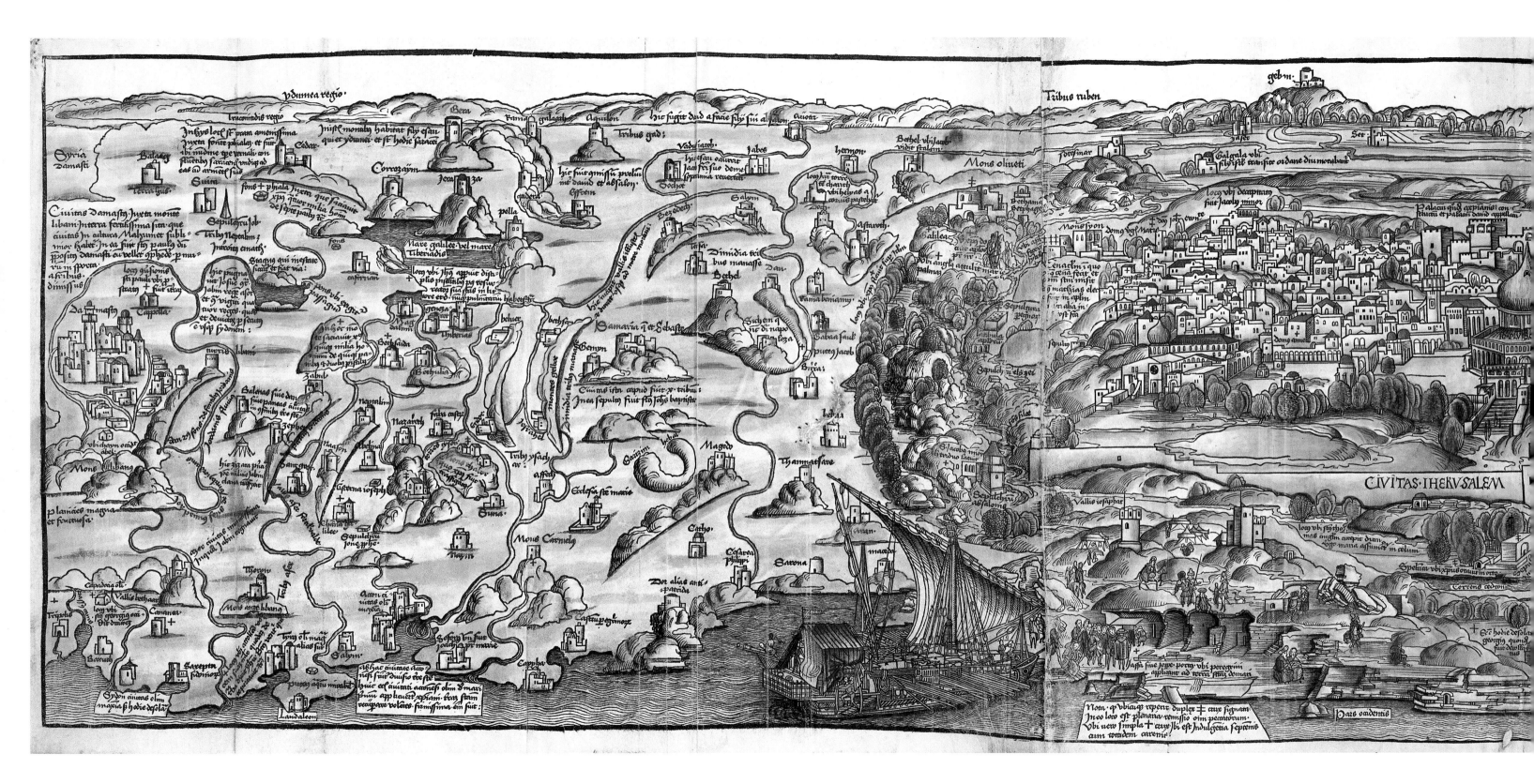

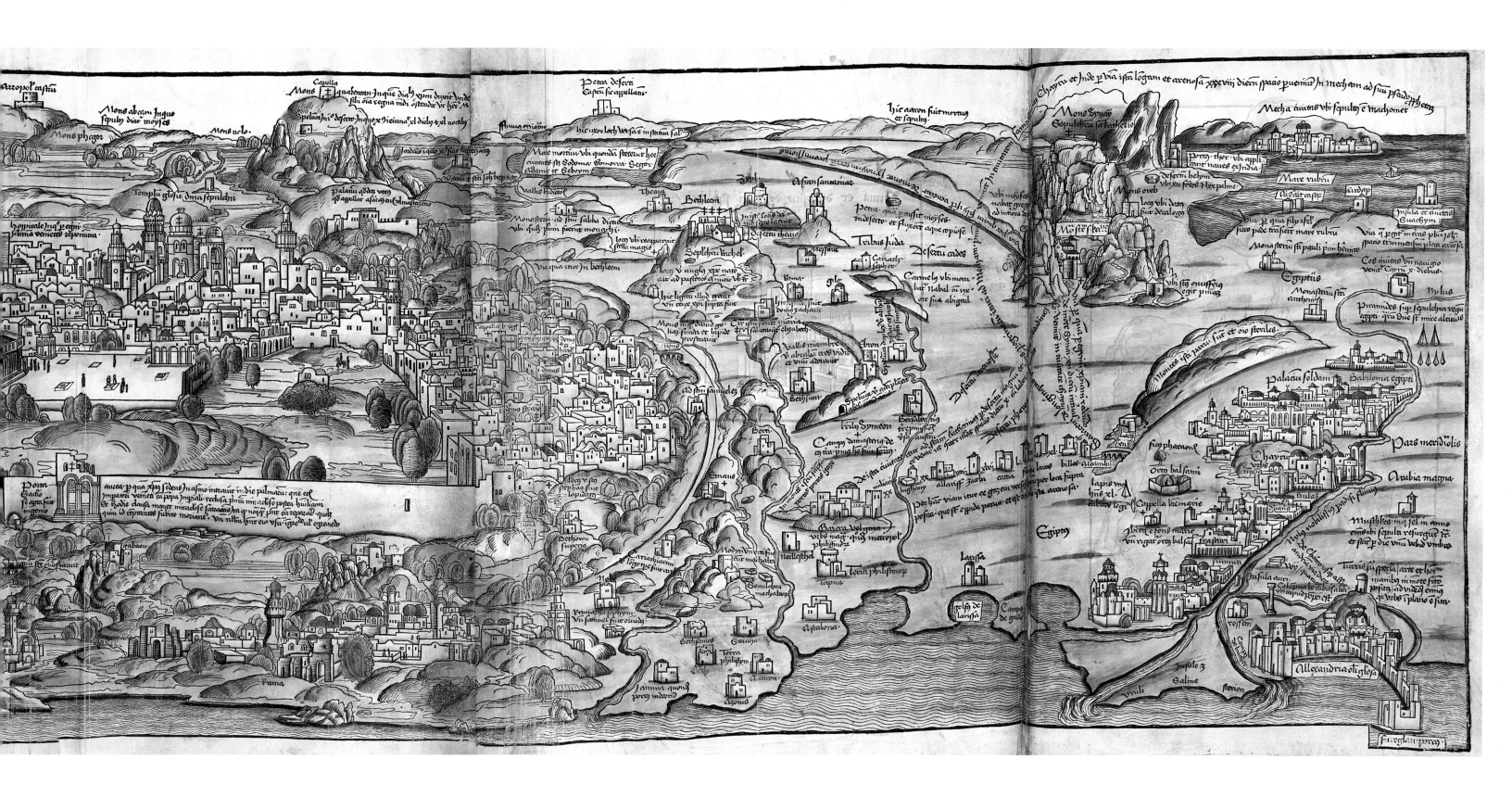

Introduction

THE PILGRIMS AND THEIR PROJECT

IN 1483, AN AMBITIOUS GERMAN CLERIC named Bernhard von Breydenbach set out to use the new medium of his day—print— to reconceptualize the form and making of a book. Our own historical situation has opened a special sympathy with those who experimented with printing in its first decades. We weigh the purchase of e-readers, navigate Wikipedia's bounty of fickle facts, contend with piracy, and debate attempts by Google Books and others to shape jurisprudence. In all these ways and others, we apprehend a future transformed, without being able to anticipate clearly how its material forms, economic models, legal systems, or structures of knowledge will work out. Breydenbach did not feel the portent of his moment in quite the same way, but he stood, nonetheless, at a juncture in the history of media similar to the one we have been experiencing with the introduction of digital technologies. New technology presented new possibilities, but as creators and entrepreneurs innovated, they opened an era when the nature of a work of art—as well as the nature of a book, an artist, and an author—stood in flux.

Of this instability Breydenbach was certainly aware; he wrote a bit about it. His project offers perhaps the best window available onto the medial shift as a *multi*media phenomenon, where the rethinking of the form and role of images is integral to the content, material apparatus, and cultural positioning of the work. He published one of the seminal books of early printing, known as *Peregrinatio in terram sanctam* (Journey to the Holy Land), the first illustrated travelogue, a work especially renowned for the originality, experimental format, and unusually skillful execution of its woodcuts. To accomplish that, he recruited a painter, Erhard Reuwich of Utrecht, to travel with him on pilgrimage to the Holy Land to research these images, create the woodcuts, and print the book. Taking an artist on such a reconnaissance mission was unprecedented, and with this travel their project engages another topic of particular concern—Christian European encounters with the Muslim Middle East. The pair grapple throughout the book with the challenge of Islam militarily, in the Ottoman Empire's successful offensives, and spiritually, in the Mamluk Empire's domination of Jerusalem and its built environment. Together author and artist presume to offer readers an authentic introduction to a Mediterranean basin caught in a contest between faith and heresy. But to do this convincingly, they must also work out their own model of authorship and art-making as they work through the problems and potentials of print.

Inspiring and facilitating pilgrimage was a stated and real aim of the book (2v, ll. 42–43; 7r, ll. 12–16; 10r, ll. 17–20). A good portion of the *Peregrinatio* is given

over to describing the course of a Holy Land pilgrimage, providing readers with geographical information, and offering practical advice, such as a table of distances between Mediterranean islands, guidelines for their contract with the captain of a Venetian gallery or with their escorts through Egypt, and an Arabic-German glossary (165r–166v, 11r–12v, 136r–137r). The excursus on negotiating passage from Venice to Jerusalem and gathering supplies parallels the handwritten instructions Breydenbach provided to a local nobleman, Ludwig von Hanau-Lichtenberg, who went on pilgrimage in 1484 with his cousin Count Philipp of Hanau-Münzenberg.[1] However, the *Peregrinatio* goes well beyond fostering pilgrimage. Its added intention is to raise readers' concern about the centuries-old, but persistent ideological disappointment of European foreign policy and the contemporary manifestation of this disappointment—namely, Europe's inability to dislodge the successive Muslim empires that had controlled the Holy Land since the fall of the last crusader outpost in 1291 and their fear of recent Ottoman incursions.

The woodcuts Reuwich produced include a complex and unusual frontispiece featuring a Venetian woman (figures 2, 45), seven city views of ports of call composed with rare topographical accuracy (one inserted in a resourcefully synthesized map of the Holy Land), renderings of the entrance court of the Church of the Holy Sepulcher (figure 12) and the aedicule over the grave of Christ (figure 89), six images of peoples of the Levant with seven charts of their alphabets (figures 7, 25, 30–32, 34), a page of Holy Land animals (figure 19), initials with the arms of the book's dedicatee (figure 4), and his own printer's mark (figure 3).[2] Printed across multiple attached sheets, four of the city views and the map fold out from the book to a length of up to 1.62 meters for the longest *View of Venice* (gatefold, figures 1, 28, 35). Such technical achievement occurred also on the smallest scale, with the frontispiece in particular made possible by the precocious intricacy of the cutting of the print block to produce plastic modeling through cross-hatching that is unmatched by other contemporary woodcuts. Breydenbach and

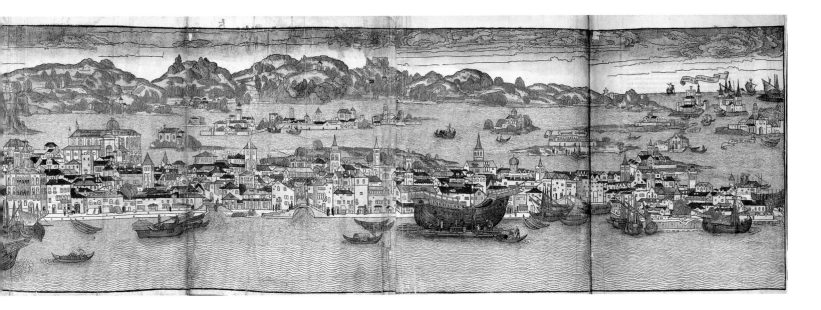

Reuwich published Latin, German, and Dutch editions of their work in 1486 and 1488 (about 180 of the Latin, 90 of the German, and 40 of the Dutch survive), and other printers translated it into French, Spanish, and Czech before 1500. The *Peregrinatio* pervaded the visual imagination of readers across Europe to inform paintings, prints, Passion parks, sculpture, maps, and other books. In total, there were thirteen editions before 1522, as the original woodcut blocks were passed from Mainz to Lyons to Speyer to Zaragoza, while also copied four times.[3]

Though some late fifteenth-century and many more sixteenth-century prints would mimic the scale and space of painting, Reuwich's work stands out for the—at first—seemingly discordant yoking of the experience of viewing a panorama to the material circumstances of reading and the bound book.[4] Artist and editor used these viewing experiences, including the visual rhetoric of perspective, as the foundation for creating a model of knowledge, authorship, and reading for print. Through pictorial, textual, and material means, the woodcuts are self-consciously constructed as eyewitness views that pronounce their origin in an artist's on-site looking and recording. The first mode of viewing proposes a single viewpoint over a unified pictorial space, while the second mode offers the close-held, dispersed, sequential perusal of reading a map or an illustrated book—or of peering closely at the details of some painted panels.

The available information about the provenance of surviving copies, albeit dissatisfyingly meager, supports the supposition that the period readership adopted both approaches to the images. The Nuremberg patrician Hans Tucher's own pilgrimage account was formative for the text of the *Peregrinatio*, and his hometown compatriot Hartmann Schedel's *Liber chronicarum* (known as the Nuremberg Chronicle) would in turn look to the *Peregrinatio* for influence. Both these print authors owned copies of the first German edition that retained the full complement of illustrations.[5] Yet a recent census of the forty-four copies of that edition extant in Germany shows that this is true for less than half of them.

While some of the copies were no doubt unintentionally damaged or fleeced for their salable parts in later centuries, these results suggest, circumstantially, that some of the views were removed early to be used as independent images.[6]

The panoramic viewpoint of the views belies the book's sympathies with the values and working methods of period cartography. At the heart of the *Peregrinatio* lies the *Map of the Holy Land* that surrounds the *View of Jerusalem* embedded within it, and the process for assembling this chart presents a microcosm for the construction of the book as a whole (gatefold). The *Peregrinatio* was created at the end of a century when late medieval *mappae mundi* were gradually giving way to charts that incorporated the modern findings of merchant-navigators into a systematic geographical framework like that described by Ptolemy. This cartography is not necessarily distinguished by the accuracy of its topography, but rather by an impulse to gather information from several types of sources and to integrate it, which means harmonizing geographical schemes that imagine and visualize space in disparate ways. Reuwich uses this critical procedure for collecting and collating knowledge in the construction of the *Peregrinatio*'s *Map of the Holy Land*. For the book as a whole, Breydenbach writes that he spared no expense or effort in gathering materials. This seems to be the case, as the text itself brings together the works of well over a dozen authors on various topics from pilgrimage to current events, and almost every image provides the spectacle of a place, person, or animal that readers would have never before seen.

Author and artist then wrap the product of this cartographic model—the map itself and the entire *Peregrinatio*—in the unifying cover of eyewitness authority, expressed as the artist's view, depicted visually in his 'views.' The pictorial genre of the 'view' reached its greatest circulation in the eighteenth century, when such works for sale as a token of the Grand Tour came to be known as *vedute* (Italian for "views"). That term functions handily in art history to distinguish the genre and its products from other uses of the English version of the word. To call the *Peregrinatio*'s cityscapes *vedute*, however, would be to burden them proleptically with a history that was just emerging. They help invent a genre whose conventions and meaning were hardly resolved in the 1480s. For that reason, the cityscapes and their like will here be called simply 'views.' At times, single quotes will distinguish them from other types of views—such as the artist's view (what Reuwich beheld on the trip), the author's view (what Breydenbach opines in the book), or the reader's view (what a period person experienced through the *Peregrinatio*'s pages). The choice to keep such a multivalent word is meant also to reconnect the pictorial work to its most fundamental rhetoric: the visual proposition that all 'views' arise from an act of viewing, namely, the artist's view of the sites before him. Implicit within the *Peregrinatio* are also other types of views, even though we do not usually call them that—the cartographic view as expressed materially in the map; the view of space that the map engages in the reader; and the pilgrims' cognitive map that structured their view on the road. By foregrounding so distinctively the pictorial form of the 'view,' the book catches up the reader in a connection between his own view and the artist's.

The *Peregrinatio* project relies upon the pretense that everything has come together in the artist's and author's field of view, where it is endorsed as credible because they saw it. The book uses this visual testimony to cohere the elements of the book (mechanically reproduced text and image), to elide the seams among diverse sources, and to create an author. The instabilities brought about by print were the subject of explicit commentary and action in Breydenbach's milieu. With his concern for giving the book a new

form, filling it with novel sights, and building the cover of assertive authorship, Breydenbach gave an answer to that particular challenge.

After Breydenbach and Reuwich and the facts of their pilgrimage are introduced in this chapter, chapter 2 will look at how Breydenbach and his circle understood and responded to the print dilemma through the person of the author and his partner, the artist. The images of the *Peregrinatio* are constructed to say "I, the artist, saw" as a visual argument working in tandem with the text's repeated declarations that they are, indeed, records of the artist's act of viewing. These statements are amplified by their singularity; this is the first time the artist for a published book is identified or promoted in the text. Reuwich's city 'views' are among the very first, and the use of the trope of the view here also amplifies themes developed by its earliest progenitors, such as Petrarch and Jan van Eyck. Later in the early modern era, the claim of printed images to be reliable copies of nature or other images will become routine.[7] In the *Peregrinatio*, we see how this notion of authenticity was originally orchestrated.

Chapter 3 takes up the question of the *Peregrinatio*'s portrayal of the European encounter with Islam: how the theme of crusade pervaded the politics and financial strategies of church, empire, and press; how the *Peregrinatio* packaged the issues; and how its choices contrasted with the presentation of Islam in some of its source material. The *Peregrinatio* exemplifies the intersection of crusade rhetoric, indulgences, and print innovation that marked the culture of print in Mainz. The visual materials that show off what the team learned in Venice, some of their freshest materials and most forward-looking, serve this emphasis on crusade. The book's text and images are not just organized to follow a pilgrimage, but to describe also a journey from a bastion of orthodoxy and resistance to Muslim aggression,

Venice, to the Holy Land, a region overrun by heresy. The story of the *Peregrinatio*'s reception of the Levant is also the story of its relationship to Venice and vice versa. The *Peregrinatio* team and Venetian artists are mutually admiring and wide open to each other's influence, but their different picturing of Islam demonstrates how its presentation can vary starkly with audience.

The *View of Venice* may be the *Peregrinatio*'s longest image, but the *Map of the Holy Land with View of Jerusalem* is its core construction, most essential to its message and most illustrative of the type of intellectual and artistic activity that animated the project. The creation of the map epitomizes the creation of the book. Chapter 4 parses the map to demonstrate this, while recouping its value in the context of period cartography.

Chapter 5 continues the focus on that woodcut, zooming in on the *View of Jerusalem*, which takes control of the center of the landscape. While Muslim patrons composed the built environment of Jerusalem itself to generate an Islamic experience of the space, Reuwich fights pictorially for a sovereign Christian view. He depicts a vantage near the place where pilgrims earned indulgences for viewing sites that Muslims forbid them to visit. This was a moment in the tour that served simultaneously to remind the pilgrims of Christian subjection and to overcome their subjection by means of a view. Reuwich offers a woodcut 'view' with the same double purpose of displaying both the center of Christian sacred history and an object lesson on the contemporary threat. He translates into a picture a practice shared then and now by all three Jerusalem religions, their setting up distinct, physical outlooks—contingent views dependent on vantage—that nevertheless show the city as they believe it to be absolutely. The artist's personal experience of viewing the city endorses the 'view' he prints, which the

reader then inhabits, encouraged by the routine of spiritual pilgrimage; and through the image of the artist-author's authority, the contingency of the Christian point of view, physical and metaphorical, is fixed in place as a true image of Jerusalem.

Bernhard von Breydenbach and His Pilgrimage

The frontispiece introduces Breydenbach, or rather the lady on the pedestal does, with her extravagant dress amplifying the traditional conception of a shield holder—usually a fetching hostess or a playful creature such as a wild man, who presents a heraldic display (figures 2, 10).[8] The person offering the shield lends the arms her good looks or his vitality, while providing an opportunity for exploring the female form or drolleries of costume and pose. On the last page of the *Peregrinatio*, a woman crowned with an exotic turban and sheer veil tenders a shield with Reuwich's own printer's mark (figure 3).[9] On the frontispiece, she fulfills her role by gesturing to the shield, helm, crest, and title of Breydenbach, which are given pride of place on her right. Across her body, they face the achievement of Count Johann von Solms-Lich (*Johannes Comes in Solms et dominus in Mintzenberg*), an eighteen-year-old nobleman who also made the pilgrimage. He was escorted by a knight in the service of his family, Philipp von Bicken (*Philippus de bicken miles*), whose somewhat smaller and more wilted armorial bearings assume a lower position on the pedestal, commensurate with his station.[10] Beyond Breydenbach's noble birth, the frontispiece also invokes his church office, through the inscription below his shield that announces him as "Bernhard von Breydenbach, Dean and Chamberlain of the Church of Mainz" (*Bernhardus de breidenbach decanns et Camerarius ecclesiae*

Moguntine), and through the pairing of this with the arms of his superior, the archbishop of Mainz, inserted across the opening in an initial that begins the text in the Latin, Dutch, and some of exemplars of the German editions (figure 4).

With the heraldry of the archbishop, the book's dedicatee, Breydenbach pulls a fourth, more august personage into orbit. Breydenbach's return from pilgrimage and his publishing activities coincided with the prime of his career, which was spent entirely in the service of the Mainz archdiocese. Born around 1435 to a family in the lower ranks of the nobility with a seat at Breidenbach, about eighty miles north of Mainz, Bernhard was educated from a young age at the school attached to the cathedral in Mainz, then from 1456 to 1458 at the University of Erfurt, which lay within the extensive territories subject to the archbishop.[11] In 1450, Breydenbach was named a member of the cathedral chapter, a body of twenty-four clerics (each required to trace his noble descent through all sixteen of his great-grandparents), who elected the archbishop and assisted him in the running of the diocese. The archbishop was *ex officio* one of the seven prince-electors who met to choose each new Holy Roman emperor. Indeed, he was the chairman (*Archcancellarius*) of the prince-electors, with power and clout to represent to the pope, advise the emperor, and address affairs throughout the realm. Accordingly, the responsibilities and prestige of this cathedral chapter exceeded the norm, and the canons were generously supported by income from the chapter's own significant territories and landholdings and from additional benefices and posts they filled. Breydenbach, for example, was appointed a canon at three local churches and a fourth about forty-five miles to the east in Aschaffenburg. There is evidence that already before his pilgrimage he also played a role in supervising the printing projects of the archdiocese on his superior's behalf: his arms

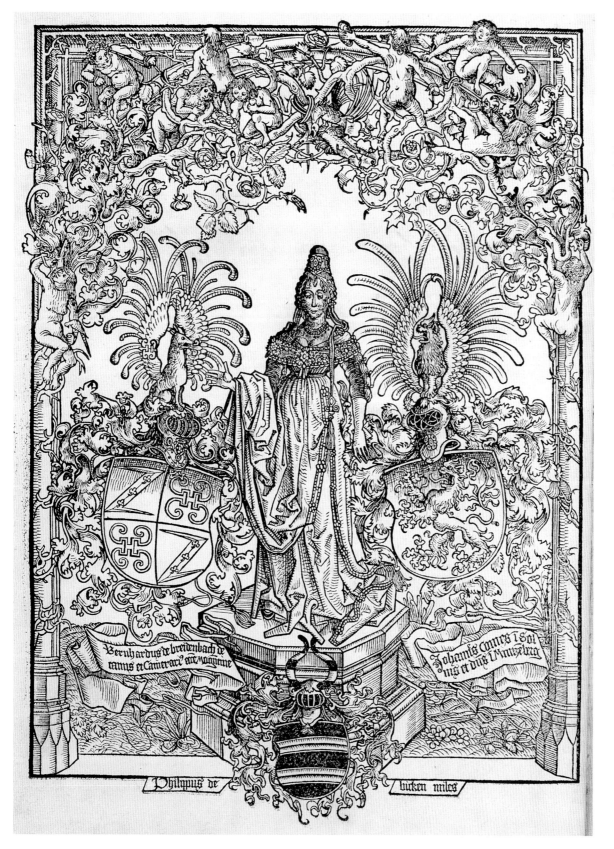

Beruhardus de breidenbach de
canus et Camerar? ecc magunne

Johannes comes & Sol
ms et dns Mutzelbrig

Philippus de bicken miles

FIGURE 2
Erhard Reuwich,
frontispiece from
Peregrinatio Latin, fol. 1v.
Beinecke Rare Book
and Manuscript Library,
Yale University, Zi +156,
Copy 2.

De cautela contra pediculos ac pulices et muscas in mari
Halt vbi supra

Accidit autē peregrinanti copia pediculoꝛ in coꝛpoꝛe propter ſu
doꝛem et puluerem ac balnei paucitatē· Cꝶ cū euenerit coꝛpus
eius cathaplaſmetur cū argento viuo occiſo· cū oleo adiuncta
ariſtologia longa et defeſti·Mane quoqꝫ balneum ingrediatur et coꝛ
pus eius fricatione valida mundetur·caputqꝫ cū caraſablito et boꝛaco
lauetur· Raſi autē vbi ſupra· Pediculoꝛū grauatione proħibent vſus
balnei et lauacri· panoꝛ frequēs mutatio· proprieqꝫ vt panus q̃ carni
adħꝛet lineus ſit·tarde nāqꝫ pediculis repletur·ħuiuſmodi autē inter
ficit argentū viuū extinctū ſi oleo miſceatur·et ex eo fila lanea inunga
tur·que ſup ſe aliq̃s impendat aut ex eis ſe cingat· Pulices cū ħerba
que dicitur canchar in lecto poſita fuerit quaſi ebrij et paraſtrici fiunt·
nec ſalire nec ſe mouere poſſunt·Si vero aqua in qua tribuli cocti fue
rint domus roꝛetur·pulices omnino deſtructur· aqua ſimiliter in qua
ruta decoquitur aut oleander eos interficit· Culices ex fumo palee et
ex fumo vaccini ſtercoꝛis et q̃ maxime ex fumo calami et nigelle fu
gantur· Muſce vero aqua in qua niger elleboꝛus coquitur et arſenici
citrini vel olibani fumo necantur· Alia pleraqꝫ medicinalia puta cō
fectiones et ħmoi ſanitatis pſeruatiua· conſeruatiua aut confoꝛtatiua ſa
tis comunia ſunt·et facile quiſqꝫ peritū medicū poteſt ħabere cōſultū
qui ħas voluerit ſubire peregrinationes· ſup ħijs rebus quas ſibi inter
peregrinandū necceſſarias arbitrabitur· Ideo de eis ſupſedere q̃ quid
piam ſcribere maxime ꝙ me nō ſatis deceat malo·

Sanctarū peregrinationū in montem Syon ad venerandū xpi ſe
pulcrū in Jerūſalem·atqꝫ in montē Synai ad diuā virginē et matrē
Katħerinā opuſcuⱡum ħoc cōtentiuū p Erħardū reüwich de Traiecto
inferioꝛi impreſſum In ciuitate Moguntina Anno ſalutis ·M·cccc
lxxxvj·die·xj·Februarij Finit feliter·

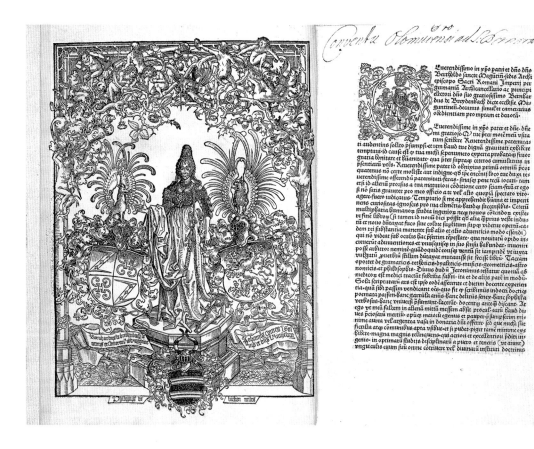

FIGURE 4
Erhard Reuwich, first
opening of *Peregrina-
tio* Latin, fols. 1v–2r.
Beinecke Rare Book
and Manuscript Library,
Yale University, Zi +156,
Copy 2.

appear at the bottom of a metalcut on the colophon page of the 1480 *Agenda Moguntinensis* (Mainz Agenda). Issued under the name of the archbishop with his arms depicted at the top of the metalcut, this publication outlined the liturgical formulas for various rites as practiced in the diocese (figure 9).[12]

Breydenbach's pilgrimage took place midcareer with at least three members of the traveling party brought together some time around February 1, 1483, when Breydenbach sent letters to Mainz requesting that his painter join him at the residence of Count Johann in Lich about fifty miles northeast of Mainz. Breydenbach seems to have called the painter in order to create a portrait of the young man, and documents confirm the artist answered the summons. A portrait made in 1528 by Hans Döring, presumably a copy of the lost original, professes to show the count at that age.[13] Breydenbach is documented in Lich at least once more, returning to Mainz on April 13, and in that week he received permission twice over to absent himself from his duties, with one permit authorizing a six-month absence from a diocesan law court on account of plague and a second consenting to a year's absence from the cathedral chapter for pilgrimage.[14]

On April 25, 1483, the traveling party formally set out from Oppenheim, a town about eleven miles south of Mainz on the Rhine, and reached Venice after fifteen days of travel. There they spent three weeks gathering provisions for the trip, touring relics and other sites, and contracting with the captain of one of the two galleys that transported pilgrims east

that season. Holy Land pilgrimage was an organized affair, with galleys licensed by the state, and upon arrival at the eastern Mediterranean port of Jaffa (now Tel Aviv), pilgrims were handed off from the care of their captains to Franciscan monks, the Latin Church's representatives in the region, who would take responsibility for shepherding them through their stay. The *Peregrinatio* group set sail on June 1, hopping among the ports of Parenzo (today Poreč, Croatia, June 3–4), Zara (Zadar, Croatia), Corfu (June 12), Modon (Methoni, Greece, June 15–16), Rhodes (June 18–22), and Cyprus (June 26–27), before arriving in Jaffa at the end of June just before the second galley of pilgrims, who had been cruising on a parallel course. There they were held in immigration detention until Mamluk officials arrived to process them, after which they were released to the Franciscans, who led them by donkey into Jerusalem on July 11 via a stopover in Rama.

A highlight of their time in the Holy City was the overnight lock-in at the Church of the Holy Sepulcher from July 12 to July 13, when the noblemen of the party were dubbed Knights of the Holy Sepulcher in a ceremony during the vigil.[15] They also climbed the Mount of Olives; walked the Via Dolorosa, the path Jesus took from his imprisonment to his crucifixion; visited the Franciscans at their base on Mount Sion; and took excursions out of town to Bethlehem, Jericho, the River Jordan, and the Dead Sea. After ten days, most pilgrims began the trip back to Jaffa for the voyage home, but the *Peregrinatio* party and some others decided instead to make the arduous trek south to Saint Catherine's Monastery at the foot of Mount Sinai. They waited in Jerusalem until August 24, in the meantime getting a chance to enter some sites that had been closed to the larger contingent, in particular the birthplace of the Virgin Mary, which had been converted to a (very prestigious) madrasa.

The expedition through the Egyptian desert to Mount Sinai took thirty days, and from Saint Catherine's they took to the desert again for eleven more days, heading west to Cairo, one of the world's largest cities, which they explored for twelve days against the background of Ramadan. They admired a troupe of exotic animals, a new mosque commissioned by the sultan, and the sultan himself holding court in the palace. Merchants in the market mistook them for a lot of slaves, offering to purchase them from their guides for ten ducats each (150r, ll. 30–35). On October 19 they embarked for a week-long passage downriver to Alexandria, where Count Johann succumbed to illness on October 31 and was buried with all the ceremony Breydenbach could muster in the Coptic Church of Saint Michael. The *Peregrinatio* mentions his death only briefly, but the description of Count Johann in the register of pilgrims making the trek to Saint Catherine's monastery reads as eulogy: "Lord Johann of blessed memory, a Count of Solms and Lord of Münzenberg, in years the youngest and least, but in nobility and mind like no other, indeed, the foremost."[16] They were finally able to take ship for Venice on November 15, but, delayed by rough weather, they did not make it into port until January 8. The two noble survivors, Breydenbach and Bicken, donated a stone relief of the Virgin and Child to the Mainz Cathedral of Our Lady in thanksgiving for their safe return (figure 5).[17]

In Jerusalem, the *Peregrinatio* pilgrims' path dovetailed with that of two others who would write their own accounts of the journey. Felix Fabri, a Dominican preacher from Ulm who traveled in another galley on the way east, was on his second trip to the Holy Land, and he would go on to compose four texts about his travels: a Latin account known as his *Evagatorium in Terrae Sanctae, Arabiae et Egypti peregrinationem* (Wanderings in the Holy Land, Arabia, and Egypt on pilgrimage); a guide to

spiritual pilgrims called *Sionpilger* (Sion pilgrims); an abridged redaction of the Latin account in German; and a rhymed itinerary of his first pilgrimage in 1480.[18] Paul Walther von Guglingen, an Observant Franciscan, had made his way to Jerusalem in July 1482, penniless in true mendicant style, and he stayed there for a year at the monastery on Mount Sion, until Breydenbach invited him and Fabri to continue on to Egypt with the *Peregrinatio* party. He made productive use of his extended stay in the Holy Land, compiling information—albeit strongly and at times vituperatively biased toward his Latin Christian point of view—about the peoples and languages of the region, in particular Muslims and Arabic.[19] The text recognizes this when it tags him in the list of pilgrims who made the trip to Mount Sinai as one of two friars, "who know many languages" (137v, ll. 4–6).

Fabri shared a galley with Breydenbach's group on the voyage back to Venice (158r, ll. 5–9), and Fabri reports that once there, Breydenbach invited him over to his accommodations, where they talked about the planned *Peregrinatio* and where Fabri had to turn down an offer to return with Breydenbach to Mainz.[20] In his *Evagatorium*, Fabri repeatedly praises Breydenbach and the *Peregrinatio*, albeit enough to suggest a bit of name-dropping, and Breydenbach returns Fabri's admiration in describing him in the list of Sinai pilgrims: "a very learned teacher of Holy Scripture and a renowned, serious preacher in Ulm, who has been to Jerusalem before, an experienced father" (137v, ll. 13–15). This testimony suggests that the two authors shared not just a formative journey, but also a common outlook on the legacy of the experience. Fabri's accounts provide extensive corroboration of the *Peregrinatio*'s description of events, often filling in details of elements that the disciplined *Peregrinatio* text mentions only with succinct restraint or passes over altogether.[21]

FAC MECV SIGNV IN BONO VT VIDEAT
QVI ODERVT ME ET CONFVNDANTVR
QVONIAM TV ADIVVISTI ME ET CON
SOLATA ES ME REGINA CELORVM

Shortly after Breydenbach's return to Mainz in early 1484, a new prelate, Berthold von Henneberg, was elected by the canons of Mainz Cathedral, and it is Henneberg's arms that stand at the head of the *Peregrinatio* text. Henneberg vacated the position of dean of the cathedral chapter to assume his new rank, and Breydenbach was selected as his replacement. In that first year as dean, Breydenbach was also the impresario for another highly influential and visually ambitious book, an herbal called the *Gart der Gesundheit* (Garden of health), printed in March 1485 by Peter Schöffer, with text assembled by a local physician, Johann von Cube (figures 11, 21).

Throughout his career Breydenbach accumulated numerous additional positions that culminated in these years to signal his growing duties

as one of the archbishop's closest aides. For the cathedral chapter, he administered the largest town in their territory, as well as the goods and finances of the chapter itself, which included their library. Henneberg granted Breydenbach the privilege of traveling to Rome to represent Mainz at the coronation of Pope Innocent VIII in August 1484 and to retrieve the papal confirmation of the archbishop's election and the pallium for his formal investiture. While there, Breydenbach was given the honorary dignity of apostolic protonotary. In addition, he continued under Henneberg in the office of chamberlain to the archbishop, a role that occasioned his travel to attend state occasions and involved him in the governing of the city of Mainz, both in conjunction with the town council and the courts and in the oversight of the university there. Already in 1477 under a previous archbishop, Breydenbach had presided as chamberlain over the trial for heresy—and conviction—of a member of the Erfurt faculty who had written against indulgences and other doctrines. Breydenbach's standing in the diocese leaves no doubt that he functioned during the years of the publication of the *Peregrinatio* in a way that was compatible with the archbishop and his policies. These details of Breydenbach's biography also explain how he could afford the pilgrimage and underwrite publishing projects, as it is generally assumed, lacking other evidence, that he funded the printing of the *Peregrinatio* out of his own pocket.

The Role of Erhard Reuwich

Erhard Reuwich of Utrecht has a name, though there is meager biography or artistic history to attach to it. The *Peregrinatio* repeats that name three times: (1) in the front matter, where Breydenbach's bringing along a painter promotes his authorial diligence and initiative; (2) in the colophon that identifies Reuwich as the printer; (3) and at the beginning of the second division of the book, where Breydenbach lists the travelers who trekked to Mount Sinai. There he is "the painter called Erhart Reuwich, born in Utrecht, who drafted [*hatt gemalet*] all the pictures [*gemelt*] in this book and carried out the printing in his house."[22] His surname refers to the town of Reeuwijk, less than twenty miles west of Utrecht, and painters with this name are recorded in guild rolls and at work in the two local churches. Hillebrant van Rewyjk, active at the Buurkerk between 1456 and 1465 and dean of the guild in 1470, seems the right generation to be Erhard's father.[23]

A Solms-Lich family account book records that Count Johann's brother, who assumed the count's title after Johann's death in Alexandria, gave "6 albus" (a small tip) to Breydenbach's painter and *snytzer* (carver) after the pilgrims' return in 1484.[24] The new Count Philipp of Solms-Lich would go on to serve at the courts of Maximilian I, Charles V, and Frederick the Wise; to be portrayed by Albrecht Dürer (drawing), Lucas Cranach (oil study), and Cranach's follower Hans Döring (panel painting); and to patronize the building and rebuilding of local churches and family properties with Döring as his court artist. It is tempting to speculate that he could have begun this career by financing the *Peregrinatio* as a memorial to his brother, but he was only fifteen years old in the spring of 1484 and is not mentioned in the book. Some scholars have read the term *snytzer* as "sculptor," but it can just as easily refer to the making of woodcuts, which require the carving of a woodblock.[25] There was usually a division of labor, however, with the draftsman turning his design over to a specialist block cutter, who stood lower in the workshop hierarchy.

The trio of noblemen in the *Peregrinatio* party were accompanied by an equal number of attendants,

as was customary for pilgrims of rank, and Reuwich appears to have traveled in this socially recognizable role. Breydenbach specifies that he booked passage for six from Venice, and while he only names four of the group, Felix Fabri confirms the number in his list of Sinai travelers and identifies the other two: Johannes, called Hengti, steward and expert cook; and Johannes Knuss, Italian interpreter.[26] The *Peregrinatio* speaks of Reuwich as a painter, separate in status from the lords and their servants, and Fabri also singles out Reuwich for mention as a painter.[27] Here, though, Fabri describes him as "Erhard, a certain companion, armor-bearer [*armiger*], and servant to the count."[28] The descriptor *armiger* may be used here as a mild honorific, as the term traditionally meant a squire, in the sense of a man with his own coat of arms who serves a nobleman without being a knight himself, though not all men who performed such duties were entitled to a family sigil. In recounting the illness of Count Johann, Walther von Guglingen writes that "Johannes the cook and Eckart the servant" wanted to take the first shift sitting vigil at the sickbed during the night the young man died.[29] Presumably, then, the gift to Reuwich from the new count was a tip for services rendered during the pilgrimage.

Beyond the illustrations of the *Peregrinatio* and the *Gart der Gesundheit*, no other extant works have been definitively ascribed to Reuwich, though he can be reasonably linked through documents to two lost paintings and some surviving painted glass roundels.[30] The first is the painting of Count Johann made before the group departed. The second is a panel with a view of Jerusalem that was documented in the eighteenth century hanging in the chapter house of the Mainz Cathedral near an intarsia trunk Breydenbach bought in Venice, presumably for the galley voyage.[31] In December 1486, "Master Erhart, the painter" from Mainz arrived in

Amorbach with his assistant William. They delivered and installed painted glass roundels for a new administrative building and archiepiscopal residence (*Amtskeller*) finished under the patronage of Henneberg. Erhart, also referred to as "the glazier from Mainz," finds mention in the project's account book six times, and scholars have largely accepted him as Erhard Reuwich.[32] Just as woodblock cutters executed the designs of another hand, so too could specialists transfer another artist's design to glass, and Reuwich may not have to have been a glazier.[33] Four of the original windows have survived, showing *Saint Martin and the Beggar*, the *Resurrection*, the arms of the archbishop, and the arms of the archbishop's mother. Overall, the pattern of these commissions suggest an émigré who traveled down the Rhine and found work creating and executing designs in various pictorial media at the court of the archbishop of Mainz, in particular in the personal retinue of Breydenbach.

Not only does the colophon of three editions of the *Peregrinatio* name Reuwich as the printer, but the German text further specifies that he printed the books "in his house" (137r, ll. 32–34). The books are printed, however, using the type of Peter Schöffer, a printer active in Mainz since he worked with Johannes Gutenberg in the 1450s in the very earliest days of the invention of printing with movable type. Schöffer also had ties to the three printers in Lyons, Speyer, and Zaragoza who received the original woodblocks for use in their later editions.[34] When the partnership of Gutenberg and Johann Fust split in 1455, Schöffer joined with Fust, eventually married Fust's daughter, and then continued on alone after Fust's death in 1466.

The fact that Reuwich used Schöffer's type and printed no other books has led scholars to question whether he in fact printed the three editions of the *Peregrinatio*, particularly the text, on his own press.[35]

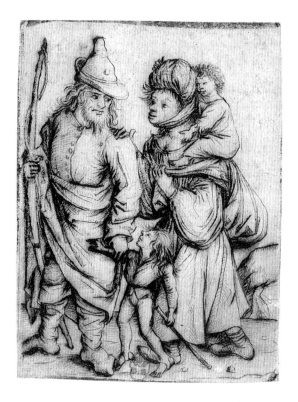

FIGURE 6
Master of the
Amsterdam Cabi-
net, *Romani Family*,
c. 1475–80, drypoint.
Bibliothèque nationale
de France, Paris.

maps). He published these along with a few other editions before going bankrupt and leaving the trade. For Reuwich, like Dürer after him, the colophon may obscure any number of different possible arrangements, but with the salient result that the artist claims the production credit for himself.

Most of the discussion of Reuwich's identity has centered around a debate over whether he should be identified with the Housebook Master and/or the Master of the Amsterdam Cabinet, the artist(s) behind two bodies of work that are often thought to stem from the same individual. The Housebook Master takes his name from his pen-and-ink illustrations in the *Medieval Housebook*, a manuscript with an assortment of texts about such topics as medicine, mining, and military strategy produced around 1475–90 for a German noble court in the Rhine region. The Master of the Amsterdam Cabinet created an unusual and inventive collection of drypoints, most of which are held in the Rijksmuseum (figures 6, 7). Several paintings also seem to belong to the Housebook Master's corpus, namely the double portrait of the *Gotha Lovers* and two sets of religious painting for churches in Mainz and Frankfurt, and scholars have vigorously contested the relationship among these three groups of works: illuminations, drypoints, and paintings.[36] Adriaan Pit made the first comparison to Erhard Reuwich's woodcuts in 1891: the mounted Turk in a print by the Master of the Amsterdam Cabinet resembles the zurna- and drum-playing riders in the *Peregrinatio*'s Ottoman military band (figures 7, 8).[37] Since then, a meticulous comparison of the style and imagery of the *Peregrinatio*'s images with the works attributed (tentatively and firmly) to the Housebook Master and/or the Master of the Amsterdam Cabinet has fueled even more discussion.

Through this debate, two arguments have been put forward to support the Masters' identification as

Breydenbach had also worked with Schöffer very recently to produce the *Gart der Gesundheit*. The possibilities for arranging the logistics and financing of printing projects were still quite fluid, however, so it was not unknown for a printer to earn a fee by renting out his type or other equipment, rather than getting more deeply invested with an ambitiously expensive undertaking. The credit in the colophon may indicate that Reuwich assumed a role that would have been something like executive printer, directing the design of the book, particularly the foldout woodcuts, and overseeing the logistics of printing in Schöffer's shop. He could be compared also to Lienhart Holle, discussed in chapter 4, who had long-standing ties to the printing industry but only set up shop when he came into possession of some unique luxury visual materials (his uncle's

Reuwich. First, the coincidence of the artists' biographies provides circumstantial evidence. Certainly, these personalities were active in the Rhine region at the same time, working for the lower nobility. The patron of the *Gotha Lovers*, for example, was most likely Count Philipp von Hanau-Münzenberg, who traveled with Breydenbach's handwritten pilgrimage instructions and who in 1490 would become the father-in-law of Count Johann's brother, the new Count Philipp von Solms-Lich.[38] An artist of Reuwich's quality, entrusted with a project like the *Peregrinatio*, should have a larger oeuvre, the thinking goes, just as the Masters should have a name.[39] The second argument discerns evidence of a single hand in the similarities of style and motif in the Masters' work and Reuwich's illustrations for the *Peregrinatio* and the *Gart der Gesundheit*. Reuwich's hatching—most obviously the fuzz on the jaw of the lady of the *Peregrinatio* frontispiece—recalls peculiarities of the Master of the Amsterdam Cabinet's drypoints, where the modeling is built up through short strokes that leave a sketchy corona around the figure. With both Reuwich and the Master, this hatching suggests an artist attempting to transfer the techniques of a draftsman to a new print medium without the training in engraving that most late fifteenth-century intaglio printmakers took from their background as goldsmiths or sons of goldsmiths.

This type of analysis has focused on the question of who did what: first, whether aspects of the images of *Peregrinatio* are too skilled or coarse to attribute to one or both of the Masters; then, as a corollary, whether Reuwich himself drew each image in its entirety from life, as the *Peregrinatio* text claims. And if not, who did? For example, if Reuwich composed the *Peregrinatio*'s expansive spaces, namely the image of the forecourt of the Church of the Holy Sepulcher and aspects of the city views, then he had a better grasp of perspective than the

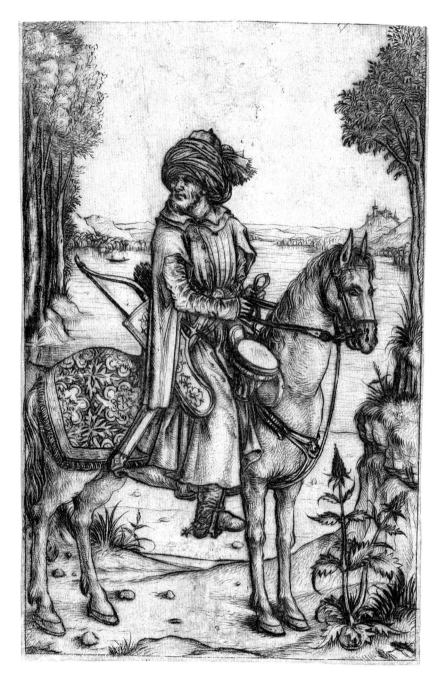

FIGURE 7
Master of the
Amsterdam Cabinet,
Turkish Rider, c. 1490,
drypoint. Rijksmuseum,
Amsterdam.

supera (haud dubiũ) trãsmisit·grecanã tantum gentẽ sub hasta vendi
pcepit· Vnde factũ est vt omnes caldis platee· et vie· cruore occisorũ
replerentur· Interea ptoris vrbis filia vnica· virgo castissima· puella
decora facie·et venũsto aspectu·thurco ob suã pulcritudinẽ ingentẽ· ad-
ducta·cum turpitudint et sede comixtioni consentire prorsus rēnueret·
protinus iugulata proqҙ fide castitatis martirio proculdubio corona-
ta·sponso virginũ ҳpo sponsa ipa in euũ est in cestis cõiũcta Porro qui
in arce erãt data sibi a thurco fide de vita seruanda· pacto qҙ firmata qҙ
salui euaderent si arcem libere in deditiõe traderẽt· exinde cõfidenter
exierũt·sed moҳ egressos ipse fidefragus tyranus arce potitus· omnes
ad vnũ iussit extemplo trucidari·Hunc in modũ(profecto miseran-
dum) ciuitate pdita·occisis incolis·cede expleta·venetoҙ capitaneus·
classe soluta·qũa omniũ arbitratu sola omnipotentis volũtate excep-
ta facile tantã defensasset vrbem si vir fidus et fortis finisset· cũ paruo
honore·fructu nullo·opprobrio sempiterno· rebus infectis· ymmo tur-
pissime neglectis·venecias remeauit·moҳ apud senatũ accusatus·de
fensionis quidem locũ accepit· sed post multas inũanũ adductas fal-
sas rationes et excusationes in peccatis·tandem nõ satis digna ҳ me-
ritis accepit vltionẽ·exilio relegatus·atqz ppetuo profligatus cũ omni-
bus suis a ciuitate veneciarũ in opidũ cui est vocabulum Vtinũ· Ita
res ҙc·finem accepit tristem prorsus et infelicem·

¶ Hoc modo equitant Thurci tempore pacis dũ ob aliquã solemni-
tatẽ siue solacij causam·festiuiori vtũtur apparatu·Guerrarũ vero tpe
eodẽ pene habitu ҙ armatura alia·ensibus scҙ accincti ҙc in pẽlũ pgũt·

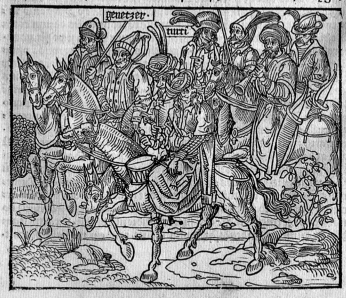

Masters.[40] At the same time, if the deft handling of the frontispiece is contrasted to the *Peregrinatio*'s other images of people, then the discrepancy can be explained if the execution of that introductory tour de force had been delegated by Reuwich to the Master.[41] (These comparisons largely ignore the presumed, but unknown, intervention of the block cutter, upon whose skill the full printed success of the drawn design hinges.)

When Hans Tietze and Erika Tietze-Conrat attributed the *View of Venice* to a lost original by Gentile Bellini and gave Bellini's copy of the *Peregrinatio*'s *Saracens* priority, they took another tack, recognizing early on in 1943 that Reuwich seems to have relied on others' designs.[42] Some scholars have more loosely speculated that Reuwich could have found a model for the *Map of the Holy Land with View of Jerusalem* in the Franciscan library at their monastery on Mount Sion.[43] The Tietzes' suggestion lay largely dormant, though explicitly rebutted by Jürg Meyer zur Kapellen in his monograph on Gentile Bellini, until recently revived by Frederike Timm with new research.[44] She has analyzed Reuwich's *View of Venice* and several other city views to show that they omit conspicuous new buildings and fortifications and, therefore, are likely based on acquired images drawn earlier. From there she argues that the advanced artistic elements in most of the images could be based on a conjectural cache of Venetian drawings.[45]

Timm goes too far in proposing that most of the frontispiece, all the views except Rhodes, the image of Saracens, and the illustrations from the Church of the Holy Sepulcher came from a single cache of Venetian sources out of the Bellini workshop.[46] With its arbor of gnarled tracery and its raucous foliage, its Venetian woman and its putti, the frontispiece is one of the most tantalizingly hybrid works of its day, though nonetheless clearly one invented by a Northern artist. Neither the *Saracens* nor the *View of Jerusalem* was originally drawn by a Bellini, as will be examined in chapters 3 and 5. The depiction of a just completed madrasa demonstrates that the view was put together by an artist who had seen the Holy City in 1483, the year of Reuwich's visit. Chapter 4's investigation of the map shows the integration of elements particular to the pilgrimage and the *Peregrinatio* that also would not have come from a single found model. Nevertheless, Timm's basic point and the attempts of earlier scholars to reattribute the *Peregrinatio* illustrations are all well taken: Reuwich did not draw every image in the *Peregrinatio* from scratch on-site, as the text would have us believe.

More fundamentally, however, the discussion to follow steps away from this method of analysis that seeks to distinguish original work from researched material in order to assign Reuwich an oeuvre that can then be connoisseurially assessed against other prints and drawings. Reuwich relied upon a heterogeneous array of sources, as the analysis of the map in particular demonstrates, while interpolating his own observations, visually collating the collection, and translating them into woodcuts. It is for this effort that he is properly described as the artist of the *Peregrinatio*. Whenever Reuwich is referred to here as the artist of the book, that language acknowledges the artistic value of that process. The phrase "Reuwich's image" will refer to a woodcut printed in the book or to the presumed final design for the woodcut that was transferred to the block, not to any sources that may have informed the print or been copied into it. They are not the same thing. To dwell on the attribution of the sketches is to conflate authorship of the original drawings with the rest of the intellectual and material effort to produce the *Peregrinatio*. To dismiss Reuwich as draftsman elides the achievement of the *Peregrinatio* as a printed book. The value of the work lies exactly in the unusual, *Peregrinatio*-specific procedure for

designing and producing the printed whole. Hunting for the origins of the *Peregrinatio*'s mimesis has obscured an appreciation of the book's other success as multimedia bricolage.

Instead of asking who first sketched the images of the *Peregrinatio*, we can ask how it is that we and the *Peregrinatio*'s earliest readers came to believe that Reuwich produced them himself based on on-site observation. We believe it because artist and author designed the *Peregrinatio* to convince us that it is so. Why and how did they do that? No matter their origin, the *Peregrinatio*'s images were highly original to their readers. How and why did author and artist achieve that novelty? The answers to these questions point directly to the concerns and strategies at the heart of their project to rethink the making of a book. The creators of the *Peregrinatio* do not take their readers' confidence for granted; they labor to earn it. As we watch their efforts, we witness the formulation of mechanisms by which images claim truth and authors assert authority—a process stimulated by print.

WHEN BREYDENBACH'S TOMB WAS opened eighty-five years after his death to help accommodate the tight squeeze of a nearby burial, his corpse was found "still wholly intact and unconsumed" with a lush growth of ruddy beard, all preserved by means of the "balsam, myrrh, cedar oil, and other fluids" he had brought home from his travels.[1] The incorruptible body is a familiar hagiographical trope, where it signals the miraculous grace reserved for saints. Here it is applied to the creator of a famous book, who has achieved the physical sign of the saints' dignity and eternal life through his reputation as an author and the special alchemy of his trip to the east. The *Peregrinatio* team built that reputation for him within the material confines of a printed book by working to stage the book's reception. Some of the impetus for this lies in the publishing environment in the circle of the archbishop of Mainz, where print was an explicit subject of policy deliberation and action; Breydenbach takes up the terms of the Mainz debate in the front matter of the *Peregrinatio* quite overtly. In a diocese worried about the print industry's decentralization and degradation of knowledge, the *Peregrinatio* provided a model for print through its process for assembling a diverse selection of new materials, made convincingly authoritative by their consolidation under a strong yoke of authorship. In text and image, the *Peregrinatio* is constructed to argue for eyewitness testimony as a guarantor of credibility, and Breydenbach pulls printed images into service to do this work of reimagining the author's material presence in a book.

The Censorship Edict of 1485

The first book on which Breydenbach is documented to have worked, the 1480 Mainz *Agenda*, provides an example of one way bishops harnessed print technology to strengthen the reach and effectiveness of institutional leadership: they issued episcopally authorized editions of the liturgy. Falk Eisermann's study of the press of Georg Reyser in the service of the Würzburg prince-bishop shows how the bishop's arms were used at the front of a 1479 Würzburg missal as a license to advertise the authority of the critical edition, as part of the bishop's public self-fashioning, and as part of a larger program to use print in the central administration of his diocese.[2] Quality control was so crucial to that commission that readers were employed to check for errors in each printed copy, a measure that eliminates any labor-saving advantage to mechanical reproduction

and suggests a certain suspicion that the technology was not foolproof.[3] The Mainz *Agenda* presents a standardized version of diocesan practice, produced under the name of the archbishop (at that time Diether von Isenburg) and with his arms as a visual sign of his endorsement.

For the printer Peter Schöffer, whose press issued over 80 percent of Mainz publications in these years, similar commissions of missals and ordos represent a considerable aspect of his output. From 1476 to 1488, the ten years before the publication of the *Peregrinatio* through its last Mainz edition, his press published five broad categories of works, all in Latin except for the last: papal and ecclesiastical pronouncements, including indulgence materials (seventy-two editions); works for a clerical audience, such as confessors' manuals or a commentary on the psalms (five); liturgical texts, in particular ordos and missals (eight); texts for academics and university students on law, logic, and Latin style (five); and works and announcements in Latin or German for a more general audience, such as almanacs, an invitation to a shooting match, and a vernacular cookbook (ten).[4] This last category includes the *Gart der Gesundheit*, but not the three editions of the *Peregrinatio*. Miscellanea may edge out liturgical books for sheer numbers, but the five missals for the different dioceses represent the press's most significant critical and typographical projects in these years. As a participant in the enterprise that first developed movable type, Schöffer carries a pioneering pedigree that belies the conservative content of his later production. This conservatism lies not simply in the number of works for a clerical audience, which still comprise the majority of readers of any kind, but in the number of editions issued by a central ecclesiastical authority or its agent, as a means of promoting homogeny in the religious services of his jurisdiction.

Beyond the strong episcopal presence in Mainz printing through commissions, the archbishop sought to shape press output by another means. Less than two weeks after his formal installation, Archbishop Berthold von Henneberg sharply criticized the publishing industry in an edict that provides rare documentation of an early institutional response to the technology through an attempt at censorship.[5] The directive requires that books on any subject translated into German be examined by scholars at the universities of Mainz or Erfurt or by similarly credentialed clerics in Frankfurt before they can be printed or sold. Ignoring the mandate risked excommunication, confiscation of the volumes, and a penalty of one hundred gold coins. Although Frankfurt did not have a press before the sixteenth century, the city's semiannual fair was already a nexus of the international book trade, so that the archbishop's decree represents an early attempt to manage print media at a key node in the network for the circulation of both books and industry monies. The edict also invokes the unique status of "our golden Mainz" as the origin of the new art with a rhetorical flourish that seems to reflect a real sense that Mainz authorities have a responsibility, if not a special prerogative, to defend the "honor" of the art of printing in order to keep it "most highly refined and completely free of faults."[6]

The oldest documented copy of the edict, from March 22, 1485, was addressed to the priest in charge of pastoral care (*pleban*) for Frankfurt's most important foundation, the Church of Saint Bartholomew. It was sent to the city council of Frankfurt with a summary letter in German, and it instructed them to choose one or two credentialed scholars, to pay them an annual stipend, and to let the *pleban* (himself a doctor of theology) and the other scholars evaluate the translated works for sale at the city's fair. On May 1, the prince-bishop of Würzburg, one of

the archbishop's suffragans, had the mandate printed to be read also from the pulpit.[7] The order was then reissued by Henneberg on January 4, 1486, in a version that named four scholars from the University of Mainz to serve as a review board there, with one expert from each of the four faculties of theology, law, medicine, and arts, and a letter to Henneberg's suffragan bishops exhorted them to enforce the order with secular leaders. In the directive, the archbishop expresses particular horror at the translation of the text of the mass (*Christi libros missarum officia*) and other works that express "divine matters and the apex of our religion," as well as the provisions of canon law, but the composition of the Mainz review committee and references to "works in the remaining fields" make clear that he was concerned with texts across a wide range of subjects.[8]

The archbishop introduces his edict by echoing his former mentor, Nicholas of Cusa, in extolling a "divine art of printing" for making human learning easily accessible. But men have misused the gift. In their greed for money and vainglory, "some foolish, rash, and ignorant people" seek to expand their sales, so they translate texts into the vernacular.[9] Henneberg objects to this on several counts: language, reading context, and shoddy product.[10] Over the long history of using Latin for sacred matters, the language and its users have developed terms that lend Latin a professional finesse that vernacular languages lack. Moreover, just as a body of qualified readers has reached consensus over conventions of Latin usage, so the meaning of texts is properly determined through the give-and-take of scholarly debate. It is not just that poor approximations of subtle texts are being put in the hands of the "common people" and "laymen, uneducated men, and the female sex."[11] These audiences cannot understand them because they do not participate in institutional—as opposed to private—reading practices, where extracts of raw

Scripture are buffered by interpretation: "Let the text of the Gospels or Paul's letters be seen [as an example]; no reasonable man can deny that you need to supplement and fill in from other texts." And what of texts, he asks, whose meaning "hangs from the sharpest debate" among scholars in what is meant to be a "catholic" church?"[12] The edict champions an ideal of expertise that arises from lifelong study of the most recondite writings. While he is at it, Henneberg also decries basic errors or deceits in works from other fields: the incorporation of raw falsehoods, the use of false titles, and translators' attributing their own inventions (*figmenta*) to distinguished authors.

The archbishop is concerned in part about the fixity of sacred texts, which suffers through poor translation, but he is also concerned about stability of meaning, which arises not from the text itself but from its reading context. Henneberg approaches this as a social problem, rather than a problem with the medium per se, and according to his analysis, it is the structure of print commerce that undermines fixity and stability.[13] He intervenes, therefore, to try and engineer these qualities. In creating review boards, he inserts a new readership between printer and consumer, effectively restructuring the flow of works so that they are intercepted and vetted by institutional representatives who stand in for the scholarly community that traditionally shaped a work's reception. It is not just a question of fixing a text, but of maintaining the proper parameters for evaluating interpretations.

The archbishop seems also to see himself, the church's anointed representative and the head of the clerical estate in the empire, as the guardian of sacred writings with the charge to control their dissemination. The concept of copyright per se did not yet exist, and the legal conception of licensing was still in its infancy. Henneberg acts, however, much like a copyright holder (to express his actions in

forward-looking terms). He invents a justification for his right to control not just the Bible itself or liturgical books, but all texts written in the sacred language of Latin on subjects touching Christian doctrine or God's creation. Then he establishes a mechanism to assert his privilege.[14] This works in tandem with quality-control strategies adopted by dioceses in commissioning new editions of their liturgical books: these circulate like critical editions, proofed and distributed from the center, under the imprimatur of the bishop.[15]

Breydenbach's Self-Presentation as an Author

The Latin text of the *Peregrinatio* was composed in the year of the edict, and the German version was published six months after the edict's reiteration.[16] Moreover, the *Gart der Gesundheit*, Breydenbach's herbal, came to press six days after the edict, from Schöffer's press, which had just been used to issue a different archiepiscopal order and would continue to be favored by the archdiocese.[17] Considering Breydenbach's particular standing as a holder of high clerical office who was thoughtfully active in the printing industry, scholars have considered that he himself may have suggested the edict, ghostwritten it, or otherwise molded its content.[18] With fluid energy, he engages Henneberg's arguments in the dedication to the *Peregrinatio*, casting his project to make a book as a project to take advantage of the benefits of printing while avoiding its hazards. The edict, issued by the archbishop, and the *Peregrinatio*, orchestrated by a member of his circle, should be considered in tandem—a stick to impede the circulation of problem books followed by a positive model of how books should be produced.

Woven throughout the dedication are the expected statements of the author's inadequacy, especially in the face of the dedicatee's extravagantly praised merit. Breydenbach is the widow of Mark 12:41–44 and Luke 21:1–4 who makes the greatest offering because she offers all she has to give, even if it is but a paltry contribution in absolute terms (2v, ll. 23–24). Even within that formula he achieves a moment of self-congratulation in acknowledging that the countergift of the dedication is incommensurate with the goodwill, great love, graciousness, and favor the archbishop has always shown him, as everybody knows (3r, ll. 31–39). Breydenbach goes beyond these common expressions of modesty, however, to invoke the editing and correcting work of Henneberg and his representatives:

> If this work also be lightly valued at first glance and, consequently, does not come to be very much edited [*gestraffet*] or corrected, as nothing important hangs on it, still I do not want to let it come out without your princely grace's knowledge and consideration of it beforehand, not only to demonstrate reverence to your princely grace . . . , but also because I want to add advantage to this little book and work. . . . If this work were seen to come, checked and examined, from your gracious princely hand, it would undoubtedly gain more credence, luster, and worth. Above all for the reason that . . . nothing ever came under the rasp and test of your princely grace (which is quite sharp and takes off all the rust) that did not emerge most excellently straight, cleansed, and clarified. (2v, l. 43, through 3r, l. 14)

He invites the archbishop's scrutiny, setting himself up as a model of proper submission to central oversight, with measures of sycophancy and market savvy as well. He does not just humbly petition for his patron's approval; he explicitly submits to his or

other scholars' corrections. This dedication appears first in the Latin edition (2v, ll. 15–25), where there is no issue with translation and where, therefore, it serves as a voluntary social performance that enacts the paradigm of the edict without being compelled by its terms.

At the head of this dedication text stands the initial with Henneberg's arms, the visual suggestion that the book does indeed come examined and tested from His Grace's hand (figure 4). Breydenbach's verbal supplication beneath an image of the archbishop repeats the structure of the metalcut in the 1480 *Agenda*, where a disabled indigent makes a meager offering to an enthroned Saint Martin, a bishop and the dedicatee of Mainz Cathedral (figure 9). The arms of the archbishop are strung above the saint, and the arms of Breydenbach hang below him at the level of the beggar. The layering of Breydenbach and the see of Mainz over the beggar and patron saint encourages the image to be read as an adaptation of the typical dedication miniature in a manuscript, where the author, on bended knee, presents a copy of his book to his enthroned patron. Here Breydenbach in all humility, a supplicant aided by the charity of Saint Martin, offers up his work to a patron who blesses him in return *ex cathedra*.

Breydenbach asserts that the *Peregrinatio* is intended for the edict's ideal audience of clerics and educated elites, particularly preachers.[19] The geographical description of the Holy Land is meant to elucidate the *Map of the Holy Land with View of Jerusalem*, so that it may serve "all who read or preach the Holy Scripture, which I especially want to encourage with this" (57r, 30–32). They will absorb the *Peregrinatio*'s information and then do the real work orally, disseminating the book's message and arousing enthusiasm for it through sermons or reading aloud. In other places the author hopes this oral appeal will publicize the threat of Islam: if reading this book or hearing it read convinces noble men to resist the Turkish menace, then this book will be useful, he writes (167r, ll. 19–21). In another section, the *Peregrinatio* incorporates the work of a scholar found to be too soft on Islam and, therefore, potentially misleading for the general public. To mitigate that, the table of contents in the German edition points out a passage that is to be read "because of the common folk and uneducated people" in order to clarify the Islam section, and that passage is set off in the text with its own subheading (5r, ll. 7–10; 100r–103r). In the Latin edition, the same passage finds no special mention or typographical distinction, a difference that suggests how the production team attempts to guide the audience of the translation and address the concerns of the edict (4r; 86r–88r).

In reality, the *Peregrinatio* seems to have spread out of the hands of the elites through vernacular translations and new editions. At least the first of these editions was implicitly authorized by Reuwich, if not Breydenbach, when he provided the new printer in Lyons with the blocks. (Selling or renting blocks to another publisher was a common practice that allowed the original printer to make some money off others' editions, since the new publisher could pirate the work with impunity with or without the initial printer's cooperation.) Though early provenance information is rare, we know of at least one German copy that was read under different circumstances by members of "the female sex." The Dominican nuns in Offenhausen, about thirty miles west of Ulm, coveted their German edition enough to try and deter errant borrowers with an inscription: "The book belongs to the women of Gnadenzell. Anyone to whom they lend it should return it as required and right away."[20] These nuns may very well have received their copy from Felix Fabri himself, who wrote a history of their house to contrast conditions before and after its reform in 1480.[21]

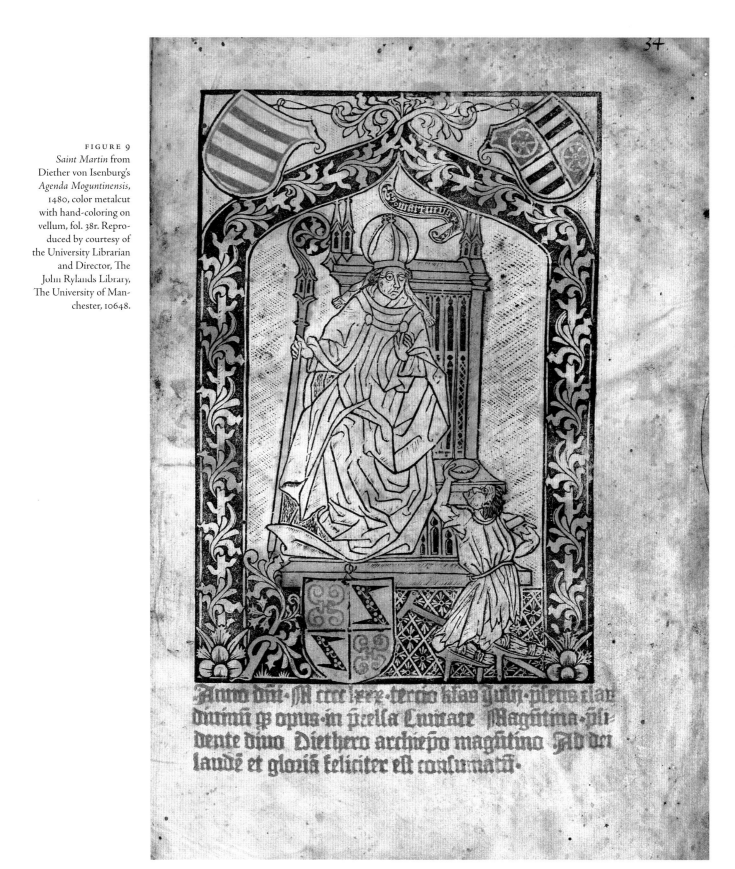

Breydenbach's decision to pitch his work to elite masculine readers and the steps he takes to elevate his address should not be taken for granted. Female audiences, particularly those confined to cloisters, clamored for their own experience of the Holy Land, and their spiritual advisors obliged with texts that adjust style and language to their target. Felix Fabri's four works about his travels were each tailored to a different audience. The Latin account was meant for readers like himself, while the German *Sionpilger*, composed in the early 1490s at the request of some local women of his order, refashioned his material as a guide to spiritual pilgrimage for them. Fabri's guide sets forth twenty rules to direct the pilgrims' behavior and state of mind before scheduling a devotional program of 208 days of imagined travel to the Middle East and back. Where Breydenbach hopes his book will serve as a prelude to real pilgrimage, Fabri crafts his book as an explicit substitute for physical travel. For more popular audiences he produced a German version of his Latin account, much condensed, and an even shorter account in verse intended to facilitate memorization of the order of holy sites. Francesco Suriano was less chameleon, but his treatise, discussed in the next chapter, was another example of an account pitched for women in a "simple style" that reproduces the instructional interchange between a nun and the priest assigned as her spiritual director.[22]

Breydenbach is well aware that pilgrimage accounts belong to a popular genre with a mixed audience. His characterization of the *Peregrinatio* as "lightly valued" and unimportant has a literal meaning apart from conventions of humility. The author seeks to remind his judge that he is not presenting the type of book, a work of theology or sacred scripture, that requires vigilant scrutiny. At the same time, Breydenbach seeks to distinguish his account of the Holy Land from the others that have gone before it, and although his efforts go well beyond the rhetorical posturing of the dedication, they are reflected in his argument there. Echoing Henneberg's edict again and borrowing from Jerome, who quotes Horace, Breydenbach launches an attack on substandard books:

I have come to the opinion that . . . there is no end of making new books. (If anything of these times can be called new. I mean such things as receive new clothes only on the outside or are painted over in a different color than before yet their substance remains unchanged . . .). . . . New findings are getting well out of control. . . . It has already come to the point that . . . anyone who can simply hold the stylus or follow the particular forms of writing, he can turn [things] and move [them] around, and he thinks he has made a new book. And this is not only happening in the liberal or natural arts, such as grammar, dialectic, rhetoric, music, arithmetic, geometry, astronomy, and general philosophy, but also, what is more, in the sacred divine scripture. As Saint Jerome attests: doctors handle medicine and smiths that to which they are entitled, so the same for every craft. So it is alone the art of writing, especially the holy [scripture], that everyone presumes to understand. The educated and uneducated write poems and make books—the chatty crone, the witless old man, the blathering sophist—indeed, all people presume to write, to mutilate writing [*zu ryssen die geschrifft*], and to say something different that they neither know nor understand.[23]

The "foolish, rash, and ignorant" translators targeted in the edict are here even more colorfully disparaged as ninnies in comparison to the untouchable, sainted paragon of biblical translation, Saint Jerome. By the

end of this reproof, Breydenbach has subsumed the edict's concern about shoddy translation and greedy, deceitful practices into a criticism of more general incompetence in the making of books, with the implication that by composing books members of the craftsman class overstep their appropriate social roles. This, too, complements the edicts' implicit assertion that the prerogative for creating and disseminating knowledge belongs to the clerical estate. The great works and great rewards belong to men of superior intellect who dedicate themselves to sacred or human learning from youth to old age, Breydenbach writes—another sentiment that parallels the archbishop's mandate (2v, ll. 18–21).

Breydenbach does not presume to be one of those scholars. He claims another basis for his expertise: his completion the previous year of a lengthy pilgrimage, "as is recognized and known" (2v, ll. 34–35). As Breydenbach continues in the dedication, he develops an argument that says in essence, I may not be presenting your princely grace with a worthy work of the high genre of theology, but I have taken unusual care in composing a useful book with a pious purpose on a subject that suits my abilities and social station. He then alludes to the novel extent and effect of his working process by describing his "little book" (*bůchlyn*) as having "a form and size perhaps not seen before and brought to print with writing and pictures together" (2v, ll. 38–40). While following the archbishop's argument in many ways, Breydenbach has at the same time subtly shifted the definition of expertise. The foundation remains knowing and understanding a subject matter appropriate to your class, but in this case that knowledge is grounded in personal experience, rather than longtime scrutiny and debate. In denigrating books that only pretend to be "new," he has added an implicit call for some kind of originality. First he sets up the inference that his book offers that in contrast to those that merely "turn and move" things, and then he makes it explicit—a form and size not seen before, combined text and image, based on his own experience.

Shortly after the dedication, in a section entitled "Explanation of Intent" or "Expression of the Opinion of the Creator [*angeber*] of this Work," Breydenbach will add two more claims that distinguish his project, and, therefore, implicitly bolster his justification for publishing: the extent of his research and his careful editing. First, Breydenbach emphasizes that during the journey he "investigated and learned all the things necessary to know with special diligence," "sparing no expense." For this purpose, he thought it worthwhile to bring along a "clever and learned painter, Erhard Reuwich of Utrecht."[24] In attaching the account of Reuwich's work to his own, Breydenbach promotes the painter's contribution as the visual counterpart to his own research. The three times Reuwich is named are the first times an artist is identified in the text of a printed book he illustrated. Breydenbach doesn't just claim to have taken a painter with him on pilgrimage for the purposes of researching a book; he actually did. Describing it in the text in these terms was equally exceptional.

In that same section, in the Latin edition, Breydenbach also mentions that he had a learned man add explanatory material in Latin and German to his own offering (*ad votum meum*) (7v, ll. 8–10). Via Felix Fabri we know the collaborator was Martin Rath, a Dominican and Master of Theology at the University of Mainz, a colleague of the faculty members that the archbishop appointed to the censorship edict's review board in January 1486. According to Fabri, this outside expert organized the building blocks of the text and assured the quality of the language.[25] Fabri also seems to credit Rath with composing the catalog of Holy Land heretics, but that section closely follows a text by their traveling companion Walther von Guglingen. In the German

Peregrinatio, the verb *straffen* stands in for the more detailed sketch of the commission in the Latin (10r, l. 27). Meaning "to edit," literally "to tauten," the word is also used to express the correcting work of the archbishop and his most learned scholars in Breydenbach's dedication (3r, l. 1). Although the text does not advertise the contribution of the editor as it does the work of the artist, the editing process had a significant impact on the shape of the work, and it seems an important aspect of Breydenbach's strategy for setting his book apart as a piece of careful scholarship for a sophisticated readership.

The extent of Rath's intervention has caused scholars to ask if he should be considered the book's author.[26] However, Breydenbach robustly claims the author function for himself.[27] While keeping the editor anonymous, he refers to himself as the work's "*auctor principalis*" in the Latin edition (116r, ll. 42–43) and "*angeber*" (10r, ll. 1–3; 137r, l. 30) in the German, takes clear credit for the book's conception and research in the front matter, and incorporated a travel account couched in the first person. How Breydenbach builds his authority in the book with forethought and purpose becomes clear from assessing the disconnect between what he claims about the text and images and what modern scholarship has shown about their origins.

The theory of medieval authorship articulated by A. J. Minnis, in particular for the twelfth through fourteenth centuries, often serves as a starting point for examining how later medieval and early modern authors and their transmitters (e.g., Dante, Chaucer, or Caxton) altered, exploited, or lived within the traditional framework while creating elements of our modern notions of authorship.[28] Via Bonaventure, Minnis describes a spectrum of writers, from scribes who copy, to compilers who gather works and copy, to commentators who compile while adding some of their own explanations, to authors, whose own analysis forms the basis of the work, corroborated by other sources compiled to support them. This is not a spectrum of originality, as all four types of writers are understood to be mediating the ultimate theological authority of God in the Latin language of the Vulgate. The author has the greatest authority, from his long-standing reputation and his texts' reception as formative members of a delimited canon, but there is no special privileging of the type of writing at that end of the scale.[29] It is this same understanding that undergirds the archbishop's conception of the church as the (so to speak) copyright holder of sacred scripture and many other texts, as the church is the earthly guardian of the sacred truths from which all kinds of writing derive.

For "writers" of visual images, an analogous conception of draftsmen as mediators of nature comes to the fore in a court case in Speyer in 1533, where Johann Schott of Strasbourg sued a rival Frankfurt printer, Christian Egenolf, for plagiarizing his press's *Herbarium Vivae Icones*, a landmark in the production of herbals, richly and intelligibly illustrated from life.[30] It is amusing in our context to note that Egenolf used the new images he copied to update, not Schott's text, but Breydenbach's *Gart der Gesundheit*, and he uses this different textual model as one point in his defense. More slyly, Egenolf argues that both books reproduce nature, in the form of the plants themselves, so that Schott cannot claim a privilege or special invention. The court's opinion has not survived, though Egenolf's blocks reverted to Schott, suggesting that the court had begun by this time to recognize at least the printer's monetary investment in commissioning the blocks, if not the intellectual investment in the images' design. Yet Egenolf's argument, however self-serving, witnesses a conception of printmaking similar to that of authoring based in transcribing an external truth, even if that conception was in the midst of change.

When Breydenbach (or his source) leans on the Bible or a recognized author like Virgil (160r, ll. 6–8), he often mentions it, but he brings together without attribution a very long list of other texts: the pilgrimage account of Hans Tucher of Nuremberg; information about the peoples of the Holy Land and laments over the Muslim occupation of the Holy Land from the manuscript of Walther von Guglingen; a geographical description of the Holy Land attributed to Burchard of Mount Sion, a crusader-era monk; reports by the patriarch of Constantinople, the head of the Hospitallers, and other anonymous authors of Ottoman attacks in the Mediterranean; and many others.[31] The origin of much of the source material of the book does speak for Breydenbach as the primary researcher, as so much came from Venice or his traveling companions. For example, beyond the borrowings from Walther von Guglingen, it seems plausible that Fabri, who carried Hans Tucher with him on at least one of his journeys, brought that account to his friend's attention.[32]

There would be no contradiction for Breydenbach in the fact that most of the text of the *Peregrinatio*, including the first-person narrative of the travelogue, is drawn from other sources with interpolations as well as editing to streamline and customize the prose. Outside sources are compiled to support his contribution, which rests not necessarily in his analysis, but more fundamentally, in his eyewitness testimony that gives the collection its unifying purpose and imprimatur: "I, the person named as author, saw [what these other sources confirm]." Rather than mediating the theological authority of the Word through writing, he and his artist, or rather, their viewing, mediates the worldly Christian and natural order through images (as well as text). The censorship edict speaks of knowledge as a consensus that arises through discussion among learned persons, and this had traditionally taken the written form of a text scaffolded with other texts, as with the Pauline Epistles that Henneberg used as his example. In the *Peregrinatio*, it is Breydenbach and Reuwich's first-person observations that are scaffolded by the compiled texts and by the images. The use of outside source material implicitly validates what the *Peregrinatio* team claims to have seen.

The origins of this support structure are obscured, however, by the act of ventriloquism that subsumes them under the first-person narrative and authorial claims of the text and images. In perhaps the most telling maneuver, Breydenbach emblazons his arms and the arms of the two other noblemen in his party at the center of the *Peregrinatio*'s attention-grabbing frontispiece. In honoring these three, the *Peregrinatio* frontispiece draws upon the common practice of Holy Land pilgrims' commemorating their journey with public monuments, which ran the gamut from entire churches to chapel furnishings (like those provided by William Wey to the Chapel of the Holy Sepulcher at his monastery in Edington) to single images (like the stone relief of the Virgin and Child given by Breydenbach and Bicken to the Mainz Church of Our Lady) (figure 5).[33] They gave the relief in thanksgiving for their safe return, and many pilgrims' donations were similarly motivated. Pilgrims also put objects commemorating their accomplishment on display in other contexts where they did not serve a cult function. This was the case, for example, with the painting of Jerusalem that Breydenbach hung in his chapter house. Successful completion of a Holy Land pilgrimage also conferred social honors. After being dubbed Knights of the Holy Sepulcher during the all-night vigil at the Church of the Holy Sepulcher, many then adopted the Jerusalem Cross as a heraldic device on portraits and other works marked with their arms.

The use of a printed image as a vehicle for commemorating a pilgrimage was, however, a new form invented for the *Peregrinatio*. In the first decades of printing, publishers experimented with empty first pages; title pages with just type; title pages with type and ornament, a woodcut illustration, or a printer's mark; or pictorial pages without any title information. While a title page grew increasingly common from 1480, the form of the paratext at the very front of the book had not yet stabilized as a pictorial hook to draw readers or as a label to identify books that had just begun to circulate far from their origin. Opening a book with a full-page woodcut across from the first page of text was and remained a highly unusual choice.[34]

Here on the inside, it turns the direction of its address, figuratively as well as literally, from an appeal to the reader to a commentary on the text. The adaptation of the *Peregrinatio* frontispiece in the *Liber chronicarum* will turn the focus back to the reader by replacing the lady and her heraldry with God the Father and two wild men, who display empty escutcheons ready to receive the arms of the volume's owner (figure 10).[35] (The *Peregrinatio*'s views are equally influential for the Nuremberg Chronicle's famous profusion of city skylines.[36]) The example illustrated here happens to have belonged to the author, Hartmann Schedel, who has illuminated it with his own markings. The frontispiece of the other book orchestrated by Breydenbach, the *Gart der Gesundheit*, offers the same fill-in-the-blank bookplate, suspended from a foliage canopy that is in many other ways a prototype for the *Peregrinatio*'s opening image (figure 11). These swaps that displace the insignia of book's readers (*Gart*) for its modern creators (*Peregrinatio*) and then back again to that of its readers (*Liber chronicarum*) begin to suggest the very distinctive choices of the *Peregrinatio* opening.

In featuring a convocation of eminent classical, Muslim, and Christian physicians who contributed to the knowledge collected in the book, the frontispiece of the *Gart der Gesundheit* is more typical of incunabula that adapt the conventions of medieval manuscripts. One type of manuscript frontispiece depicted an author on bended knee offering his work to a patron, as implied allegorically in the metalcut of the Mainz *Agenda*. That genre aside, medieval author portraits by and large depicted well-established authors of sacred texts. The fifteenth century did see a rise in secular and vernacular author portraits, as seen in the *Gart*, but the depicted writers, such as Aristotle, Aesop, or Chaucer, generally had long-standing literary reputations. Or a frontispiece can play to the new market for printed books with an image directly illustrating the content of the work. Peter Drach's 1505 edition moves Reuwich's image of the entrance court of the Church of the Holy Sepulcher from the interior of the book, where it originally introduced the description of the church, to the title page, where it advertises front and center what Drach wanted to market as the substance of the work (figures 12, 13). Reuwich has brought unusual technical care and prowess to bear on constructing an image that substitutes the visual rhetoric of nobility and the social sheen of the Jerusalem pilgrim for more traditional renderings of canonical authors or the book's subject matter. And he chooses to place this unconventional, but forceful, framing of the foundation of the authority of the book where no image was necessarily even expected.

The Artist as Eyewitness

Just as Breydenbach asserts himself as author in the text, so the images strengthen his voice by adding the

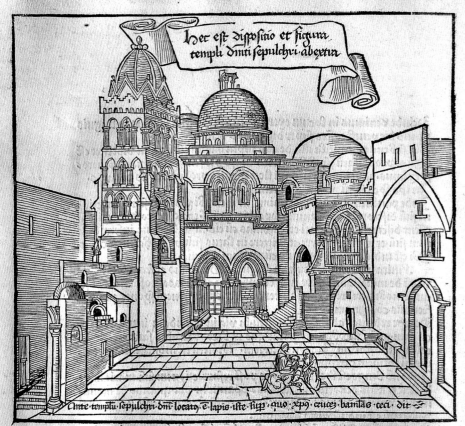

Hec est dispositio et figura
templi dñici sepulchri aberria

Ante templu sepulchri dñi locata, e lapis iste supp quo xpg cruce bamtas cecidit

De ingressu in templum dñici sepulcri et processiõe initi facta
ad loca sacra.

Je.yij. Jułii ḫora vesperaru in ipm venerandu dñici sepul
cri templu a paganis. id est rectoribus ipius ciuitatis sancte
Jerosolime fuim9 admissi et numerati ostijs p eos apertis.
pro qua re vnusquisqz nostru quinqz eysoluit ducatos. nec
vnqz alias ḫoc aperitur templu ab eis. nisi vel propter aduenietes pere
grinos. vel fratres mutandos qui ibi pro custodia deputātur. Moyqz
nobis intromissis templu clauserūt. Intrauerūt aute nobiscū Gardia
nus ipe et plures suoqz cõfratrū. Quaprimū aūt deuotus quisqz yia
nus vel peregrin9 in templū ḫoc pedem posuerit. plenariã cõsequitur
remissionem.

Est autē ḫec dispositio templt eius dem sacratissimi. Ecclesia ipa rotū
da est. et ḫabet p diametrū inter columnas septuaginta tres pedes. ab
sidesqz que ḫabent p circuitū a muro exteriori ecclesie dece pedes super
sepulcrū dñi. qð in mediū eius dem ecclesie est apertura rotunda ita vt
tota cripta sancti sepulcri sit sub diuo. Galgatḫana autē ecclesia adḫe
ret isti. et est oblonga loco chori ecclesie sancti sepulcri adiūcta. sed parū
demissior. sunt tamē ambe sub vno tecto. Spelunca in qua est sepulcrū
dñi ḫabet in lõgitudine octo pedes. in latitudine similiter octo vndiqz
tecta marmore exteri9. sed interi9 est rupes vna sicut fuit tpe sepulture

eyes of the artist. On July 14, 1483, Reuwich stood on the Mount of Olives, faced Jerusalem, and took in the view as an artist, a pilgrim, and a publisher in the nascent printing industry. We know he stood there as an artist because he translated his experience into the woodcut *View of Jerusalem* embedded into the *Map of the Holy Land* (gatefold). We can even call this image a perspective view because the print uses rough strokes of linear perspective in arranging the city's most prominent monuments and because the disposition of urban topography aligns with the view from a single, identifiable vantage. From written testimony of pilgrims traveling with him, we can corroborate his presence at that vantage and pinpoint the date when the tour group looked down at the city to collect indulgences. And we know he considered the view as an innovating publisher because the book issued under his name tells us that the trip was in part intended as a research and reconnaissance mission to gather fresh and reliable material. We come to believe all these things first and foremost, however, because the view of Jerusalem and the other illustrations in the book have been designed to convince us that they are true.

To persuade, the *Peregrinatio* uses first a new kind of visual rhetoric—the emerging genre of the 'view'—that here takes on special functions when inflected by the text and conjoined to another nascent media format, the printed book. More specifically, while the wider genre of the view looks out on any expansive landscape or vista, the *Peregrinatio's* views of Venice, Modon, Candia, Rhodes, Parenzo, Corfu, and Jerusalem belong also to the subgenre that pictures cities and towns. While they are not the first examples of the city view in the west or even in the north, they are among the very first, made at a time before the city view or the city plan had coalesced as a genre, with shared purposes, conventions, and meanings. The type of city view showing

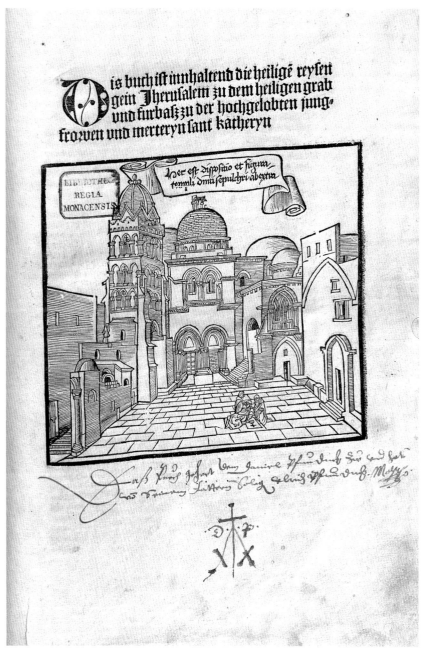

FIGURE 13
Frontispiece from Brey-
denbach's *Peregrinatio*
German, 1505, woodcut,
fol. 1r. Bayerische Staats-
bibliothek München, 2
Inc.s.a. 245.

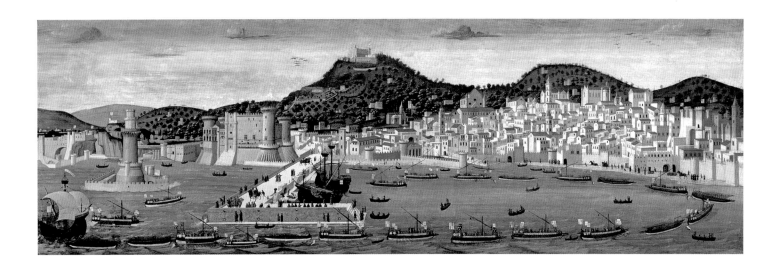

a panorama that transcribes observed urban topography seems to have crystallized in the 1480s with the almost simultaneous creation of several views of Italian cities. A forerunner from circa 1466–86 is the painted *Tavola Strozzi*, which depicts a panorama of the return to Naples in 1465 of the victorious Aragonese fleet after the Battle of Ischia (figure 14). A woodcut view of Florence with a chain around its edge remembers a lost engraving by Francesco Rosselli, dated to the artist's stay in the city between 1482 and 1490 (figure 15). From 1484 to 1487, Pinturicchio frescoed the Villa Belvedere at the Vatican with a series of views of Florence, Genoa, Milan, Naples, Rome, and Venice, now largely destroyed. Correspondence and other written testimony attest the loss of further examples, most importantly one view of Venice (*Venetia in disegno*) reported to have been created by Gentile Bellini for Mehmed II and another (*retracto*) drafted by his father, Jacopo Bellini, and retouched by Gentile in 1493 for Francesco II Gonzaga.[37]

Although the *Peregrinatio*'s illustrations belong to this development chronologically, their eccentric context opens their meaning beyond what is typical for this particular category. Juergen Schulz developed the term "emblem" to describe how the medieval progenitors of city views symbolized moral values rather than communicating topographical information or conveying a portrait likeness. Maps and seals represented cities as a compact grouping of structures, usually conventional but occasionally with recognizable components. Schulz's term "emblem" serves as both a functional and formal description.[38] Even with the introduction of a new style that presented cityscapes with atmospheric or linear perspective as if seen from a fixed, open vantage, city views were still regularly instrumentalized for political purposes, if not also for moral or religious ones.

The political content of maritime triumphal entries could not be clearer, though the *Tavola Strozzi*, likely displayed in the home of Filippo Strozzi, would also have advertised his personal triumph in helping finance the 1464 flotilla while making his fortune in exile in Naples.[39] In addition to a view of Otranto (where Mehmed II's forces were repelled from Italy in 1481), Filippo's inventories record three views of Naples, none of which

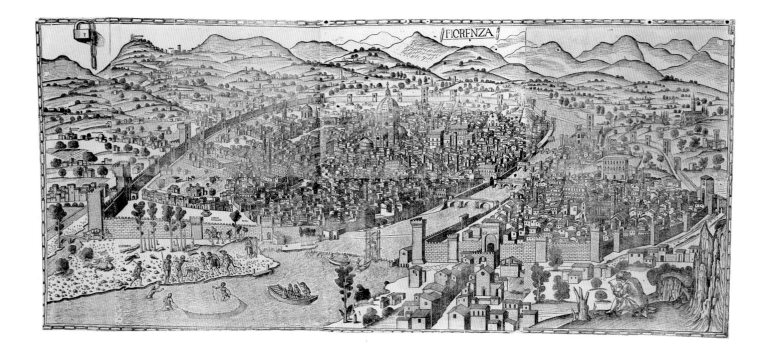

definitively match the *Tavola Strozzi,* and he commissioned a fourth as part of a *lettucio,* sent as a gift to King Ferrante.[40] David Friedman has argued that the *View of Florence with a Chain* encodes rhetoric in praise of the city. The exaggerated prominence of the Duomo at the center of the image, for example, evokes Solomon's Temple in Jerusalem and the Florentines' conception of their city as a New Jerusalem with the cathedral at its heart. Reuwich's treatment of the Temple as the Dome of the Rock may have influenced Rosselli.[41] Pope Innocent VII's motivations for commissioning the Belvedere cycle remain murky. He may have wanted to revive a classical form of villa decoration as well as make a political statement about his authority to marshal the forces of rival Italian city-states.[42] If the Belvedere cycle did have political meaning, then it would join the other three Italian images in breaking from the emblem format, while still remaining tied to its basic conception as a work of civic or personal and familial promotion.[43]

Reuwich certainly used his images to convey political messages, as we will see in chapters 3 and 5 for the *View of Venice, View of Rhodes,* and *View of Jerusalem.* Since the beginning of its development, however, the overarching genre of the 'view' has also carried an authorial voice within it that the *Peregrinatio* brings strongly to the fore. Picturing or writing about the view from a mountain or other commanding vantage has a long history, as an expression of the subject's experience of vision and of man's relationship to the built and natural environment.[44] While people of all eras have climbed mountains and gazed out at the vista, in the Middle Ages they did not publicly relish that kind of view as an important category of experience or as an appropriate subject for literary or visual representation. In our era, the view from above, photographed from a skyscraper or by

FIGURE 15
After Francesco Rosselli, *View of Florence with a Chain,* c. 1500–1510, woodcut. Kupferstichkabinett, Staatliche Museen, Berlin. Photo: bpk, Berlin / Kupferstichkabinett, Staatliche Museen, Berlin / Jörg P. Anders / Art Resource, New York.

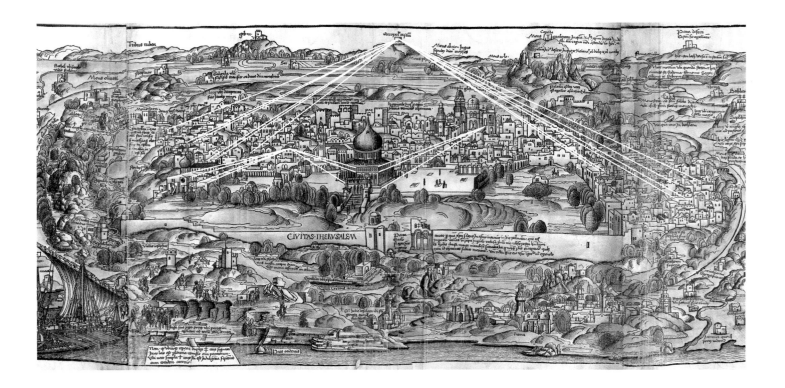

a satellite, can recapitulate the power of technology and rationalized systems, like modern cartography, to provide an overarching, abstract, and seemingly neutral representation of space. For the Romantics, the view could offer a privileged moment of revelation by bringing the subject in contact with the sublime. Beyond different periods' particular articulations of the genre and the issues it evokes, the view plays a fundamental role in the overarching history of Western art since the Renaissance. One of the core histories of that tradition describes an ongoing exploration of the interplay between mimesis and the viewing subject, brought together in the format of the painting that posits a slice of the world constructed as a slice of the viewer's field of vision.

The meanings of the word "view" reflect this conflation of an act of seeing—an instance of sight or an individual's field of vision—with the object of

sight—the prospect seen or depicted in a picture. These are then further entangled with the multiple uses of the word "perspective": it describes both an individual's view (with emphasis on how a particular vantage delimits the field of vision) and the artistic techniques by which such a view is represented, in particular atmospheric and linear perspective. And, of course, both words can refer literally to sight centered in the eye or metaphorically to mental or spiritual attitudes or cogitations. Within this rich semantic arena, the *Peregrinatio*'s woodcuts make most potent use of the intersection of "view" and "perspective," of the way in which an image of a vista, a 'view,' can point back outside its frame to the artist's or viewer's implied standpoint, his "perspective" or point of view.

The mathematical system that is the technique of linear perspective relies on this link between the

artist's standpoint and the image, and the manipulation of linear perspective has provided a basic means for investigating and expressing the relationship of viewer and viewed. The development of the pictorial genre of the 'view' in the fifteenth century dovetails, then, with another of the century's most vigorous artistic experiments, the development of linear perspective. Both are often analyzed in terms of their ability to deliver heightened mimesis, just as the achievement of the *Peregrinatio*'s images has been measured against their topographical accuracy. But the genre of the 'view,' the technique of linear perspective, and the *Peregrinatio*'s woodcuts also generate meaning in this other way, by exploring the dyad of viewer and viewed—or rather, the triad of the viewing artist, the viewing reader of the *Peregrinatio*, and their shared view of the people, places, and animals depicted. Embedded in a book, the *Peregrinatio*'s images speak also with an author's voice to a reader across a text, and it is this overlay of author-artist, reader-viewer, and text-image that makes the woodcut views of the *Peregrinatio* such an unusual and potent contribution to the emerging genre.

The *Peregrinatio*'s city views are helped along by their coarse use of elements of linear perspective, exemplified by the rendering of the Dome of the Rock (*Templum Salomonis*) in two-point perspective on the center stage of the *View of Jerusalem* (gatefold, figures 16, 84). The precinct around the Dome of the Rock, a plateau largely enclosed by porticos, walls, and buildings, is known as the Temple Mount in Judaism, for its legacy as the former (and future) site of the two destroyed (and to-be-restored) Jewish Temples. In Islam, it is the Haram al-Sharif (Noble Sanctuary) that Muhammad visited during the first part of his miraculous Night Journey (Koran 17:1). Italian experiments with perspective often worked with just such an octagonal shape isolated in a piazza; for example, the Second Temple inspired by

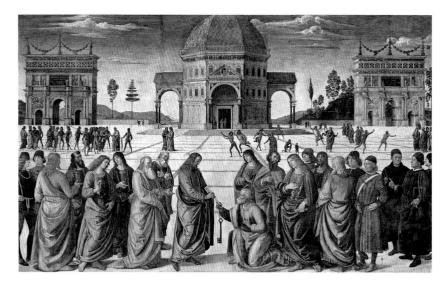

the Dome of the Rock in Perugino's circa 1480–82 *Christ Giving the Keys to Saint Peter* (figure 17) or Brunelleschi's rendering of the Florence Baptistery, one of linear perspective's most foundational moments. The orthogonals from the roof of the Al-Aqsa Mosque can be integrated into the Dome's perspective scheme; they intersect those from the left of the Dome of the Rock at a rough vanishing point midway between the two buildings.

That is the extent of any diagrammable precision. The orthogonals of the roofs of the structures around the Christian Via Dolorosa loosely come together in a zone above the Dome, where they meet their counterparts from the other side of the city. There are pockets of apparent disorientation, for example at the far right corner of the Haram, where the rendering compromises the clean lines of the complex. There is also a tipping forward of the front of the city that can be taken as a tactic to elevate Golgotha, which lies toward the rear. Of course, the streets and buildings *in situ*, including the elements of the Haram itself, are not laid out in a clean rectilinear pattern, so that perfect convergence

FIGURE 17
Pietro Perugino, *Delivering the Keys to Saint Peter*, 1482. Sistine Chapel, Vatican. Photo: Scala / Art Resource, New York.

would have required the artist to willfully remap the city according to an ideal plan. The heterogeneity of the pictorial space does not betoken flaws in the execution of an ideal. As discussed in chapter 5, for example, the minarets on the north (right) side of the Haram were recorded in detail independently and inserted into the composition, to be absorbed by formal techniques for proposing a unified view. With Reuwich, heterogeneity does not fracture perspective; rather, perspective and the rhetoric of the 'view' coheres the heterogeneity of artistically assembled elements that represent the historically and geologically complex space of the city.

The effectiveness of the *View of Jerusalem* as a work of perspective does not, however, rely on the geometric discipline of true linear perspective. Its persuasiveness arises from the image's ad hoc construction *from* a distinct perspective, and the text's verbal scaffolding of this visually rhetorical structure. For the *View of Venice* (figure 1), the island of San Giorgio across the canal from the Doge's Palace provided the standpoint; for the *View of Jerusalem*, it was a vantage on the Mount of Olives (figure 18), as explored in chapter 5. The images' power comes not from intellectually principled and rigorously consistent geometry, but from the binding of panoramic views both to the material circumstances of a book and to a narrative context that insists on the images' origin in an act of viewing.

Reuwich's views are the first explicitly connected to an artist's act of on-site looking, and the text is emphatic in establishing this relationship. Breydenbach does not just name Reuwich three times; he expounds his purpose in detail. The painter was brought along to portray the well-known cities skillfully (*artificiose effigiaret*) to the extent that it is possible to do so accurately (*quoad magis proprie fieri poset*) (7v, l. 7). In the German, the formulation that describes this drawing connotes a true

relationship to the original (*ab entwürffe, eygentlichen ab malet*) (10r, ll. 23–24). The beginning of the Latin encomium to Venice repeats this in another form, advertising that the city "is portrayed here according to what was seen" or that the city, "[shown] here was afterward portrayed as it looks" (*civitas veneciarum . . . hic sub aspectum consequenter effigietur*) (10v, ll. 40–41). The first is preferable to match the present tense of the verb, but the German translator seems to have found ambiguity. He uses the same phrasing as earlier, but interjects an odd parenthetical gloss on the Latin *consequenter*: "the mighty city and dominion of Venice follows after this, accurately drafted by the learned hand of the painter (afterward and maybe on par with)" (*eygentlichen [nach dem vñ eß mag syn vff eben] ab etworffen mitt gelerter handt des malers*) (14r, ll. 28–30). The absence of an image is also used to bolster the artist's credibility by seeming to demonstrate his willingness to withhold a picture rather than substitute someone else's experience or imagination. Even though pilgrimage galleys generally stop at the "rich and mighty" city of Ragusa, a strong wind kept their boat from nearing that port. Consequently, there is no view of Ragusa in the *Peregrinatio* because the city "was not visible enough to us that it could be accurately drawn by the painter."[45]

These passages also acknowledge the role of collecting and collating material, especially in the map, and together the praise of that work and the particular emphasis on the Holy Land sites support what the themes and organization of the volume also convey: the *Map of the Holy Land with View of Jerusalem* was the intended heart of the artistic program, even though the *View of Venice* filled more woodblocks. The Latin edition specifies that Reuwich depicted "the arrangements, positions, and forms of the succession of more powerful cities that make up the route of the passage by land and sea from the port

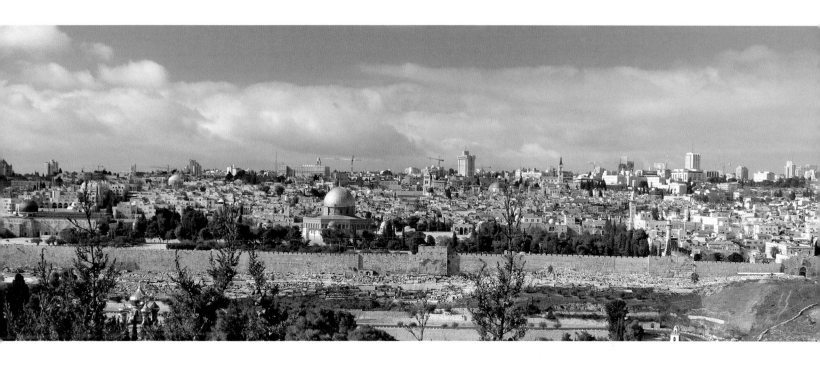

of Venice and especially of the sacred sites in the Holy Land" (7v, ll. 4–7). The artist did not just portray these elements; he also "transferred them to his map, a work beautiful and pleasing to see" (7v, ll. 7–8). In German his subject is "the notable places on water and land . . . and especially the holy places around Jerusalem" (fol. 10r, 23–24).

These Animals Are Truly Depicted as We Saw Them

This verbal and visual strategy is not limited to the city views. The caption on Reuwich's collection of animals reminds the reader that they, too, are supposed to be "truly depicted" as the pilgrims "saw them in the Holy Land" (figure 19).[46] Seven examples of Holy Land fauna are brought together within a single frame above those words, which the presence of a unicorn (*Unicornus*) seems swiftly to belie.

For today's viewer this mythical beast is perhaps the first, most conspicuous sign that we might have reason to doubt the images' claim to be based on an artist's on-site transcription of what he saw, though we would be wrong to read its inclusion as a deliberate lie. Frederike Timm has pointed out that Reuwich's views of Venice (figure 1), Parenzo, and Modon (figure 35) omit conspicuous fortifications and other structures erected before his arrival, while otherwise depicting the cityscape with unusual accuracy. The absence of the more recent structures suggests that woodcuts are based on acquired images drawn decades earlier. For Parenzo, a shift in the viewing angle suggests that Reuwich combined two views in order to create a more complete report.[47] The ploy of explicitly excluding Ragusa is all the more notable, as the pilgrims do include views of Candia, which they saw from sea but where they do not seem to have landed, and Corfu, where they stayed for only a short while at anchor on the outbound journey and

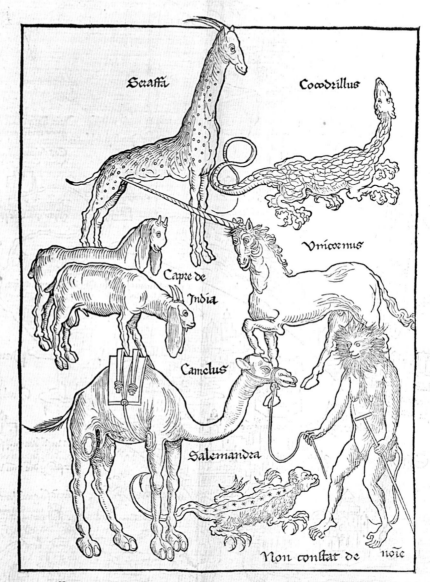

for a short winter's overnight on the return trip.[48] At issue here is not the original authorship of the drawings that underlie *Peregrinatio* woodcuts, but the intellectual and material labor of convincingly transforming heterogeneous materials into a unified body of work.

Elsewhere in the *Peregrinatio*, the author's declarations in the text implicitly caption the views with the statement "The artist saw this," but with the animals, the claim and the proposed object of sight come together on one sheet. This single page succinctly diagrams how the rhetoric of the eyewitness is constructed—and then used to credential and cohere a work that is in fact composed of elements drawn from representationally and epistemologically diverse sources. For this menagerie, the verbal statement's visual corollary is not the structure of the perspective view, but the pictorial format used to illustrate categories of flora and fauna in books of natural history, as in illustrated printed editions of Conrad's *Buch der Natur* (Book of nature) (figure 20).[49] Each chapter of Megenberg's book discusses one category (e.g., animals, birds, sea wonders, fish, bugs), and each begins with an illustration of members of the category loosely arrayed in a simple frame with minimal setting. The members of each group share certain characteristics of form and habitat (for example, wings and air for birds), and the illustration shows off the diversity of forms within the group while visualizing the textual catalogue that constitutes the text. Reuwich has borrowed a framing device that normalizes his collection as a category of natural philosophy. This repeats more succinctly how the peoples of the Holy Land are cordoned off in a documentary register, where they cater to curiosity with their own menagerie of costumes, but within a visually and textually disciplined framework, as explored in the next chapter.

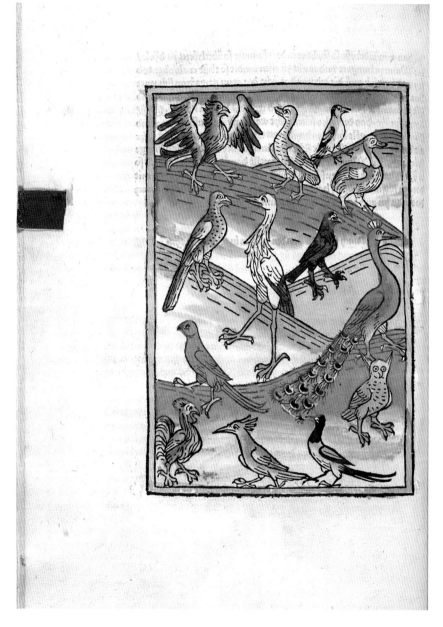

FIGURE 20
Birds from Conrad von Megenberg's *Buch der Natur*, 1481, hand-colored woodcut, fol. 81v. Library of Congress, Rosenwald Collection, Inc., 1481 .K6, 0151.

The treatment of individual animals encapsulates different types of experiences of the exotic, and the presentation of the group as a whole exemplifies how, as a book, the *Peregrinatio* framed and disciplined the expression of those experiences. At first glance, the "Indian goats" (*capre de India*) seem curious only for being utterly pedestrian amidst a collection of real rarities. But they belong where they are across from their partner, the unicorn, as marvels that work their wonder only in tandem with the viewer's expectations. Each of the Indian goats carries a single attribute that marks its difference from the homegrown variety: pendulous ears. In this period, well before the introduction of Eastern breeds, European goats sported only short, pointy ears. Pilgrimage accounts testify to the fascination of these types of differences, namely long ears and tails, in the most quotidian of animals, goats and sheep.[50] For the unicorn, the artist and his party had a name and a mental image before they had the opportunity to observe a real specimen. They brought with them an expectation waiting to be fulfilled, and it was. The knowledge the pilgrims (and the reader) bring with them about goats opens them up to a moment of surprise.

Reuwich had good reason to believe there were unicorns in the Holy Land; his Muslim guide pointed one out on September 20. The *Peregrinatio* relates that, while crossing the Sinai Peninsula to Saint Catherine's Monastery, the pilgrims saw "a big animal, much bigger than a camel," that their guide told them "was truly a unicorn" (139v, ll. 39–41). Felix Fabri specifies that they espied the animal standing at a distance on the top of a mountain. According to his account, the pilgrims thought it was a camel at first until their guide identified it as a rhinoceros or unicorn and pointed out the single horn growing from its head.[51] The pilgrims might not have believed their guide, however, had tourists' wonder

and wishful thinking and their own cultural mythology not already predisposed them to find unicorns in the wilderness of the Holy Land.

At other moments, the pilgrims, or at least Fabri, did suspect their guides were having a little fun at their expense. The guides' state of mind remains elusive, though of course Fabri thought he had figured it out. When he came to them on September 16 to ask the name of their campsite, as he did every evening on their way through in the desert, a guide paused and then announced, "Albaroch," with apparent mirth and to the general hilarity of the listening camel drivers. Or so Fabri imagined. They pressed the monk to write that down, which he did, despite what he understood as their continued laughter.[52] Fabri seems to have conveyed the information he gathered to Breydenbach, who gives many of the same campsites, including the place "named Abalharock in the Arabic tongue" (140r, l. 17). Ever tenacious, Fabri researched the meaning of the name when he returned home and claimed to have found the answer: al-Buraq ("lightning" in Arabic) is the winged mount that the archangel Gabriel let the prophet Muhammad ride from Mecca to Jerusalem for his Night Journey.[53] Fabri self-consciously suspects he was the butt of a jest, but he may have in fact received a straight answer. The group does seem to have been camping in a tributary of the Wadi el-Bruk, which can be said to flow to (*al*) Bruk.[54] Just a few days later, that same guide called the creature they saw in the distance a unicorn.

The giraffe represents a different outcome of the impulse to map experience with names. The animal carries an Arabic name (*scraffa*), one of the many transliterations brought back by pilgrims in this era to form the root of "giraffe" and its variants in European languages. The adoption of the foreign word marks a shift from *camelopardus* (literally, camel leopard), the Latin name used by the

Christian Fathers to remember a largely forgotten beast. Here the Arabic name also helps mark out the path of the pilgrim's wonder. Handlers brought a giraffe, a lion, and a baboon riding a bear to entertain the group in the courtyard of their lodging in Cairo.[55] Reuwich or one of his companions must have asked, "What is that?" and recorded what they heard of the answer, "Zarafa." In the act of transcription, the word slipped away from the Arabic toward what would become the German *Giraffe*. The visual form of the giraffe slipped, too, away from an actual giraffe toward the form the animal would take in the European imagination.

At the bottom of the frame, a humanoid form with an electric mane, a tail, and a walking stick faces a camel (*Camelus*) he holds on a tether. For this beast, the artist declares he does not know the name (*Non constat de nomine*). If the giraffe represents the foreign import or the lost object found under a new name, the ape-man stands as the object whose utter strangeness defies culture and its naming. The scale of the creature and the anthropomorphization bestowed by the props delay our recognition that he is simply a baboon, a "canine monkey" (*simia canina*), as Fabri calls the primate he saw with the giraffe, using an archaic descriptor carried forward in the name for one baboon species, *Papio cynocephalus*.[56] A former owner of a *Peregrinatio* in Houghton Library (f Typ Inc 156) helps bring the portrait into focus by coloring red the distinctive fleshy rump. The artist encourages us to mistake the monkey underneath the two miscues of scale and situation, perhaps to evoke the dog-headed people, the *cynocephali*, who were one of the legendary monstrous races thought to inhabit the margins of the world. Perhaps we see instead a caricature of the camel drivers who the pilgrims had to follow blindly and with some unease through the desert. Maybe he is the artist's last laugh at them. Or maybe he is just a play on the human characteristics that made monkeys a symbol in this era of man's folly and baser instincts. Either way, the artist himself is responsible for playing up the comedic or uncanny qualities of the baboon, and his refusal to name may reflect his ignorance as much as his desire to heighten the viewer's sense of wonder.

Each member of this zoo represents a moment of curiosity and that curiosity's visual expression. And each of these is composed of varying measures of preconception and openness, cross-cultural communication and uncertainty, and facticity and interpretation. Even within a class as narrowly defined as "Holy Land animals," these examples hint at the heterogeneity of the artist's encounters. We must also count al-Buraq, precisely because Reuwich does not depict him. He is the creature who translates from the Islamic cultural imagination only as an artifact of a pilgrim's self-consciousness in the face of his own vulnerability as an alien. The frame set around the group reduces them to a set of animals varied in physical form but alike as statements of fact; however, membership in Reuwich's category is not simply defined by a shared habitat. With the visual conventions of the page and then the caption, the pilgrims' complex perceptual experience of each animal is reduced to a straightforward truth statement, "we saw them," that functions much like the classification "birds have wings." Having been observed by the pilgrims becomes the property that delimits and naturalizes the set. This is how experience becomes information in the images of *Peregrinatio* and how the information in turn obscures the complexity and heterogeneity of the experience and its recording.

By such means, the *Peregrinatio* develops the authority of a duo, Breydenbach and Reuwich, who function as "artist-author" in a manner that strategically recharacterizes the nature of their actual contribution. He arises from the very structure of

the natural history box or the city views, which frame a collection of elements representing heterogeneous sources or aspects of experience in a way that obscures their origins beneath the leveling testimony of the artist's gaze. The historical Breydenbach uses the authority of this construction to resolve (or try to resolve) one of the challenges of his project: how to develop the new medium of print while remaining obedient to the established social structure of knowledge. Even if based at least in part on sources handwritten or drawn by others, the "investigating and learning," in other words, the seeking out, identifying, purchasing or manually reproducing, and integrating of the necessary materials would indeed have required "special diligence" that "spared no expense" during the course of their travels. What most distinguishes Breydenbach from the rabble of other would-be publishers whom he disparages is that by his lights, he does "know . . . [and] understand" the subject matter of his book. The sheer abundance of images and their freshness are meant to advertise this, as are Breydenbach's social credentials of hereditary nobility, knighthood earned through pilgrimage to the Church of the Holy Sepulcher, ecclesiastical office, and submission to the archbishop's judgment.

Foremost, Breydenbach *knows* because he *saw*; he has sifted the material of the book through the filter of his experience, so he professes, and used his experience (and his wealth) to gather the material of the book. This is the purpose of the repeated claims that the artist observed the sites and accurately depicted them. The assertion that the artist-author has seen everything represented to the reader then slides into the claim that everything is represented to the viewer as seen by the artist-author. The slip from one formulation to the other happens so smoothly that we initially overlook that it is the images—more precisely the formulation of images as the artist's

view—that conjure the sleight of hand. Casting their material in the first person of the view makes visible Breydenbach and Reuwich's strong claim to the special knowledge of the eyewitness.

At the same time, the creators of the *Peregrinatio* are also working within a traditional epistemological system that locates the ultimate source of authority in the communal consensus of a body of educated interpreters. These are the institutions for reading and scholarship that the archbishop moves to protect through his edict. Breydenbach seeks to position himself as an author who assimilates to a collective authority at the same time he adds to it; he undertakes to speak in the first person in order to have the *Peregrinatio* better accepted as a third person statement. This is, to his mind, a fundamentally conservative endeavor, but it demands a balancing act between "I saw" and "it is," between the voice of an author and outside authority, and between the individual's perspective and the communal overview. These are the demands that shape the assembly of the *Peregrinatio* and the crafting of its images.

Gart der Gesundheit (Garden of Health)

This understanding of the symbiosis of text and image can aid in interpreting Breydenbach's other major book project, the 1485 *Gart der Gesundheit*, whose *modus operandi* provides a dry run for the *Peregrinatio*. The name "herbal" that is applied to this type of work—a compendium of therapeutic plants with some minerals and animals—understates the genre's importance as a mainstay of period medical knowledge. While Schöffer's 1484 Latin *Herbarius*, the same kind of book, contained 151 woodcuts, the *Gart* incorporated 382 (including the printer's mark). It introduced sixty plants, ten animals, and eight minerals that had not been depicted in earlier

herbals, including Schöffer's *Herbarius* or even the manuscripts that transmitted the classical and medieval tradition. While over 300 of the illustrations were copied from miniatures in such manuscripts, as many as 77 seem to have been drawn fresh for the *Gart*, an assessment based on their style, their clearly identifiable form that is similar or true to nature, as well as the absence of any known models for them (figure 21).[57] The *Gart* was the first guide to medicinal plants in German and the first herbal in any language to supplement woodcuts copied from manuscripts with woodcuts based on drawings from life. It was also just as successful as and perhaps even more influential than the *Peregrinatio*, with at least twelve copycat editions before 1500 and over sixty before Linnaeus, for example the litigated version published by Christian Egenolf and discussed above.[58]

The text of the *Gart* was composed by Johann von Cube, who was named the city physician for Frankfurt in 1484. The core of the book is divided into 484 short chapters that each treat a different substance, and for each chapter Cube compiled information from standard works of medieval German medicine and pharmacological botany, in particular *Älterer Deutscher Macer* (older German Macer) and Conrad von Megenberg's *Buch der Natur*.[59] The Codex Berleburg, a miscellany of such works, has been identified as one direct source for the text and as many as 29 of the illustrations, though likely fewer.[60] Such vernacular works filtered the writings of classical authorities at quite some distance, but it is these prestigious authors with a certain patina, such as Galen and Dioscorides, whom Cube names.[61] Marginal notations and recipes for medicaments demonstrate that Breydenbach himself owned the Codex Berleburg at least in the years 1475–77, although the content of the annotations in multiple hands suggests that during this time others

FIGURE 21
Lavender from Johann von Cube's *Gart der Gesundheit*, 1485, woodcut, fol. 193r. Library of the Arnold Arboretum, Harvard University, Cambridge, Mass., Oversize KA G19.3 1485.

contributed recipes to address Breydenbach's various ailments (hair loss, weakening eyesight, loss of virility, and other problems related to aging as well as dermatitis, chest congestion, etc.).[62]

Nowhere does the *Gart* name Breydenbach, and beyond the Codex Berleburg, the evidence for his role in the project comes from a familiar-sounding passage in the foreword. There the unnamed author brandishes Breydenbach's signature rhetorical credential: dissatisfied with the available visual material, he undertook a pilgrimage that gave him the opportunity to learn in the company of an artist, who depicted the plants accurately.

> I had such a laudable work [the *Gart*] begun by a master learned in medicine, who according to my desire brought together in a book the potency and nature of many useful plants out of the [works of the] esteemed masters of medicine Galen, Avicenna, Serapion, Dioscorides, Pandectarius [Matthaeus Silvaticus], Platearius, and others. As I was in the middle of drafting and portraying the plants, I noted that many noble plants are those that do not grow in these German lands. I did not want to render those [just] on hearsay due to that, different from their correct color and form. Therefore, I left the work I had begun incomplete and hanging until I finished getting ready to travel to the Holy Grave, also to Mount Sinai where the body of the beloved virgin Saint Catherine rests in repose, in order to earn grace and indulgences. However, that such a noble work, begun and incomplete, should not remain behind [and] also so that my journey would not only save my soul, rather the whole world would want to come to [the] city [i.e., Jerusalem], I took with me a painter of reason with a deft and subtle hand. . . . I myself

learned there with diligence about the useful plants and had them portrayed and drafted in their correct color and form.[63]

The frontispiece pointedly underscores these claims with its collection of scholars, presumed to represent Cube's bringing together of said esteemed medical masters, and in the background a date palm evokes the Holy Land (figure 11). Were the painter of the pilgrimage not mentioned in the foreword, the compositional similarities between this frontispiece and other *Peregrinatio* woodcuts, in particular the framing arbor and the multicultural assortment of costumes, would still be enough to announce Reuwich's participation (likely together with other artists). In the *Peregrinatio*, the figuration of Breydenbach's credentials replaces the many contributors shown here, a reformulation that marks the shift in overall strategy toward bolstering Breydenbach's single authorial voice.

Scholarly consideration of this passage has focused on trying to reconcile or highlight the discrepancies in the foreword's account with the facts of the book. Johann von Cube's generous referencing of antique authors can probably be explained by the period understanding of lines of transmission; they did not distinguish categorically between original and reworking as we do. More saliently, the fresh illustrations from life (or in some cases perhaps from unknown, unusually high-quality models) by and large represent plants either native to middle Germany or nonnative cultivars available there, as, for example, the indigenously more southern lavender depicted here. Several excuses have been proposed for this, but these literal preoccupations minimize the real achievement.[64] As in the *Peregrinatio*, the emphasis is on the importance of Breydenbach's own research, and the artist's work is tied to his.

Certainly, the passage implies that Reuwich was brought along to make images of exotic flora, but it does not state that outright. Breydenbach is a bit cagey here, on the one hand flourishing the prestige of pilgrimage, but on the other hand subtly hedging his claims about the result. The text reiterates the stated aim of the *Peregrinatio*, that the painter was brought along to create images that would entice others to pilgrimage. And while the *Peregrinatio* says that for the city views Reuwich "drafted from" or "drew from" (*ab entwürffe, eygentlichen ab malet, eygentlichen . . . ab etworffen*), in the sense of drawn "from" life, the *Gart* omits that preposition. This may seem a subtle point, but it gets to the pith of the claims of the *Peregrinatio*. Now that the writer, and by implication the painter, have seen the plants, they can be portrayed accurately. He is vouching for their correctness based on his personal experience and conscientious research, enabled though travel.

The Artist-Author's View in Petrarch and Van Eyck

To watch Breydenbach position his works is to observe how an early printed book labored to establish its credibility and cohesiveness and how printed images benefited from this labor. The author bolsters his authority with the credibility of the images as authentic views; at the same time, the images gain credibility as authentic views from their association with an authoritative book, a book made authoritative through the author's conception and presentation of the *Peregrinatio* project. "View" here is used in its broadest sense as an instance of physical sight, as the more general input of experience, or as learned opinion. "Authentic" means the image avers to conform to the experience of the artist, who has recorded the sight himself or verified the representation against what he himself saw.

The bulk of this work in the *Peregrinatio* is carried out by the 'views,' and from its earliest Western medieval history the trope of the view was occupied with exactly the balancing act developed in the *Peregrinatio*. Either Breydenbach or Rath knew the writings of Dante, as the text of the German edition evokes the fable of the Old Man of Crete described in Canto 14 of the *Inferno*, a noteworthy allusion for a German cleric in the 1480s (33r, ll. 16–24).[65] There is no such sign that they knew his younger Florentine compatriot Petrarch, whose literary letter known as the "Ascent of Mount Ventoux" (*Familiares* IV, I) introduced the trope of taking in the view from a mountain. Yet that seminal work explored the triangle of viewing, reading, and authorship in a manner that closely anticipates the *Peregrinatio*'s struggles and solutions. In it, Petrarch describes an arduous climb as a parable of his struggle to keep to the spiritual path, the same basic metaphor that Dante had used to structure his cleansing journey up the island mountain of purgatory. Petrarch's letter begins with the pretext of wanting to provide the addressee, a friend, with immediate access to the author's interior life, and Petrarch as subject becomes visible to his friend (and other readers) through a narrative of his efforts to negotiate his entanglement with the outside world. He seeks the physical achievement of reaching the top, where he receives the sensory reward of the vista, but we recognize the discomforts and detours of Petrarch's trek as an allegory of spiritual labor and subjectivity, as a pilgrimage.[66]

At the summit, just as he is admiring the view, he serendipitously opens the copy of Saint Augustine's *Confessions* that he carries with him to an admonishing passage: "And men go about to wonder at the heights of the mountains, and the mighty

waves of the sea, and the wide sweep of rivers, and the circuit of the ocean, and the revolution of the stars, but themselves they consider not." "Stunned" and "angry" that he "should still be admiring earthly things who might long ago have learned . . . that nothing is wonderful but the soul," Petrarch continues, "I turned my inward eye upon myself."[67] That passage converts the commanding vista into a representation of the dangerous ambitions of man, and at this moment of the letter's climax it is neither Petrarch's interior self nor any perception of the world that provides that insight, but the reading of a book.[68] Here the parable of the ascent suggests Petrarch should assimilate himself to a guiding text that anchors knowledge, even self-knowledge, in outside textual authority.

Petrarch then turns away from Augustine's counsel as soon as he descends and sits to pen an account of his expedition—without delay, so he says, in order to capture the mood of the day. It is the act of authorship *after* the epiphany that addresses the self to the outside world. If isolated from the rest of the text, the narrative of the climb proposes a progression from engagement with the world to inner withdrawal, but the full up-and-down arc of the letter reverses this sequence. The author may turn from the vista and fall silent for the trip downhill, but he cannot remain silent for long. Petrarch turns to acknowledge the pull of his own authorship and self-witnessing, in particular, his self-assertion against the received testimony of other texts.[69] The letter's denouement in an act of writing connects back to its preamble, which promised to articulate the author's interior life; together they create a circuit that cycles between inner scrutiny and public confession, soul and world.

Standing on the peak of Mount Ventoux, Petrarch oscillates between two ideals, vista and book. They do not simply represent the world and the soul, but models of authorship and reading: the author who articulates the path of the soul through its worldly journey versus the reader who bows silently to sage authority. With the turn to the book, the view may seem to find rejection, but it is the interaction between the view and the book that provides the motor that propels the cycle of authorship. This pattern of independence and submission resembles the confessional cycle of sin and repentance, and the familiarity of the pattern sanctions Petrarch's personal experience with the paradigms of the church. Yet, beneath his sincere enactment of this orthodox process, one cannot help but suspect that the embrace of Augustine and the resolve, this time, to hold firmly to the lessons of his book coexist coyly with anticipation of the inevitable fall toward assertive authorship. Breydenbach and his artist attempt to reach the same equilibrium between eyewitness authorship and responsible reading with similar successes and failures, though without Petrarch's hint of knowing acceptance of the impossibility of sustaining balance at the summit.

The view arises here as a metaphor for the author's field of action. Petrarch's letter enacts the double duty of the eyewitness, who sees and testifies. Of course, this indivisible partnership of seeing and speaking, referent and image, is already inherent in any genre of representation as such. But Petrarch's 'view' does not just demonstrate this process. It justifies the act of authorship by outlining the rhetorical oscillations necessary for constructing a text around the representation (or pretext) of extroverted, personal experience in a culture that privileges introspective imitation of established authorities. This is the same basic challenge that Breydenbach and Reuwich assume.

In alternating between the ideals of reader and author, Petrarch moves also between imitating and emulating Augustine: as a reader he submits to Augustine's teaching; as an author he adapts the

Christian genre of autobiography-as-confession that Augustine originated. This mode of self-fashioning, especially in spiritual matters, widely pervades the culture of late medieval devotion and representation. The practice of Holy Land pilgrimage and the literary genre of pilgrimage accounts both find much of their justification in following the physical path of holy persons as an affective stimulus to following their spiritual path. One path of the rise of the subject as an object of reflection and representation goes something like this: the lay spirituality inspired by Saint Francis invites the soul-searching of humanists like Petrarch, followed by Martin Luther and his fellow Protestants; the individual then becomes conscious of itself as an entity for cultivation and representation in the struggle between conscience and society, interior and exterior, each to be balanced and rebalanced in different people, places, and times as one or the other side of the scale is encumbered or uplifted by *sensibilité*, technological rationalism, or the other cultural forces of the day.[70] This is a version of Petrarch's conflict between reading and authoring, conformity to outside authority and self-independence, writ large. Breydenbach and Reuwich attempt to recoup the oscillation at the top of Petrarch's mountain as a moment of balance. They try to fashion the book as a model of knowledge that both harnesses subjective engagement, as eyewitness author and affectively engaged reader, and then sublimates the subject's work into the ordered space of a socially sanctioned collective. They try to create a type of work that takes advantage of the new muscle of the subject, understood in the modern sense as the assertion of individual viewpoint, while still embracing the sense of the term as used in the period—an individual who submits to authority.

Both Petrarch and the *Peregrinatio* team imbue their account with suggestions that have convinced readers of a direct relationship between a trip up a mountain and its verbal or visual image. Petrarch swears that he opened his copy of *Confessions* without seeking any particular passage.[71] He chooses a local landmark, writes a letter, and heads it with a date (April 26, 1336), three specific gestures that propose a real-time day trip. We can be certain that Reuwich stood on the Mount of Olives and looked down on the city, even though Petrarch may not even have made the journey.[72] Reuwich uses a perspective construction that implies an individual vantage point, and as we will see, he describes both the topographical relationship of sites in the city and the Muslim architecture, including the most recent Mamluk architecture, with conspicuous accuracy. Yet, with Reuwich as with Petrarch, we cannot be sure how much of his account derives more from purposeful manipulation of other material. The question of whether they write about their own experience of a particular view should not, however, obscure the more important question: To what purpose do they say they do? For Petrarch, this device helps open the fissures in the strict analogy of author and model, so that we can watch a subject write himself into the cracks of his emulation of literary models. It also introduces something like the different degrees of reality in a painting with fictive architecture framing a narrative scene or in a play with a play within it. Petrarch appears to us more immediately than the other authors he invokes. In a similar fashion for the *Peregrinatio*, too, the conceit of a personal view establishes the author-artist's voice and distinguishes it above any others.

In its significance for the development of the 'view' as a trope about art-making, Petrarch's *Ascent* is matched in the visual arts by Jan van Eyck's *Rolin Madonna*, one of the works that enabled the Netherlandish landscape tradition (figure 22). In the *Rolin Madonna*, Van Eyck does more than introduce the view as a subject for painting, however; he visually

suggests the view as a metaphor for the painted panel. A man with his back to us in the middle ground bows over a balustrade, while next to him another man watches him peer out. The figures help lead the viewer's eye through the open channel between the donor and the objects of his devotion, to the very back of the aerie and beyond into the depths of the picture. The abundance of churches on the right side of the riverbank and the perfect alignment of the bridge with the Christ Child's gesture of blessing suggest a transcendent interpretation for the city on the right or for the act of crossing over to it from the donor's side of the river. The landscape seems to mirror the tableau in the foreground, where prayer bridges the divide between the donor and the sacred persons.[73] Whatever the meaning of the landscape, the middle-ground figures each repeat a position of the viewer standing before the painting, who both peers through an architectural frame at the view and watches the man in the red robe do the looking. With this device, Van Eyck draws an analogy between the experience of looking at the painting and looking at the view—particularly this exceptional fantasy of a 'view,' made possible by the artist's fine work and imagination.[74]

Here, as elsewhere, the artist revels in the power of his own fictions, but for all the realistic refinements of Van Eyck's style, the *Rolin Madonna* offers an inventive simulation that is at once the artist's great achievement and the work's boundary. In terms of pictorial forms, Reuwich may operate in the landscape tradition launched by Van Eyck, but he assumes a distinctly different model of authorship and authenticity. Van Eyck makes claims to facticity, but he uses his mastery of realistic rendering to exceed or point beyond the mundane, as here, with the suggestive landscape and divine audience. In contrast, period viewers were meant to understand Reuwich's city views as factual images, where

the presentation of the picture as a 'view' connotes the artist's on-site viewing, not, as in Van Eyck, the artist's art. By virtue of medium alone, Reuwich's woodcuts are more modest than Van Eyck's painted panels. But, while Reuwich's claim to simple truth may seem humbler than a virtuoso demonstration of artistry and invention, it is a powerful claim for an artist. And it results from the peculiar interaction of the making of art and the making of a book.

Christopher S. Wood has argued that this difference between the claim to art and the claim to documentation marks a fork where the history of art, namely painting, and the history of prints diverge.[75] He also uses Reuwich's reportage of the Holy Grave (figure 89) as an example of how the claim to mimetic resemblance begins to supplant older means of securing the authenticity of a copy.[76] Reuwich embraces the 'view,' however, not just for the persuasive power of mimesis, but for its diegesis—a schema borrowed from painting. Here the fault line does not run between the artwork and the counterfeit, but between mere resemblance and works that function by telling a story about their own creation and the viewer's place in their system. The *Peregrinatio* brings together several tactics to accomplish this—it structures the book as a journey (as discussed in chapter 3); it uses the logic of Netherlandish pictorial space to cohere its central image (as discussed in chapter 4); it summons the visual rhetoric of perspective (linear and otherwise); and it supports this with textual rhetoric about the *painter*'s view. And above all, it implicitly invites the viewer to step into the space the artist has opened for him, in the manner of the pervasive practice of spiritual pilgrimage (as discussed in chapter 5). The artist represents "I saw," and the viewer, in assuming the artist's vantage via the image, repeats "I see."

Reuwich was a real person, but the artist of the *Peregrinatio* is a useful construct who comes

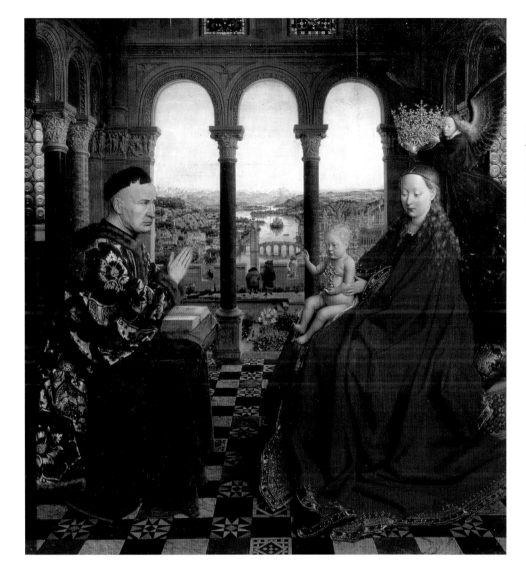

FIGURE 22
Jan van Eyck, *Virgin and
Child with Chancellor
Rolin*, c. 1435. Musée
du Louvre, Paris. Photo:
Gianni Dagli Orti /
The Art Archive at Art
Resource, New York.

together most persuasively through the viewer's
participation in the diegesis of the image, when
the viewer activates the testimonial force of the
view by taking the artist's view as his own. When
Reuwich embedded his view of Jerusalem into the
map of the Holy Land, the pull of the view from a
vantage on the Mount of Olives was so strong that
he defied the orientation of the map to include it.
Reuwich's map is oriented with east at the top and
the Mediterranean at the bottom, following the
conventions of one of his source maps, but his view
from the Mount of Olives looks west. To give us
that view, Reuwich has rotated the city 180 degrees,
so that we look both down from the mount and at
its image in the map (*Mons olivetti*) (figure 23). The
Mount of Olives figures twice in the Reuwich map,
once as the invisible standpoint from which we, the
artist and his readers, look out across Jerusalem,

and once as the point where the map turns into the artist's view. Exactly *there* at the map's *Mons olivetti*, the cartographic plain of Samaria and Galilee tilts backward, diverted and foreshortened around the back of the holy metropolis, as pictorial space rises into the foreground. The point on which the artist stood in depicting Jerusalem is pictured in the image as the spot where a map view is transformed into a view of the experience of the artist/pilgrim.

Select Passages Discussed in Chapter 2

FROM THE AUTHOR'S STATEMENT, *PEREGRINATIO* LATIN (ABBREVIATIONS EXPANDED)

22 (7r) Intentionis explicatio ·

 · · ·

40 Porro quo hanc meam profectionem siüe (vt aiunt
 reysam · vtilem non solüm michi sed et alijs fidelibus facerem · et maxi-
 me generosorum clarorumque hominum animos in eam ipsam magis magisque
43 commouerem · operam nauaui quam exactam · vt inter peregrinandum me de
 1 (7v) omnibüs que scitu necessaria diguaque essent cognitum facerem certiorem
 studiose singula perscrutando · nec vllis parcendo expensis · Huius rei
 3 gratia ingeniosum et eruditum pictorem Erhardum scz rewich de traiecto
 inferiori opere precium duxi mecum assumere vti et feci · qui a veneciano por
 tu et deinceps potiorum ciüitatum · quibus terre pelagique transitu applica-
 6 re oportet praesertim sacrorum in terra sancta locorum dispositiones · situs et fi
 guras · quoad magis proprie fieri posset · artificiose effigiaret · transfer-
 retque in cartam opus visu pulcrum et delectabile · cui declaratorias notu
 9 las · vel latinas · vel vulgares feci per quendam alium doctum virum ad vo-
 tum meum apponi · Quod quidem perfectum opus · impressorie artis ammi-
 niculo cunctis habere volentibus communicandum · vtinam atque vtinam · inten
12 to optatoque haud vacuum fructu euadat ·

FROM THE AUTHOR'S STATEMENT, *PEREGRINATIO* GERMAN, FOL. IOR

 1 Der meynung diß bůchs angebers vßdruckung ·
 [A]lle obertzelte ding vnd vrsachen wol besyndet vnd betrach
 3 tet ich Beruhart [*sic*] von Breydenbach . . .
17 . . . Daz aber sollich myne reyß nit alleyn
 mir · sunder auch andern menschen mochte nůtz werden · vnd besunder
 der edelen oder ander gelerten vñ prelaten gemůt so gemeynlichen dise
20 fart vermogen · dar zů geneygter wůrden · hab ich besundern flyß ange-
 wendet vff der fart · alle ding so nőt weren zů wissen vnderscheydlichen
 zů erforschen vnd erfaren · auch eyn gůten maler zů mir genōmen · der
23 die namhafftige stett vff wasser vnd land ab entwůrffe · vnd furnem-
 lichen die heyligen stett umb Jerusalem eygentlichen ab malet · do mit
 diß nachgende bůch sollich reyß beschribende lustlicher wurde so eß zů
26 vernunfft durch geschrifft vnd zů gesicht durch figuren wurde dyenen ·
 als man das hyenach vindet mit grossem flyß vorhyn wol gestraffet ·
 getrucket geschaffet werden · do mit eß dester gemeyner wůrde ·

Dē

12 nach habe ich solichs lŏblichs werck lassen anfahen durch einen mey-
ster in der artzney geleret · der nach myner begirde vß den bewerten
meistern in der artzney Galieno Auicenna Serapione Diascoride

15 Pandecta Plateario vnd andern viel kreuter kraft vñ naturen in
ein bůch zů samen hatt bracht · Vnd do ich vff entwerffunge vñ kun-
terfeyung der kreuter gangen byn in mitteler arbeyt · vermerckt ich ·

18 das viel edeler kreuter syn die in dissen teutschen landen nit wachsen
Darvmb ich die selben in irer rechten farbe vnd gestalt anders ent-
werffen nicht mocht dan von hŏren sagen · Deßhalben ich solichs an-

21 gefangen werck vnfolkomen vnd in der fedder hangen ließ so lange
biß ich zů erwerben gnade vnd ablaß mich fertiget zů ziehen zů dem
heiligen grabe · auch zů dem berg synay da der lieben iůgfrauwē sant

24 katherinē korper rastet vñ ruwet · Doch daz solich edel angefangē vñ
vnfolkomen werck nit hynderstellig bliebe · auch daz myn fart nicht
allein zů myner selen heyl · sunder aller welt zů stadt mocht komen ·

27 Nam ich mit mir einen maler von vernunfft vnd hant subtiel vñ
behende · . . .

35 . . . in durch wanderůg solcher konig
rich vnd landen · Ich mit fliß mich erfaren hab der kreuter da selbest
vnd die in iren rechten farben vñ gestalt laßen kunterfeyen vnd ent-

38 werffen ·

Mediterranean Encounters

LADY VENICE, HOLY LAND HERETICS, AND CRUSADE

IN LARGE PART, BREYDENBACH DESIGNED the *Peregrinatio* to arouse anti-Islamic zeal and enthusiasm for acting against Muslim power in the Levant, a purpose that is quickly apparent within the opening folios of text. This goal so strongly informs the book's presentation of the Mediterranean that the question of crusade comes first in exploring how the *Peregrinatio* portrays the peoples and places of the region, the subject of much of its most arresting imagery. Through the course of the book, Breydenbach specifies explicitly that he intends the *Peregrinatio* to serve several purposes: to encourage Holy Land pilgrimage, to offer information about the Holy Land for preaching and Bible study, to inspire a love for the Holy Land that will lead to its Christianization, to spur leaders to protect Christendom and the Holy Land from Muslims, and to serve as an educational prophylactic against Islam and other heresy.[1] Even the first two of these goals, oriented toward Christian devotion, are not just meant as ends in themselves, but also to prompt Christians to learn about and reject the invader. This becomes clear when an introductory synopsis of the book culminates with a prayer for God to infuse Christians with a love and desire for the Holy Land that leads to its recapture: "I ask the almighty God that he not only open the way to these lands for his true believers, but that he also infuse in them a great love and desire for the same, so that sometime they come again under the power and territory of Christianity, in praise to God and to the honor of all Christian people, Amen" (10v, ll. 9–13). He returns to this purpose also at the very end of the volume, when he uses similar language to explain his inclusion of reports of recent Ottoman advances:

> As I wrote at the beginning of this book, what I very much want to follow from this, the fruit of my work, is that from all that I have written, the heart and mind of pious Christian people is excited, strengthened, and ignited every day more and more against the grave, dangerous, and bloody enemy of the Christian name and faith, against the Turks and Saracens to afflict them in turn as they have afflicted us . . . because they intend to inflict grief on our lands, to lay waste to them, and wipe out the people, which they have also done in recent years. (167r, ll. 8–18)

The progression between these two passages also enacts the common slippage between the historical goal of the Crusades—retaking the Holy Land— and their new focus on defending against a different Muslim foe, the Ottomans, who did not govern the

Holy Land at that time. (In 1516, they would wrest it from the Mamluk Empire, based in Cairo.)

In choosing the theme of crusade for a rhetorical showpiece, the author joins a pervasive trend from 1453 through at least the mid-sixteenth century, as writers and public speakers took advantage of the emotional power and moral logic of the topic in composing political addresses of diverse sorts. Margaret Meserve has examined the spate of Latin responses to the Battle of Negroponte that were foisted upon local presses by Venetian humanists, for example, and Johannes Helmrath has drawn attention to the role of the *Türkenrede* (Turks speech) in the development of the art of oration at German Reichstage, where arrangements and taxes for a military response were regularly debated.[2] Breydenbach's use of print to promote crusade also neatly fits with the general state of affairs in the printing industry in Mainz. Campaigns to finance crusade in turn financed the printing industry with frequent commissions for a variety of supporting documents, and Mainz printers, in particular Peter Schöffer, subsisted by serving as a tool for bishops' consolidation of authority, including their selling— quite literally—the pope's plans to unseat the infidel in the East.

Ironically, the *Peregrinatio*'s most conspicuously novel materials, those showing off the imported influence of Venice, are arranged to serve this institutional purpose. For while the verbal rhetoric of crusade may have been pervasive in political and religious culture generally and in print shops specifically, the *Peregrinatio* team assembled a visual argument distinctly their own. Venice, glorified metaphorically as a bulwark against Muslim expansion, looms large in the book's largest cityscape, in views of several of her Mediterranean territories, and in the guise of a woman on the pedestal of the book's

very first page (figures 1, 2, 4, 45). She and her stalwart Christian metropolis are juxtaposed with a parade of heretics and the fallen city they occupy (Jerusalem).

At the same time that the *Peregrinatio* admires Venice thematically, it draws from her artistically, while also returning the favor by providing Venetian painters with fresh material for their own visualization of the Levant. Most formatively, in Venice the pilgrims lodged under the roof of Peter Ugelheimer, a Frankfurt expatriate closely tied to local printers through investment and friendship. He possessed a considerable collection of printed books, illuminated by local artists, that integrate a version of Islamic culture. Their presentation of Muslim learning serves as a foil to underscore the purposeful choices of the Mainz team, who harnessed Venetian formal influences to distinctly different ends. Reuwich's encounter with Venice is an independent subplot in the *Peregrinatio*'s larger story of pilgrimage, printing, and artistic exploration. It is likewise an integral element in the book's framing of Christendom's engagement with the Islamic Mediterranean.

Crusade in the 1480s and the Turks Tithe

The papacy had been attempting to unify Europe behind a new crusade since the Ottoman sultan Mehmed II captured Constantinople in 1453. Diplomatic maneuvering turned to official combat in 1463, when Ottoman advances in the Mediterranean and eastern Europe, including the capture of Venetian maritime territories, spurred the Venetian government to declare war. Pope Pius II died at the Italian port of Ancona waiting for crusading forces promised by other European powers to arrive, but the Venetians carried on without them, through the

dramatic loss in 1470 of their colony at Negroponte (today the Greek island of Euboea), until finally suing for peace in 1479. The cessation of hostilities with Venice freed Mehmed II to pursue campaigns against other Mediterranean powers, starting with the Christian Order of Hospitallers, who held the island of Rhodes, and then the Kingdom of Naples. In 1480, Ottoman forces laid siege to Rhodes for three months, a menacing if ultimately unsuccessful venture, before sailing on to seize Otranto in the Kingdom of Naples, a beachhead in the boot of the Italian Peninsula that they held for thirteen months. The death of Mehmed II in May 1481 notwithstanding, by the spring of 1483, when Breydenbach planned his pilgrimage, the recent history of Ottoman expansion looked like a two-decade march across the Mediterranean toward Italy. Breydenbach purposefully bolsters this impression by reprinting reports, one after another, on the fall of Constantinople, the loss of Negroponte, the siege of Rhodes, and the capture of Otranto to culminate the book (167r–180r). Of the attack on Otranto, the *Peregrinatio* recounts, "The Turk . . . set his heart and mind against Italy, even against Rome, in order to throw down the highest seat of the Christian faith" (179v, ll. 30–32).

When a papal conclave met in August 1484 for the election that month that would raise Innocent VIII, these events still reverberated in the politics and political propaganda of the papal court and European Christendom. The cardinals drew up a capitulation, an (unenforceable) pact of policies to be followed by the new pope, and on top of various reform initiatives, their agreement set a minimal level of papal income to be devoted to defending against the Ottomans, doubled that minimum with the realization of a military campaign, and called for the convening of a church council to advance crusade.[3]

In the buffer zone of land between the Holy Roman and Ottoman Empires, King Matthias Corvinus of Hungary had kept the Ottomans at bay with a series of victories, leading to a peace agreement in 1483. Despite this, aggressive maneuvers continued on the edges of eastern Europe, where the Turks captured two Black Sea forts on July 15 and August 9. News of this reached Rome at the beginning of the new papacy, and reports also arrived in those first couple of months from wary recent targets, namely, Naples and Rhodes, that the Ottomans were preparing another naval assault on Italy. Breydenbach, who had been dispatched to Rome to represent Mainz at the papal coronation, was present at the curia during September and October, when he obtained an indulgence for a Mainz confraternity and received his title of apostolic protonotary. On November 21, acting on the terms of the capitulation and in response to the newest developments, the new pontiff circulated an encyclical among European leaders to try and muster support again for crusade.[4]

In retrospect, this, like earlier papal efforts, may seem quixotic or, more cynically, a political gambit, but the taxes routinely instituted to raise money for these failed ventures seemed all too real to those assessed to pay. Since the First Crusade of the twelfth century, a tax on clerical income, applied by the pope or the emperor in different jurisdictions at different times, had been a crucial source of revenue for funding initiatives against Muslim powers in the Holy Land, Spain, and elsewhere.[5] In February 1481, the prince-bishop of Wurzburg, for example, had used his printer, Georg Reyser, to issue forms and guidelines for male and female monastics to use in paying the Turks tax recently requested at a minor Reichstag in Nuremberg. The Wurzburg bishop followed up in October with a printed notice demanding that recalcitrant clergy in arrears must pay up,

and then turned to the press two more times in December and January, once to threaten to excommunicate clergy who submitted payment to a rival local secular lord and once to lift the interdict.[6]

As no crusades materialized, there was considerable skepticism among fifteenth-century taxpayers that the money was properly used. Innocent VIII began another push for crusade in late 1486 with the sending of two ambassadors to the Holy Roman Empire to lay the diplomatic groundwork, inveigh against the Turkish threat, and get permission for the institution of a new levy.[7] The German clergy, already taxed by the empire, had organized against the burden of a Turks tithe in 1472, and they revived their complaint even before the new papal tax was officially promulgated in April 1487.[8] In March 1487, Henneberg was called upon to address his clergy's resistance officially by representing their case to the pope and the emperor and then by acting as a go-between in the back-and-forth over the issue through the Reichstag of 1495. As dean of Mainz Cathedral, Breydenbach must have taken part in these conversations in March and June 1487, when the dioceses of Constance, Basel, and Strasbourg brought their complaints before his chapter, who agreed to take up the matter with the archbishop and other Mainz clergy. The protest broached larger "taxation without representation" issues, in the sense that the clergy argued that they did not consent to the tax, and Henneberg's handling of the incident can be seen as part of his career-long pursuit of the goal of reforming the administrative and representative structures of the empire.[9] With rhetoric in support of crusade and the ostensible justification for the levy, the *Peregrinatio* was certainly timely, appearing in February and June 1486, just as the pope was turning his attention back to this issue in Germany and just as German grumbling was about to gain strength.[10]

Mainz Printing and the Selling of Crusade

Beyond taxes, the papacy increasingly turned to indulgences to raise money for anti-Ottoman operations.[11] Mainz's role in publicizing such indulgences reaches back to the very earliest years of European printing, when in 1454 a press using Gutenberg's type produced letters of indulgence for the defense of Cyprus. These were accompanied in the same year by a six-folio *Warning for Christendom against the Turks*, written in German and similar in its substance to a section of the *Peregrinatio* that likewise entreats rulers to take the crusaders' cross (120r–125r).[12] Crusade, papal policy, German debate over that policy, and printing come together in the matter of indulgences in a way that prepares for the preoccupations of the *Peregrinatio*. Hellmut Lehmann-Haupt has calculated that Peter Schöffer printed 128 small items in the years 1461 to 1490, 60 of which have to do with the Turkish threat. All of these 60 concern indulgences and their administration in some way and, therefore, trace their impetus, directly or indirectly, to the pope.[13] The printing of indulgence materials provided the bread and butter of Mainz publishing, as it did elsewhere.[14] These included blank indulgence certificates to be filled out with the name of the purchaser and sealed upon sale; papal bulls proclaiming new indulgences, explaining their terms, providing instructions for confessors, and appointing commissioners; public letters between the pope, emperor, and commissioners reiterating or clarifying aspects of the indulgence; and *summaria* that concisely announce and outline the benefits of an indulgence. The stated desire to find money to fight the Ottomans was the dominant stimulus for indulgence policy and, therefore, indulgence publications in the last quarter of the fifteenth century.

Indeed, it was ostensibly the need for crusade that motivated tactics to commercialize indulgences

in these decades, and it was these changes to the indulgence product that would, in the short term, raise new theological and policy questions to be addressed in print and would, in the longer term, arouse persistent criticism from Martin Luther and others. As we have seen, in 1477 Breydenbach helped prosecute one precocious heretic who had written against indulgences. That was just after the pope confirmed that indulgences purchased for dead persons were effective in reducing their sentences in purgatory, as part of a ten-year indulgence campaign begun in 1476 to raise money jointly for crusade and for the rebuilding of the Cathedral of Saintes.[15] The universal cause of crusade, which went beyond the regional matter of the cathedral, was used to justify the preaching of this indulgence beyond France, and Sixtus IV's first bull announcing the indulgence was printed in Mainz by Schöffer.[16] Other indulgences followed in 1480 to 1482 in the wake of events at Rhodes and Otranto, and several of these were also printed by Schöffer with supporting documents.[17] When the Saintes indulgence issued by his predecessor expired, Innocent VIII extended it and reallocated all of the proceeds for papal activities to defend Christendom from the Ottomans.[18] The Saintes campaign was also the first run by Raimundus Peraudi, who was named commissioner for a new crusade indulgence issued in Germany as part of the same fresh initiative that stirred up resistance to the Turks tithe in 1487. These crusade letters of indulgences were published by Schöffer in at least twenty editions in 1488 under the name of Peraudi.[19]

Beginning with the Saintes campaign and continuing through the 1480s, Peraudi implemented new features that made indulgences more attractive to the market. Whereas the efficacy of earlier indulgences had been exhausted with one use, this and later indulgences were made valid for repeated reapplication after further rounds of confession and contrition.[20] Extending plenary indulgences to the dead seemed to threaten the need for commissioning private masses for souls in purgatory, a major source of revenue for individual foundations. In response, Sixtus IV and Peraudi clarified the complementary nature of the two practices. Allowing a choice of confessor raised the possibility that purchasers would seek out a sympathetic and lenient ear, so to combat this Peraudi issued detailed instructions for confessors in an attempt to set uniform standards.[21] Each of these documents was distributed through print, and by Lehmann-Haupt's count, Peraudi commissioned so many printed documents that they form the majority of Schöffer's crusade indulgence–related publications. The stated imperative to raise money for crusade motivated a retooling of indulgences to increase their commercial appeal. That innovation in indulgences went hand in hand with their exposition and promulgation through printing. Papal attempts to mobilize Western Christendom against the Ottoman Empire may ultimately have had negligible effects on the military situation, but they had tangible repercussions domestically by providing the watchword for aggressive fund-raising activities with significant political, social, and theological consequences.

The voluminous use of printed materials to facilitate the sale of indulgences at this time has led the incunabula scholar Falk Eisermann to characterize the phenomenon as a "media event."[22] The campaigns were by no means carried exclusively through written, let alone print media. Publications directed at the laity were intended to be announced from the pulpit in the vernacular, and Peraudi, other commissioners, and their subcommissioners traveled extensively on preaching tours that drew focused bursts of attention and funds through the hoopla surrounding a distinguished cleric's reception and public declamations.[23] That said, in addition to using printers

to replicate *summaria* and blank forms, Peraudi and the pope leaned on print media as a means of centrally disseminating policy and, likewise, managing its consequences from the center. In this, the use of printing for indulgence campaigns coincides with episcopally authorized editions of liturgical texts, a phenomenon discussed in the last chapter and another significant component of Schöffer's work in this era. Both types of works attempt to harness print technology as a mechanism for strengthening the reach and effectiveness of institutional leadership. The *Peregrinatio* fits well the profile of a typical Mainz publication in these years: it was issued by a diocesan official who turned to Schöffer for help in using printing as a tool to rouse enthusiasm for a new crusade in implicit support of institutional fiscal policies and ideology.

The *Peregrinatio*'s Journey Between Venice and Heresy

The overarching organization of the volume, word and image, supports the work's textual appeal for greater resistance to Islam. The *Peregrinatio* team has composed the book so that the pilgrim's journey from Venice to the Levant is framed as the reader's progress from a stronghold that defends Latin Christendom to a foothold for the Islamic heresy that threatens the true faith. Of course, their voyage is also a religious pilgrimage from home to spiritual homeland (via curious foreign stopovers). Overall, author and artist present the Holy Land with a double vision that vibrates between offering up the center of Christian sacred history and an object lesson in the state of a contemporary conflict. Chapter 5 will address the book's Christian devotional view, while this chapter lays out the visual arc of its other mode of address.

The reception of the *Peregrinatio* confirms that period readers also saw and valued this basic duality between devotion and crusade. The first part of the 1522 French edition draws from the *Peregrinatio* pilgrimage, while the second part revives and reworks the crusading theme by stringing together histories of European campaigns against Islam from Charles Martel through recent Portuguese incursions into India. That second section opens with a foldout with two images, one of the pope giving his blessing to European princes departing for the Crusades and one of French forces before Jerusalem. They are accompanied by a poem urging "Christians, young and old, kings or poets, princes, merchants, bourgeois . . . to follow the cross in order to attain paradise"; that last line is repeated as a refrain through four verses.[24] Even a Czech digest of 1498 recognizes the two basic themes of its source material, the devotional pilgrimage and the agitation against Islam, by choosing to print two works based on the *Peregrinatio*, a *Treatise on the Holy Land* and a *Life of Muhammad*.[25]

Breydenbach sets up the *Peregrinatio* as the report of two chronologically consecutive pilgrimages, one to Jerusalem and a second to Saint Catherine's Monastery at the foot of Mount Sinai. Accordingly, he divides the book as a whole into two divisions, one for each of the two *peregrinationes*. By bracketing off his wanderings in Egypt and the return trip, he strips the first, more developed division of the book of any movement that would distract from the juxtaposition of two poles. This first division structures the pilgrims' progress as a chiasmus of fashion plate, praise/censure, and pictorial view. It begins with an image of a Venetian woman, a "speech of commendation" (*oratio commendaticia*) to Venice's Christian virtue, and a foldout visual paean to the city's grandeur. Then it concludes with the map and view of the Holy Land and Jerusalem, a caustic catalog of

the gross errors of Islam and other heresies, and a visual parade of the infidels and heterodox Christians who hold these false beliefs. The opposition is one of people and place cast also as the contrast of militancy against heresy versus surrender to it.

Freed of the gravitas of Jerusalem and the theological freight of a cleric's discussion of deviant doctrines, the second division echoes the themes and patterns of the first, though with a reverse movement from the sacred site back to the contemporary world. That segue from sacred time at Mounts Sinai and Saint Catherine back to the starkly present-day passes via an extended and even admiring account of the modern city of Cairo, followed by a list of Mediterranean islands and an Arabic glossary, and then the *Peregrinatio*'s most sustained coverage of current events in its reports of the last decade of Mediterranean defeats. At the very end, below the colophon, a turbaned woman holds an escutcheon with the printer's mark, and the comments of one reader show that at least he understood her as a Turkish damsel (figure 3).[26] If so, then the entire work is spun visually between two emblematic shield holders, the pilgrims' bare-shouldered Venetian and the printer's Ottoman in a translucent half veil.

This journey and the book as a whole are launched by the frontispiece featuring a Venetian, one of Reuwich's most original and meaningful offerings of the culture of foreign lands.[27] One reader went straight for the element of her dress that Northerners seem to have found most conspicuous: he took a pale yellow wash to her décolletage and then picked out the scrota visible on several of the putti climbing the arbor above her (figure 24). This copy of the book once belonged to a monastery of Observant Franciscans in the Moravian city of Olomouc, though we cannot know if this was the work of one of the friars. Nor is it apparent if the reader meant to highlight or to obscure these details. Either way, they

certainly drew his attention. This might seem a surprising interaction between artist and reader to open a book about the sacred sites of the Holy Land, but the curiosity of such a low-cut dress and the reader's attention to it recapitulate a common experience of pilgrimage.

Virtually every European pilgrim to the Holy Land passed through Venice, and pilgrim after pilgrim commented on exactly those aspects of that city's distinctive dress that are most striking on the lady in the *Peregrinatio* frontispiece. They expressed indignation at women's immodesty or fascination with the richness of their adornments, particularly the piles of false hair and jewels. Brother Paul Walther von Guglingen, whose manuscript account of the peoples of the Holy Land is adapted by Breydenbach, censures the exposed shoulders and décolletage while suggestively declining to give voice to the ladies' other sins. Felix Fabri, the Dominican preacher from Ulm who likewise traveled with Breydenbach from Jerusalem, disparages Venetian ladies for going about dressed more like the famous pagan temptresses Helen and Venus than like Christian women. In 1491, yet another German pilgrim, Dietrich von Schachten, draws attention to the ladies' teasing attempt to cover their bosom with sheer fabric, while comparing the women's piling dyed and frizzy hair on their heads to the Germans' binding up the tail of a horse.[28]

The book opens then just as an actual pilgrimage does, with a first encounter with the exotic luxury, foreign mores, and grandeur of Venice embodied in the curious fashion of their women. Almost a decade later, Albrecht Dürer would visualize this little drama, where German curiosity, admiration, and class-consciousness face up to Venetian splendor (figure 25). A woman in the costume of a Nuremberg burgher's wife surveys a Venetian, who stands out in front and taller (undoubtedly boosted

by her high platform shoes), without returning the Nuremberger's interest. The lady of the *Peregrinatio* frontispiece also makes sure to show off one of her chopines peeking out beneath her skirt on the left.

The presentation of such a woman in the *Peregrinatio* is all the more novel because Venetian mores encouraged the sheltering of respectable women from both the street and portraitists. The Veneziana's display in the *Peregrinatio* is a unicum in the north, but it is also a rarity even within her native city. There are few Venetian images of women in

contemporary dress from the 1480s, and after that it is only in the 1490s, almost a decade after the publication of the *Peregrinatio*, that more secular images of women appear that strongly corroborate the source of the fashion.[29] Recognizing the woman of the frontispiece's singularity makes even more pointed her contrast with the women of the Mamluk Empire that open the *Peregrinatio*'s illustration of the heretical peoples of the Levant (figure 26). Both offer striking first specimens of the women of the East.

Before Reuwich, figures in imagined Eastern dress did populate illustrations of biblical events or chronicles, battles against Eastern foes, tales of Alexander, or travelers' tales.[30] Artists such as Martin Schongauer fabricated turbaned characters as studies for biblical scenes that took place in the East or as independent compositions, and heads of Moors appeared regularly as crests attached to coats of arms.[31] None of these images had the pretense to eyewitness validity that the *Peregrinatio* establishes for Reuwich. Of all Reuwich's studies of foreign peoples, it is this Venetian, not the Saracen, who stands out for the drama of her placement (on the page and in the book), the splendor of her costume, and the surplus of observed detail. Her own exceptional rendering makes her especially suited for her role as ambassador, not just for the city, but for the distinctiveness of the *Peregrinatio* and its illustrations. Reuwich offers detailed and precise observations, beginning with the high-waisted, off-the-shoulder overgown, slit in front to reveal a second skirt below and with the outer edge of each sleeve also slashed to allow the chemise to puff through between ties that hold the sleeve together. A fringe of wavy hair softens the woman's face beneath her sugarloaf hairdo, while rich embroidery or jewels in a variety of floral motifs extend the vegetal profusion of the rest of the image to the borders of her person.

Most of the pilgrims who reported on the ladies of Venice, particularly the clerics, sneered at the attributes that the *Peregrinatio* woodcut puts on display, and Dürer famously recast one of his Venetian models as the Whore of Babylon in his *Apocalypse* woodcuts (figure 27). (Yet, beyond Fabri's allusion to Helen and Venus, none of the pilgrims acknowledges the possibility that the women they see may belong to Venice's famous collection of courtesans.) Reuwich's visual record of Venetian womanhood offers a more admiring attitude that harnesses this very

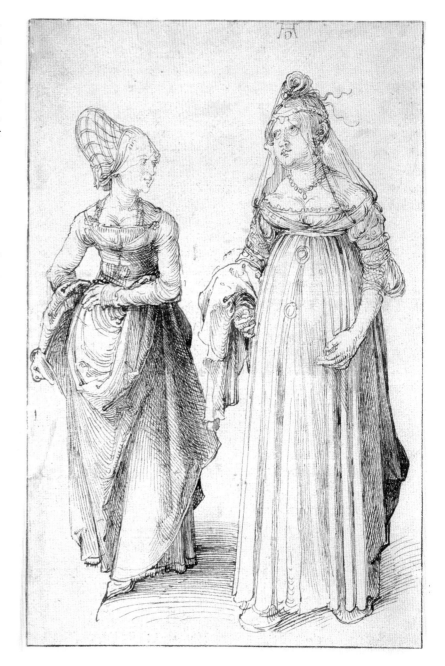

vt in eis erudiret israelem et vt consuetudinem haberent preliandi ꝛc.
Sic fortassis idipsum non incongrue dici potest in proposito vt scili
cet sarracenos dimittat dñs vel in flagellum vel exerciciū populi xpia
ni. Sed ego nichil temere diffiniens id doctoribus relinquo. Hoc vnū
scio psalmista testante. quia iudicia dei abissus multa ꝛc. Quis autem
nouit sensum dñi. aut quis consiliarius eius fuit. Apostolis etiā cla
mat. O altitudo diuitiarū sapientie et scientie dei. ꝗ incōprehensibilia
sunt iudicia eius. et inuestigabiles vie eius. Et tantū de Sarracenis.

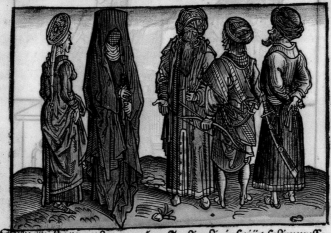

Sarraceni lingua et littera vtitur Arabica hic inferius subimpressa.

Dal	Dal	Keh	Heith	Gzim	Tech	Te	Be	Aleph
ꝛ	ꝛ	ꝛ	ꝛ	ꝛ	ꝛ	ꝛ	ꝛ	ꝛ
Ayn	Dacz	Ta	cdachua	Sad	Schzin	Szyn	Zaym	Re
ꝛ	ꝛ	ꝛ	ꝛ	ꝛ	ꝛ	ꝛ	ꝛ	ꝛ
hehe	Nün	Mym	lam	lam	caph	kablz	ffea	Gayn
ꝛ	ꝛ	ꝛ	ꝛ	ꝛ	ꝛ	ꝛ	ꝛ	ꝛ
dolfuda in poxe	ye	lamoleph	wau					
ꝛ	ꝛ	ꝛ	ꝛ					

exotic magnificence, as he uses this woman to introduce both his book as well as the coats of arms of the book's noble backers. The lavish coloring and vellum substrate of two copies in the British Library suggest that they were specially printed and decorated under the auspices of the book's creators as presentation copies. If so, then it is interesting to note that that colorist, who uses a different palette for each exemplar, nonetheless consistently misunderstands, perhaps intentionally, the extent of the woman's exposure, rendering opaque the cloth above the jeweled neckline. That would have been a diaphanous tease of a covering separate from the rest of the gown, as the uncolored image and other colored ones suggest.

This eye-catching figurehead is followed shortly by further textual treatment of the city. After prefatory materials, Breydenbach cursorily describes the pilgrims' departure for Italy before immediately outlining the content of their contract with their sea captain. The text then lists the relics of Venice and environs, a standard set of sites sought out by pilgrims waiting to take ship. Any meaty description of the city is reserved for the next section, the speech of commendation that praises Venice for her prosperity, her empire, and her role in defending Christian territory.[32] Across six pages, the *Peregrinatio's* oration lays out the author's admiration for Venice as an exemplary Christian capital that stands alone against the Turks, echoing themes current in the propaganda of Venetian diplomats.[33] Its inclusion, together with the reports of Ottoman conquests offered at the end of the *Peregrinatio*, shows the Breydenbach team collecting contemporary materials, including Italian ones, that address and respond to current events in the Mediterranean conflict. But, while the reports of the battles of Constantinople, Negroponte, Rhodes, and Otranto offer recent history and news from the front, the speech of commendation is detached from any specific history to

FIGURE 27
Albrecht Dürer, *Whore of Babylon* from *Apocalypse*, 1498, woodcut. Bibliothèque nationale de France, Paris. Photo: Bridgeman-Giraudon / Art Resource, New York.

present Venice as the persistent Christian heart and anchor of the Mediterranean basin, a vital cultural and military counterpoise to Muslim domination and heresy in the East.

It begins by praising the history of the city's founding by refugees from Troy and the strengthening of her ranks by rich and powerful men fleeing

the tyrant Attila's persecution of Christians. The author proceeds to admire how the city's expansion brought more lands under the shelter of this social order, and he then sketches the territories of the empire, including the agricultural bounty of the Veneto and the coastal towns and islands of the Adriatic and Mediterranean. He supports his portrait of an empire with a laudatory description of the number of available soldiers and ships, the outfitting and provisioning of the military, the size and productivity of the shipyards, the volume and reach of the city's sea trade, and the enforcement of military discipline. While these topics may seem like separate items in the flow of the text, they all serve to elaborate the central image of the strength and grandeur of the Venetian Empire by extolling her noble origins, longevity, prosperity, good government, industry, and military might. In comparison to the accounts of other pilgrims, with their tourist's wonder at false hair and bare shoulders, this text remains unusually focused and exclusively concerned with issues of state.

The speech of commendation culminates with an evocation of Venice's virtue and piety, understood as a specifically Christian rectitude that protects Christians and Christian interests at home and to the tips of her wings. "In their lands, the Venetians tolerate no sects contrary to the laws of God" (16r, ll. 34–35). This concise statement resonates strongly in a book that is at other moments preoccupied with detailing the varieties of heresy and condemning their proliferation in the Holy Land. The Venetians do not just persecute heresy at home, they bring all their strength to bear against the enemies of Christ abroad:

> For a long time all alone out of Christendom, she [Venice] has done her part because of her love, piety, and fortitude by contesting, persecuting, afflicting, indeed dislodging in many places, with great cost and work, truly, diligently, and in a manly fashion, the unholy Turks, the strongest and most harmful enemy, hater, and curser of Christian blood, indeed persecutor of the cross of Christ. [She] has set herself as a wall for the Christian Church, so that of those who give help and support from all the wide territory of the Church, no one else, spiritual or temporal, is found who so greatly demonstrated their faith and piety to God and the Church so entirely without a doubt (16r, l. 36, through 16v, l. 4).

This passage does not bring the encomium to a close: continuing the classical flavor, the author tacks on a final paragraph commending Venice's good government and then invoking Cicero, who could not create praise that does justice to this topic. But this passage does bring the entire essay to a climax. The details about shipyards and sea trade explain how the city sustains her empire. When such strength meets such solid Christian faith and fortitude, the city can fulfill a vitally important mission.

No other Christian power, neither the pope nor the emperor, could match Venice in its dedication to and efficacy in resisting the enemies of Christ; Venice stands, then, as a role model of Christian engagement with the forces of Islam. The republic's distinction as a model of Christian attitudes and actions in the region explains the choice of the frontispiece costume and leaves little doubt that the lady is meant to reference Venice, not some other luxurious figure or ideal. The pomegranates growing up the right side of her arbor reinforce the implicit call for others to follow Venice's model and join the cause. Since the writings of Pope Gregory the Great, the mass of seeds encased in a single hull has symbolized how one faith unifies the innumerable peoples of the church.[34] In this context, the grandeur

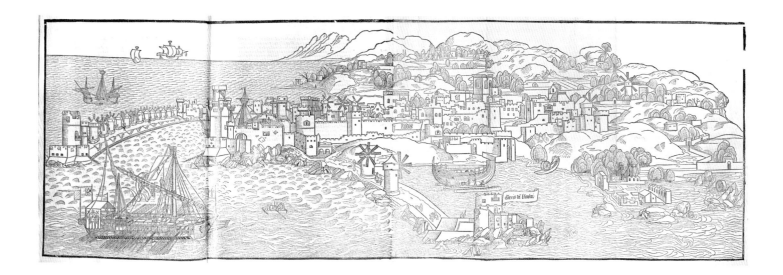

and elevation of a Venetian lady on the frontispiece befit her role as a representative of her city, and she stands as a particularly fitting emblem for the purpose of the book.

The view of Venice, the largest illustration of the book printed over eight leaves, was intended to complement the speech of commendation (figure 1). At the beginning of that section in the German, Breydenbach tells his readers to expect the image to follow, which it does in every edition (14r, ll. 28–30). The view of Venice does not just impress through the sheer scope of the panorama covering 180 degrees of the artist's field of vision from the *Theloneum* (Customs House) at the tip of Dorsoduro to the Rio di San Martino. The breadth of the view allows the *Peregrinatio* also to convey the bustle of shipping, commerce, and maritime power through detailed vignettes of ships, as well as daily life and work, at the foot of the city's proudest landmarks. Together, the exceptional city view, frontispiece, and encomium signals an outsized role for Venice in the conception of the *Peregrinatio*. The *Peregrinatio* account then continues with brief reports of islands in the Mediterranean, illustrated with five smaller

views of Parenzo (modern Poreč, Croatia), Corfu, Modon (modern Methoni, Greece) (figure 35), Candia (modern Heraklion, Crete), and Rhodes (figure 28). All of the images are wholly integrated into the text; the first or last two leaves of the foldouts are bound in the book with text printed on the recto of the left bound leaf or the verso of the right one. Damage to towers in Rhodes and the corpse hanging from the gallows on the shore in the background remind viewers of the depredations of the Ottoman siege of 1480 and the execution of a traitor in its aftermath (an event reported in the *Peregrinatio*'s account of the battle) (figure 28).[35]

After crossing the Mediterranean, the pilgrims arrive in the Holy Land, and the author describes their tour of the sites in and around Jerusalem, followed by a geographical description of the region from Damascus to the edge of the Egyptian desert and a descriptive list of that area's many mountains. After the geographical material, the treatment of the far pole of their journey pivots from devotional information back to the book's other focus on contemporary concerns. Here, at the far end of the first division of the book, the *Peregrinatio* lays out

FIGURE 28
Erhard Reuwich, *View of Rhodes* from *Peregrinatio* Latin, fols. 33v–36r. Beinecke Rare Book and Manuscript Library, Yale University, Zi +156, Copy 2.

a catalog and history of heresy that implicitly con-trasts the sullied state of the Holy Land with the Christian rectitude of the port of embarkation fea-tured in the first view. The text continues with sup-plementary information on the history and errors of Islam and other Christian heresies represented in the Holy Land. After a preamble (79v–81r), this opens with a disparaging biography of the prophet Muhammad (81r–85r) and short refutation of the Koran "for the sake of the simple laity" (85r–85v), followed by a dialogue between a Muslim and Petrus Alphonsus, a famous convert to Christianity from Judaism in the twelfth century (85v–89v). The Mus-lim confronts Alphonsus with the articles of Islamic faith and asks why Alphonsus did not embrace *them*. Petrus responds at length, refuting each article in turn. After the dialogue, the *Peregrinatio* persists with a twenty-eight-page discourse "on the Sar-acens and their customs and errors" (89v–100r), followed by a commentary opposing any points in the preceding pages found too conciliatory toward Islam (100r–103r). In particular, the *Peregrinatio* tells us that the doctor who wrote those pages erred in arguing that the Saracens, however reprehensible, are the best of all types of idolaters because they honor Christ in their own way.

Then begins a catalog of the peoples of the Holy Land, with Saracens at the head of the series both to crown the examination of Islam and to stand as the outer limit of a scale of heresy that runs from Islam to Judaism through the Eastern Christians—Greeks, Syrians, Jacobites, Nestorians, Armenians, Georgians, Ethiopians named "Abyssinians or Indi-ans," and Maronites—to the orthodoxy of Latin Christendom. While the other images of people accompany a textual entry from one to four pages in length, the *Saracens* illustrate the entire sup-plementary material on Islam, or at least the long text on "their customs and errors" that precedes

them. Reuwich only had time to illustrate five of the entries (Saracens, Jews, Greeks, Syrians, Ethi-opians) (figures 26, 30–32, 34), but where an image does not appear he left space for one, as if it had been planned but never executed. In the Latin edition, all but five entries (Nestorians, Armenians, Geor-gians, Maronites, and Latins) are also accompanied by a table that exhibits an alphabet that is meant to belong to the group's language, though the Jacobite Syrians, somewhat confused with Egyptian Copts, are represented by Coptic. The German edition adds an Armenian alphabet. In between the last of the heretical groups and the Latins, the author interpo-lates a "necessary and weighty disputation" against the errors of Christians who stray from the Western church's true teaching (113v–117r).

After the Latins come a trinity of laments over the heresy of the East and Western rulers' neglect of the problem: "A short lament over the Holy Land, especially Jerusalem" (118r–118v); "Another lament over the whole orient" (118v–120r); and a "A lament over the woeful state of the churches in the West with a serious admonition first in general, but after that especially to the princes of the empire to be more diligent in helping and protecting the churches" (120r–125r). If Venice is a role model, then in this last lament Breydenbach fears that pope, king, princes, knights, and clergy will not live up to that ideal, instead slumbering "a difficult dan-gerous sleep" that leaves the West vulnerable (120r, l. 36). This lassitude and Christianity's tribulations stem from a moral decline throughout all sectors of society: "the entire world is set in an evil fire or in evil within which they burn" (123r, ll. 9–10). That metaphor provides a clue to the meaning of a pas-sage from Vincent of Beauvais's thirteenth-century *Speculum Historiale* that follows these laments to conclude the first division of the book (125v–126v). This closing sequence repeats the basic message of

the laments, both its direct appeal to leaders and its more general admonition against turpitude, but in a different form. In a dream, an angel guides Emperor Charles the Bald (d. 877) to hell to show him how members of his line and their advisors burn as punishment for their failings and poor policies.

As examined more closely in chapter 5, the view of Jerusalem (gatefold) foregrounds visual markers of the Muslim control of the city in order to rouse the type of grief that inspires these laments, while at the same time offering imaginative entrée into a landscape assembled for Christians' visual possession. This final foldout, the six-leaf *Map of the Holy Land with View of Jerusalem*, belongs, then, with the supplementary material at the end of the first division, just as the *View of Venice* belongs next to the commendation that sets up the juxtaposition. And indeed, the text indicates explicitly that the author expected the information in the geographical description to elucidate the *Map of the Holy Land* located near it in the volume.[36] Just as the view pivots from supporting Christian devotion to promoting zeal against heresy, so would it accompany the verbal material that makes this pivot within the text.

The map's actual placement varies. In Latin editions, there is no printed text on the bound leaves, and the map appears near the end of the book as a whole, after the pilgrims' safe return to Venice and before the Mediterranean mileage chart, Arabic glossary, and accounts of contemporary Ottoman aggression. This anomaly was not the original intent. Rather, it signals that Reuwich was rushing to finish on February 11 in order to get Breydenbach and the books to Frankfurt, where the imperial estates (and their attendant crowds of potential customers and influential readers) had convened before February 16 for the election of the emperor's son, Maximilian I, as king of the Romans, making him coruler of the empire and formal heir.[37] The printing of the text

of this edition seems to have been pushed forward before the map blocks were completed. In the German edition, the map moves up to the end of the first main division of text, just after the material on Islam and Holy Land heresies. In the Dutch edition it falls with the geographical description, where the text anticipates it.

The *Peregrinatio*'s designers intended, then, that two pairs of texts and image—the encomium to Venice and the laments for the Levant, the view of Venice and the view of Jerusalem—should frame the first division of the book and present the pilgrims' understanding of the balance of culture and power in the region. We can add the women of the *Peregrinatio*, the Venetian of the first image and the Saracens of the first image of heretics, to these pairs that establish a face-off between Venice, the guardian, and Islam, the occupier. The author's description of the Holy Land must include a lament of its loss; his call to rouse Christian interest in the Holy Land and pilgrimage must spur them also to learn about and reject the invader. The great empire of Venice carries the Christian standard in the Mediterranean, and the city garners its special importance in the *Peregrinatio* for playing this role. The author and artist took care to set texts and images about Venice against the material on Islam. In the absence of an outpouring of God's grace to restore those lands, Venice stood against their unholy rulers.

Other Heretics of the Holy Land

Amidst the abundance of curious information in Reuwich's images of the heretic peoples of the Holy Land, there is nonetheless an underlying reticence that works to support the *Peregrinatio*'s claims to facticity. The choice of subject matter has been limited to what the pilgrims could plausibly claim

to have seen, and the woodcuts' staging within the book further sequesters them in a distinctively documentary register. This discipline comes into clearer focus when comparing what the *Peregrinatio* team did to what they could have done; particularly with their presentation of the peoples of the Holy Land, they knew of other options that they modified or ignored. Much of the artistic effort of the book lies in its assembly as a type of multimedia bricolage. The juxtaposition of the *Peregrinatio* and its alternatives draws attention to the intellectual and creative agency behind the work and behind the illustrated printed book as an art object.

While most of the *Peregrinatio*'s supplementary material on Islam was not commonly found in pilgrimage accounts, description of the peoples of the Holy Land occurred quite frequently, and Reuwich has invented a series of illustrations for this established textual tradition. The various Christian sects were usually presented as part of the tour of the Church of the Holy Sepulcher, and they belong to the tradition of verbal images of that most meaningful place. The convention of attaching the nations to the church surely arose from literal experience. As is still the case today, the Christian groups each maintained a presence at altars and chapels assigned to them, and Latin pilgrims saw them there.[38] Pilgrimage accounts often list the nations together with the altars they tend, and the conditions of this literal experience then point easily toward a larger metaphor.

Among the stations of the Church of the Holy Sepulcher, a round stone under the dome of the crossing was said to mark the center of the world. In a drawing based on Reuwich's that was used to illustrate one of the manuscript accounts of Konrad Grünemberg's 1486 pilgrimage, the inscription above the dome, hovering over the entrance portal, makes this explicit (figure 29). The Latin pilgrims saw the members of world Christendom assembled together under the shelter of the church that is the hub of both the Christian Church and the globe of the earth. In the *Peregrinatio*, as in other accounts, the mention of the nations comes directly after the description of this geographic and spiritual axis. To describe the sects as a circuit of altars and heresies arrayed around this stone in the Church of the Holy Sepulcher is to describe a microcosm of the world.

However, while the *Peregrinatio* briefly mentions the presence of the nations in its description of the Church (50r, ll. 10–15), implicitly acknowledging their customary placement, it points readers toward the more comprehensive treatment later in the book, shifting the main discussion of the nations from the tour of Jerusalem to the end of the long discourse on Islam. The groups have been removed from the symbolic confines of the Church, so that instead of a centripetal model spun around the Christian center of the world, the *Peregrinatio* sets up a binary opposition between the true belief of the regions of the Latin Church and the heresies that hold sway in the Islamic East. In making this change, the *Peregrinatio* also removes readers' experience of the nations from one kind of imaginative practice to another, from a devotional procession through space to the reading of a treatise. With this repositioning, the nations become entries expounded in a catalog of heresy, a printed roster, rather than exotic voices encountered under an ecumenical roof. Each image relates to its corresponding text, much as, for example, each image in the *Gart der Gesundheit* illustrates the entry about the properties and medicinal value of that substance.

This reframing channels readers' engagement with the peoples exclusively through the voice of the author and his artist's visual witnessing. It segregates

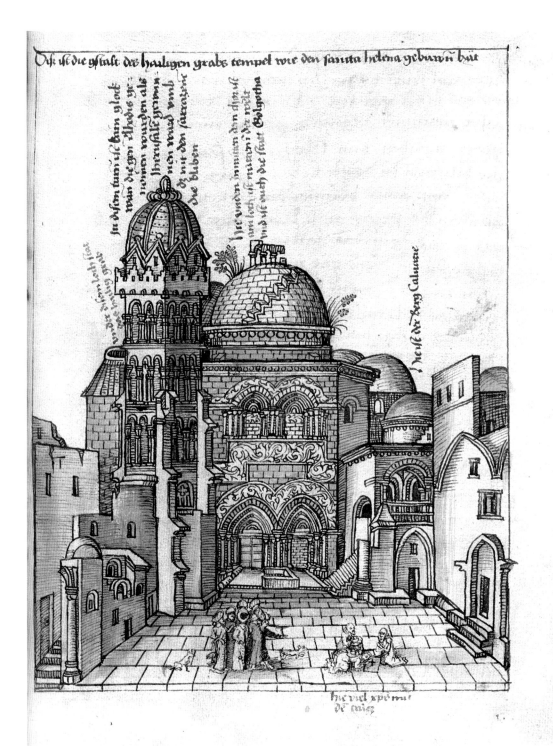

FIGURE 29
Entrance Court of the Church of the Holy Sepulcher from Konrad von Grünemberg's pilgrimage account, 1487–94. Forschungsbibliothek Gotha, Chart. A 541, fol. 69r.

the heretics from a moment when accounts of the Holy Land routinely open themselves up to being absorbed into the reader's stay-at-home spiritual exercises. The nature of this shift comes to the fore when Breydenbach's different approach is contrasted with two other works on the Holy Land from the same era, Francesco Suriano's *Treatise on the Holy Land* and the travelogue of the 1479 pilgrim Hans Tucher (known to be a key source for the text of the *Peregrinatio*). Both treat the nations of the Holy Land together with their description of the Church of the Holy Sepulcher, and both outline a procedure for readers to transpose a tour of the church into their own local space.

For two years, from 1481 to 1483, Francesco Suriano, a Venetian, served as head of the Franciscan monastery in Beirut, an auxiliary to the Franciscan mission on Mount Sion in Jerusalem. After a year at the house on Mount Sion, he returned to his home cloister in Umbria and in 1485 answered the request of his sister, also a Franciscan, to share his knowledge of the Holy Land. Suriano revised his work twice and saw it printed in 1524, after returning to the Holy Land for two terms as head of the entire Franciscan mission and after a stint as a papal legate to the Maronite Christians in Lebanon. Suriano composed the book as a dialogue between himself and his sister, where she poses questions and offers comments on his responses.

The narrative flow of the book generally follows the order of a pilgrimage to the Holy Land, and Suriano makes this organizational principle explicit when he titles the work a "little treatise on the indulgences of the Holy Land with explanations." Suriano states explicitly that he put aside the great fatigue from his travels only for the benefit of his sister, that she might have "consoling spiritual nourishment" from the holy sites by reading about them publicly or privately.[39] In the middle of the work, he gives the distances among the sites in the Church of the Holy Sepulcher, to foster the nuns' imagination of pacing out the intervals, and then follows this with a version of the liturgy that the Franciscans in the Holy Land had designed to lead pilgrims on procession through the Church. Suriano intends for the nuns of his sister's convent to reenact this ceremony on a day of silence and fasting. As the nuns have no male cleric to serve as preacher, he places the exposition of the ceremony in the mouth of the Virgin, giving the performance the flavor of a liturgical drama.[40] The homology between the pilgrim's experience and the readers' experience of the Church of the Holy Sepulcher rests on the experience of procession (and themes in the liturgy) among a circuit of stations.

Immediately after presenting the liturgical drama of the procession through the Church of the Holy Sepulcher, Suriano gives a wholly different tour of the same space. He enumerates and individually describes each of the Christian sects with a presence in the Holy Land, and he does this by presenting them as inhabitants of separate nooks of the same church.[41] The ideal of a catholic church finds reification in the physical architecture of the Church of the Holy Sepulcher. Of course, for each nation Suriano launches into an explication of the heresies that divide them from the Latins, while also recounting their origins and describing the peculiarities of their practices. The space of the Church of the Holy Sepulcher does not reflect the ideal of one church, holy and apostolic. Rather, it models a temporal order more like the mundane world itself. After a brief excursus on the recent Franciscan mission to Christians in Ethiopia, Suriano explains to his sister about the marker that indicates the exact middle of the world. The logic of the sequence of the presentation of material suggests that the cluster of nations drawn to this centerpoint personifies an idea of a Christ-centered world, if not the fact of one.

Like Suriano, Tucher presents the Church of the Holy Sepulcher to his audience in more than one way. He pitches his book at men like himself who are interested in the Holy Land perhaps with an eye to traveling there themselves, and he helps that readership visualize the experience of visiting the Church of the Holy Sepulcher by leading them on a walking tour of it as if it were his parish Church of Saint Sebald in Nuremberg.[42] Tucher begins by likening the portal leading from the courtyard into the Church of the Holy Sepulcher (depicted by Reuwich, figure 12) with the portal leading from the graveyard of Saint Sebald into that church.[43] Both doors stand on the south walls of their structures, toward the western end of the wall, and visitors walk north through them. Tucher maintains this parallel orientation throughout the tour, and the entire comparison hinges on it. The reader imagining Saint Sebald proceeds next to Saint Catherine's choir at the west end of the church; the Jerusalem pilgrim finds the grave of Christ at the corresponding spot in the Church of the Holy Sepulcher.[44] The circuit continues until the pilgrim has followed the entire Franciscan-led procession of the Church of the Holy Sepulcher. The route ends at the stone in the Holy Sepulcher that marks the center of the world, placed as if "it were in the choir of Saint Sebald where stands the choir screen on which the boys sing."[45]

Once again and even more forcefully than in Suriano's text, an image of the Church of the Holy Sepulcher is constructed for readers out of their own familiar pathways in their regular house of worship. As Reiner Haussherr notes in his article on this passage, the kinds of architectural iconography usually identified by modern scholars do not play a role in Tucher's model. For example, if Tucher were concerned with homologies of structure and meaning, the east choir of Saint Sebald, where the

remains of the titular saint stood on the high altar, would make the most obvious comparison with the Holy Grave in the rotunda of the Church of the Holy Sepulcher.[46] Tucher presents a conception of ecclesiastical architecture whose meaning can grow wholly out of a viewer's real or imaginative itinerary through built space. The particular features of the Church of Saint Sebald seem incidental except as signposts along the itinerary, so that he proposes a portable image of the Church of the Holy Sepulcher that could be transferred to any space. His route sets the parameters for a performative act of visualization or procession, and the image's relationship to its model depends on this act, not on any iconic resemblance between the fabric of the churches.

In Tucher's text, as in Suriano's, the tour of the different Christian groups follows directly after the imaginative procession, with the nations identified according to the location where each has its altar in the church.[47] These authors treat the Church of the Holy Sepulcher first as a stage for a liturgical or imagined procession and then as a microcosm of Christendom. Through this doubling, they offer two related but distinct strategies for representing the Holy Land. First they formalize a virtual, wholly Latin Christian experience of the complex. Then they address some of the realities of the contemporary situation of Latin Christendom, but within a framework where the space of a church provides conceptual order. Suriano and Tucher wrote texts, but their texts develop imaginative practices based on the use of built ecclesiastical spaces. They emphasize an experience of the Church of the Holy Sepulcher as a building, which for them means a space ordered and experienced as a procession among an itinerary of ritual or sacred sites. Breydenbach or his editor retains this aspect of Tucher's text, but he purges Christian heretics from it, resettling them outside any real ritual space or an imagined one that

could be relocated and made concrete in the reader's home architecture.

Reuwich's image of the church portal expels them from that space as well (figure 12). He suppresses the church's Muslim superintendents who watched over the complex from a bench near the entrance, staging instead a court empty of voyeurs who would mar the devotions of the lone group of pilgrims—or by extension, the book's readers—gathered around a stone where Jesus fell under the cross. The enclosed seating area seems a neutral element of the architecture, even though it is positioned perpendicular to the trumeau, but open to the left, to corral pilgrims approaching the operational left door. Fabri, for one, was embarrassed "to be let into Christ's church by Christ's blasphemers," who held the keys.[48] The absence of these Muslim custodians is made all the more conspicuous by their reinstallation in the redrawing in the Gotha Grünemberg manuscript, which regularly restores, as here, the Muslim populace (figure 29).

Half of Reuwich's images of peoples—the Saracens, Greeks, and Ethiopians—visually support this reframing of the material as a catalogue by posing groups of figures with minimal setting and narrative context. The format anticipates the fashion plates of the costume books that became popular from the middle sixteenth century, such as Cesare Vecellio's *De gli habiti antichi et moderni di diverse parti del mondo* (Of ancient and modern dress of diverse parts of the world), published in Venice in 1590.[49] Reuwich does not isolate individuals or present them in a static frontal pose, as Vecellio and others will, but in these images, he divides the figures into two categories, separates each category with a gap of empty space, and often labels them: female Saracens and male (figure 26), lay Greeks and a cleric (figure 30), an Ethiopian priest and a layman (figure 31). The Saracen women almost appear as if two

studies of the same figure, one seen *en face*, wearing a set of veils that obscures her headpiece and dress, and one seen in profile without veils, hitching up her skirt to reveal her shoes. Conversational gestures knit together figures within the same category or figures of different categories divided by a gap: the left male Saracen nods and holds out his palm, while his companions watch him; the arm of a mustached Greek juts out of his pack as if to introduce the monk to the side; and the Ethiopian monk gesticulates with open mouth at his secular counterpart, who responds with his hands.

It is the other half of the *Peregrinatio*'s people that challenges the discipline of the textual and visual catalog with elements of more anecdotal observation. The illustration to the entry on Jews is the most narrative and, notably, the one that most directly reinforces the censorious pronouncements of the text (figure 32). In addition to enumerating the theological errors of Judaism, the entry denounces the injury to Christians from the usury charged by those "miserable hellhounds," Jewish moneylenders who operate, it asserts, with the protection of Christian leaders and to their profit. The German edition elaborates at greater length and with more colorful language than the Latin, presumably for the sake of its different audience and to take its own advice that "all Christian people should warn their children and good friends" (104v, ll. 7–8). To make this abstract point concrete, the author includes a table of interest outlining the payments on a debt of one Frankfurt gulden over twenty years (104v–105r). The reference to Christian leaders and the use of Rhenish currency make explicit that this diatribe attacks European, not Palestinian, Jews. In contrast, the manuscript travel instructions that Breydenbach wrote for Count Ludwig von Hanau-Lichtenberg, a document more practical than polemical, do recommend a Jewish merchant in Jerusalem. "Mardocheus" will act in

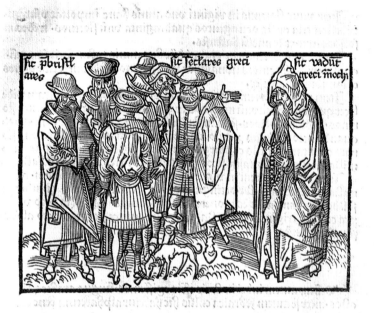

FIGURE 30
Erhard Reuwich, *Greeks*
from *Peregrinatio* Latin,
fol. 90v. Universitäts-
und Landesbibliothek
Darmstadt, Inc. IV 98.

De grecis quorū etiam plures sunt
in Jerusalem.

Orro sanctam ciuitatem Jerusalem incolunt hac tem
pestate plurimi diuersarum nationum homines qui se
ꝑpiane religionis professores · ore quidem ꝓnūciant ·
factis autem negant · vtpote heresibus et varijs erroꝛi·
bus implicati · et hoꝛum dum illic essem Anno scilicet
Millesimoquadringentesimooctuagesimotercio · circi·
ter mille erant ibidem in vtroꝗ sexu · etiam paruulis
exceptis ydiomate vtentes et lingua ipsoꝛum sarracenoꝛū · inter quos
cōmixtim habitant · eoꝛū etiam moꝛes in multis fide sua excepta imita·
tur · ꝑsertim quo ad exterioꝛem conuersationem et ciuilem · Nimirum
quoniam iuxta Senece prouerbium · ex conuictu moꝛes foꝛmantur ·

FIGURE 31
Erhard Reuwich,
Ethiopians from
Peregrinatio Latin,
fol. 96v. Universitäts-
und Landesbibliothek
Darmstadt, Inc. IV 98.

¶ De Abbasinis siue Indianis et eorum cerimonijs
Erosolimis quoq; hysce tribus habitāt viri nō pauci. q̄ Abba
sini.alio vero nomine Indiani ab india puincia vocātur. de
dominio et subditione potentissimi regis.quē psbiterū Johānē
appellant.q̄ quidē maxim9 atq; serenissim9 rex cū omni populo suo se
ȳpianū profitetur.Hij p beatū Thomā apostolū ad ȳpi fidē ab inicio
legūtur cōuersi.Ipe quoq; modernus rex.currēte dn̄ice incarnationis
Anno.M.cccc.lxxxij.p ambasiatā suā romano pontifici Sixto q̄rto
obedientiā fecit.et nostris moribus atq; statutis huiliter petijt informa
ri.Isti abbasini siue indiani ōes sunt nigri instar ethiopū et multū ze
losi serūctesq; ad visitandū loca sancta.Deuote et prolixe orāt.officia
diuina more suo psiciūt reuerēter.Amāt pauptatē.in multa inopia et
rerū penuria vitā agentes.etiā si multū habundent.lineis et coloratis
vrūtur indumētis.circūligātes capita sua tā viri q̄ mulieres lineis pe
plis blauij coloris.Nudisq; pedibus discalciati incedūt ʒc.Et q̄q̄
ista faciāt et obseruēt.tamen prochdolor a certis prauis erroribus nō
sunt alieni neq; immunes.Nā circūcisionē carnalē seruāt more sarrace
norū et jacobitarū puulos suos circūcidentes.nō attendētes miseri qd
apostolus minaʒ.Si circūcidimini inquiēs.ȳps vobis nichil proderit
Adūrūt quoq; infantes suos in frōtib9? ferreo calamo.in modū crucis
Alij in genis.alij sup nasum.pleriq; in omnibus hijs locis.credentes
eos p hmoi adustionem ab originali peccato mūdari.Cūq; ego miseris
cōpatiens q̄ alias satis boni homines videntur.p interptem inquirerē
cur hec facerēt q̄ omino romane ecclesie essent aduersa.cui se nup.missa
obedientia sua subiecissent.Responderūt(vt verū fateat)se circūcisio
nem accipe nō q̄si sacramentū necessitatis.ß ob reuerentiā ȳpi q̄ et ipse
fuit circūcisus.Adustionē vero obseruare pro eo q̄ scriptū esset et dictū
p Johannē baptistā de ȳpo Ipe vos baptisabit in spū scō et igne.Sed
informati a nobis.dicebāt de cetero se velle his ptermissis baptismū in
aqua suscipe scōm ecclesie romane morē.Sed nō solū in isto ß in alijs
multis aberrāt.Nā in fermēto cōficiūt instar greco₂. sub vtraq; specie
sacramentū cōferūt paruulis et adultis. et illos p simplices sacerdotes
faciūt cōfirmari adhuc infantes.In officio misse.ritus quosdā habent
singulares.Studiose ad missam cōueniūt laici eo₂.psertim in solenni

FIGURE 32
Erhard Reuwich, *Jew*
from *Peregrinatio* Latin,
fol. 88v. Universitäts-
und Landesbibliothek
Darmstadt, Inc. IV 98.

De Judeis q̄oꝝ̄ etiã plericp hijſce temporibus Jeroſolt
mis manent.

Vnt pterea Jeroſolmis hijs temporibus ħabitantes
judei vtriuſcp ſexus·circiter quingenti· in ſua pſidia et
obſtinatione ptinaciter pſeuerantes·velamen moyſi ħa
ßentes fixe ſup facies ſuas· ne lumen inſpiciant verita
tis·necp conertantur et ſanentur·vtpote qui indignos
ſe iudicantes vite eterne· verßū reſpuerūt ſalutis·vias
rūcp dn̄i noluerūt ſcientiã ħaßere· atcp ipm̄ vite interemerūt auctorc̄
impie ad pylatū cōclamantes· Ganguis eiꝰ ſup nos et fiſios noſtros
Et quia noluerūt ßenedictionem· elongaßitur aß eis prociil· Nam et
deo et ħominibus odißiles facti ſunt· ſed et ſarraceni et barbari eos pre
ceteris nationibus pſequūtur·ħaßēt pꝛexoſos·Et cum ceterarū ħic re

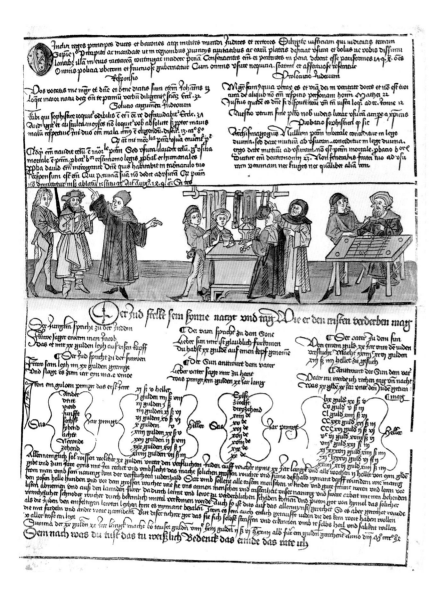

of money in his right hand points over his desk at a standing client, who seems to be removing his cloak. The aggressiveness of the moneylender's gesture—his hand hangs as a stark outline against a blank ground—captures something of his perceived menace. If the client is, as it seems, handing over "the shirt off his back," then perhaps the scene plays upon the German version of that phrase to suggest that Jewish usury costs Christians "den letzten Hemd." Reuwich did not invent this iconography; while not a direct source, a (rare) anti-Semitic broadside published in Nuremberg in 1484 features a rack of similarly pawned clothing within a Jewish shop above another table of interest (figure 33).[51]

The image of Syrian Christians also reflects disparaging comments made in the entry, though again, as with the moneylender, the image takes up an element of the social, rather than theological, critique (figure 34). Three vineyard workers take a break from cultivation to rest on the ground and enjoy a meal set in a bowl in the middle of their circle, while a fourth worker remains standing with a harvest basket on his back. The vines, hoe, water pot, repast, and repose coalesce to create a full-fledged genre scene that complements the *Peregrinatio*'s statement that the Syrians are "fearful men and scared and for that reason unsuited to war or fighting, but skilled at tilling fields and manual labor." After noting how well the Syrians toil, the text proceeds to castigate them as heretics, liars, and thieves who kowtow to their overlords by carrying "the secrets of the Christians to the ears of the Saracens" (107v, ll. 7–14).

Reuwich engages here with the developing genre of images of peasants, an increasingly popular subject for independent representations, particularly in the prints by the Master of the Amsterdam Cabinet and his contemporaries. These prints generally visualize negative sentiment similar to that articulated in the *Peregrinatio*, but with a bit of humor,

FIGURE 33
Broadside against
Jewish usury, 1484,
hand-colored woodcut.
Deutsches Historisches
Museum, Berlin. Photo
© DHM / The Bridge-
man Art Library.

good faith toward the count, Breydenbach counsels, "more [so] than anyone else in all of heathendom."[50]

While the *Peregrinatio* notes that "about five hundred" Jews of both sexes live in Jerusalem, there is no other aspect of text or image that distinguishes the entry as a commentary on the Jews of the Holy Land as distinct from those of the Rhineland (103v, ll. 1–5). In the woodcut, a seated man holding a bag

FIGURE 34
Erhard Reuwich, *Syrians*
from *Peregrinatio* Latin,
fol. 92v. Universitäts-
und Landesbibliothek
Darmstadt, Inc. IV 98.

De Surianis qui Jerosolimis et locis illis manentes etiam se
asserunt esse xpianos.

Eterum sunt etiã Jerosolimis quidã alij Suriani appel-
lati a ciuitate Sur quondã peminenti vt aliqui dicūt· Vel
Syriani a prouincia Syrie· a qua et syri nominãtur· Hij
in terra orientali sub diuersis regibus et principibus sarrace-
nis atqz barbaris iugo seruitutis opprimūtur abolim· semp tributarij
et serui· homines inbelles et prorsus inepti ad prelia· vtpote timidi et
formidolosi·vnde nec arcūbus vtūtūr aut sagittis vt ceteri·sed ad agri
cūlturam et alios inferiores labores sint aptiores· Sunt etiã ex ma-
gna parte heretici·homines dolosi·duplices animo atqz mendaces· ami-
ci fortune·et ad munera accipienda promptissimi·Furtum et rapinam
quasi pro nichilo habet· Secreta xpianorum vbi possunt ad infideles
proditorie deferūt et sarracenos· inter quos nutriti et cõmixti didice-
runt opera eorum mala· Vxores suas more sarracenoꝛ diligentissime
inclusas custodiūt·et tam ipas ꝗ filias suas in publicū non sinūt exi-
re·nisi linteaminibus inuolutas· velatasqz panno nigro super facies
suas· ne ab alijs videantur. Os eorūm filie adeo custodiūt accurate·vt
non nisi desponsate a maritis·prima nocte copule transacta·possint vi-
deri·quéadmodū et sarraceni circa filias suas itidem seruant· exemplo
patriarche Jacob qui ad rachelem se existimãs ingressum expletis nū-
ptijs·mane reperit Lyam· Hij Suriani·grecorū institutiones ritus et

offering rustics as comic characters with coarse features and manners that often lead into a moralizing comment. The Master of the Amsterdam Cabinet portrays his peasants more gently than most, but a series of peasant shield holders with hayseed heraldry, for example, pokes fun at social pretension. He has only a single peasant image—depicting a family of vagabonds, thought to be Romani—that seems wholly devoid of this satirical inflection (figure 6). Reuwich's Syrians may not charm us with the touches and soft glances of the Master's Romani, but they, too, are rendered without vulgar physiognomy, ridiculous behavior, or amusing attributes. His woodcut is deadpan, where most contemporary peasant images are clownish.

There is one last image of foreigners in the *Peregrinatio*, near the end, between the account of the Ottoman victory at Negroponte and their defeat at Rhodes. Eight musicians ride together in a relaxed group conversing and making music, and the labels *genetzer* and *turci* correctly identify that this type of Turkish military band accompanied Janissary (modern German *Janitschar*) troops in particular (figure 8). The musician nearest the viewer wears an Ottoman-style turban wrapped around a *taj*, a high cap, and beats a small drum called a *nakkare*, while looking over his shoulder at another turbaned horseman playing a woodwind *zurna*. Two other riders wear the *börk*, Janissary headgear that Western artists will soon absorb, like the turbans, into the common vocabulary of Ottoman costume, as seen at the front of the crowd on the left of Dürer's *Whore of Babylon* (figure 27). From the fourteenth to the nineteenth centuries, this type of marching band was a characteristic tradition of the Turkish forces effectively deployed to inspire troops and intimidate opponents.[52]

Reuwich's image stands alone on a page with a long caption describing the scene as Turks in peacetime, as they look when riding in triumph or for recreation. When they go to war, the author tells us, they wear the same clothes, but other weapons (172r, ll. 1–4). Again, the caption draws a contrast between subcategories of an essential group, even if here the battle gear is not pictured, in order to accentuate the claim to clinical observation. In the middle of texts meant to turn the reader against the bellicose Turks with stories of the rape of nuns and other atrocities, Reuwich depicts Ottoman soldiers celebrating the fruits of victory. Despite the specificity of the woodcut, however, it is not at all clear that Reuwich had the opportunity to see a Janissary squad. Though the pilgrims did visit towns like Modon that were surrounded by Turkish territory, they simply did not set foot in the Ottoman realm, nor do they mention an encounter with an Ottoman diplomatic delegation, who might also have had such a retinue. The caption's evocation of the players' absent battle gear can be understood, then, as the *Peregrinatio* team's effort to put back on message the image of enemy cavalry that was available to them.

The anecdotal flavor of these images writes large an important aspect of the panoramic views, which impress the viewer with their sweeping scope but then draw him closer for a myopic, meandering tour of lively details that inhabit the cityscapes. The previous chapter argued for the testimonial force of the essential structure of the perspective view in persuading the reader of the artist's authority as eyewitness, but these picaresque embellishments carry the promise of authentic experience just as the skyline does. Outside the walls of Modon (Methoni), to take one example, Reuwich depicts a cluster of yurt-shaped structures and lumpy pyramids that seem to offer the first visual record of a Romani settlement, one of the largest and oldest in Europe and one among many in the Peloponnese (figures 35, 36).[53] The artist gives these dwellings a

distinctly different shape from the boxy cottages that populate the hinterlands of his other cities or the taut tents that would be expected of an Ottoman encampment, but this is the only clue to differentiate it from other observations on the same scale—shipwrights at work, passengers ferried to a waiting carrack and a vessel with a two-masted lateen rig, barrels and barrel heads waiting on a wharf, a fisherman dropping a line. None of these other elements finds mention in the text, unless the barrels contain the town's trademark sweet "malmsey" wine (29r, ll. 8–9). The idiosyncratic shelters do: "Before that city [Modon] there are also many huts, about three hundred, in which live quite a few poor people, black and unshapely as Moors, just like the gypsies that sometime come in these lands. They lie and say that they are natives of Egypt, when the Egyptian land is very far from this city. They are probably from Gippe, an area that lies near this city. They are generally betrayers of Christians and spies against them."[54]

This small item packed into the outskirts of what was then a declining port offers as significant an ethnographic observation as the more influential Saracens and Turks. At the same time, the Romani settlement affects our perception of the other details of the city views by commanding the same weight in the image as any of the seemingly negligible vignettes likely to be passed over as playful interpolations. Neither author nor artist qualifies the authenticity or the consistency of the surrogate experience they present in the form of a view. As we have seen, the perspective format of the view and the author's claims implicitly (and with the animals explicitly) caption each image with the statement "This is what the artist saw." That assertion proposes to equalize all aspects of the image, and in doing so, to convert such anecdotal details indiscriminately from ornamental flourishes into observed moments.

Venice Influenced, Venice as Influence

This strategy for communicating their credibility worked. It is a testament to the rarity of Reuwich's images—and their cogency—that artists in Venice drew upon them for works created for the European audience with the most extensive direct contact with Levant. Reuwich was one of a small group of artists of the late fifteenth century, including Gentile Bellini, who were able to travel to make images of the people and architecture of the Muslim East. The images they brought back were mingled with some peeks at dignitaries visiting Venice and a dose of imaginative interpolation. This mix then provided the fodder for Bellini, Vittore Carpaccio, Giovanni Mansueti, and others to develop a genre of paintings where biblical or hagiographic narratives that took place in the historical Levant are depicted in settings dressed with contemporary Eastern architecture and fashion.[55] Reuwich's fashion-plate approach sets up the woodcuts to serve as the pattern drawings or *simili* that would be used to populate the works popular from circa 1490 to 1525.

Bellini visited the Ottoman court of Mehmed II in Istanbul, and it has been suggested (without any supporting evidence) that he stopped in the Holy Land and Egypt on his way home, affording an opportunity to create his own cache of eyewitness studies of Mamluk architecture and costume.[56] Julian Raby's close examination of details in Gentile's paintings refutes this idea, however, by showing how Bellini draws upon others' Mamluk observations, such as the form of the emblem of the sultan Qait Bey.[57] For our understanding of the *Peregrinatio*, his analysis is important for establishing that Bellini and Carpaccio copied the printed woodcuts, not vice versa. In turn, that attests in two ways to the success of the book's program, both the team's editorial decisions and their tactics to project authority: the

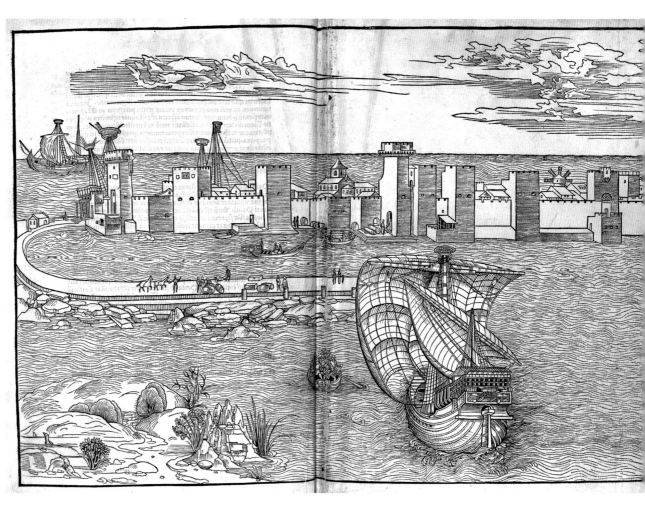

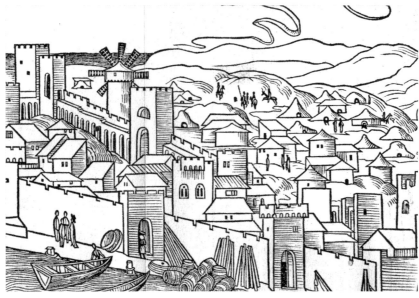

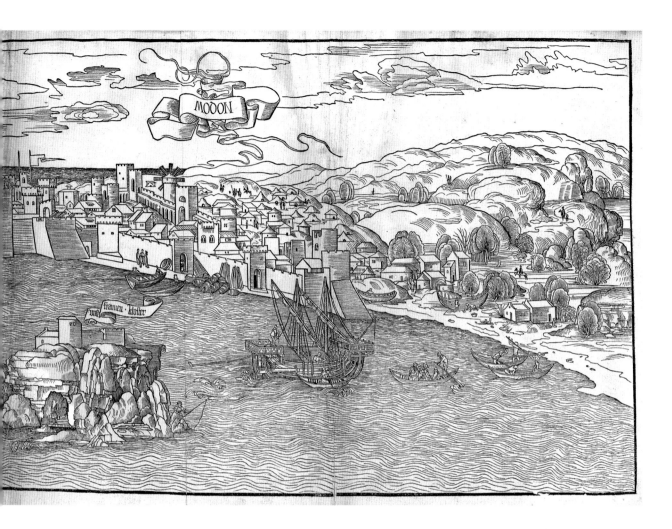

woodcuts were accepted as authentic observations by cosmopolitan artists, and the artistic influence traveled in a full circuit between Italy and Germany.

As Raby has shown, a drawing in the Princeton Art Museum provides the key to any question of the order of influence among Reuwich, Carpaccio, and Bellini by demonstrating how the Venetians adapted the woodcut of Saracen women (figures 26, 37). The clearest moment of translation comes in Carpaccio's adjustment of the *ṭanṭūr* (a type of hat) of the woman on the left: first he follows in charcoal the shape of Reuwich's *ṭanṭūr*, which is inadequately

foreshortened, so too flat; then he retraces it in pen, tipping it up to clarify its consonance with the proportions of the headdress of the veiled woman to the right. He straightens the exuberant folds of the mantle of Reuwich's veiled woman, so they respond to the plumb pull of gravity, but he extends the vertical striations on her head down the whole length of her overgarment. This insight into Carpaccio's process confirms that he was working from the *Peregrinatio*, and Bellini's translation of striations into stripes on the standing woman of the *Saint Mark Preaching in Alexandria* (1504–7) shows

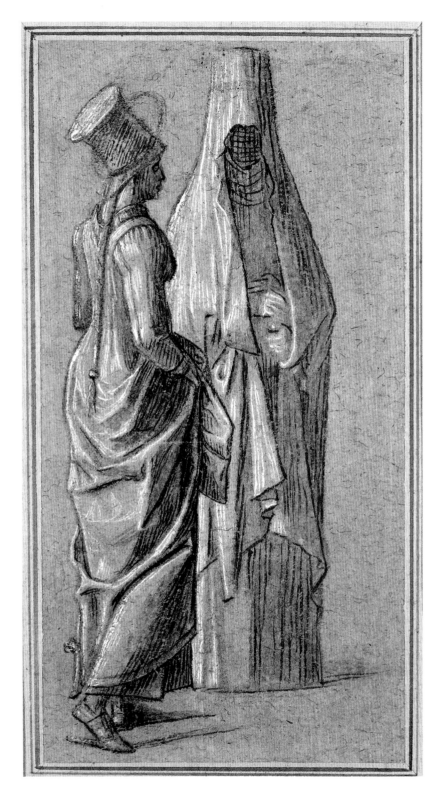

him, in turn, looking to Carpaccio's interpretation (figure 38).[58]

Reuwich's veiled Saracen is multiplied to fill out the seated crowd on the square in Alexandria, while the *Peregrinatio* pair appear together at the edge of Carpaccio's *Triumph of Saint George* (1504–7) (figure 39). There they face one of Reuwich's Ethiopians across that same canvas. Again in the middle ground of the *Sermon of Saint Stephen* (circa 1514), both Saracens and Ethiopian return in the same orientation to each other (figure 109). Women with similar dress or poses recur in *Saint George Baptizing* (circa 1507) and *Saint Stephen and Companions Ordained Deacon* (1511). The male Saracen seen from behind with a bow and curved dagger turns up three times. And the *Peregrinatio*'s *View of Jerusalem* serves extensively as a source for the architecture of *The Triumph of Saint George* (figure 39), *Stoning of Saint Stephen*, and *Sermon of Saint Stephen*.[59]

The *Peregrinatio*'s utility testifies to the reception of Reuwich's images as factual documents and their influence on European visualization of the East. Reuwich's models convince even when, as in the case of the lay Ethiopian, the costume does not seem to have been inspired by real dress or, therefore, observation. In contrast, the artist who illustrated the Gotha Grünemberg manuscript replaces the *Peregrinatio*'s Ethiopians with a group of men and women with the darker faces and short, curly hair seen in contemporary depictions of Moors, for example, on Hans Tucher or Hartmann Schedel's coats of arms (figures 10, 40). That manuscript carefully adapts most of the prints of the *Peregrinatio* by hand, often following Reuwich exactly, but also regularly expanding excerpts of a print into whole compositions with new, interpolated details. Here they dance together to illustrate a passage that the Grünemberg account copies from the *Peregrinatio* about the Ethiopians' pious and spirited jumping,

FIGURE 37 (*opposite*)
Vittore Carpaccio,
Two Standing Women,
c. 1495–1516, pen and
ink, brush, and wash
heightened with white
gouache over chalk on
paper. Princeton

University Art Museum.
Gift of Frank Jewett
Mather Jr. (x1944-
274). Photo: Bruce M.
White.

FIGURE 38
Gentile and Giovanni
Bellini, *Saint Mark
Preaching in Alexandria*,
1504–7. Pinacoteca di
Brera, Milan. Photo:
Scala / Art Resource,
New York.

FIGURE 39
Vittore Carpaccio,
Triumph of Saint George,
1502–7. Scuola di
S. Giorgio degli Schia-
voni, Venice. Photo:
Scala / Art Resource,
New York.

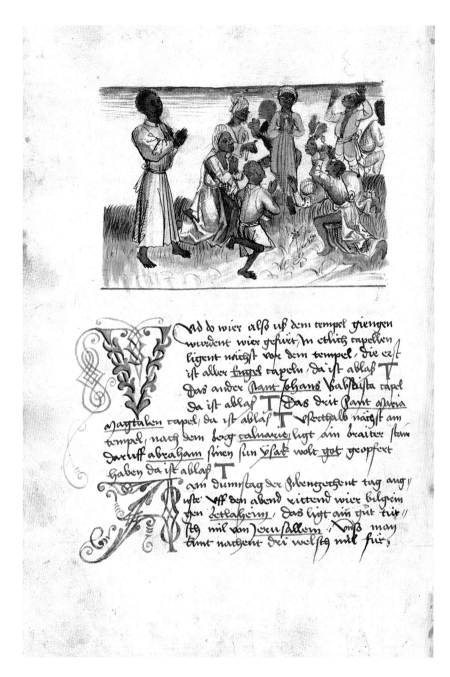

FIGURE 40
Ethiopians from Konrad
von Grünemberg's
pilgrimage account,
1487–94. Forschungsbi-
bliothek Gotha, Chart.
A 541, fol. 80v.

clapping, and singing to celebrate weddings and religious festivals (112v, ll. 18–24). The Grünemberg artist's attention to skin color and other physical traits underscores the absence of these markers in Reuwich's images, even though the *Peregrinatio* text does specify that the "Indians are all black like the Moors" (112r, ll. 14–15). The manuscript draws attention to these types of differences a second time with an image of Mamluks (not found in the *Peregrinatio* series) that shows four men identically dressed, but with different complexions, as if to emphasize the heterogeneous origin of the Egyptian sultan's warrior slaves.[60]

What They Took from Peter Ugelheimer and What They Left Behind

The *Peregrinatio* joins a succession of works that seek out visual forms for representing the foreign reaches of the Mediterranean, which includes Venice itself for the northerners. There is artistic agency here in selecting and shaping, so that the available source material does not itself determine a work's visual argument about alien people. The particularity of the *Peregrinatio*'s treatment of Islam, its distinctive choices and pretense to reportage, stand out most plainly in comparison with another mode for visualizing Islam in Venice, one more contemporary with the *Peregrinatio* and known to the artist and author from their visit. It seems quite certain that Reuwich would have had the opportunity to view some of the Veneto's most splendid book illuminations.[61] Northerners still dominated the Venetian publishing industry at that time, and during Reuwich's twenty-two-day stay in Venice, his party and some other German nobles lodged with Peter Ugelheimer. Ugelheimer, a Frankfurt expatriate who lived in Venice during the 1470s until 1485,

was for many years the partner and close friend of Nicolas Jenson, a Frenchman by origin and Venice's preeminent book publisher until his death in 1480. During his time in Venice, Ugelheimer amassed an exceptional collection of books published by his associates and then lavishly illuminated by Benedetto Bordon, Girolamo da Cremona, the Master of the Seven Virtues, and the Pico Master, as expansively catalogued by Lilian Armstrong for the 1994 *The Painted Page* exhibition.[62] Sixteen printed volumes and one manuscript from his library have been identified.[63]

Breydenbach's handwritten travel instructions imply that his party could stay with Ugelheimer because he was a personal contact of theirs.[64] In the *Peregrinatio*, he expresses his appreciation for Ugelheimer's hospitality, courtesy, and faithful help several times, specifically for supporting them in contract negotiations with the captain of the Venetian galley, but also for "other [things]" (11r, ll. 29–33; 11v, ll. 2–6; 13r, ll. 6–9). According to an account book from the family of Count Johann von Solms, the young nobleman who traveled with Breydenbach, Ugelheimer, and his wife maintained contacts with the Solms family via the Frankfurt fair, a semiannual occasion for settling accounts. Ugelheimer visited the autumn fair in 1483 while the pilgrims were still in the Holy Land and received letters from Count Johann's mother to take back to Venice to deliver to her son. The family later transferred money to Ugelheimer to fund the pilgrims' return journey, and Ugelheimer's wife repaid the excess at the Lenten fair in 1484. The family gifted Frau Ugelheimer a gold cup at that time, presumably in recognition of the pair's services to the pilgrims.[65]

Such conduits for the exchange of visual ideas and materials between German expatriates in Italy and German printers at home are relatively invisible in our conception of the period, at least

FIGURE 41
Benedetto Bordon, frontispiece from Justinianus's *Digestum novum* (Venice: Nicolas Jenson, 1477), illumination on vellum, fol. 1v. Forschungsbibliothek Gotha, Mon. typ. 1477 2° 13.

these roles for putti in the borders and bas-de-pages of books of the 1470s and '80s, a conceit used frequently in the decoration of Ugelheimer's volumes (figure 41).[68] In the twelfth-century crusader lintel, removed after an earthquake in 1927, tight spirals—more ropey stem than leafage—entangle trios of figures, including birds, a centaur, a harpy, and several nude men with exposed genitals (figures 42, 43). The pilgrims almost certainly stopped to examine it, as Fabri describes the scenes from the life of Christ in a second, historiated lintel over the left-hand door, noting also that the lintel had been defaced.[69] In the *Peregrinatio*'s image, two classicisms come together, those of the Romanesque and the Renaissance.

Often the literature on the frontispiece—largely essays discussing the work of the Housebook Master and its relationship to Reuwich's illustrations—describes the putti as "children."[70] Reuwich puts his figures to work as true putti, recognizable for their role in holding together the artifice of an architectural frame. With the conspicuous exception of Hans Memling, artists did not import them into the North before Reuwich, and Memling provides the exception that proves the rule in a triptych from before 1488, where putti string up garlands in the arch framing an enthroned Virgin and Child.[71] Reuwich's putti would travel quickly to the Spanish royal monastery of Miraflores in Burgos to cavort in the foliage of the sculpted canopy above the tomb of Infante Alfonso, begun in 1489 and finished in 1493 (figure 44). The arcing form, though not the timing, proposes that the artist, Gil de Siloé, a Netherlander working for Queen Isabella, may have been influenced secondhand through the adaptation of Reuwich's frontispiece for the 1493 Nuremberg *Liber chronicarum* (figure 10).[72]

when compared to our awareness of the artistic aftermath of Albrecht Dürer's Italian journeys in 1494–95 and 1505–7. Breydenbach had also collaborated on the 1480 Mainz *Agenda* with a printer who had come to town after a stint in Foligno, where he published what was likely the first edition of the *Divine Comedy* and could have been the source for the *Peregrinatio*'s allusion to Dante.[66] He was not alone in his Italian connections. As we will see in the next chapter, Felix Fabri also worked with a printer in Ulm, who engaged a runner to retrieve German translations of Italian texts commissioned from Germans resident in Florence. That runner, whose uncle produced deluxe cartographical manuscripts in Florence, would bring one manuscript back to Ulm to print himself as the first northern edition of Ptolemy's *Geography*, richly illustrated. The second edition would be sponsored by a Venetian living in Ulm.

The woman of the frontispiece is not the only Venetian in that woodcut. The putti also came north from the *Serenissima*, likely via Ugelheimer's collection, but also perhaps sanctioned by the foliate lintel formerly above the walled-up right-hand door to the Church of the Holy Sepulcher.[67] Venetian illuminators, for example, the Master of the Putti, developed

Opening a book with a full-page woodcut across from the first page of text, as the *Peregrinatio* does, was a highly unusual choice, and this seems a second

element inspired by the designs of Ugelheimer's library.[73] Ugelheimer's books often open in that configuration with a lavishly painted miniature on a page without printing on the left facing the first page of text on the right. That frontispiece generally features Ugelheimer's arms in an architectural framework with a quote that extols his role in helping bring the book to press, just as the *Peregrinatio* uses very similar means to build up Breydenbach as author.[74] Two of the inscriptions illustrated here are representative (figures 41, 46, although the second is split between the frontispiece, which is not shown, and the facing page of text, which is):

PETRVS UGELHEMER FRANCFORDENSIS BENE NATVS

POSTERIS HVNC LIBRVM VOLVIT ESSE SVIS

Peter Ugelheimer of Frankfurt, well born,

desires this book for his posterity.

AVREA REDDO TIBI Q, VGL

EMER PETRE DEDISTI

DIV QUE FELIX

I give back to you, Peter Ugelheimer,

the gold [things] that you gave.

For a long and happy time.

Ugelheimer's acquisition of these books has been characterized as payment in kind for his investment, part of the compensation due to a moneyman, and the "gold things" makes this explicit.[75] The *Peregrinatio* borrows not just the format of these books, but the facing image's basic purpose and compositional means—the framing of the arms of a book's creator in order to commend his role.

Moreover, the relief of the Virgin that Breydenbach and Bicken donated to celebrate their homecoming bears an inscription incised with a roman-style majuscule script, a very precocious example in Germany of the lettering that Italian humanists developed from classical models (figure 5). That was used also to inscribe the Venetian intarsia trunk that Breydenbach set out in the chapter house. Jenson is renowned for having pioneered the use of antiqua script in print, and upon Jenson's death, he had bequeathed his friend Ugelheimer the letter punches to make the matrices for this type.[76] Breydenbach was likely influenced by a typeface like Jenson's, though there are other possible conduits, for example, the many Roman or Romanesque monuments in Mainz, none of which alone explains the form of his inscription.[77]

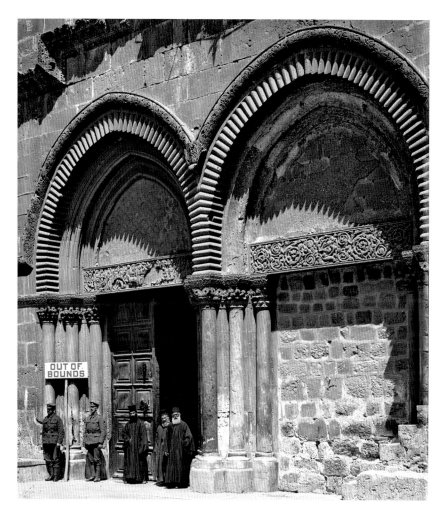

FIGURE 43
Portal of the Church of the Holy Sepulcher, Jerusalem, c. 1917, before removal of lintels. Library of Congress, G. Eric and Edith Matson Photograph Collection, LC-DIG-matpc-02255.

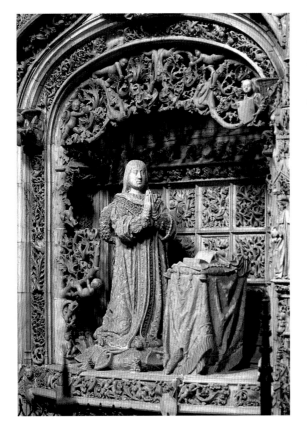

FIGURE 44
Gil de Siloé, Tomb of
the Infante Don Alfonso
(detail), 1489–93. Car-
tuja de Miraflores, Bur-
gos. Photo: Scala / Art
Resource, New York.

To inventory imported ingredients is not to lose sight of the frontispiece's thoroughgoing hybridity in its integration of some Venetian surprises into recognizably homegrown forms. This is a unique and seamless mélange that goes well beyond mere borrowing. To take one example from Breydenbach's circle, the metalcut of the 1480 Mainz *Agenda* had already set forth the basic principle of a graphically energetic arbor framing a figure of honor, elevated by furniture and set in a shallow space (figure 9). Reuwich has retained the function of the stylized carved gold tracery of Northern painted panels—its ornamental performance, organic architecture, and three-dimensional presence—while recasting it as a pergola of living vines. The coloring of one copy of

the German *Peregrinatio* may pick up on this by rendering the vines and their leaves all in yellow except for fruit and blooms picked out in green and red (figure 45). Since at least Rogier van der Weyden's *Descent from the Cross*, still relevant for painters like the Master of the Saint Bartholomew Altarpiece in Cologne, Northern artists had playfully juxtaposed the implied open landscape behind a strip of painted lawn and the closed solidity of a frame, box, or backdrop. Reuwich adopts these conventions but focuses his interest on the interplay between natural growth and manmade imitations. He conflates plants that flourish with the flourish of ornamental embellishment in a way made possible only by the unmatched skill in carving the woodblock.

When the *Peregrinatio* team took ideas from Ugelheimer's magnificent library, they also left the collection's treatment of Islam behind. Islamic figures appear again and again in the books from Ugelheimer's collection, as the figural focus of the page, in illuminated initials, or in the ornamental follies of architectural frames. In one, a work seeking to harmonize Islamic medical scholarship with classical philosophy, he lounges on an Eastern carpet contemplating an armillary sphere, a model of the cosmos, propped on his knee (figure 46). The artist positions the philosopher to make a visual pun by superimposing his head over the classical profiles in the roundels that ornament the frame behind him. Turban to beard, this suggestively Islamic figure seems as if memorialized in the format of antique coins or their Renaissance adaptation, portrait medals, a format chosen to elevate the depicted person through its idealizing dignity, patina of longevity, and association with classical rulers. In addition to these iconographic figurations of the East, eight of the volumes in Ugelheimer's collection have period bindings in a Mamluk- or Ottoman-influenced style, including

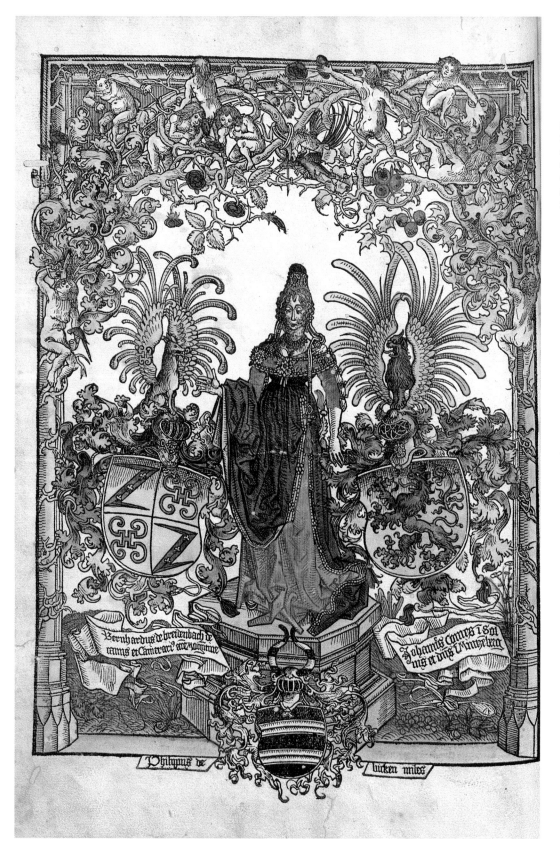

FIGURE 45
Erhard Reuwich, fron-
tispiece from *Peregrinatio*
German, hand-colored
woodcut, fol. iv. Bayer-
ische Staatsbibliothek
München, 2 Inc.c.a. 1727.

FIGURE 46
Master of the Seven
Virtues, title page with
Philosopher from Petrus
de Abano's *Conciliator
differentiarum philosopho-
rum et medicorum* (Ven-
ice: Johannes Herbort,
de Seligenstadt, 5 Feb-
ruary 1483), illumination
with print on vellum,
fol. 2r. The Hague,
National Library of the
Netherlands, 169 D3.

two of the most splendid examples known, which display intricate cutwork over a colored painted or silk underlayer with impressions of Roman coins set into the pattern (figures 47, 48).[78] The faux Roman coins integrated into the covers of the Ugelheimer volumes put forward, at the level of design, an integration of classical and Islamic history carried out iconographically in the volumes' painted embellishment.

Aside from satyrs, putti, and deer, the most frequent recurring character in the Ugelheimer illumination is a philosopher in a turban who appears across all elements: author portrait, frontispiece, and bas-de-page. At the top of the first text page of an edition of Aristotle's works, he sits on the ground in a landscape in dialogue with Aristotle, seated above him on a rock (figure 49). The Byzantine-style hat, understood as Greek, identifies the first author.[79] Therefore, his turbaned interlocutor is presumably Ibn Rushd, known as Averroës, the Muslim scholar active in twelfth-century Spain and Morocco whose interpretations of Aristotle undergird the profoundly formative influence of Aristotelian studies on Western thought. Where Aristotle is called the Philosopher, Averroës is the Commentator, and this edition includes Averroës's gloss. A small bronze plaquette with a seated Aristotle in a Greek hat conversing with one of his late antique commentators—in a turban—seems to have been based on this Ugelheimer illumination, and it shows the prevalence of the turban as a marker of sage authority, equally classical or Islamic.[80] In a similar vein, one of the 1498 Czech excerpts from the *Peregrinatio* invented a woodcut frontispiece of a scholar instructing pupils, reprinted also on the last folio, where the Janissary *börk* replaces the turban to signal a Muslim classroom (figure 50). Such woodcut teaching scenes, albeit without the foreign dress, were commonly placed on the front of books directed at the university market to advertise them as textbooks.[81]

FIGURE 47
Front binding from Justinianus's *Digestum novum* (Venice: Nicolas Jenson, 1477). Forschungsbibliothek Gotha, Mon. typ. 1477 2° 13.

In the fifteenth century (and well into the sixteenth), the study of Aristotle by means of Averroës still played a significant role at the university in Padua, where the Muslim scholar's continuing influence distinguished the course of study there.[82] The titles in Ugelheimer's collection reflect how Jenson and other Venetian printers targeted that local university market by printing works for the scholastic as well as the legal curriculum.[83] In this, they were operating with a much different market and business model than Peter Schöffer and the other Mainz printers, and the contrast between Ugelheimer's collection and the *Peregrinatio* exposes the extent to which the visual reception of Islam depends on such issues.

Averroës was certainly not the only Islamic scholar on the syllabus in Padua. For medicine, the *Canon* of Ibn Sina, known as Avicenna, remained fundamental. On the first page of the Aristotle edition's second volume, it is likely Avicenna who appears in a crowned turban next to Averroës; Saint Thomas Aquinas in a Dominican habit; and four authors with Greek hats, including Aristotle, Plato, and perhaps Porphyry (Porphyrius in Latin), whose text is included in the volume (figure 51).[84] It was certainly this type of multinational grouping, with historical and regional diversity signaled by headgear and attire, that inspired the meeting of minds at the front of the *Gart der Gesundheit*, a medical text. Breydenbach claims to have tasked a doctor with bringing together the works of the "esteemed masters of medicine" (2v), and the frontispiece visualizes exactly this gathering of honored authors. A turbaned scholar, perhaps Avicenna, is featured in a trio granted places of honor at the front of the stage, where they debate the virtues of a sprig of bittersweet nightshade (figure 11).[85] Reuwich's use of a turbaned figure here, to exactly the same purpose as his Venetian counterparts, demonstrates that this inclusive model of scholarship and its imagery was fully available to him. Such a collective author portrait is notably rare, particularly when staged as an academic conversation, and the illuminations from Ugelheimer's Aristotle provide two of the best precedents.[86] The *Gart* frontispiece offers the strongest evidence that Breydenbach and Reuwich knew this formulation— and purposely set it aside in the *Peregrinatio*.

Michael Barry has recognized the turbaned Averroës in Ugelheimer's Aristotle as one of the progenitors of the easterner in Giorgione's *Three Philosophers* from circa 1506 (figure 52).[87] Giorgione's painting offers a visualization of a Renaissance model of knowledge, which has also been interpreted more precisely as the education of philosophers according to Plato, and the role of such a figure in that context helps explain his appearance as a leitmotif throughout the Ugelheimer illustrations.[88] Giorgione uses visual metaphors to suggest the movement of the cosmos: with the rising sun in the background, the landscape segues from darkness into light and ignorance to enlightenment, as the three ages of men,

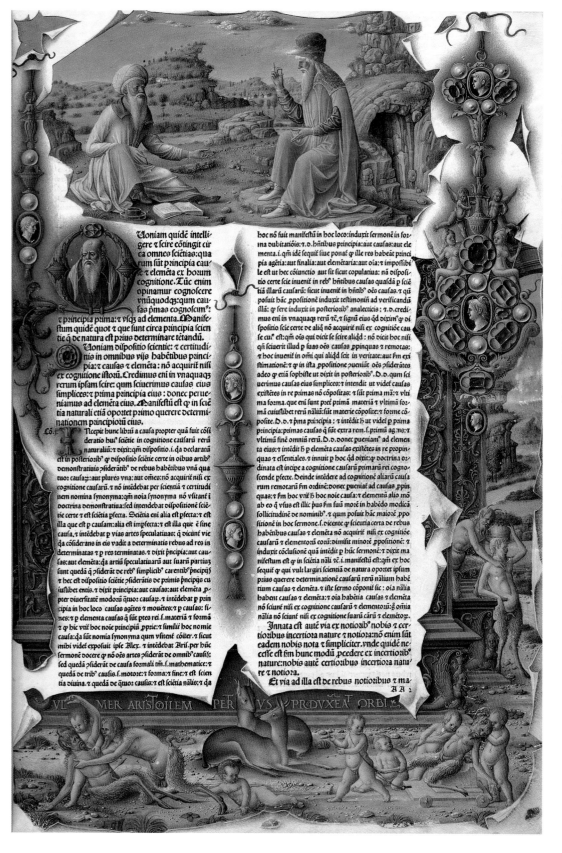

FIGURE 49
Girolamo da Cremona,
page with *Aristotle
and Averroës* from
Aristoteles' *Opera* with
commentary by Averroës
and Porphyrius's *Isagoge
in Aristotelis Praedica-
menta* (Venice: Andreas
Torresanus, de Asula
and Bartholomaeus
de Blavis, de Alexandria
in part for Johannes
de Colonia, 1483),
illumination with print
on vellum, vol. 1, fol. 2r.
The Pierpont Morgan
Library, New York,
PML 21194-95. Pur-
chased in 1919. Photo:
The Pierpont Morgan
Library, New York.

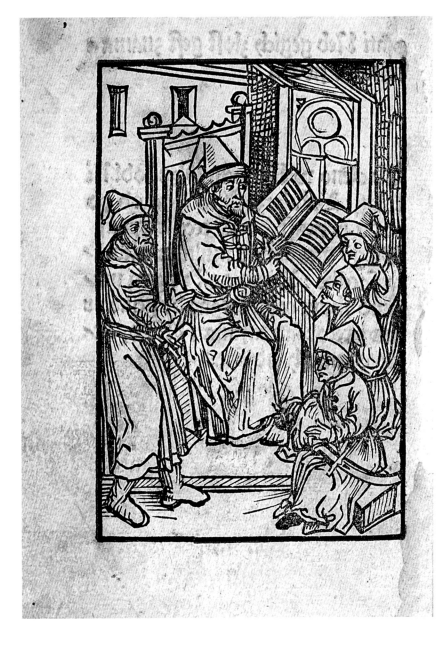

young to old, evoke the passing of the seasons. The turning of the cosmos acts upon the men as human beings, but they in turn subject the cosmos to examination and reflection, and the scientific activities of these thinkers blend into the artist's visual poetry of time. This study and poetry describe the Renaissance conception of natural philosophy, based in the received accomplishments of past thinkers. Here Giorgione, like Reuwich in the *Gart*, materializes that history as a symbolic grouping of philosophers.

At the center of the group, in the prime of life, facing the viewer rather than the metaphoric light, stands the figure in contemporary Muslim garb, who is descended from Ugelheimer's illuminations. Barry's interpretation (the most recent of dozens) supports a proposition made by Arnaldo Ferriguto in 1933 that the authors represent three specific ages of the Renaissance historiography of philosophy: Aristotle for the classics on the right; Averroës for medieval thought in the center; and the new modern humanism embodied by the youth.[89] Giorgione's easterner stands in a framework that understands the world through the lessons of scholars from the whole of the Mediterranean, a hub whose shores define the extent of antiquity's sphere of influence. Neither the Ugelheimer illustrations nor the *Gart* frontispiece explicates the historiographical model with Giorgione's poetry, but Giorgione amplifies those earlier works' same core understanding of the place of Islamic scholars in world intellectual history.

This treatment of Islamic history in Ugelheimer's illuminations is not just foisted on Islamic culture from the outside. After conquering Constantinople in 1453 at the age of twenty-one, the Ottoman ruler Mehmed II cultivated his image as a new Alexander on the way to repeating his predecessor's global conquest.[90] Now the Caesar of Rome's eastern capital, he intended to reconstitute the old empire by winning control of its western capital as

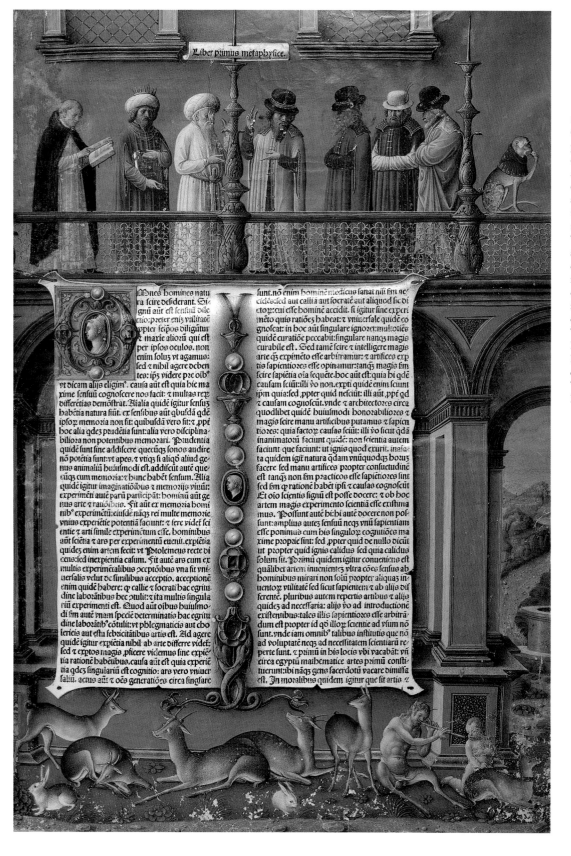

FIGURE 51
Girolamo da Cremona,
page with *Gathering
of Philosophers* from
Aristoteles' *Opera* with
commentary by Averroës
and Porphyrius's *Isagoge
in Aristotelis Praedica-
menta* (Venice: Andreas
Torresanus, de Asula
and Bartholomaeus
de Blavis, de Alexandria
in part for Johannes
de Colonia, 1483),
illumination with print
on vellum, vol. 2, fol. 1r.
The Pierpont Morgan
Library, New York,
PML 21194-95. Pur-
chased in 1919. Photo:
The Pierpont Morgan
Library, New York.

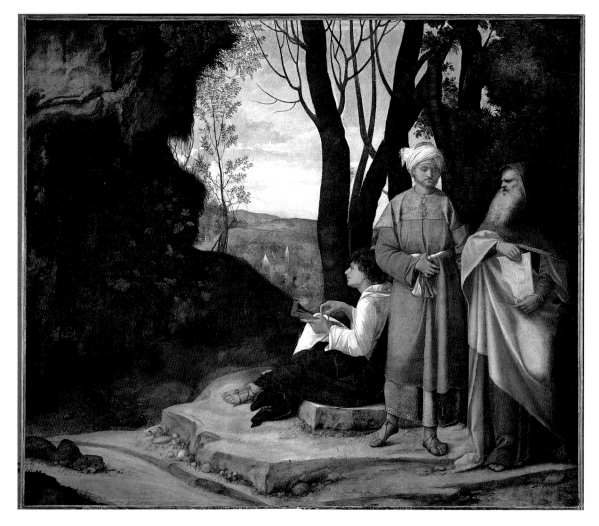

well, which he successfully began with his invasion of the Italian Peninsula, only to die a year later. This is hardly a historical perspective that Breydenbach acknowledges, if he knew about it, but the sultan's campaign of self-representation echoed verbally in the speeches and deliberations of worried Venetians and other Italians. It circulated visually in the plentiful number of portrait medals cast from ten different types during his lifetime and as commemoration after he died.[91] One was produced in Venice by Gentile Bellini, likely just after his own return from

Istanbul in early 1481 (figure 53).[92] Perhaps the artist who illuminated Ugelheimer's volume with the pun of Muslim scholar-as-portrait roundel in 1483 was inspired by the currency of medals of Mehmed II circulating and commemorating his image in Venice at that time (figure 46).

Breydenbach has brought forth much from Venice—women's fashion, humanist praise, city views, putti, the frontispiece format, antiqua lettering, an intarsia trunk, maps (as we will see in the next chapter), and a martial spirit—but he does not

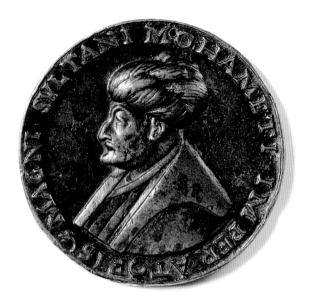

import anything like this. In lieu of the semiotically fuzzy poetics of Ugelheimer's books, where Islamic headgear can become a marker of a respected if imprecisely defined antiquity, the *Peregrinatio* team substitutes a visual and textual rhetoric of contemporary specificity that almost entirely ignores the realm of allegory, symbolism, historical appropriation, or even drollery (after the grand gesture of the frontispiece). The threats of the raw present day suffice. The Reformation era will develop a language of aggressively damning visual propaganda, each side depicting the other's leader as the seven-headed satanic beast of the Apocalypse, to give just one example, here combined with denunciation of the sale of indulgences (figure 54). There is none of that here either.

The *Peregrinatio*, a work renowned for the extravagance of its illustrations, is parsimonious in its pretense to facticity, so much so that later editions inserted new cycles of illustrations to accompany their rearrangements of the text, as seen in the 1522 French and 1498 Czech editions. The Spanish edition of 1498 adds sixty-seven images from the life of Christ, the Virgin, and saints to the materials about the Holy Land.[93] Beyond the ornamental frame of the arbor and its putti, the *Peregrinatio* team resists any such imaginative staging, including only people, persons, cities, and situations that they can declare to have seen for themselves. Breydenbach seeks to serve his purpose by speaking forcefully and also truthfully about the crisis, and the visual program, supported by the text, is arranged to establish a special credibility as his tool of persuasion. The chapters that follow continue to examine how he achieved his objectives.

The *Map of the Holy Land*
ARTIST AS CARTOGRAPHER

THE CHURCH OF THE HOLY SEPUL-cher shelters a chronogram of sacred history written as an arrangement of sites that remember events from the burial of Adam through the place where the mother of Emperor Constantine is said to have found the True Cross. In close proximity to the site of Christ's own death, burial, and self-disinterment stand both the tomb that sealed the denouement of the Creation story and the excavation that endorsed Christianity's triumph as the religion of empire. Sacred time loops back on itself there, using the physical coincidence of geography to make visible the centripetal logic of Christian history that continually circles around the hub of Christ's life from promise to fulfillment and from the beginning of the world to the end of days. As we saw in the last chapter, there is one stone that serves as an *omphalos*, marking the navel of the world. Its placement here makes explicit the alignment of terrain and history through space and time's sharing of a single center. In his account of the Church of the Holy Sepulcher, the pilgrim Felix Fabri invests the omphalos with both sacred and classical authority.[1] According to Orthodox lore, Christ pointed to this stone and said, simply and unequivocally, "This is the center of the world." The ancients had a more complicated procedure, Fabri reports, for adducing the

same conclusion: they erected a pillar and observed that it cast no shadow at noon. This phenomenon can be observed, we now know, at any location in the tropics (between 23 degrees north and south latitude) on the one day a year when the sun passes directly overhead. On the equator this happens semiannually on the March and September equinoxes, and it is in this sense of lying on the equator that the ancients' procedure would demonstrate that a site sits at the "center of the world." Jerusalem lies at about 32 degrees north latitude, however, so the phenomenon can never be observed there. Nonetheless, a knight in Fabri's party begged permission to repeat the classical experiment, climbed to the roof of the church, used his body as gnomon, and returned claiming success.

Fabri does not entirely understand or accept the mechanics of the proof. Indeed, he goes on to reject explicitly the entire notion of an equator, as he understands it, and he discards another theory that all points on a sphere are equal, placing each person at the center of the world from his own standpoint. He falls back on Scripture to resist attempts to remove the center of the world from a fixed point and diffuse it across a band or to recharacterize it as a contingent phenomenon. The knight's action does not belong to the category of independent

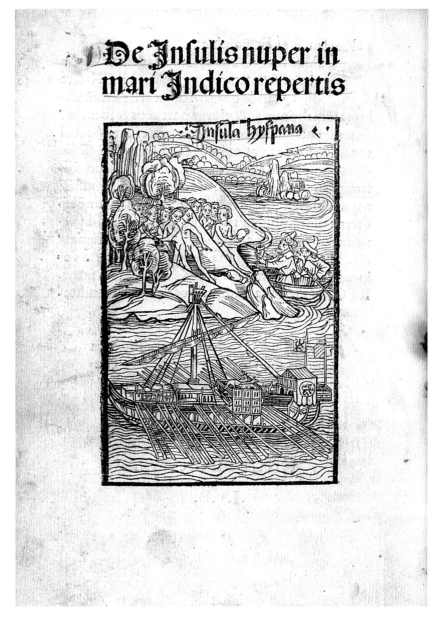

De Insulis nuper in mari Indico repertis

Insula hyspana

to stone in the Church of the Holy Sepulcher, the knight's climb exemplifies the desire to make sacred history and geography personal through physical experience. To perform his observation, the knight ascends to an outlook on the roof in line with the center stone, a station depicted by Reuwich as a ruined arcade on the dome over the crossing of the crusader church (now the Orthodox Catholicon), and illustrations based on Reuwich's visually emphasize the outlook's accessibility by adding steps (figures 12, 29). Fabri understands this structure as having being built expressly for the knight's purpose, and in the mind of a pilgrim like him, the perch is quickly assimilated to the logic of ritual outposts that defines his understanding of the space of the church.

The episode also elucidates a process that distinguishes the geographical imagination of the fifteenth century, at least as it had seeped into the popular sphere of the pilgrim, by demonstrating an impulse to reconcile geographical schemes that conceptualize space in distinctly different ways. The knight uses his body to bring sacred and antique geography, devotional experience, and natural philosophy into convergence, an endeavor that complements Reuwich's strategy of aligning different means of representing space within the viewpoint of the artist-pilgrim. This era negotiated no fewer than three types of world map: medieval diagrams known by the Latin name *mappae mundi* that picture the geography of sacred history (figure 60); portolan charts drawn by Catalans and Venetians for mariners trading and skirmishing in the Mediterranean basin (figure 69); and visualizations of Claudius Ptolemaeus's second-century treatise *Cosmographia*, known in English as Ptolemy's *Geography*.[2] In all three, the basic shape and extent of the *ecumene* (the inhabited world as known to ancient Greece) remains similar to that represented in Europe since antiquity, though they each reflect a different aspect

empirical observation that harbingers later astronomical undertakings. Rather, it demonstrates how a pilgrim's desire to make belief experiential can motivate actions and observations that look deceptively like empirical practice. In the context of pilgrimage and, in particular, the ritual progression from stone

of the fifteenth century's conceptualization of the space of that world. The most noteworthy works of this moment seek to resolve in a single image the best information from different systems of representation developed to express varied conceptions of space—the patently ideological, together with the empirically observed and measured, together with the historical or foreign, especially classical.

This cartographic model for collecting, vetting, and envisaging knowledge is Reuwich's model for the creation of his *Map of the Holy Land* in the *Peregrinatio*, and his particular, adaptive handling of this method places him among a choice group (gatefold). As we will see, he knits together the "world landscape" of his native Netherlandish painting tradition; pieces of his own pilgrimage experience; Breydenbach's text; portolan charts; city plans; Arab and other itineraries of travel between Gaza, Cairo, and Lower Egypt; texts and images based on the Christian geography of the Church Fathers; and an early fourteenth-century map associated with a crusader-era description of the Holy Land. Such a period cartography that values collating and integrating disparate sources and representational systems provides a counterpoint to models of art-making that more narrowly emphasize pictorial inventiveness or mimesis. Looking at the *Peregrinatio* project through this lens of cartography, we see that the process for constructing the book has been conceived much like the construction of a map and that the model for an artist here matches cartography's values, procedures, and goals.

By the beginning of the sixteenth century, European voyages of exploration will have begun to bring back information that markedly alters the shape and scope of navigational maps. The *Peregrinatio* contributes to the first imaginings of these discoveries by providing models for two images of Columbus's ships in the Basel edition of the letter announcing

his discoveries. In the first, a delegation in a tender sent out from what was the Venetian galley anchored outside Reuwich's Rhodes now proffers a diplomatic gift, a prunted beaker, to a group of naked natives on the island of Hispaniola. In the second, a carrack that plied the Mediterranean in front of Reuwich's Modon now represents Columbus's ocean fleet (*oceanica classis*) (figures 28, 35, 55, 56).[3] The operational needs of these expeditions, as well as the trade and conquest that follow, would spur the further development of representational systems that plotted spatial relationships according to the logic of nautical instruments and what they can measure, for instance, compass heading and latitude, but not yet longitude. The world map of Gerhard Mercator, published in 1569, stands as an

archetype of the modern map that arose in the wake of these ventures.[4]

Cast retrospectively in the shadow of these later developments, the history of cartography in the 1400s faces many of the same challenges that confound the writing of other histories of that era, colored in hindsight by the Reformation and post-Columbian encounters. Attempts to characterize the fifteenth century for its own sake have gotten caught in a historiographical debate that either contests the antecedents of a rupture circa 1500 or works to gainsay any clear break.[5] For cartography, this means that maps optimized for navigation, with their expansion of the bounds of the ecumene and their revised and refreshed margins of wonder, grow into the dominant model of a world map and displace earlier mapping schemes to another kind of curious periphery. Even specialist studies of fifteenth-century cartography succumb to this language, and there is a debate whether the nature of a scholar or cartographer's engagement with Ptolemy's *Geography* marks a modern versus a medieval outlook.[6] Of course, the charts from the sixteenth century and beyond are not just navigational tools, but also pictures of the limens of curiosity and the space of economic and state competition.[7]

As modern scholarship seeks to tease apart the technical and conceptual strands that inform early modern and modern maps, much fifteenth-century scholarship sought exactly the opposite: to bring together conceptually dissimilar genres. At the end of the fourteenth century, the *mappae mundi*, portolans, and a fragmented knowledge of Ptolemy's *Geography* coexisted without much attempt to collate the three traditions into a single worldview. In 1397, an expatriate from Constantinople brought the full Greek text of *Geography* to Florence, where it was translated by 1409 and circulated in humanist circles.[8] The introduction of Ptolemy's work added another tradition to the ferment, stirring cartographers and some scholars to sift through, evaluate, and consolidate the different types of information available to them. Elements of Ptolemy's ideas could be easily absorbed by period practices for imagining and understanding geography, rather than changing them, so that the real significance of the introduction of *Geography* lies in the stimulation and consequences of this process of collecting, comparing, and reconciling, rather than in the basic acceptance of Ptolemy's ideas.[9] Fabri's knight-as-gnomon is attempting exactly this as he uses a procedure inherited from antique science for determining one's global position to confirm the late medieval *mappa mundi* conception of Jerusalem as the center of the earth. This integrative process is particularly characteristic of Venice, which had a strong tradition of practical geography and eyewitness experience of the East (for example, Marco Polo), as opposed to Florence, whose humanists were more inclined to admire Ptolemy's work as a transmitter of classical learning for its own sake.[10] The *Peregrinatio* may be its most Venetian in this approach to geographical representation, to the extent that Reuwich's process in constructing the *Map of the Holy Land* is here offered as a synecdoche for his method in producing the *Peregrinatio* as a whole.

This fecund period of development engendered many hybrids. Chief among them was Fra Mauro's world map from before 1460 (probably first begun around 1448), created "*a contemplation*" of the Signoria, a phrase that may offer respect to the Republic or indicate his intention to present the work to them as a gift (figure 57).[11] The map was copied in 1457–59 for the king of Portugal, though that version has been lost. In the 1490s, decades after Fra Mauro's death, Piero de Medici sent two painters to Venice to make a copy, also lost, for his palace in Florence.[12] While the Venetian Empire was spread

across the Mediterranean, deeply engaged in trade and conflict with the Ottomans and Mamluks, the Portuguese were exploring the west coast of Africa to try and circumvent these powers' control of transit through their territories to the east. Fra Mauro retains the *mappa mundi* format while investigating information from other sources, including Arab maps, reports from Portuguese voyages, and accounts of contemporary travelers and earlier ones, in particular the Venetian Marco Polo. He then integrates certain data from portolans, Ptolemy, and other classical and patristic sources into a dense display, self-consciously explaining many of his selection criteria in the margins around the landmass.[13] The premier cartographer of the era first decided which of the three basic schemas to use and then considered which information to accept from other types of sources and how to arrange it. Other surviving works that collate multiple schemes include Andrea Bianco's 1436 atlas with portolans, a *mappa mundi*, and a Ptolemaic projection of the world; a Genoese world map of 1457; a Catalan map of roughly the same period (without Ptolemaic influence); a group of three maps from circa 1440–70, associated with the scholarship of Klosterneuberg Monastery in Austria (and for whom Ptolemy seems more a name than a major influence); and the Wieder-Woldan map, engraved in Venice circa 1485–90. The hybrid maps and atlases of the fifteenth century are ecumenical, both for their consonance with the physical space of the ecumene in its original Greek sense as well as for their attempt to create a catholic visualization of that ecumene by finding common ground among disparate versions.

Fabri saw Fra Mauro's map on May 31, 1483, as part of his tour of Venice while waiting to embark for the Holy Land, and it seems plausible that Reuwich and Breydenbach would also have encountered it, either in Fabri's company or in the

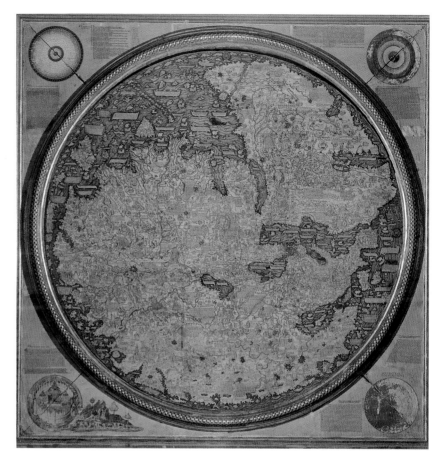

course of their own circuit of the city in those same weeks.[14] The map was on display in a chapel of the Church of San Michele on the lagoon island of the same name, where Fra Mauro had lived as a member of a Camaldolese community. In Reuwich's *View of Venice*, an island behind the main mass of the city bears the tag *ad sanctum Michaelem*, though the silhouette of the church pictured matches that of San Cristoforo della Pace, situated at that time on a closely neighboring island in front of San Michele (from the artist's perspective) and separated from it by a canal (figure 58). The canal was filled and the islands joined in the mid-nineteenth century, when San Cristoforo was also rebuilt with a new form.

FIGURE 57
Fra Mauro, world map, 1448–60. Biblioteca Nazionale Marciana, Venice. Photo: Scala / Art Resource, New York.

their devotions while passing time in Venice: an early sixteenth-century woodcut broadside confirms this tourist practice, as it brings together images of over a dozen saints who share only the fact that they are each the patron of a church Fabri visited and can be invoked against one of the perils of the voyage.[16] The more customary the practice, the more likely that Breydenbach and Reuwich also followed it.

Mappae Mundi

Reuwich did not produce a world map, so he did not use the *mappa mundi* format as the foundation for his work, as Fra Mauro did, choosing instead a map of the Holy Land that was often attached as a modern addendum to editions of Ptolemy. Nonetheless, the *mappa mundi* tradition persists as a formative element of the *Peregrinatio*, both in the artist's and author's own understanding of the shape of the world, which they use to make sense of their experience of the landscape they travel, and in their transmission of this to their viewers. The simplest *mappae mundi* diagram the world as a circle bisected horizontally with the bottom hemisphere then bisected vertically—a T-in-O plan (figure 59). The half-circle above the T represents the largest of the Earth's three known continents, Asia, with Europe in the bottom-left quadrant of the O and Africa in the bottom right. Another schema, derived from Macrobius (fifth century) or Ptolemy via Islamic geography, divides the circle into five or seven horizontal zones according to climate or the length of the longest day. The middle zones (near the equator) were often described as "torrid" regions too hot to support human habitation or even brief transit. The most interesting and well known of the *mappae mundi*, such as the Hereford map discussed below, maintain the fundamental layout and

FIGURE 58
Erhard Reuwich,
View of Venice (detail:
San Michele) from
Peregrinatio Latin,
hand-colored woodcut,
fols. 13v–20r. The Bodleian Libraries, The University of Oxford,
Arch. B c.25.

Fabri makes the same mistake as Reuwich, reporting that he saw a "very fine world map" in the "new and fair church" of San Cristoforo at the monastery of the "white order." The Camaldolese monks wore an entirely white habit, and while the church of San Cristoforo was about thirty years old, the Church of San Michele had just undergone a major renovation that transformed it into one of the formative monuments of Renaissance architecture in Venice.[15] Their shared confusion suggests that Fabri and the *Peregrinatio* team compared notes, either at the time or later, or perhaps Fabri tried to jog his memory with Reuwich's image. He reports visiting both churches in succession before embarking for the Holy Land, as he made a tour of local sacred sites, in particular those with special promise for transmitting the concerns of pilgrims about to undertake a hazardous journey. The Angel Michael would smite their heathen enemies, he prayed, while Saint Christopher would bear them safely across the sea. In making these stops, Fabri was following a standard itinerary for pilgrims keen to get a jump on

orientation of the T-in-O while greatly elaborating the shape of the continents, surrounding their contiguous landmass with water, and adding copious toponyms, icons, and annotations. These captions and pictures visualize places, peoples, animals, and curiosities from works of natural history by church fathers like Isidore or classical authors like Pliny, as well as places, persons, and events from the Bible.

Breydenbach has the T-in-O arrangement in mind when he writes of the pilgrims' cruise down the Nile: "On one side [we had] Asia, on the other Africa, two parts of the world that the Nile divides or separates from one another" (153v, ll. 33, 36–37). Breydenbach is also familiar with a Christian version of the zone schema that understands the band of heat as a barrier to the Garden of Eden. In the Sinai Desert, the pilgrims encounter a stretch of land that they are told "has no end in the east." "Many believe," writes Breydenbach, "that this is a part of the land where no men on earth live anymore because of the overwhelming heat, called *torrida zona* in Latin, that reaches to the earthly paradise" (139v, ll. 7–8, 11–14). He invokes these hot spots again as an impediment to discovering the source of the Nile. "In past times many sultans have undertaken to find out where the Nile has its source. . . . But, although [the sultans' ships] sailed far beyond India, they had to turn back when they could not find any end to the river Nile. In addition, they said they sailed so far beyond India that there was no more human habitation, but such great heat that no person could stand it" (152r, ll. 16–22).

Breydenbach's conflation of India with subequatorial Africa arises from a common version of the *mappa mundi* that depicts the landmass of Africa distended east to fill most of the space that correctly belongs to the Indian Ocean.[17] In the Hereford map, the Red Sea (at the upper right) divides Africa below from Asia above, with no other water except

the global ocean that encircles their fused mass (figure 60). Even the Fra Mauro map maintains a vestige of Africa's bend eastward, seen at the top of the circle. Though given shape on maps, these African areas below the Red Sea and beyond the Nile represent the mainly unknown East, and India was thought to lie somewhere far in that direction. This is the cartographical notion behind Breydenbach's presenting Ethiopian Christians resident in the Church of the Holy Sepulcher as "Indians" in the catalog of the peoples of the Holy Land (figure 31).

FIGURE 59
T-in-O map from Saint Isidore of Seville's *Etymologiae*, twelfth century. British Library, London. Photo: HIP / Art Resource, New York.

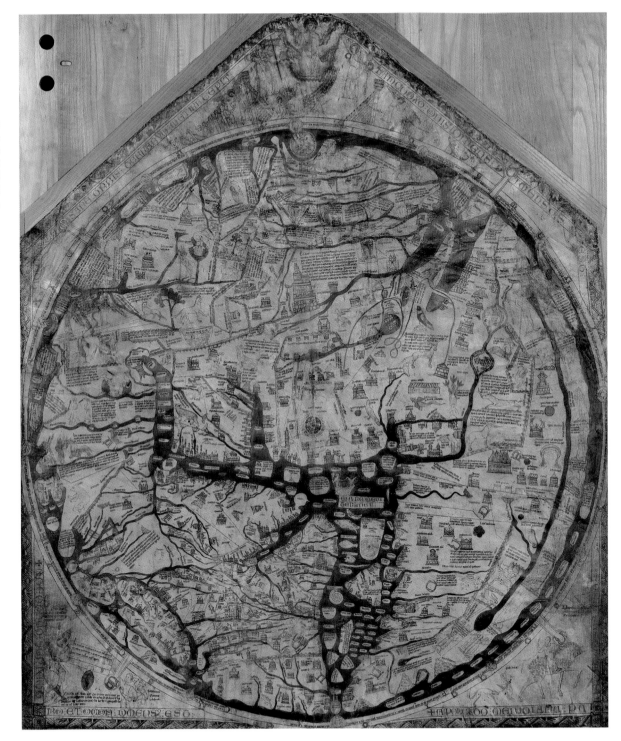

Breydenbach may not be able to plot his own passage through the Sinai by means of a *mappa mundi*, but he orients himself according to such a map's form, particularly as he draws deeper into the empty expanse at the edge of his world that corresponds to the *mappa mundi*'s own limits. His interpretation of his global position in *mappa mundi* terms demonstrates these maps' utility for understanding real topography.

They served another, more fundamental purpose, however, by giving pictorial expression to the model of sacred space-time expressed in the convergence of sites on the floor of the Church of the Holy Sepulcher. The most articulate example, the late thirteenth-century *mappa mundi* in Hereford Cathedral, embedded the map in the resonant form of a triptych and expounds its Christian model with a pictorial frame: a *Last Judgment* reigns over the disk of the earth from a gable, and lost wings with the Angel Gabriel and Virgin Annunciate once bracketed the world between them.[18] This configuration eloquently expresses how *mappae mundi* can offer a two-dimensional, more detailed view of the globe often depicted at the feet of the *Majestas Domini*: this is the world as Christ's dominion, the realm of God's creation and Incarnation that is the stage for the great circuits of sacred history and the smaller echoing cycles of each individual person's birth, death, and salvation (or damnation).[19] On the Hereford map, Jerusalem sits at the center of the circle as the center of this cosmology and also as a microcosm of it. Just as the sphere of the world sits at the feet of Christ as Judge, so along the same center axis the circular walls of the Holy City take their place at the base of Christ Crucified, like a mortise for his cross (figure 61). Together, crucifix and Jerusalem echo in miniature the encompassing structure of the map.

In Reuwich's *Map of the Holy Land with View of the Jerusalem*, the Holy City rises behind the port

FIGURE 61
Hereford world map (detail: Jerusalem), c. 1285. Photo © The Hereford Mappa Mundi Trust and the Dean and Chapter of Hereford Cathedral.

of Jaffa to push aside the landscape of towns, rivers, and mountains that charts the rest of the Levant from Damascus to Alexandria over 1.52 meters (gatefold). Jerusalem claims the center of the map and the viewer's attention through its own outsize muscle, while calling upon the meaning of the city in *mappae mundi* by adopting the distinctive hieratic scale, round walls, and axial placement of such maps. At the edges of Jerusalem, the pictorial space of the image shifts from the relatively flat expanse of a map to the distinctive perspective of the view. For that reason, it is easy to overlook at first these aspects of the treatment of the Holy City that signal the importance of *mappae mundi* for this woodcut, the pilgrimage experience, and the *Peregrinatio*.

The artist who circumscribed the world of the Hereford map set the spike of his compass in Jerusalem, then stretched the stylus to reach almost to the

very edges of the parchment. The outsized circle he created dominates the available space, even intruding into the pediment to push the *Last Judgment* into a relatively much smaller margin. The unusual size and prominence of the world map in the composition defy typical art-historical categories, so scholars at first looked to the work's more conventional aspects—its iconography, triptych format, and likely provenance from a chapel—to suggest that it may have been meant to serve as an altarpiece.[20] More recent research has refuted this, arguing instead that it, like the Fra Mauro map, was on display to pilgrims in a church, hung at eye level next to the tomb of Thomas of Cantilupe, a local candidate for sainthood whose campaign met success in 1307. There it may have served as a visual aid to preaching and instruction, one of the *Peregrinatio*'s intended functions.[21] Documentation of the viewing context for *mappae mundi* (those not bound in books) is sparse, but the contents of yet another pilgrimage chapel—the chapel of two-time Jerusalem pilgrim William Wey—suggest how a map produced much closer in time and context to the *Peregrinatio* can be folded into the program of a church without serving as a backdrop to the Eucharist. The Wey *mappa mundi* would not have been nearly as large or elaborate as its predecessor at Hereford. Instead, it was firmly embedded in an assemblage of objects that brought together multiple manifestations of the Holy City: the liturgical Jerusalem of the Easter celebration; Jerusalem's eschatological promise of redemption as the site of Jesus's triumph over death and the future site of his return; and a contemporary Jerusalem that lent the luster of its distance, danger, and sanctity to the person of a returning pilgrim like William Wey.

Wey belonged to an Augustinian order with a house in Edington, England, and the manuscript account of his journeys contains an inventory of the furnishings, including both the book itself and a *mappa mundi*, that he bequeathed to a chapel in their church upon his death in 1476. The Wey inventory describes the chapel as "made to the lyknes of the sepulkyr of owre Lorde at Jerusalem," a signal that it played a central role in the distinctive liturgical drama of the Easter celebration in England.[22] On Good Friday, a consecrated host and a crucifix—the real body of Christ and an image of him—would be deposited in a structure in the "lyknes" of Christ's tomb. Over the weekend the host and crucifix would be removed surreptitiously, so that a trio of worshippers could discover the empty chamber on Easter morning, in emulation of the three Marys who visited Christ's tomb and found he had risen (figure 104).[23] For most of these Easter sepulchers, as presumably at Edington Priory Church, the element of likeness did not arise from the structure's physical resemblance to the Holy Grave in Jerusalem, but from its function matched with the shape of either a permanent tomb monument in a local style; the typical wood casket and canopy used in funerary services; or a special tabernacle, sometimes distinguished by Passion imagery.

Indeed, the furnishings in Wey's chapel feature Easter week iconography, including cloths painted with *Christ as the Gardener*, *Christ Appearing to His Mother*, and the three Marys and "thre pylgremys"; linen cloths with black crosses to cover images during Lent; and a gathering of paper pages with miniatures of the Passion. The cloth with the three Marys explicitly links the biblical past, its contemporary reenactment in the Easter ritual, and Holy Land pilgrimage by pairing the discovery of Jesus's resurrection with present-day Jerusalem pilgrims; the Marys and the pilgrims repeat their visit to the tomb on an object placed in a chapel for a ritual that recapitulates the same. This connection is continued implicitly in the chapel's collection of objects that pictured sites in the Holy Land or makes them

present through physical relics. Beyond the *mappa mundi* and the pilgrimage account, these include two leaves of parchment with images of the Mount of Olives and the "tympl of Jerusalem"; a stone with a depression of the dimensions of the mortise for the Cross; a Holy Face and a crucifix brought back from the Holy Land; stones from Calvary, the Holy Grave, Mount Tabor, the Flagellation column, the place where the Cross was buried and found, and the site of the Nativity; and a map of the Holy Land (based on the same crusader-era regional map Reuwich used).[24] In connecting the map, book, and relics to a liturgical space and, particularly, Easter rites, Wey incorporates these items into a strong, preexisting, and highly structured system for imagining the Passion. The pilgrimage artifacts, including the *mappa mundi*, become just one among many complementary "likenesses" of the sacrifice of Christ in the chapel complex that together amplify the resonance of the Eucharist by figuring elements, including the setting, of the event it reenacts.

In charting the meaning of Jerusalem, *mappae mundi* fit into the logic of any fifteenth-century chapel, which are always already a proxy for Jerusalem, with each altar its own hub in the cycle of liturgical time's recapitulation of sacred history. Just as in the Church of the Holy Sepulcher, so also on an altar table Golgotha and the Holy Grave are brought together in one place when the consecration of the Eucharist reenacts the Crucifixion over a stone slab *qua* sepulcher. Regional pilgrimage then replaces the mostly unfeasible journey to the Levant. With its visual emphasis on the Holy City as both the *axis* of the Christian *mundi* as well as a microcosm of it, the world map reinforces the chapel's conflation of the local present and the sacred past, by recalling the Jerusalem archetype and visually glossing its significance as the focal point of the encompassing system of creation.

However, though the tradition of locating a terrestrial center point in a sacred precinct goes back to the *omphalos* at the sanctuary at Delphi and elsewhere in the ancient Greek Mediterranean, the Christian emphasis on Jerusalem as that center arose only in the crusader era along with the military and political focus on the city.[25] The placement of Jerusalem at the hub of Western maps begins in the mid-thirteenth century, so that this visualization of the city is not an artifact of some general Christian medieval worldview per se, but a phenomenon limited to a particular window of time. This is the era between two losses. The first is the fall of Jerusalem in 1244 and the failure of the crusading venture as a whole shortly thereafter, when Christians had to mourn and begin to come to grips with their exile. The second is the fall of Constantinople in 1453, when, *pace* Breydenbach, Europe began to move from lingering dreams of an offensive campaign to a defensive alert against the threat of Turkish invasion.

The recentering in the thirteenth century engendered a side effect: on *mappae mundi*, Hereford or any other European site finds its place in the Lord's dominion, but it is a place manifestly eccentric to the fixed umbilicus. For a chapel like Wey's, this disrupts the self-sufficiency of its substitute geography by anchoring the Holy City at a distance. A *mappa mundi* works to establish the meaning of *here*, that is, the church where it is displayed or the devotional community of the viewer, in relationship to *there*, the center point of the image and the place that a church's altars emulate in their ritual and symbolic purpose. The map reinforces the congruence of *here* and *there*, local altar and Jerusalem, while at the same time preserving their ultimate distinction. Visualizing this wedge as a spatial separation draws attention to the condition and implications of exile, giving form to the theological and emotional heart of the

crusader cause—or its echoes in the longing of later Jerusalem pilgrims and would-be neo-crusaders attentive to the persistence of their displacement. Fabri's resistance to recasting the omphalos as a contingent phenomenon can be understood as more than just pre-Cartesian recalcitrance or lack of imagination. He resists the implications of designating each church as the wholly adequate center of a circle of salvation. The distinction between Jerusalem and its substitutes also underlies the special prestige that accrued to persons having undertaken and successfully completed a pilgrimage to the Holy Land, a blessing that returning travelers commemorated with votive images and other displays—a genre of socioreligious exhibition to which the Wey chapel and the *Peregrinatio* certainly belong.

Reuwich borrows more from *mappae mundi* than the scale, shape, and placement of Jerusalem; he pulls also from the maps' ability to serve a theological and political purpose in representing the Holy City's presence and absence. Where Wey brought together a group of artifacts under the umbrella of a chapel, so Reuwich's *Map of the Holy Land with View of Jerusalem* brings together many of the same elements between the covers of a book—the omphalos of the *mappa mundi*, a map of the Holy Land, and images of the Holy Grave (printed on the back of the foldout), Mount of Olives, and "Temple." In the next chapter, we will see how Reuwich uses the prominence of distinctively Islamic architecture in his rendering to disrupt a Christian viewer's immersion in the city with an affective reminder of its infidel occupation. The *mappa mundi's* balance between presence and absence lies at the heart of the *Peregrinatio* project: Jerusalem is brought into the devotional space of the reader—through its picturing as a view and in the visual and other rhetoric emphasizing its importance—only to be distanced by reminders of its contemporary alienation.

The Burchard Map of the Holy Land

If the outsized Jerusalem is the umbilicus of Reuwich's map, then its backbone was provided by a type of map associated with a textual description of the Holy Land, *Descriptio Terrae Sanctae*, written by Burchard of Mount Sion before the final fall of the Latin Kingdom in 1291. This is a regional map of the Holy Land that runs, as in Reuwich's map, from the Mediterranean Sea in the west along the bottom of the page to the mountains that bound the east of the Jordan River valley along the top (figure 62, 63). Left to right, the map begins where Reuwich's does, at Damascus in the north, but ends before Reuwich's at a river just south (right) of Bersabee that marks the traditional border between Palestine and the Egyptian desert. In the *Peregrinatio*, the space of Jerusalem erupts into this span, so that the left third of Reuwich's version corresponds roughly to the left half of the other examples shown.

This type of map has been considered a pair with Burchard's text since the nineteenth century on the basis of correspondences between places mentioned in the text and toponyms in the maps, a conclusion encouraged by a separate letter by Burchard that mentions the existence of a map.[26] Yet, while the *Descriptio* and the map each became common throughout Europe, in manuscript and eventually in print, they usually appeared independently of each other and in diverging contexts that separately shaped their reception. The first printed edition of the *Descriptio*, for example, was integrated into an overview of world history and geography called the *Rudimentum Novitiorum* (Primer for novices), first published in 1475, but there the text is accompanied by a different map of Palestine, one that is topographically imaginative and wholly unrelated to the tradition of the Burchard type. The most influential instance of the map appears without the text in a

circa 1321 crusading manifesto that would transmit it, still unaccompanied by the full *Descriptio*, to fifteenth-century editions of *Geography*. Moreover, Burchard's text follows a peculiar geometry in ordering the spatial relationship among sites that is nowhere evident in the so-called Burchard map. He divides the Holy Land into six divisions radiating in a semicircle from the last crusader capital, Acre, on the Mediterranean Coast and then proceeds methodically in his description along each of the six vectors of his ideal pattern in turn.

Indeed, the strongest conjunction of Burchard text and so-called Burchard map occurs in the *Peregrinatio*. There Breydenbach reprints the *Descriptio* (with the text but not the map taken from the *Rudimentum*) between his accounts of the pilgrims' time in Jerusalem and their journey to Egypt, and the image is meant to occur with this section of the text.[27] Breydenbach writes that he intends for what he calls the "short description" to elucidate all the "places and particulars" in the "picture" (*gemeld*) that follows it.[28] According to Breydenbach, the description should give a better understanding of the places around Jerusalem, especially those mentioned in the Bible and especially for those who study or preach Scripture (57r, ll. 24–28, 31–32). He also links the "short description" to his own travel account by claiming, with considerable exaggeration, that his party journeyed to see everything the passage mentions during the weeks they waited in Jerusalem to depart for Saint Catherine's—the moment in the narrative where the *Descriptio* is supposed to be inserted (57r, ll. 19–21). By ending his account of their time in Jerusalem with this statement, he introduces the *Descriptio* as a continuation of his own story.

The pattern of rivers and mountains in Reuwich's map matches that of the Burchard type almost one for one, though Reuwich adapted the shape of the elements of terrain to his own style. Almost all the sites in the map are mentioned in the text of the *Peregrinatio*, either in Burchard's description or in Breydenbach's account of his journey, but Reuwich has added sites from the *Peregrinatio* text not commonly found in recensions of the Burchard map. He has brought the so-called Burchard map closer to the Burchard text.[29] This tailored relationship between the *Peregrinatio* text and map offers a particularly strong indication that the *Peregrinatio* team are responsible for the work of integrating the image's manifold sources, rather than having simply copied entire and without emendation any single map they found in their researches.

The Burchard map moves through three discrete moments in its history and reception on the way to inclusion in the *Peregrinatio*. First, from its beginning, the *Descriptio* continued the tradition of Eusebius of Caesarea's early fourth-century *Onomasticon*, a gazetteer for the Old and New Testaments translated by Jerome as *De situ et nominibus locorum hebraicorum* (On the location and names of Hebrew places). Like the *Descriptio*, both Eusebius's and Jerome's texts are thought to have been accompanied by maps, and a copy of a "Jerome" map survives from the twelfth century. These sources mediate the topography of the Middle East through the Bible, presenting an imaginary geography of the Holy Land that clarifies and complements the imaginary space generated by contemplating the sacred history set forth in the Old and New Testaments. As Breydenbach makes clear in announcing one of his purposes for including Burchard's text and map, both served a similar role for late medieval and early modern Christendom, superseding the patristic sources with an updated set of place-names now punctuated with crusader sites. Walter Melion has analyzed, for example, how the Holy Land maps in the historical addendum to Abraham Ortelius's atlas *Theatrum*

orbis terrarum (Theater of the world), produced from 1570 through 1612, nourished the devotional meditation of their readers through geographical study couched in the language of spiritual pilgrimage. Ortelius's atlas explicitly mentions and makes visible Burchard's influence.[30]

Next the map, without the full text, was adapted by Marino Sanudo Torsello for his *Liber secretorum fidelium crucis* (Book of the secrets of the faithful of the Cross), circa 1321 (figure 62). Though later than the earliest known Burchard map in Florence, the version in Sanudo's work would become the most influential early example. Sanudo intended the *Liber secretorum* as propaganda to motivate crusade in the form of a practical manual to facilitate such an undertaking, and the work's cartographic apparatus was commissioned and designed to strengthen its mission. Sanudo aggressively and resourcefully promoted his plan by personally presenting a copy of *Liber secretorum* to the pope and gifting copies to rulers at courts across Europe.[31] His book goes beyond a rhetorical call to arms to suggest a precise battle plan and provide as much useful information as possible, based on his personal experience as a merchant from a prominent Venetian family. To help convince his audience of the feasibility of the scheme and work out its logistics, he commissioned Pietro Vesconte, a well-known Venetian cartographer, to create a series of illustrations, including a portolan atlas, a Burchard map, and city plans of Acre and Jerusalem. There are six extant codices with the Burchard map and several more in works by Vesconte and a bishop tasked by the pope to evaluate Sanudo's proposal, and Sanudo's will testifies that there were once at least two versions of the map mounted on boards in Venetian churches.[32]

To instrumentalize the Burchard map to better serve their goals, Sanudo and his cartographer rebuilt the map around a grid—a unicum in the mapmaking of this period—twenty-eight units high by eighty-three units wide, with each square representing about two miles.[33] Sanudo's text then lists the sites of the region and their coordinates, starting at the upper left corner and proceeding left to right across each row, and the map follows this schema exactly. The text facilitates dissemination of the map by providing a system for consistently and efficiently replicating it in the absence of any illustration, and it allows readers to assemble an overview of the region that places the individual sites in a fixed, measurable relationship to each other. Sanudo does not limit himself to a recitation of the points in the grid; he includes other, more genuinely descriptive material, often influenced by Burchard's text. But while the sites still resonate with sacred and historical meaning, they are meant to refer first to a physical geography proposed as a theater for war.

Ordering the toponyms within a grid prepared the map for the next stage of its reception, assimilation into the framework expounded by Ptolemy. In *Geography*, Ptolemy first discusses the shape of the world and three systems for projecting the sphere of the earth onto a plane. He then offers tables of coordinates of latitude and longitude for plotting cities and topographical elements. Four aspects of the treatise were influential: Ptolemy's description of the ecumene, his system of latitude and longitude as a comprehensive means of structuring the world and collating geographical data, his tables that list places' coordinates in that system, and his procedures for structuring that grid to represent the globe on a flat surface. Ptolemy laid out many aspects of his conceptual framework in an earlier work on cosmology, known by the title of its Arabic translation, *Almagest*. Translated from Arabic into Latin, this work was well known and accepted in Europe in the Middle

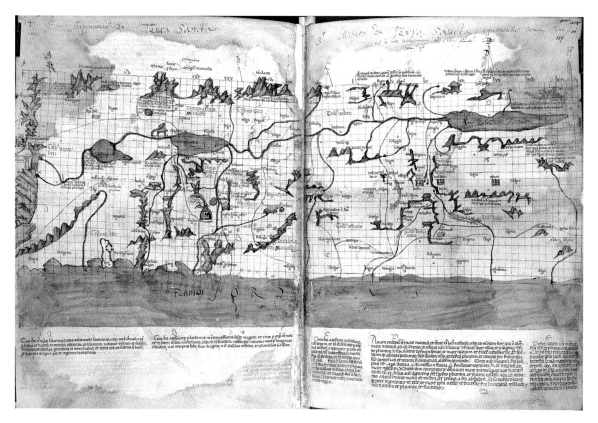

Ages well before *Geography*'s arrival. By the time Ptolemy gets to *Geography*, he assumes the abstract system of latitude and longitude as well as a theoretical understanding of how observed astronomical phenomena, such as the rising and setting of stars or maximum hours of daylight, correlate to latitude. He turns to the applied science of collating records of such observed phenomena as well as reports of distances and directions traveled along itineraries. These data allow him to describe the size and shape of the world and to position locales and regions relative to the equator and to each other.[34] The standard suite of illustrations to Ptolemy's *Geography* offers twenty-six regional maps drawn to a homogeneous scale in addition to a single, smaller-scale world map, with all twenty-seven correlated by means of their parallels and meridians.

The order of Ptolemy's representational system begged comparison with the *mappae mundi* to which most viewers were habituated. For some, like Cardinal Guillaume Fillastre, who sent the first copy of the Latin *Geography* from Italy to France in 1418, this comparison threw into relief ambiguities of the *mappae mundi*.[35] Others, like Fra Mauro, extracted information from Ptolemy while retaining the traditional scheme. Fabri's conclusions about the equator are hardly an example of the best consequences of the circulation of *Geography*, but his attempts to reconcile Ptolemy's view of the world with his own do demonstrate the type of deliberations stirred by

the text and the spread of this exercise. In debunking the principle that a gnomon that casts no noon shadow marks the center of the earth, Fabri cites evidence from specific regional maps in *Geography*: such a phenomenon is observed at locations in six of Ptolemy's maps of Africa and Asia, he argues, "and it is well-known that these places are not the middle of the world."[36]

Fabri's perusal of *Geography*'s maps in Ulm, where he was based from 1468 until his death in 1502, reveals another route for the exchange of visual materials between German expatriates in Italy and the German pilgrims of the *Peregrinatio* journey, one that runs parallel to the Ugelheimer-Breydenbach connection between Venice and Frankfurt. An Ulm native known as Donnus Nicolaus Germanus emigrated to Florence, where he made a career in the 1460s and '70s fabricating luxury *Geography* manuscripts and globes for the Vatican and other courtly clients.[37] Documents show that his nephew Lienhart Holle traveled between Florence and Ulm repeatedly in the 1470s, and he seems to have been carrying home texts for publication by Johann Zainer.[38] Fabri is known to have worked as a corrector and editor for Zainer at least twice in 1475 and 1478, so he belonged to this circle.[39] Holle left Florence between March 1472 and 1473; Zainer published the first Latin and German editions of Boccaccio's *De Claris Mulieribus* in 1473 and 1474.[40] A German translation of Boccaccio's *Decameron* was commissioned by Donnus Nicolaus Germanus from a close associate of his, a Nuremberg expatriate living in Florence under the name "Arigo," and then delivered to Holle.[41] Sometime after February 1477, Holle left Florence for Ulm again, and Johann Zainer printed Arigo's translation in Ulm around that time.[42] This picture of the network of connections would not be complete without pointing out that the Nuremberg expatriate "Arigo" who translated Boccaccio for Zainer was Henricus

Martellus Germanus, who would become a significant cartographer in his own right after the death of Donnus Nicolaus in 1480.[43] In particular, Martellus produced a cutting-edge world map from about 1489 that began with a Ptolemaic framework and then incorporated the very latest Portuguese discoveries from the rounding of the Cape of Good Hope in 1488, portolan charts, and a reconsideration of Marco Polo that greatly expanded Asia to the west.[44]

Holle also brought back one of his uncle's *Geography* manuscripts, preserved at Schloss Wolfegg, which he used as the basis for an edition printed in Ulm under his own name in 1482 (figure 63).[45] After Holle was declared bankrupt in 1484, the woodblocks came into the possession of another local, Johannes Reger, who printed a second edition in July 1486 with the support of a Venetian businessman resident in Ulm, Justus de Albano.[46] These are the first printed editions of *Geography* north of the Alps and, presumably, the ones Fabri knew. Reger's edition adds two other texts to the Ptolemy. The first, a register that serves as a gazetteer for the maps, includes annotations to remind readers of the sacred persons and events associated with each place. The second, a description of the world that integrates information from Christian medieval encyclopedists, is very much a textual version of drawn *mappae mundi*.[47] This wrapping of Ptolemy's data in the apparatus of medieval geography matches Fabri's approach to the material quite closely. Perhaps we may even catch a whiff of the influence of Fabri and the neo-crusading sensibilities of the *Peregrinatio* pilgrims, when the Reger *Geography*, published five months after the Latin *Peregrinatio*, opens with a note that uses "our mother Jerusalem" as its example in explaining how to use the notations of latitude and longitude. This introduction then continues to specify that the historical Christian triumphs of the register are meant to inspire contemporary action.

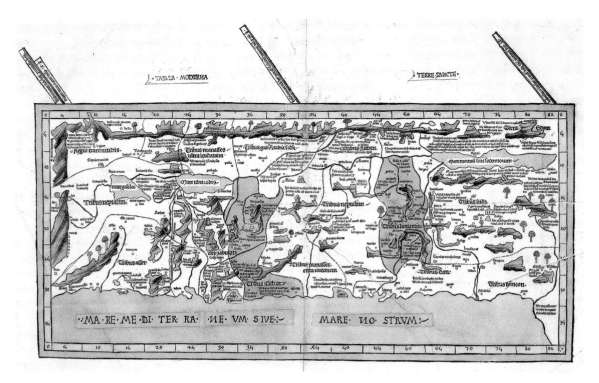

The language of the passage suggests that action can be understood either as purely devotional engagement with the Holy Land that prompts penitence or as the monetized penance of purchasing indulgences to fund the territories' recapture: "First the author does not intend to show what is the status of the Christian religion now, but what it was, so that suffering catholics should occupy themselves with providing for paying their penitential debt and by means of the victorious martyrs and holy fathers, they may attend to recovering the lost [territories] that were being sought by the confessors [of the Christian faith] in those days."[48]

Almost immediately after the production of the first illustrated manuscripts of *Geography* in the West, mapmakers began to supplement the twenty-seven antique *tabula* with newly devised *tabula moderna*. These were maps of regions little-known to Ptolemy, such as Scandinavia, or with a strong post-classical cartographic tradition, such as the Holy Land. From 1468, Donnus Nicolaus incorporated the Burchard map, copied from Sanudo, in his manuscripts together with modern charts of Spain, Italy, France, and Northern Europe (figure 63).[49] By binding these newer charts side-by-side with the classically based and *mappa mundi* material, such publishers carried out in atlas form a less forceful version of the practice of mapmakers like Fra Mauro—and Reuwich—who went beyond collecting and collating sources as successive pages to integrating them on a single sheet.

The *tabula* of the Holy Land is not the only modern material Reuwich seems to have scavenged from compilations of Ptolemy to build his map. In his images of Jerusalem, Damascus, and Alexandria, the artist incorporates aspects of a distinctive set of city

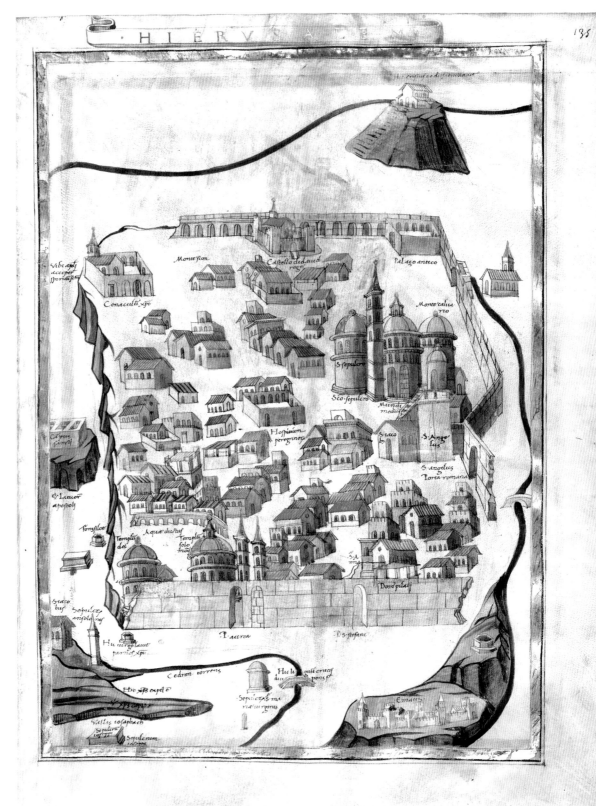

FIGURE 64
Jerusalem from Pietro
del Massaio and Ugo
Comminelli's compi-
lation of Ptolemaeus's
Cosmographia, before
1454. Bibliothèque
nationale de France,
Paris, ms. lat. 4802,
fol. 135r.

plans known only from certain manuscript recensions of *Geography* compiled in Florence before 1453 by Pietro del Massaio and Ugo Comminelli, purveyors of luxury codices like Donnus Nicolaus (figure 64).[50] In an article on Carpaccio, David Marshall realized that the quirky curve of the River Kidron around the Sepulcher of the Virgin in Reuwich's map derives from the plans of Jerusalem in these codices (figure 65).[51] Reuwich also copies a river that flows down along Jerusalem's northern boundary, passes under a bridge, and continues past the city, before skirting to the right of Emmaus. He then sews that into an element taken from the Burchard map, a stream that splits after Emmaus to feed the two rivers that frame part of the land of the Philistines (*Terra philistÿm*) on the Mediterranean coast. A hillock below at Modin (*Modyn vnde orti fuerunt machabei*) marks the seam between sources (figure 66).

Reuwich also seems to have used another city plan from the same manuscripts for his view of Damascus (figures 67). On the version in *Geography*, the city is dominated by a basilica with three campaniles, which Reuwich has refashioned as two minarets (figure 68). He simplifies the rest of the buildings and the river system, removing the city walls, but he maintains the basic flow from mountains to lesser buildings and streams to the main city. A house crowns the lower mountain on both maps, marking the spot where Cain killed Abel (*ubi chayn occidit abel ·*), a site that does not appear in Burchard's text, Breydenbach's account, or other Burchard maps.

Portolan Charts

With their trip through the Sinai Desert to Saint Catherine's Monastery and then Cairo and Alexandria, the pilgrims journey beyond the bounds of Burchard's map toward the margins of their known

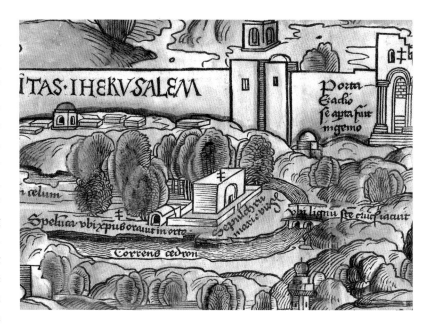

FIGURE 65
Erhard Reuwich, *Map of the Holy Land with View of Jerusalem* (detail: River Kidron) from *Peregrinatio* Latin, hand-colored woodcut on vellum, fols. 143v–148r. Photo © The British Library Board, C.14.c.13. All rights reserved 2014.

FIGURE 66
Erhard Reuwich, *Map of the Holy Land with View of Jerusalem* (detail: water system to the right of Jerusalem) from *Peregrinatio* Latin, hand-colored woodcut on vellum, fols. 143v–148r. Photo © The British Library Board, C.14.c.13. All rights reserved 2014.

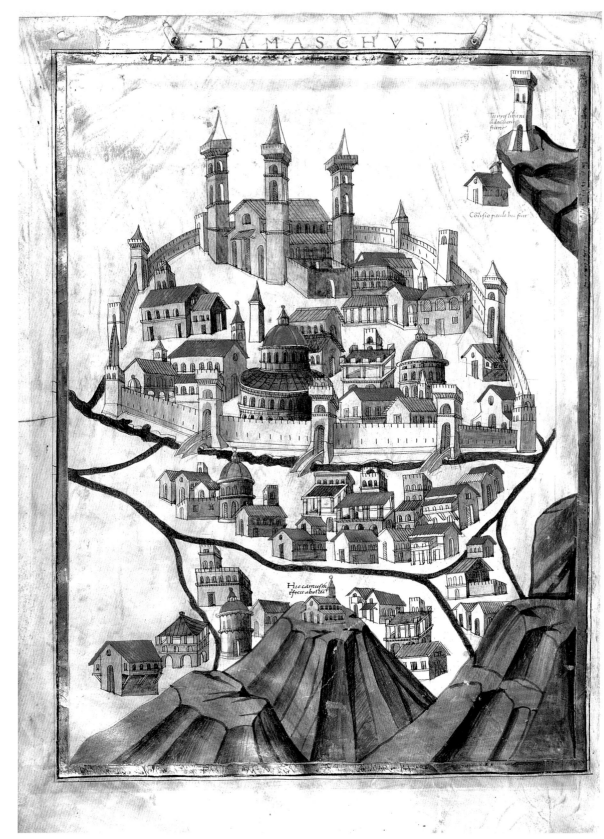

FIGURE 67
Damascus from Pietro
del Massaio and Ugo
Comminelli's compi-
lation of Ptolemaeus's
Cosmographia, before
1454. Bibliothèque
nationale de France,
Paris, ms. lat. 4802,
fol. 134v.

world. This is where Breydenbach falls back on his knowledge of *mappae mundi* to envision his location and where Reuwich draws on the visual coherence of the narrative language of painting in his need to baste together a more fragmented set of materials—portolan charts and itineraries, his own and those of contemporary caravans and other pilgrims, Israelite and Muslim. References to portolans by pilgrims are not common, and the evidence of Reuwich's detailed access to such charts arises around two clusters of toponyms along the coasts of Egypt at the Nile Delta and the Red Sea.[52] His source must have extended as far as the most extensive examples of the genre, at least as far as the western lip of Arabia. Portolan charts collected observations about the shape of the coast and relationships of distance and direction—information from pilots for pilots, and their production and use centered in the Mediterranean ports of Spain and Italy (figure 69). They were as much a novelty in northern Europe in 1486 as any of Reuwich's other imports.

Like the Burchard and Hereford maps, portolans found their origin at the end of the thirteenth century, and the timing of their emergence, together with the maps' orientation toward magnetic north, as well as the nature and size of their errors, suggest that they may have been compiled according to data collected systematically through dead reckoning guided with a compass, an instrument also devised around that time.[53] Portolan charts show with great accuracy the shape of the coast of the Mediterranean Sea, the Black Sea, and the Atlantic Ocean from northern Europe through northern Africa. Most show the placement of sites along the coasts without offering much information about inland features, and a network of rhumb lines radiates across the sheet to suggest headings for navigation. Sanudo's cartographer, Pietro Vesconte, was a formative contributor to the portolans' early

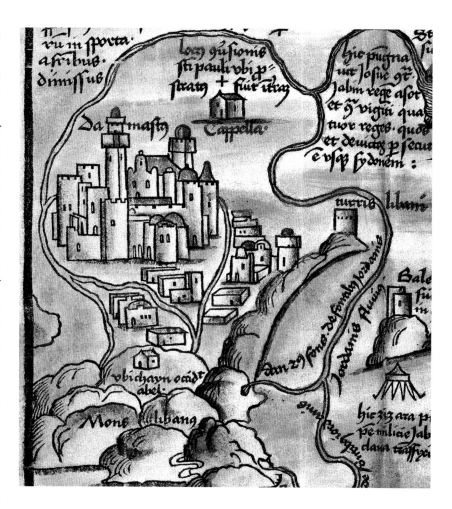

development, and his assimilation of the Burchard map to a geometrically regimented network seems a way of bringing it closer to the new standard of the portolans' surface web. The invention and dissemination of portolan charts signals the ascendance of maps assembled from empirical data and designed to be an accurate tool for physical navigation across the surface of the earth.

The seam where the Egypt sheet attaches to the rest of Reuwich's foldout runs through *Larissa* and the *golfus de larissa* next to the *Campus de gallo* and, moving down the coast to the right, *vruli*, *sterion*, and the *Campus de bucher* (figure 70). *Vruli* is meant to

FIGURE 68
Erhard Reuwich, *Map of the Holy Land with View of Jerusalem* (detail: Damascus) from *Peregrinatio* Latin, hand-colored woodcut on vellum, fols. 143v–148r. Photo © The British Library Board, C.14.c.13. All rights reserved 2014.

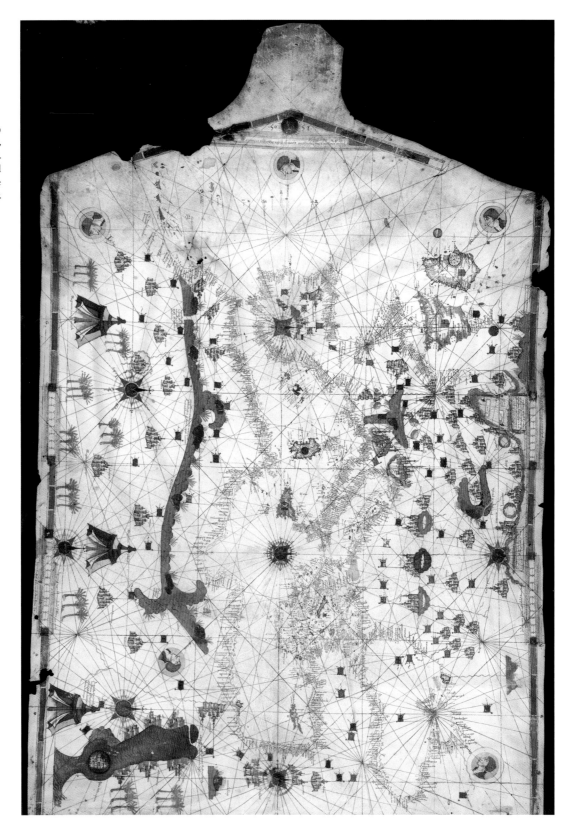

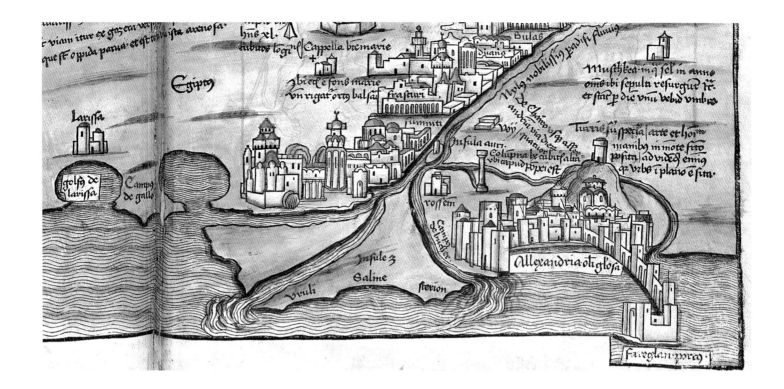

refer to a promontory and *sterion* to a small bay, both on the coast of that large island in the delta.[54] These terms are all Latin variations of toponyms that occur regularly and almost exclusively on portolans. *Golfus* (gulf) and *campus* (plain, field) translate the Italian *golfo* and *cassar, casar,* or *casale* found on charts from as early as the time of Vesconte (figure 71).[55] It is the regular shape of the two bays in this area, ovals, one on a short stem, that most clearly signals Reuwich's model, as the artist shifts his style here to reproduce the distinctive conventions common to portolan charts, in clear contrast to the more undulating inlets he adopts for the rest of the coast. The portolan tradition charts three branches of the Nile that flow through the delta to the sea, and Reuwich follows this, rather than Ptolemy's description of seven. This division of the delta into two triangles of land is at odds with the much more fragmented

topography that Breydenbach describes, so Reuwich layers what the pilgrims saw over the portolan base with the annotations *insule* et *saline* (islands and salt pans). He then inserts an extra tributary to skirt the inland perimeter of Alexandria, a version of the canal at the back of the Massaio and Comminelli plans of that city and another borrowing from their work (figure 72).

At the upper right corner of Reuwich's map, the toponyms gather around the map's only patch of clear horizon unobstructed by mountains (figure 73). Several aspects of Reuwich's treatment of this area of the Red Sea basin also confirm the use of a portolan: the correct representation of Sinai as a peninsula; the place-names *Ardap, Suachym,* and *Cos;* the distribution of icons along the Egyptian shore; and the relationship of the Nile and *Cos* to the coastal icons (figure 74). Nonetheless, there is

FIGURE 71
Jehuda Abenzara,
portolan chart (detail:
Nile delta), 1505.
Beinecke Rare Book and
Manuscript Library, Yale
University.

mountain. At the opposite end of that coast, an atoll marked *insula et ciuitas Suachym* (island and city of Suakin) stands as the furthest point of the map, directly above the *Via · qua peregrinatur in terras presbiteri Johannis spatio trium mensium per loca arenosa* (route by which one travels to the lands of Prester John in the space of three months through desert), a path of words directing us off the map to a legendary and distant Christian kingdom. The legend of a powerful Christian monarch in the East who could serve as an ally against Islam had circulated in Europe for centuries, but by the fifteenth century this Prester John was most commonly identified with the Christian ruler of Ethiopia. During that century, knowledge of the land of Prester John generally passed to Europe via a few tenuous diplomatic missions.[56] These three cities—El Tur, Mecca, and Suakin—figure a triangle of the land beyond the Holy Land, the other side of the world. El Tur serves as port of entry for remote and exotic ships. Mecca anchors the Red Sea basin as a false pilgrimage destination, the malevolent inverse of Jerusalem (*Mecha ciuitas vbi sepultus est Machomet*). And Suakin floats at the edge of the sultan of Egypt's domain on the hopeful road to another Christendom.

The influence of the portolan chart on Reuwich's construction of this area appears less in the correlation of toponyms and more in formal correspondences, namely, the shape of the headland and the visual arrangement of places. In a survey of cartographic representations of Sinai, Raymond Weil commends Reuwich for recognizing that the desert protrudes into the Red Sea as a peninsula, carving out the Gulf of Suez to the west (nearest the viewer) and the Gulf of Aqaba to the east. The first gulf appears clearly on the Reuwich map, bisected by a thin strip of land representing the *via per quam filÿ Israhel sicco pede transierunt mare rubrum* (path by which the children of Israel crossed the Red Sea

still quite a distance between Reuwich's picture of the way east and a portolan's charting of the Red Sea. This corner offers a microcosm of Reuwich's working process: by integrating personal experience, textual, and cartographic sources into a single pictorial vignette, he fuses multiple pieces of symbolic or diagrammatic information into the idiom of a unified visual experience. This transformation boosts a set of names taken from the corner of a maritime chart into an image of the rim of the known world in these last years before Columbus.

In the middle of the Red Sea, a lone boat cruises toward the open ocean with a puff in its sail and a sailor in the stern. Two more have docked, not in port, but on the edge of a caption that reads *Portus · thor · vbi applicant naues ex India ·* (Port of El Tur, where ships land from India). The port itself, represented by a three-story tower, stands to the left of its label in the lee of a distinctively high and jagged

with dry feet). The eastern gulf disappears behind Mount Sinai and El Tur's mountain and reemerges to their left. The artist has, in fact, repositioned El Tur, which should sit on the other side of the Sinai Peninsula on the Gulf of Suez. On portolan charts, the peninsula was often indicated as a similar dimple of land with an Israelite land bridge, but after the *Peregrinatio*, maps, including portolans, would forget the correct shape of Sinai until the seventeenth century.[57]

When the pilgrims emerge from the Sinai Desert at the head of the Gulf of Suez, Fabri recognizes the isthmus of land between the Mediterranean and the Red Sea as the boundary between Europe and the rumored wonders of Africa and Asia. Breydenbach and Fabri both speak of El Tur and Mecca, though they apparently did not know Jeddah, the port on the Arabian coast of the Red Sea where travelers disembarked before heading inland to Mecca and Medina. Both authors conflate the two holy cities of Islam, naming Mecca as the destination of the hajj, and then incorrectly understanding the focus of that pilgrimage as the tomb of Muhammad (which lies at Medina).[58]

Neither author mentions Suakin, a port about halfway down the western coast of the Red Sea in present-day Sudan—a final destination for some traders, a point of embarkation for African Muslim pilgrims sailing to Jeddah, an important stop for trade ships sailing up the Red Sea, and a transfer station where goods were loaded onto caravans for travel overland to the Nile. This is the most distant locale on the map, physically and metaphorically, situated outside Christianity's paths of pilgrimage, politics, and trade pointed toward the west, but just inside the bounds of Islam's adjoining networks directed largely east. If relatively few European pilgrims went beyond Jerusalem to Mount Sinai, hardly any claimed to have ventured

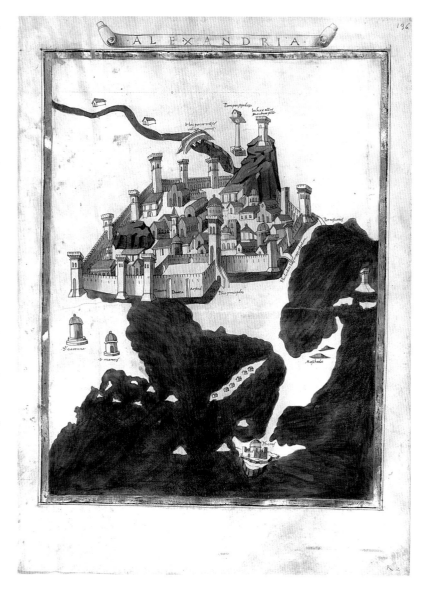

beyond Egypt down the Red Sea conduit to Asia and the far reaches of Africa. The Muslim rulers who controlled the entrance and exit to the Red Sea and the Gulf of Suez vigorously excluded European shipping and turned back Christian pilgrims whose curiosity pulled them down the coast. By preventing direct trade between Europe and the East, they ensured that Europeans had to purchase Eastern

FIGURE 72
Alexandria from Pietro del Massaio and Ugo Comminelli's compilation of Ptolemaeus's *Cosmographia*, before 1454. Bibliothèque nationale de France, Paris, ms. lat. 4802, fol. 136r.

wares from Muslim middlemen at a tremendous markup. This was the economic bottleneck that Fra Mauro's patrons battled with their colonies, galleys, and trade delegations (Venice) or their caravels tracing the perimeter of Africa (Portugal).

The appearance of Suakin in the map is surprising, as sources that name this port are rare.[59] Most portolan charts that include the Arabian Peninsula show icons for one to three towns on the west shore of the Red Sea, and they sometimes match those with a symmetrical group of icons on the eastern coast.[60] Mecca often earns separate notice as an inland site. Reuwich collapses the entire Arabian shore onto the single site of Mecca by truncating the length of the coast and filling it with a cityscape of that most holy city of Islam. On the African side of the sea, Reuwich follows the common portolan arrangement with three city icons. The first, *Aigait*

castrum (castle or fortress of Aigait), remains mysterious. Portolans with icons on this side of the Red Sea typically recognized one of the first two as Quseir with the toponym *cos* and variants, derived from the Latin-script spelling of the name as Kosseir. The other of these first icons often matches Reuwich's *Ardap* for Aidhab, an important port for ships, caravans, and pilgrims until its destruction during a trade dispute circa 1428.[61] After landing at Aidhab, goods and people traveled west overland to the Nile city of Qus, where they took to the water again to navigate down river to Cairo and eventually Alexandria. Reuwich marks Qus on his map as the last stop on the Nile: *Cos civitas unde navigio venitur Cayrum X · diebus ·* (Qus, city whence one comes to Cairo in ten days by boat).

Suakin developed as a rival to Aidhab and took over its role completely during the fifteenth century.

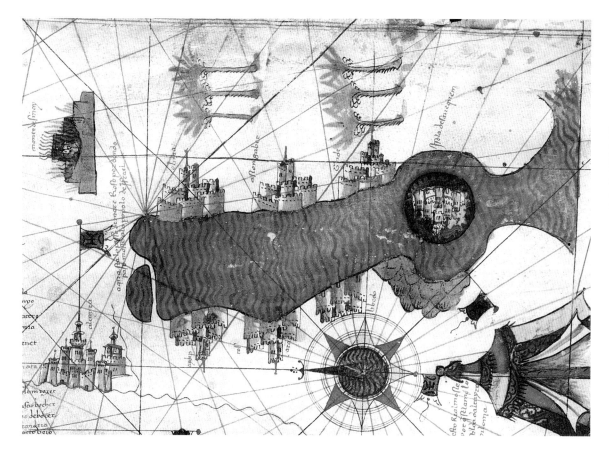

FIGURE 74
Jehuda Abenzara,
portolan chart (detail:
Red Sea), 1505. Beinecke
Rare Book and Man-
uscript Library, Yale
University.

Controlled by the Beja people and the princes of Mecca until this time, Suakin was brought more firmly under Mamluk rule around 1440. The fall of Aidhab and rise of Suakin roughly mirrored the decline of Qus and the rise of nearby Qena as the transfer point on the Nile.[62] In depicting the Aidhab-Qus-Cairo route, Reuwich reflects an outmoded state of affairs that some European portolans would continue to perpetuate through at least the Freducci map of 1497. Information about such routes seems to have arrived in Europe through the trickle of traffic between Christian Ethiopia and the Christian Mediterranean. Remarkably, Reuwich has not simply identified Suakin, he has correctly represented it as an island, although the town, a coral outcrop corralled within a natural harbor, virtually abutted the coast. Of the few sources that mention the site, even fewer specify this detail. The earliest extant portolan representing Suakin may be Jehuda Abenzara's chart of 1505, which represents the city as the only island in the Red Sea (figure 69, 74). From his name and drawing style, Jehuda is thought to have been a Catalan Jew, expelled from the cartographic center of Majorca in 1492, and all his known maps were drawn in Alexandria or Safed after that date.[63] In Alexandria, Breydenbach's party lodged in the Catalan *fondaco*, a building that served as headquarters, warehouse, residence, and consulate for the merchants from that region, so it is conceivable that he acquired a Catalan map (155v, ll. 14–30).

The Pilgrims' Itinerary and Itineraries of Other Travelers

Even with the help of a portolan, cartographic sources were spare for Sinai and Egypt, and the majority of place-names in that area of the map come from the pilgrims' own itinerary. Detecting these places where the *Peregrinatio* team intervened to bring the map closer to the *Peregrinatio* text or to their own experience requires delving into more minutiae, but these details provide important evidence that Reuwich and his advisors actively and critically collated a multitude of different types of sources. Already in the portion based on the Burchard map, author and artist begin to connect the image to their own itinerary—Breydenbach by textually framing Burchard's *Descriptio* and its accompanying *gemeld* as a continuation of his own narrative and Reuwich by embroidering the image with the sites and shape of their day trips out of town, for example, their three-day excursion to Bethlehem (figure 75). The *Peregrinatio* pilgrims left Jerusalem by one route and returned via another, and Reuwich depicts nine of those sites, taken from both Breydenbach's account and Burchard's description.[64] Other Burchard maps show only two sites, the town proper and, nearby, the house of Zacharias, who was the husband of Elizabeth and father of John the Baptist. Reuwich places the Visitation (Luke 1:39–57) around a fountain near the house of Zacharias and atop the source of a stream (*Circa istum fontem Maria salutauit Elizabeth ·*). There is no iconographic tradition of a fountain, and neither Breydenbach nor Burchard mentions one. Fabri relates, however, that the pilgrims visited just such a site: "This fountain first sprang forth in her [the Virgin's] presence when she came up from Nazareth and served Elizabeth for three months. The blessed Virgin wished to get water to carry it to Elizabeth,

who was pregnant."[65] In this case, the map reflects the pilgrims' experience rather than any text.

Beyond the simple inclusion of sites from the pilgrims' own itinerary, their spatial arrangement suggests the shape of the route taken to and from Jerusalem. At the opening of his account of the trip, Breydenbach writes, "As we rode out of Jerusalem, we came on the place where the star [of Bethlehem] reappeared to the three holy kings" (53r, ll. 28–30). In the map, this place (*locus vbi reapparuit stella magnis*) is marked by a cross (+) at the end of a long ridge that bridges the gap between Jerusalem and a high hill with Bethlehem at its crown. The words "route that goes to Bethlehem" (*via qua itur in bethleem*) lead the viewer straight along the base of the ridge from Jerusalem to the site of the star sighting. Continuing along that horizontal path, the viewer arrives at a small slab labeled as the tomb of Rachel (*Sepulchrum Rachelis ·*). Of the eight places depicted, this one comes next in the chronological order of the itinerary, and from there both the reader and the viewer progress up the hill to Bethlehem proper. After lingering in the Church of the Nativity, Breydenbach begins a new section of text to recount the pilgrims' return to Jerusalem by a different route. On the map, all but one of the remaining six sites flow down the foothills of Bethlehem's mountain right up to the edge of Jerusalem, making contact at a bridge (*pons*) below where the pilgrims left the city. Though the spatial ordering of the sites does not strictly follow their chronological mention in the text, the toponyms as a group form an arc with downtown Bethlehem at its apogee. The curve figures the pilgrims' trajectory and structures the space around Bethlehem, so that a reader can trace the narrative in the map.

One site, the Orthodox Monastery of Saint Sabba (*Monasterium · ad Sanctum Sabba dicitur ubi quondam · plurimi fuerunt monachi ·*) falls well outside the cluster, above the ridge that first guided

the pilgrims out of Jerusalem. This outlier's place-
ment is determined by a different demand of the
narrative. The pilgrims called upon the hospitality
of the Greek monks twice, once on the way home
from Bethlehem and once during another excursion
to Jericho, the Jordan River, the Dead Sea, and the
mountain where Christ was tempted by the devil.
Reuwich has placed the cloister halfway between the
clusters of sites toured on each expedition, so that it
swings between both narrative episodes.

In the Egyptian desert, Reuwich writes the nar-
rative directly into the image by marking out the
route taken by several types of pilgrims: Muslims
traveling to Mecca, Israelites wandering to the
promised land, and his own party plodding in a
mule train to Mount Sinai and then Cairo. Beyond
Bersabee, the map relies on routes of words to lead
the reader from Mount Sinai to the promised land,
from Gaza to Mount Sinai, from Gaza to Cairo,
from Mount Sinai to Cairo, from Cairo to Mecca
(figure 76). One sweeping sentence leads the reader
on the trail of the pilgrims from the former Philis-
tine home of Gaza (*Gazera vel gaza · urbs magna ·
quondam metropolis philistinorum*) on an arduous
ten-day journey to the Monastery of Saint Cath-
erine (*Monasterium sanctae katherinae*), the basil-
ica structure tucked at the base of a horseshoe of
craggy peaks with Mount Saint Catherine and

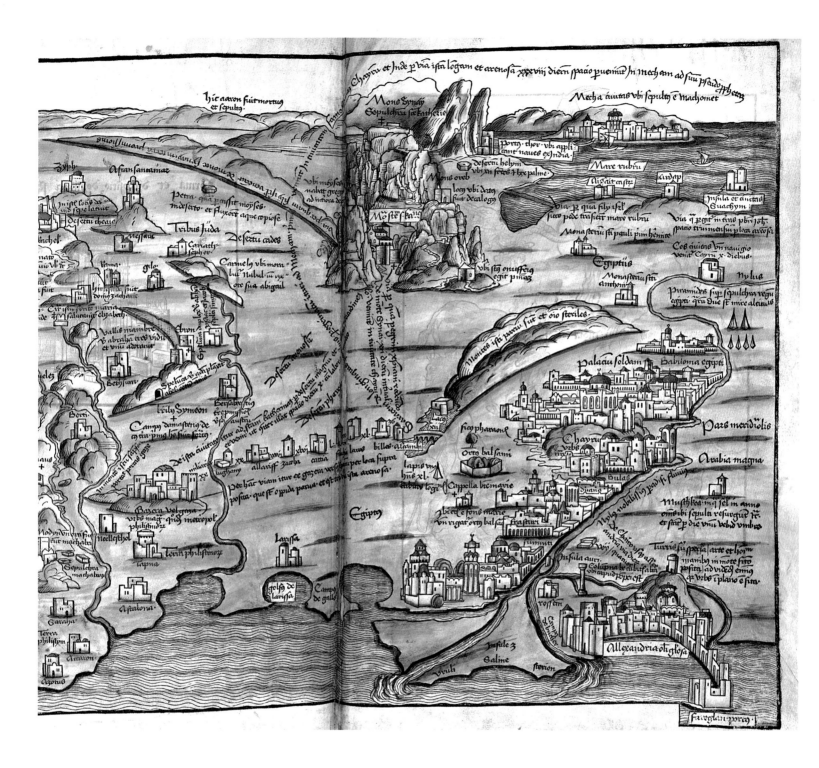

Mount Sinai: "From that city [Gaza] one goes to Saint Catherine through a great desert and a vast wilderness, and generally one comes to that place with great effort in the space of ten days."[66] In the map, the taller of the two peaks, today called Mount Saint Catherine, is labeled as Mount Sinai (*Mons Synaÿ*) with the sepulcher of Saint Catherine (*Sepulchrum sanctae katherinae*) at its summit. Its close neighbor to the right, where Moses received the Ten Commandments, today called Mount Sinai, is marked as Mount Horeb (*Mons oreb*) with the chapel commemorating the gift of the Decalogue (*locus vbi datus fuit decalogus*) at its top. Another trail marches from this spot straight down, arriving at a hamlet on a pond just below a range of mountains: "Route by which Christian pilgrims, returning from Mount Sinai, come into the city of Cairo after a period of twelve days."[67] The way from Gaza to Cairo is marked by a series of caravan stops, each named with the distances between them given in miles, and the entire path is underscored by a parallel trail of words: "By this route one goes from Gaza to Cairo by the places above, which are small towns, and that entire route is full of sand."[68] This string of stations forms one arm of an isosceles triangle with the descriptions of the pilgrims' journeys to Sinai and Cairo as the other two sides. Such a tight configuration frames the Gaza-Cairo run in relationship to the pilgrims' own zig and zag, making clear that it should be understood as the direct alternative to the pilgrims' Sinai detour.

In reality, no leg of the journey followed a path as straight as the map implies with tidy intersections at a single point: on exiting Mount Sinai, the pilgrims backtracked for several days along their route of approach; they arrived at the Red Sea well below its end and traveled along its coast for several days; and the caravan trail from Gaza follows the Mediterranean coast for several stations before arcing inland toward Cairo. The eight place-names along the Gaza-Cairo route in Reuwich's map appear to be a transliteration from Arabic and an artifact of the pilgrims' oral questioning of locals and other travelers. Fabri's transcription of the place-names spoken by his guides matches the modern nomenclature well enough to enable the reconstruction of the pilgrims' route in some detail.[69] His party did not travel the Gaza-Cairo road, but on their approach to Cairo, at the head of the Red Sea, they met a group of Christian pilgrims who had. At least six of the stations can be identified with points on the itineraries of other pilgrims, but none of these other itineraries matches the *Peregrinatio*'s closely enough to be considered the source. The second toponym, *allariff*, represents El Arish, a coastal town that Reuwich records a second time just below as *Larissa*, following the orthography of portolans. *Cattia* records an oasis used through at least the nineteenth century, and Bilbeis (*billes*) denotes a city about thirty miles northeast of Cairo.

In weaving together text and image, Reuwich does not limit himself to the story of his own party, but includes the travels of other pilgrims—Christian, Islamic, Israelite—so that he traces out the significant themes and typologies of the entire *Peregrinatio* around the visual hub of Mount Sinai. The Israelites' route from there into the promised land runs toward the northeast (upper left), with the words written upside-down as if a reflection of the Christian pilgrims' own track toward Saint Catherine's from Gaza.[70] The Muslim journey from Cairo to Mecca hooks elegantly around the back of Mount Sinai and off into the unknown distance of the map's upper right corner: "Saracens from distant parts about to go on pilgrimage to Mecca come first to the most celebrated city Cairo and from there arrive in Mecca at their pseudoprophet by that long and sandy route in the space of thirty-eight days."[71]

Breydenbach introduces the second part of the *Peregrinatio*, devoted to the pilgrims' trek to Saint Catherine's and beyond, by reminding his readers of the sacred history of the Sinai Desert and mountain. (133r–135v). His five-page tribute seems to touch on all the relevant events in the Bible and the life of Saint Catherine, but he chooses to begin by invoking how God "illuminated and honored the pathless desert and the frightening uniformity" with a memorial to the "richness of divine sweetness" in leading the Israelites to the promised land (133r, ll. 9–10, 12–14). This opening justifies the pilgrims' own journey by summoning the Old Testament precedent for wandering in that desert and implying a typological link between the historical and contemporary crossing. Reuwich conveys this connection visually by linking the paths of the two groups into a single Judeo-Christian arc, which he arranges to echo the curve of the border of Jerusalem and as the visual inverse of the overlapping arc of Islamic pilgrimage heading in the opposite direction.

To explain an excursus on Muslim pilgrimage in his account, Fabri makes clear that he understands their hajj as a through-the-looking-glass image of his own journey: "So now on account of these pilgrims of Muhammad, I have left my own pilgrimage for a time and have made a pilgrimage with them in imagination, that I might see the difference between our pilgrimage and their pilgrimage; for we journey to the sepulcher of Jesus Christ, the son of God, and seek after the relics of the most chaste virgin Saint Catherine; whereas they journey to the sepulcher of Muhammad, the son of the devil, and seek slaves of that most wanton harlot Venus."[72]

Mount Sinai's proximity to the Red Sea in the physical topography of the desert is subordinate to the mountain's role as the focal point guiding this pair of overlapping parabolas. In isolation, separated from each other and segregated as mere text, each route represents the itinerary of a historical group of travelers. Juxtaposed and remade as image, they figure an imagined cultural geography. The space at the foot of Mount Sinai carved out by the intersection of these two itineraries faithfully maps the imaginary space of the desert, even if a map of physical geography would prefer to extend the Gulf of Suez much further between Mount Sinai and the rest of Egypt. The pilgrims did cross paths in the desert with two caravans, at least one traveling west toward Egypt along the road from Mecca, or as Fabri says, from the "furthest parts of the East," and the other likely heading from the port at El Tur toward points northeast of the Sinai Peninsula.[73]

The symmetrical and intersecting paths refigure the shape of this encounter to posit visually the existence of a cultural force equal and analogous to Christianity, though backwards. The pilgrims of Islam travel to and from cities outside the bounds of the Holy Land proper, and their course takes them through the desert in exactly the wrong direction, away from the promised land. Reuwich's map negotiates the problem of the presence of Islam in a manner similar to the way his view of Jerusalem does, as explored in the next chapter. It does not suppress the presence of Islam altogether. Rather, it uses Islam, as Fabri does, as a foil to underscore the exclusive privilege of the Christian journey and as a spur to engaging with that endeavor's special sanctity.

Netherlandish Pictorial Space

Reuwich is using text to mark these routes, but it is here not a question of word over image, but of words as images, of the transformation of the very words of the book into a part of the picture. Unexpectedly, it is these lines of printed text that betray the artist's

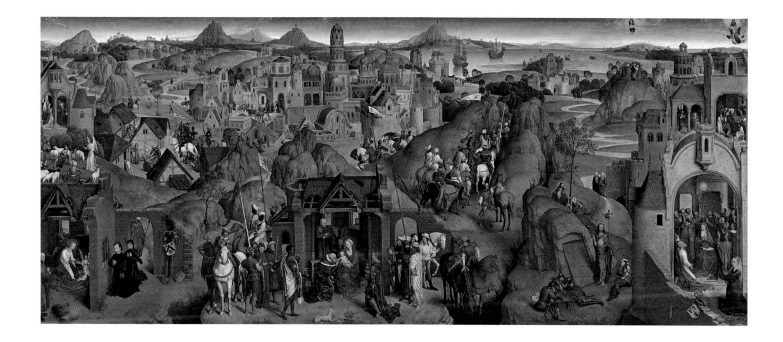

most painterly roots by adopting a Netherlandish (and Rhenish German) technique where the traverse of pictorial space—a path from point to point in a cohesive landscape—leads from one moment to another in time. The influence of a Northern spatial conception provides a counterpoint to the components of the map imported from Italy, and this element, drawn from outside the realm of cartography and from artistically closer to home, plays an important role in rounding out our understanding of the *Peregrinatio*'s digesting of diverse sources.

Though the device of a unified space housing sequential events had roots in earlier Netherlandish and German painting, it found especially canny expression in the work of Rogier van der Weyden and was further developed by his student and artistic heir Hans Memling, Reuwich's contemporary (figure 77).[74] Memling seems to have brought knowledge of similar experiments in early fifteenth-century Cologne painting with him when he moved to Bruges, and such constructions spread to German prints.

This is witnessed by two woodcut fragments, also probably from Cologne, circa 1450–60, remnants of a much larger image (1.12 x 1.20 meters) that showed Jerusalem as a continuous cityscape of stations of the Passion (figure 78).[75] These spatial arrangements have roots, then, just up the Rhine from Mainz.

In the 1470s, it was Memling who began to use groups of figures to bridge the gap between moments, so that, for example, in the Turin *Scenes from the Passion* from circa 1470, the viewer moves via crowds of onlookers from Saint Peter's denials underneath the crowing cock to Jesus's appearance before Pilate and then from the Ecce Homo to the procession leaving the city gates for Golgotha.[76] On the 1489 *Shrine of Saint Ursula*, Memling, like Reuwich, structures the story of a pilgrimage with each of the painted panels ringing the sides of the reliquary representing a different site in that saint's road to martyrdom via a religious journey to Rome (figure 79).[77] The road from Basel, populated by a handful of Ursula's ten thousand virgin companions,

FIGURE 77
Hans Memling, *Scenes from the Life of Christ and the Virgin*, c. 1480. Alte Pinakothek, Bayerische Staatsgemaeldesammlungen, Munich. Photo: bpk, Berlin / Alte Pinakothek, Bayerische Staatsgemaeldesammlungen, Munich / Art Resource, New York.

swings first toward the Alps at the back of that panel, pauses for the frame, and then picks up again in the hinterlands of the neighboring panel, guiding the virgins down from the mountains through the gates of their destination (figure 80). Where Reuwich speaks of a route around the mountain, Hans Memling paints it, and the *Peregrinatio*'s string of words could just as well have been a wholly figural file of wandering peoples.

The utility of this type of connective tissue comes to the fore in a work like the 1480 Munich *Scenes from the Life of Christ and the Virgin*, where it allows Memling to juxtapose with greater clarity two distinct types of temporal sequence (figure 77). Roads and riders lead the viewer back and forth through the deep space of the painting along moments in the story of the Magi and the Resurrection, while invisible axes across the flat space of the picture

FIGURE 78 (*opposite*)
Fragments from
*Jerusalem with Scenes of
the Passion*, 1450–60,
hand-colored woodcut.
Hood Museum of Art,
Dartmouth College,
Hanover, New Hamp-
shire; purchased through
the Florence and
Lansing Porter Moore
1937 Fund, the Robert J.
Stasenburgh II 1942
Fund, the Julia L. Whit-
tier Fund, the Barbara
Dau Southwell '78 and
David P. Southwell T'88
Fund for European Art.

FIGURE 79
Hans Memling, Shrine
of Saint Ursula, 1489.
Musea Brugge © Lukas-
Art in Flanders vzw.
Photo: Hugo Maertens.

plane link elements paired by Christian typology.[78] At far left, for example, in a diptych opening onto an interior, the angel Gabriel greets the Virgin to announce the conception of new life. Through a matching doorway on the right Jesus announces to her his rebirth. Along the midline of the work, the ground under the tower of Synagogia sinks out of view, while the humble stable of Ecclesia pushes to the fore on an outcropping that arises from a geolog- ical fissure. Above them both, the star that heralds this seismic shift also pivots right to begin a chain reaction along the top of the painting, where the yel- low celestial light opens wider and wider into the coronas that admit Christ and then his mother to heaven. It is the story of the Magi who tie together the furthest reaches of the pictorial space, as they wind from the far depths of the landscape on the left to the central foreground ledge and then back on the right, straight into the horizon.

Memling uses the Magi's appearances to build a more comprehensive cosmological framework à la the *mappa mundi* tradition. The three sons of Noah, who each populate one of the three known continents of the T-in-O, presaged the three kings, who each represent one of those regions in paying homage to the Christ Child. From the brow of

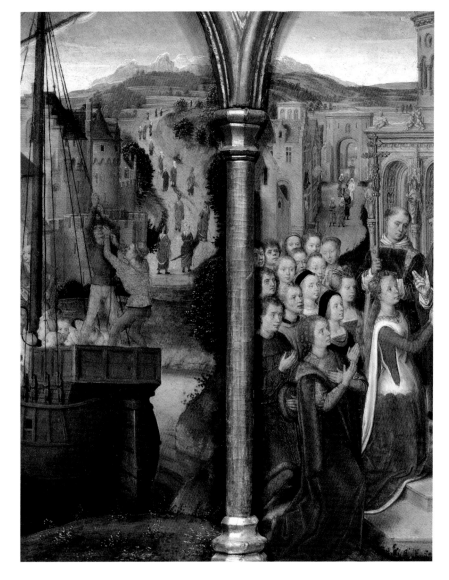

of that letter to write the sacred environs of Jerusalem twice over into the center of his geography. The Temple towers first straight up into the point of convergence of the Magi's gaze at the center of the crossbar along the top of the picture plane. Then, at the bottom of the T's vertical stroke, along the Temple's axis, nearby Bethlehem hosts the Magi's bodily convergence on Christ's presence.

Memling's *Scenes from the Life* provides an early but characteristic example of the "world landscape" tradition in Netherlandish painting, where the viewer seems to fly above terrain that is irregularly compressed and elided in the middle distance in order to make possible the illusion of an impossibly penetrating view into depth.[79] It is the unity of place across this capacious environment that both coheres disparate elements and provides room for their expressive arrangement. Even the *Shrine of Saint Ursula* uses a similar strategy: just as the framing arcade divides the sides of the reliquary into discrete panels that each represent a place and a moment, so a contiguous horizon (together with tactics like the marching virgins) counteracts any partition. In the carefully crafted balance between a unified field and a sequence of individual elements, we see the artist's conception of pictorial space as a space of equilibrium, and his work to make that so.

The composition of Memling's *Scenes from the Life* bears a striking resemblance to Reuwich's woodcut. In both, Jerusalem rises out of the center of a landscape where meandering footpaths and rivers lead to sugarloaf mountains, and a sea poised to the upper right of the Holy City opens a gateway to realms beyond the curvature of the earth. The comparison helps demonstrate how Reuwich brings his training as a Netherlandish painter to his work as a cartographer, using the structure of a world landscape to enfold his own blend of elements,

three peaks in the background of Memling's landscape, each Magus observes the guiding light that has just appeared in the heavens, and their stargazing triangulates the position just outside the Holy City, where they will come together with Christ (figure 81). Memling has transcribed the T of the O onto the surface of the painting, using the shape

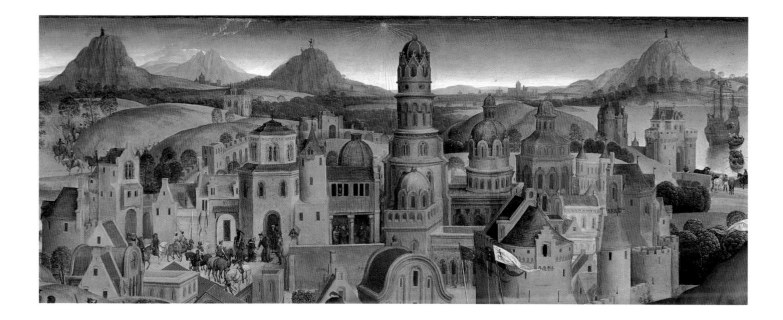

including *mappa mundi* cosmology and convention, a tabula *moderna*, city plans, a portolan chart, itineraries from his own tour, interviews en route, the Bible, and other book learning. The pictorial space imported from his native painting tradition is at once both just another element in the synthesis and the special glue that binds the sources together. It is not a particularly Italian space, and its use here as an enfolding element provides another sign that the map was assembled by a Netherlandish artist on the Rhine, however Venetian the rest of the process and no matter the number of individual Mediterranean sources he incorporated. The layering of elements of meaning across different dimensions of pictorial space using diverse devices (for example, chronological narrative, metaphor, and symbolism) has required viewers to read fluidly both across the picture plane and into the landscape for at least a generation, since Jan van Eyck's *Rolin Madonna*, Rogier's remix in the *Saint Luke Madonna*, or his *Columba Altarpiece* (figure 22).[80] This precedent normalizes

the fluctuation between flat map and perspective view in Reuwich's image, even if he does not manage to integrate the two fully as visually simultaneous and overlapping schemes.

Reuwich may express this landscape wrapper using the visual idioms of a Netherlandish painter, but the organizational tactic is not unique to the pictorial arts or to him alone of his traveling party. Felix Fabri offers a textual counterpart with a verbal map of the Middle East, written as a view from Mount Saint Catherine. On September 24 and 25, Fabri and some of the hardier members of the party, including Count Johann and two of his servants, but not Breydenbach or Reuwich, ascended this peak, the highest in the region. From that point, Fabri noted, their outbound trek turned homeward, so he stood at the far boundary of his experience of the world.[81] In describing the view, he moves almost seamlessly between the scenery that would have been visible to him and lands that lie beyond his horizon: "We stood on the brow of Saint Catherine's Mount

FIGURE 81
Hans Memling, *Scenes from the Life of Christ and the Virgin* (detail: Jerusalem and Magi observing star), c. 1480. Alte Pinakothek, Bayerische Staatsgemäldesammlungen, Munich. Photo: bpk, Berlin / Alte Pinakothek, Bayerische Staatsgemäldesammlungen, Munich / Art Resource, New York.

and viewed the lands, provinces, and districts that lay round about, and we could see even to the very distant parts of the world, because we stood exceeding high."[82] Parsing the vista according to the circle of the winds, he casts his eyes in each of six directions in turn: "Next we cast our eyes towards the south, into the gulf of the Red Sea, and beyond its channel we saw exceeding lofty mountains. In that place is that most desolate wilderness the Thebaid, wherein the most approved monks once dwelt. This wilderness is bounded on the south by the ocean, and by the Nile, the river of Egypt, on the west."[83]

The descriptions of these more distant parts are embellished with anecdotes about their particular wonders or citations from the Bible. For the wilderness of Thebaid, the cradle of Western monasticism, Fabri informs his reader that Saint Anthony, Saint Arsenius, and three Saints Macarius, among others, settled there. But, from the vantage of Mount Saint Catherine, it is not possible to see beyond the haze of the hills of the Sinai Peninsula to the Thebaid or the Nile. To discern these distant boundaries, Fabri must cast his eyes elsewhere—to a map. This is particularly clear in the description of an ocean boundary to the African wilderness, where Fabri demonstrates the same conception of that continent as Breydenbach does, based on the maps of the day that show Africa truncated at its furthest edge by the great sea that encircles the ecumene. The pattern of his prospect to the south is repeated for each direction until Fabri has portrayed a full panorama that stretches his view to the boundaries of Egypt, Babylonia, and India. The passage knits three modes of verbal and visual period geography: an eyewitness experience; a drawn map, here translated into an informal ekphrasis; and descriptions of places and wonders culled from texts or again maps. In weaving together these three geographical modes, Fabri, like Reuwich, has built his "world landscape" by rhetorically repackaging a collage of elements as the single, cohesive view of an on-site observer.

The pattern of intersecting arcs of words in Reuwich's image draws a cultural and spiritual landscape out of the shape of the path of travel, as the trail of so many Magi or saintly virgins does the same with sophisticated purpose in other contemporary pictures. From the perspective of the history and theory of mapmaking, the visibility of such itineraries can often be seen as a symptom of the immaturity of a discipline that does not yet know how to suppress particularity in favor of the pretense of an even surface. This criticism is there even in theoretical works sympathetic to idiosyncratic eruptions. Michel de Certeau, for example, contrasts the limited perspective of the itinerary with the overarching view of the modern map and posits a teleology where itineraries, personal fragments of geographical knowledge, are absorbed with increasing thoroughness into the map, an objective whole.[84] Certeau outlines his version of the modern map as part of an essay on personal experiences of space within the master system, and he seeks to recoup the personal in resistance to a totalizing regime— economic, social, political—of which the modern map would be one manifestation. Fredric Jameson also hopes to expose the functioning of ideology by calling for representational works that expose the disjuncture between personal experiences of space and ideas of space formed by the dominant social systems.[85]

The presence of the personal in Reuwich's images is meant to serve the opposite function to what these modern thinkers have suggested. In the *Peregrinatio*, the rhetorically constructed figure of the author, properly credentialed by social and political markers and by experience that lets him claim to testify as an eyewitness, is meant to support the "regime" by stabilizing the threat of the personal. The person

of the author collects informational elements and repackages them as the product of his own expert view, made into a secure whole through him. The purposeful residue of the pilgrims' own itinerary helps fabricate this rhetorical device by reminding the viewer of the organizing authority behind the book and the foundation of that authority in on-site experience. The landscape view is also not just a simple convention or compositional tool borrowed from painting, but a foundation of this strategy.

The *View of Jerusalem*

PERSPECTIVES ON A HOLY CITY

OF ALL THE SACRED SITES IN THE Holy Land, hallowed for hosting events or persons, only one commemorated a view (*locus vbi Christus flevit super Iherusalem*) (figure 23). Everywhere else pilgrims sought to stand where Christ, his forebears, or followers had touched or acted, but on the Mount of Olives, they also looked to see what he saw. The view from the Mount of Olives layered time: biblical history, contemporary reality, and the Bible's promise of a New Jerusalem at the end of days. The simultaneous resonance of past, present, and future in this view began with the New Testament description of Jesus's descent from the Mount of Olives into Jerusalem and the last week of his life. Each Gospel repeats several aspects of the story: Jesus approaches the Mount of Olives via the towns of Bethany and Bethphage, he mounts a donkey, and crowds cheer him at the point where the road begins to slope down to the city. One Gospel links Jesus's view along the way with tears in a metaphor that contrasts Jesus's clear-sightedness with the blindness of those who reject him: "And when he drew near, seeing the city, he wept over it, saying: 'If you also had known, and that in this your day, the things that are to your peace; but now they are hidden from your eyes.'" He goes on to foretell the destruction of the city (Luke 19:41–44).

Burchard of Mount Sion's *Descriptio Terrae Sanctae*, the crusader-era text appended to Breydenbach's account of Jerusalem, presents the view from the Mount of Olives as if the path of his readers intersects with the steps of Christ exactly where the spectacle of Jerusalem reveals itself (71v, ll. 13–19). As his readers reach the trail trod by Christ's donkey, they see the city shine (*resplendet* and *erglastet*), an active verb that does not figure in any of the Gospels.[1] Instead, Burchard's choice of words evokes the vision of a New Jerusalem in Apocalypse (21:10–11), where John the Evangelist recounts being taken "in spirit to a great and high mountain," where he was shown "the holy city Jerusalem coming down out of heaven from God, having the glory (*claritatem*) of God" with light "like to a precious stone." With the insertion of that verb, Burchard has added another temporal layer to his description, so that all at once he offers his reader the view that Jesus saw in the past, that the author and other pilgrims see in the present, and that the blessed will see in the world to come.

Felix Fabri, Reuwich and Breydenbach's traveling companion, does not evoke the same eschatology, but he does pause in his sightseeing to experience the intensity of Christ's vision: "We stood for a long while in this place of Christ's tears, and gazed

permanent the symbolism of the elevation of the Eucharist against the Jerusalem sky during mass. Directly below, a cross on the grille marks the heart of the city. The Dome of the Rock stands out among the urban landmarks, but it sits just off center, abutting the cross and overshadowed by it. With this screen, the twentieth-century designer of the church formalized the traditional meaning of the view: despite the city's "wretched" contemporary state and its people's blindness, Christ will redeem it and all those who see the city through his eyes.

The view from the Mount of Olives has become the most familiar version of the city skyline. It is recognizable from tourist photos snapped at a set bus tour outlook, but it is also well known as an expression of Arab aspirations to retake the East Jerusalem territory brought under Israeli rule after the 1967 War. The hill itself and the sites seen from its vantage form the heart of that contested zone (gatefold, figures 18, 84). The predominance of this particular version of the skyline does owe something to simple practicality. No position down among the warren of streets allows the same overview, and none of the other natural or architectural heights provide such a commanding tableau of the city featuring the majestic Dome of the Rock on the clear center stage of its supporting platform, al-Haram al-Sharif (the Noble Sanctuary). It is the clarity of this Muslim icon that makes this point of view so potent. Pictures from this vantage hung, for example, on the wall of Yasser Arafat's offices in Ramallah and Tunis, and one crowned Arafat and Bill Clinton in 1998 during the president's visit to Gaza (figure 83). Lithographs for sale on the sidewalk of the Roman Cardo, now a thoroughfare in the Jewish Quarter, look down on a Temple Mount where the Dome of the Rock has been replaced by messianic visions of a restored Third Temple.[3] There are other useful perspectives; before the United States financed a remodeling of the Ramallah press room, a shot of

upon the holy city, for from this place one can get a very clear prospect of Jerusalem, the Temple, and Mount Sion, the sight whereof is powerful to move the souls of the pious to tears. . . . Jerusalem, even in its wretched state at the present day, presents a sweet and delightful spectacle from this spot."[2] From Fabri's point of view, Jesus's lament applies to the contemporary situation, and the pilgrim implicitly evokes the metaphor of blindness and clear sight from Luke to distinguish his correct, Christian perceptions of the significance of the view from the errors of the Muslims who ruled the city. Today the Franciscan Church of Dominus Flevit commemorates Jesus's appraisal of the vista, and a large arched window above the altar frames the view from that location, so that the panorama itself serves as a retable (figure 82). The window's iron grille superimposes the silhouette of a chalice and wafer, emitting rays of light over the center of the city, making

the Dome's south portal hung behind the podiums, serving as backdrop to briefings, for example, with Secretary of State Condoleezza Rice and Mahmoud Abbas on February 7, 2005. It is exactly the charisma of the Dome of the Rock that other framings seek to neutralize in the Dominus Flevit window or the Ramallah redecoration.

It is Reuwich's view that opened the *pictorial* front in this fight to convert a contested space to a stable field of vision. Muslim patrons during the Mamluk period did not primarily use pictures, but rather composed the city itself to generate an Islamic experience of the space, and they did this largely by creating a centralized urban arrangement that ringed the Dome of the Rock with new construction looking out over the sacrosanct hub. And Jesus's tears notwithstanding, the convention of picturing the city from the eastern Mount of Olives was not preeminent in fifteenth-century Europe. Christian images that incorporated a Jerusalem cityscape persistently showed it as seen from the west, as if from the hill of the Crucifixion, a view that pushes the Dome of the Rock to the back. Reuwich himself had reason to portray the city from the west: as a whole, his map of the Holy Land is oriented this way, following the conventions of the Burchard map that he took as one of his models.

Nor did Reuwich picture Jesus's view from the Cross or from Dominus Flevit. He chose instead a view much farther up the hill and to the north: a view staged for pilgrims by Franciscans to recoup a Christian experience of sacred sites that were otherwise shaped by Islamic structures, controlled by Muslims, and barred to Christians. Pilgrims even received indulgences for taking in this view. The Franciscans chose this vantage and promoted it as a way to circumvent Muslim restrictions visually, and their twentieth-century counterparts enshrined the same ideological vision in the window-retable of a new church at a different site. It is not that the

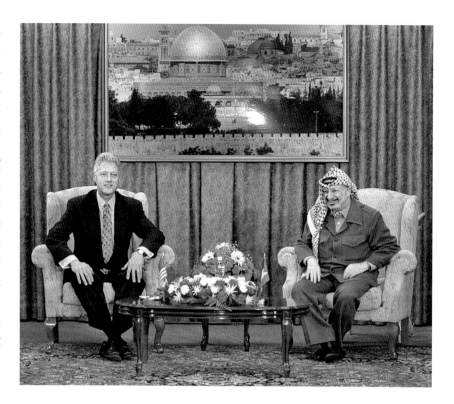

FIGURE 83
Official visit of Bill
Clinton to Gaza,
December 16, 1998.
Photo © Ira Wyman /
Sygma / Corbis.

Peregrinatio image adopts the exact vantage of the Franciscan view, though it comes close; more significantly, Reuwich adopts its purpose. He takes this Franciscan perspective—a passing, partisan moment on the Holy Land tour—and fixes it in place in print as Jerusalem, truly depicted. It is perhaps Jerusalem's particular curse as a city to be built to create illusions that contingent views are certain and exclusively true. The city shares this with the *Peregrinatio*.

The Centripetal View of Jerusalem from Mamluk Monuments

The architectural contribution of the Mamluk dynasties that ruled the Holy Land from their base in Cairo from 1249 until 1517 is often overshadowed by the Ottoman renewal that followed. Jerusalem

was an important religious destination within the Mamluk Empire, but a provincial town, and this status contributes to the conception that it was a center of only peripheral interest for its fifteenth-century overlords. With a population roughly estimated at 150,000–200,000 people, Cairo was one of the world's great cities, while Jerusalem, with maybe 5,000–10,000, was more sacred than sizable.[4] Nonetheless, patronage from residents and outsiders during the Mamluk period strongly shaped the character of the city with landmarks that still determine its Islamic space today. During the Fatimid period before the fall of Jerusalem to the crusaders, the edges of al-Haram al-Sharif abutting the town were walled off with an arcade. After retaking the city, the Ayyubids reconditioned the Haram for Islamic use, and then the Mamluks amplified this program by segregating the sanctuary from the city by a zone of Islamic religious life made up of institutions dedicated to the transmission and development of Islamic thought.[5] By the 1480s, the Fatimid border had been greatly embellished with most of the components that form the continuous enclosure that delimits the sacred precinct today. The building followed a basic pattern: religious schools (madrasas), houses for Sufi communities (khanqahs), hostels for pilgrims, and mausoleums, with attendant minarets and gates, were arrayed around the west and northern boundaries (the sides that abut the urban fabric) and then along the several main roads running west from the sanctuary into the city. Individual foundations often served two or more functions in a composite structure.[6]

Reuwich's image lavishes attention on the Haram, showing a topographical and architectural interest unprecedented in other images of the city (figure 84). The artist carefully, though not slavishly, describes the stepped and gated eastern (bottom) approach with the diminutive Dome of the Chain tucked behind it, as well as other subsidiary sites open to the air, sheltered under domed gazebos, or defined by arcades. Indeed, he studies most closely the section of the border on the western portico, where the greatest concentration of new construction was taking place at the time of his visit. Several minarets in the distinctive Mamluk architectural style rise over the city, framing the Holy Sepulcher and marking the newly buttressed boundaries of the Haram. The purpose of these structures, so highly charged as the hallmark of Islam par excellence, did not escape the pilgrims, perpetually exposed to the alien call to prayer. They recognized them as the functional and formal equivalent of the bell towers of contemporary Christian churches.[7] As positioned in Reuwich's image, the minaret in the middle of the northern (right) side of the Haram seems to stand on the square where Christ began the procession to his crucifixion (figures 84, 85). The positions of this first marker, a second at the northwest (top right) corner, and a third in the middle of the west (top) wall clearly mark them as the Bab al-Asbat, Ghawanima, and Bab al-Silsila Minarets, respectively, all but one of the pickets delimiting the perimeter of Islamic privilege. The Reuwich image does not register a truncated fourth, al-Fakhriyya Minaret, at the southwest (top left) corner. That minaret was first documented circa 1495 by Mujir al-Din al-'Ulaymi, a judge from a prominent Jerusalem family who wrote a comprehensive description of the city's landmarks that is considered an invaluable and largely reliable primary source. Another account from 1470 implies there was no minaret in that location. Possibly it had not yet been built at the time of Reuwich's visit, or it was not visible, as the tower in place today was entirely remade in its present form after 1675.[8]

The placement and appearance of the minarets, in particular the Ghawanima and Bab al-Asbat Minarets on the same (right) edge of the Haram

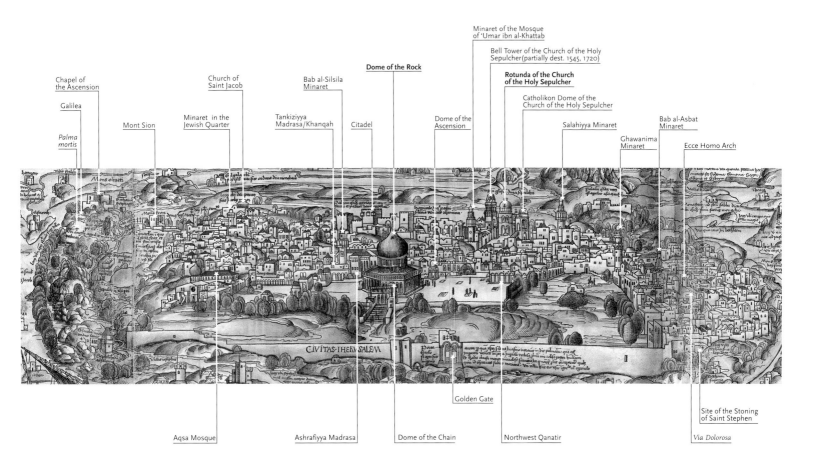

Chapel of
the Ascension

Galilea

*Palma
mortis*

Mont Sion

Minaret in the
Jewish Quarter

Church of
Saint Jacob

Tankiziyya
Madrasa/Khanqah

Bab al-Silsila
Minaret

Citadel

Dome of the Rock

Dome of the
Ascension

Minaret of the Mosque
of 'Umar ibn al-Khattab

Bell Tower of the Church of the Holy
Sepulcher (partially dest. 1545, 1720)

**Rotunda of the Church
of the Holy Sepulcher**

Catholikon Dome of the
Church of the Holy Sepulcher

Salahiyya Minaret

Ghawanima
Minaret

Bab al-Asbat
Minaret

Ecce Homo Arch

CIVITAS·IHERVSALEM

Aqsa Mosque

Ashrafiyya Madrasa

Golden Gate

Dome of the Chain

Northwest Qanatir

Via Dolorosa

Site of the Stoning
of Saint Stephen

(figure 85), provide some clues to how the view of Jerusalem was constructed. It looks as if Reuwich has switched the pair. Though typical of Ottoman construction, round shafts are very rare in the Mamluk era. The Bab al-Asbat Minaret (bottom) provides perhaps the only example outside of Aleppo, and the Ghawanima Minaret (top) is in fact square in plan like the rest of Jerusalem's Mamluk towers (figure 86). The Bab al-Asbat Minaret's shaft was refurbished by the Ottomans, and its gallery was reworked in 1927, but examination of the original base indicates that the tower was likely always round.[9] Reuwich's Ghawanima Minaret is round, and the actual Bab al-Asbat Minaret seems the model for that. The shape of Reuwich's Bab al-Asbat

Minaret is ambiguous: while that tower presents only its front face, all the other square minarets in the image show two faces, and the round one has shading to signal its curvature. The real Ghawanima Minaret also has two galleries, one for the muezzin and one where the wider bottom stories of the shaft transition to narrower upper stories. The *Peregrinatio* image captures the double gallery and the step back between the two portions of the shaft—but in its rendering of what should be the Bab al-Asbat Minaret. The Ghawanima Minaret has muqarnas corbeling beneath its galleries, a feature distinct from the rectangular corbels used to support the galleries of other minarets pictured, and Reuwich captures that peculiarity, applying it also to his Bab al-Asbat

FIGURE 84
Diagram of monuments in Erhard Reuwich, *Map of the Holy Land with View of Jerusalem* (detail: Jerusalem) from *Peregrinatio* Latin, hand-colored woodcut on vellum, fols. 143v–148r. Photo © The British Library Board, C.14.c.13. All rights reserved 2014.

Minaret.[10] This is a subtle, but important reminder that however he mischaracterizes the articulation or proportion of the minaret shafts and lanterns, his embellishments remain anchored in observed detail.

Like all the landmarks most visible from the Mount of Olives, these minarets' arrangement in the woodcut corresponds to their positions relative to each other as seen from the artist's vantage, but the accuracy of the rendering of their architectural form varies. This result would make sense if an artist stood at a single vantage to outline the basic shape and alignment of the city's most distinctive monuments, but then interpolated missing details with observations made at other times and at closer range or borrowed from other structures—or, even more likely, if he combined borrowed models and observed information. While the vista from the Mount of Olives provides a clear overview of the city's built topography and basic geometric forms, details are indistinct at that distance. (Close-up photographs illustrated here were taken near the draftsman's standpoint, but with a telephoto lens.) Moreover, when

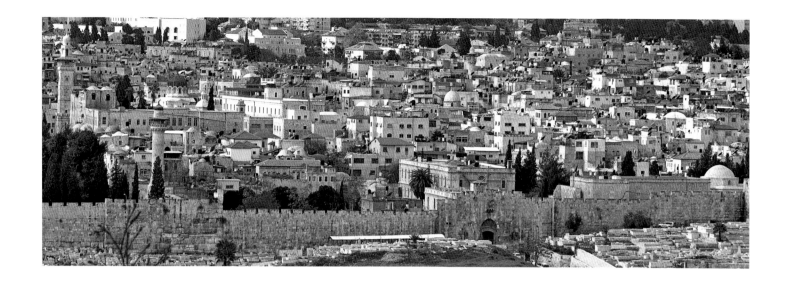

FIGURE 86
Ghawanima (top) and
Bab al-Asbat (bottom)
Minarets and Via Dolo-
rosa (middle right), pho-
tographed near vantage
for the *View of Jerusalem*
in Breydenbach's *Peregri-
natio.* Photo: author.

the view of Jerusalem is stripped of material likely inserted later, there is a much more modest and less time-consuming—and, therefore, more plausible—shell left to draw *en plein air* on the mount.

In connection with this question of the process for composing the *View of Jerusalem*, Stephan Hoppe and Sebastian Fitzner have argued that two drawings in the Munich Staatliche Graphische Sammlung (figures 87, 88) are Reuwich's own preparatory drawings, copied from Italian sources. Were that the case, they would document the process of collecting elements to fit into the framework of the view, particularly moments where Reuwich would have corrected shortcomings in the drawing from memory or other materials, for example, by altering the polygonal drum on the drawing's Dome of the Rock to the round drum of the woodcut and the building (figures 87, 96, 97).[11] But such differences seem more likely to have slipped in from the opposite direction, from woodcut to less precise and later copy, and the drawings of the Gotha Grünemberg manuscript provide many examples of the very same mutations, including the slide from round drum to polygon or from pointed arches to round in the portal of the Church of the Holy Sepulcher (figures 12, 29, 88, 95).[12] It is not that Reuwich later corrected the placement of the Church of the Holy Sepulcher relative to the Dome of the Rock, but that the copyist could not place it as far to the right as it belongs because he ran out of paper. While Hoppe and Fitzner are at pains to demonstrate that the changes could only move from drawing to woodcut, the discrepancies can, in fact, be explained according to this type of generational loss between copies or as a copyist attempting to clarify moments of illegibility in Reuwich's woodcuts, above all in his unusually muddled rendering of the Holy Grave (figure 89).[13] Traces of black under the cupola suggest that the draftsman first sketched a lower and wider canopy akin to the woodcut's before deciding to refine that architecture in pen (figure 87), a process that mirrors Carpaccio's method for adapting Reuwich's Saracen women, discussed previously (figures 26, 37). There is, then, no compelling reason to set aside the Graphische Sammlung's assessment that the watermark dates the paper to circa 1540, consistent with later copies.[14]

The attraction of the Mamluk structures built around the Dome of the Rock went beyond the

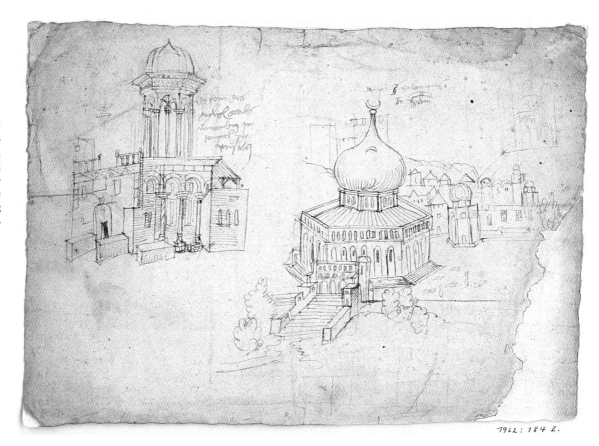

blessing of simple proximity. Though built ad hoc over more than 150 years, they are individually designed, when possible, with a suite of rooms or at least one significant interior space—most often a large vaulted assembly hall or a domed loggia—that affords a direct view of the Haram. This was enabled by a common pattern, where the ground floor of the building abutted the back of the one-story portico that edged the Haram, but the upper floor extended over the portico to take advantage of the elevated, unobstructed view from that position. Such structures include al-Tankiziyya Madrasa and Khanqah (1328–29), al-Aminiyya Madrasa (1329–30), al-Almalikiyya Madrasa (1340), al-Is'ardiyya Khanqah and/or Madrasa (1359), al-Manjakiyya Madrasa

(1361), al-Basitiyya Madrasa or Khanqah (1431), al-'Uthmaniyya Madrasa and Tomb (1437), and al-Ashrafiyya Madrasa (1482).[15] The most striking instance of this may be the Palace of Lady Tunshuq al-Muzaffariyya (1388), approximately 150 meters up the street (west) from the Bab al-Nazir (Inspector's Gate). This residence takes advantage of the higher elevation at that distance to perch a room at the near end of the house that looks downhill over the roofs of its neighbors.[16] Al-Lu'lu'iyya Madrasa (1373–74), situated up a parallel street, arranged a similar view from rooms that were probably the residence of the founder.[17] In aggregate, this construction creates a distinctly centripetal space, as the edging of the Haram responds to the pull from the center, and

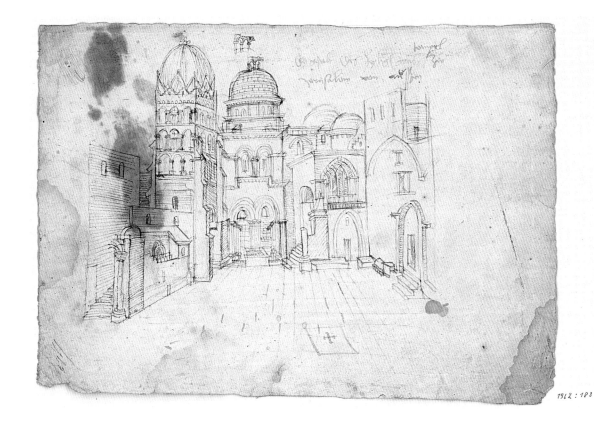

FIGURE 88
*Entrance Court of the
Church of the Holy
Sepulcher*, sixteenth
century, pen and ink
over traces of charcoal or
black chalk. Staatliche
Graphische Sammlung
München, 1962:183 Z.

those who use and inhabit the structures are drawn through explicit views or implicit arrangements toward that focal point. As these edifices were owned and frequented by Muslims, they set up a distinct experience for them that is largely denied the city's Christians and Jews, who were actively barred from many of these buildings or had less business in them.

The design and placement of these houses and religious foundations may not follow any master plan, but there is clear evidence of deliberate efforts in the fifteenth century to engineer an Islamic visual experience of the city. Two minarets on either side of the Church of the Holy Sepulcher were designed as a matched pair and positioned so that a line between them passes directly over the entrance to Christ's tomb at the heart of the Christian complex.[18]

Reuwich includes both these spires in his print, accurately albeit loosely rendering them down to the details of decoration: at the top of each, a dome on a drum sits on a wider drum pierced by a window above a roofed balcony supported by brackets (figures 90, 91, 92). In the print, the right minaret is taller, with an arched window below the balcony, where the left one shows a roundel. The left minaret does indeed have a roundel where the right has an arch, but otherwise they were designed as virtual twins set roughly equidistant from the church's main dome. Both embellished structures that were constructed by the crusaders and converted to Muslim use directly after the fall of the Latin Kingdom.

The right tower, refurbished in its present form before 1417, rises above the Salahiyya Khanqah, first

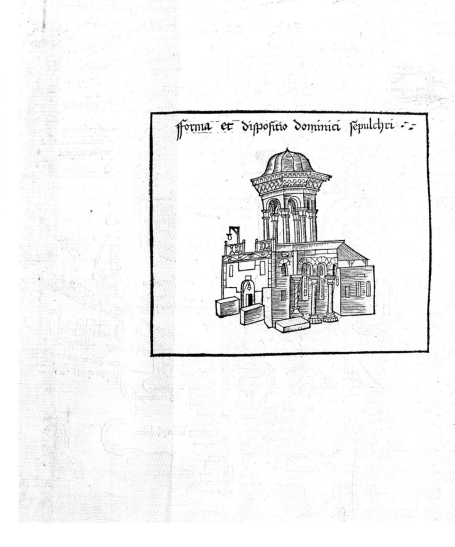

forma et dispositio dominici sepulchri

endowed in 1189 and one of the most prestigious Sufi centers in the Islamic world by the Mamluk period (figure 92). Formerly the palace of the Christian Patriarch, it was repurposed by Salah al-Din (known as Saladin in the West) after his conquest as part of a program to consolidate political control, undo the crusaders' mark on the city, and lure Muslim immigrants to repopulate it.[19] The companion spire on the left, refurbished before 1465, crowns the Mosque of al-Malik al-Afdal (today the Mosque of ʿUmar ibn al-Khattab), endowed by the eldest son of Salah al-Din in 1193 (figure 91). It stands directly across from the Church of the Holy Sepulcher to rise above the entrance court and encroach on the site of the Hospital of Saint John, the original home of the Christian religious order by that name.[20] Fabri

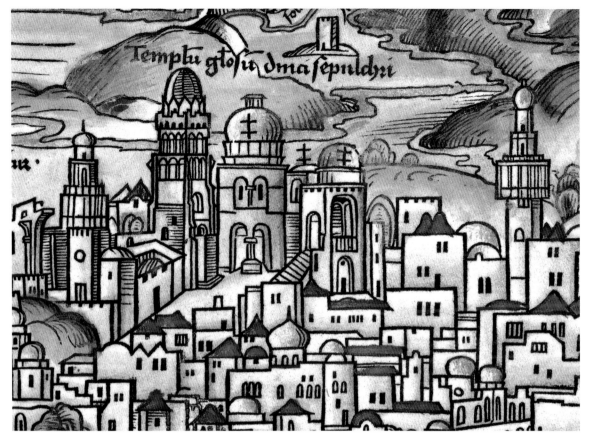

Templu gloriu dma sepuldri

describes this mosque, with its "tall and costly tower, adorned with white polished marble," in which the Saracens "shout and howl day and night according to the ordinances of their accursed creed." He imagines that the complex was built to offend Christians.[21] Mujir al-Din reports that he was told that the Christians protested the building of the Salahiyya Minaret, exactly because it would rise above the Church of the Holy Sepulcher, and the head of the khanqah harshly rebuffed their attempt to bribe him. He could be sure of his reward on the Day of Resurrection for having "built this minaret on the heads of the infidels," Mujir al-Din continues, when the prophet Muhammad communicated that message via the dream of another man.[22]

Fabri correctly recognizes that the 'Umar ibn al-Khattab Minaret was conceived in relationship to the Church of the Holy Sepulcher, though its effect goes beyond its looming over the church's entrance visually and aurally. The twinning of the towers to bracket the church is much more difficult to distinguish from his point of view on the ground, where the minarets are visible individually in some places but never together. The question of viewpoint has never been raised: If the minarets were constructed as a pair visually connected across the rotunda of the Holy Sepulcher (and the grave beneath it), to whom did they address this configuration? They can both be glimpsed from at least one location on the roof of the Church of the Holy Sepulcher near the dome to

FIGURE 91
Minaret of the Mosque
of 'Umar ibn al-Khattab
(formerly Mosque of
al-Malik al-Afdal) from
entrance court of the
Church of the Holy
Sepulcher, Jerusalem,
before 1465. Photo:
author.

FIGURE 92
Minaret of the Salahiyya
Khanqah, Jerusalem,
before 1417. Photo:
author.

the Chapel of Saint Helena in what was the canons' cloister, but they cannot be seen simultaneously. They also chaperone the rotunda quite dramatically from a vantage on the northern city walls, but the walls were rebuilt in stature and solidity only in the later Ottoman era (figure 93). The parallax of the view from the walls also spoils the careful symmetry of their spacing and, therefore, underplays their potential as punctuation. There is a similar view from the Citadel (also known as the Tower of David), but it is difficult to ascertain if its battlements would have represented a privileged viewpoint in this period. Originally a second-century BCE fortification, then much neglected, altered, and rebuilt in different eras, it was furnished in 1310–11 with a mosque and garrison, but vacant from 1472 to 1473.[23] The view from the Mount of Olives does maintain the symmetry of the minarets, but at enough of a distance to shrink

them into much less emphatic markers (figure 18). The *Peregrinatio* image from that vantage records their position in the landscape relative to other monuments quite accurately. Their asymmetry in relationship to the Church of the Holy Sepulcher is largely the result of the artist's manipulation of that monument, turning it and its entrance court ninety degrees counterclockwise to face the viewer, although the exaggerated difference in their height and their uneven distance from the church may also show the influence of a separate study made from a position with greater parallax.

Indeed, the visual force of the pair of minarets comes into focus only on the Haram itself, a standpoint denied the Christian pilgrims. Modern towers, cupolas, high-rises, and antennae have encroached on the horizon of the city seen from beside the Dome of the Rock, and this accounts for most of

the protrusions into the skyline visible behind the domes of the Church of the Holy Sepulcher as well as for the black Lutheran dome that partially obscures the left minaret (figure 94). Were this clutter removed, the two minarets would float with the church rotunda (and the church's once much taller bell tower) above the urban sprawl to temper any challenge to the Dome of the Rock from its Christian doppelganger.

The Dome of the Rock was conceived in direct relationship to the Church of the Holy Sepulcher, so that the architectural stroke of the minarets culminates a rivalry that came into being with the earliest Islamic presence in the Holy Land. In 70 CE, to punish a revolt, the Romans blew up the Second Jewish Temple, Judaism's sacred site and the center of Jewish religious life. The original Christian complex built by Emperor Constantine to house the Holy Sepulcher, Calvary, and the site of the finding of the True Cross faced the empty mount where the Temple had once stood. Constantine's ecclesia looked out over the ruins of synagogia. In the seventh century, very early in the history of Islam and during the first period of Muslim rule in Jerusalem, the second Umayyad caliph appropriated the destitute site and reconsecrated it with an Islamic structure.[24] A Muslim structure, adorned on its exterior with a glittering mosaic of a garden paradise, now occupied the place where, according to all three religions, heaven would soon meet earth at the end of days, whether as the site of the appearance of a heavenly Jerusalem (as evoked by Burchard), the rebuilding of a new Temple (as seen in the lithographs on the Cardo), or the final judging

FIGURE 93
Church of the Holy Sepulcher between the Minarets of the Mosque of 'Umar ibn al-Khattab (left) and Salahiyya Khanqah (right), photographed from the Jerusalem city walls. Photo: author.

of souls.[25] Now Constantine's complex had to face down a robust, assertive competitor that presumed to supersede it.[26] The church's rotunda over the grave of Christ followed the model of an antique martyrium with a centralized plan crowned by a dome (with the holy rock of Golgotha nearby), and the new Islamic dome was designed to be exactly the same size as its Christian counterpart, supported by a drum of the same proportions.[27] The gold mosaic on the interior and original exterior of the Dome of the Rock amplified the comparison by speaking in the pictorial language of the monumental buildings of Byzantium, the Christian New Rome. The axis of encounter between the structures relayed the rivalry

of the two religions and their empires, but it also communicated parity.

Subsequent Fatimid caliphs acted to upset this balance, so that Muslim sovereignty was reflected in their dominance of the landscape. They first encroached on the Christian complex (already compromised through arson and natural disasters) by building a mosque over the ruins of what had been the front steps of Constantine's basilica. They then ordered the total destruction of the church in 1009.[28] Undoubtedly, the presence of a mosque before the main entrance to the complex had already forced the Christians to favor the subsidiary entrance to the south.[29] The church that they

rebuilt by 1048 formally succumbed to this reorientation, situating the main point of entry at the southern transept and closing off the complex to the east. The church no longer faced its rival. Christians subsequently reappropriated the mosque during the Latin Kingdom, but they reinforced the new orientation in the remodeling of that era. The south facade's distinctive double-arched portal and bell tower, depicted by Reuwich, date from that time, though pilgrims today do not see the full height of the medieval tower, which lost its dome and upper stories in 1545 and 1719–20 (figure 95). While Christian worship was allowed to continue there after the fall of the crusader kingdom, the keys to the complex were put in the hands of a Muslim family, who lock and unlock the door and monitor the goings-on from a bench near the entrance—still to this day. In fact, Salah al-Din named the same sheikh holder of the church's keys and head of the Salahiyya Khanqah, and members of this family remained sheikh of the khanqah until 1490, suggesting the possibility that an individual who filled both roles determined the pairing of the fifteenth-century minarets.[30] Those minarets declare the (Islamic) terms of the relationship between the church and the Dome of the Rock, reasserting the one's subordination to the other. Their full message is revealed, however, only from the vantage of a zone reserved for those who have accepted Islam, so that they reveal a clear sight, but one to which others remain blind.

The looking inward of the perimeter structures contributes to the character of the Haram itself. The planar, wide open, roughly rectilinear space contrasts dramatically with the undulating natural geology of the region or the myopic passages of the rest of the built environment. The construction along the rim largely seals off the plaza from contamination with those elements outside its bounds, so that on the

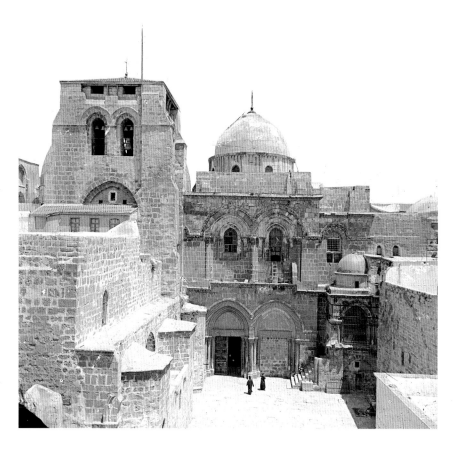

FIGURE 95
Entrance court of the Church of the Holy Sepulcher, Jerusalem, c. 1900–1920. Library of Congress, G. Eric and Edith Matson Photograph Collection, LC-DIG-matpc-00019.

Haram, too, you are encouraged to look inward. The enclosure is not perfect, but breaches are orchestrated into the spatial experience. On the east side, a view opens onto the Mount of Olives to borrow the garden scenery and reveal Islamic holy sites, such as the Mosque of the Ascension on the summit of the hill. On the west side, it is the matching minarets that do this work.

Breydenbach and his companions were invited to experience this Muslim perspective on the city. First Fabri reports how street merchants heckled his party as they attempted to approach through two of the several gates along the western frontier.[31] Then the "bishop of the Saracens' Temple" granted

the pilgrims access to al-Ashrafiyya Madrasa, then under construction along the same edge, from which they were able to get their closest look at the Dome of the Rock ("Temple"):

We came through streets of houses around the Temple to another part of the courtyard [Haram], and there at the wall of the courtyard was being built a new most costly mosque as an oratory for the sultan, in which he would make his prayers when he is present [in Jerusalem]. . . . And we went up into the mosque, and there we found many craftsmen and workers making the finest panels of variegated and polished marble and adorning both the floor and walls with pictures. The upper part glittered above with costly and gold colors, and the glass windows illuminated the building very beautifully. Moreover, in that wall that rises up from the courtyard of the Temple, there were large, high windows, not yet glazed, but open, through which we looked at the court of the Temple and the Temple itself and beheld the stunning sumptuousness there.[32]

Breydenbach speaks of gaining admittance to a structure, a "church" being built by the reigning sultan, that fits well with Fabri's description of the "mosque" (51r, ll. 14–17). The Ashrafiyya, which served as a school, assembly hall for public investigations, and mosque, was in fact erected under the patronage of Sultan Qaytbay.[33] It was the only royal foundation in Jerusalem in the fifteenth century, a complement to similar structures erected by Qaytbay that looked out on the sacred sanctuaries in Mecca and Medina. Mujir al-Din classed the Ashrafiyya as part of another august trio that included the Aqsa Mosque and Dome of the Rock itself.[34] Constructed by architects imported from Cairo (including a Coptic Christian) in the style of the capital, outfitted

with conspicuous splendor, and unique in breaking the line of the portico to encroach on the plaza, the edifice the pilgrims toured was a replacement for an earlier version that did not meet the sultan's ambitions. The design of the facade, like that of the earlier minarets around the Church of the Holy Sepulcher, was optimized to be seen as one looked back in the direction of the city from the terrace next to the Dome of the Rock.[35] Together with his improvements to the waterworks in Jerusalem, Mecca, and Medina, the Mamluk sultan's three foundations in those cities underscored his prerogative as protector of Islam's three most holy sites—a message that responded most immediately to the threat of the expansive Ottoman Empire, which would, indeed, take control of Jerusalem in 1517.[36] In inviting Christians to tour the construction site, his agents seem to be emphasizing the sultan's sovereignty over sacred space to the pilgrims as well, above and beyond using the madrasa to showcase royal magnificence. As we will see, they took the message to heart.

Reuwich's image takes care to render the architecture of this new construction and the surrounding area with relative accuracy (figures 84, 96, 97). After an earthquake in 1545, the madrasa lost its upper stories, but the artist captures them, in particular the three "great and tall" windows and the building's original height with a roofline roughly even with the base of the rectangular niche of the Bab al-Silsila Minaret to the left (south). The facade is clearly divided into three bays, which correspond to the division of the interior into two iwans on either side of a central court; rows of windows illuminate the side iwans, while a single arcade, double the height of the other fenestration, forms a loggia that opens from the central court onto the Haram. The row of six squares along the top of the left bay, as well as the crenellation along the right one, seems to translate muqarnas work, and the two strips across the

top of the central bay reflects another decorative element. These details, which specify the structure as the nearly completed Ashrafiyya, establish that the image was indeed drafted in 1483 or, at the very least, updated with on-site observations made then, which means made by Reuwich himself.[37]

The Franciscan Indulgenced View

It does, then, seem probable that Reuwich glimpsed the forbidden precinct of the Haram at close quarters from its western bounds, but his view through the imperial loggia is, of course, not the one he depicted in the print. He chose another perspective, first cultivated by his Franciscan tour guides as a countermeasure against Muslim restrictions on the itinerary of pilgrims in Jerusalem. By embedding this view in the neo-crusader context of the *Peregrinatio*, the artist draws out the critique of Muslim

dominion implicit in the Franciscan practice and develops it in tandem with the salvific claims the Franciscans attach to it.

Acquiring indulgences was one of the prime motivations for undertaking pilgrimage, and texts about the Holy Land were often presented as a list of the available indulgences, organized geographically.[38] During a pilgrimage to the Holy Land, indulgences were usually granted for setting foot on certain sites, including a plenary indulgence (remission of all sins) upon making landfall at Jaffa, the port of arrival in Palestine (44r, ll. 37–41). On Reuwich's image, sites where pilgrims receive plenary indulgences are marked with a double cross, while a single cross indicates less comprehensive benefits of seven years and seven times forty days. The only key on Reuwich's map, to the right of the galley landing at Jaffa, explains these symbols: *Nota · quod vbicumque reperit duplex ‡ crux signata / In eo loco est plenaria remissio omnium peccatorum · / Vbi uero simpla + ·*

Ibi est Indulgentia septemmis cum tottidem carenit : (figure 98).[39] The quarantine, a period of forty days, mirrored the time Jesus spent in the wilderness fasting and resisting the temptations of the devil, and seven years and seven quarantines was a standard unit of indulgence. While still at home, individuals could earn the same benefits from saying prayers before certain images—or copies of those images—or sometimes by engaging in spiritual exercises of visualization and prayer that simulated pilgrimage to indulgenced sites.[40]

In this context, the pilgrims' ascent of the Mount of Olives can be understood as simply part of their progression from one indulgenced holy site to another. Along the way, they look out at Jerusalem to gain visual access to indulgenced sites that the Muslim rulers of the city will not let them visit. There are so many of them that this act of viewing, rather than physically occupying a site, proves unusually beneficial, providing what Fabri calls "the greatest indulgences."[41] The gathering of indulgences through vision in this way seems similar to the practice of receiving indulgences for praying before a cult image or a copy of one; the pilgrims behold certain buildings instead of the Veronica or the Man of Sorrows. From there it is only one easy step to suggesting that the viewers of Reuwich's woodcut, who beheld images of buildings instead of the buildings themselves, would have looked for the saving effects of spiritual pilgrimage. The indulgences instrumentalize the view and quantify its efficacy according to the economy of fifteenth-century devotion.

They provide a framework for finding value in the landscape.

Areas and complexes reserved exclusively for Muslim use included the Dome of the Rock, its platform, and surrounding buildings; the Golden Gate; the hall where Pilate passed judgment on Christ; the House of Herod; and the House of Saint Anne, where the Virgin was born. Breydenbach relates that his party was eventually admitted to some of these structures, after the pilgrims who were not continuing to Sinai had departed Jerusalem for home, but the Golden Gate and the complex around the Dome of the Rock remained inaccessible (56v, ll. 29–32; 56v, l. 40 through 57r, l. 9). Fabri reports that the Muslim authorities prohibited Christians from approaching the Golden Gate in order to respect graves that lie in the immediate area.[42] Breydenbach does not mention them, but Reuwich depicts the tomb markers very clearly as flat slabs below the gate's caption and as two domed cubes to the left of the gate (figure 99). Even without annotations, at least one contemporary reader understood the meaning of these structures; an illustrator who copied Reuwich's Jerusalem labeled the left-hand cemetery "Saracen graves."[43]

Pilgrims gained credit for looking out at sites instead of visiting them. By this logic, it seems plausible that the indulgences could have accrued wherever pilgrims caught sight of the restricted structures. However, this was not the case, as they report only two places where they received indulgences through viewing: just outside Saint Stephen's Gate, where the martyr met his death, and near a pair of sites at the top of the Mount of Olives (figure 23). One of the sites on the Mount was called "Galilea"; the other, known as *palma mortis*, stood where the Angel Gabriel presented the Virgin with a palm to announce her impending death (*vbi angelus attulit marie palmam*). The provenance of Galilea derives from an attempt to reconcile the accounts of Jesus's appearance to his apostles after his Resurrection, events placed near Jerusalem in Luke 24:33–36, but in Galilee on a mountain in Matthew 28:16 and near the sea in John 21. The identification of a locale named Galilee just outside Jerusalem and near the summit of the Ascension also helped explain why two "men of Galilee" were on hand to witness the nearby Ascension in Acts 1:11. The name was thought to derive from the area's use as a campsite for Galileans visiting the city in biblical times.[44] The consistency of real pilgrims' testimony about the placement of indulgences-by-view reflects the standardization of the tour of Jerusalem given by Franciscan guides from the monastery on Mount Sion. With a monopoly on Holy Land tourism, the friars shaped the topography of sacred sites by identifying them, specifying their location, and communicating the size of their attendant indulgences.

It seems certain that the Franciscans were, in fact, the first to establish and promulgate the tradition of indulgences attached to Holy Land sites, even though the pilgrims and most others thought they had been instituted by Pope Sylvester during the reign of Emperor Constantine (44r, ll. 32–36).[45] Around 1472, when a Franciscan at the house on Mount Sion compiled a list of the indulgences and the extant documentation, there were no papal bulls, albeit the lack did not raise any concerns.[46] In the fifteenth and sixteenth centuries, three different popes instituted six indulgences in Jerusalem, but the first documented official sanction of the full complement of Jerusalem indulgences came only in 1561.[47] There is also no tradition of Holy Land indulgences before the middle of the fourteenth century, when pilgrimage resumed in earnest after the fall of the Latin Kingdom in 1291 and the consequent expulsion of Latin Christians from the region. The kings of Aragon and Naples negotiated (and paid for) the installation of a Franciscan mission on Mount Sion and the friars' rights to celebrate mass at the Church of

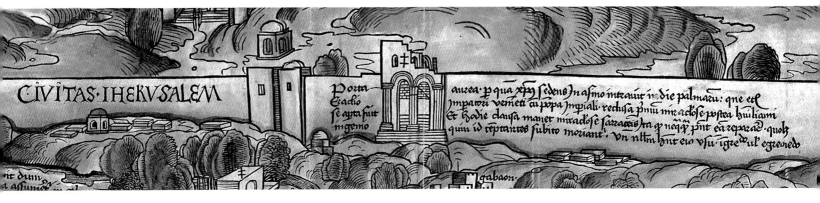

CIVITAS·IHERVSALEM

the Holy Sepulcher, Tomb of the Virgin, and Church of the Nativity.[48] The coincidence of the conclusion of this deal circa 1340 and the development of a tradition of Holy Land indulgences shortly thereafter points to the friars as the ones responsible for it.[49] By the late fifteenth century, the Guardian of the Holy Land had assumed the privilege of creating indulgences as the papal legate in the region.[50] Once instituted, the list of indulgences remained stable, as the uniformly accepted presumption of legal legitimacy took hold and the roster was set down and circulated in pilgrimage guides and accounts.[51]

Saint Stephen's Gate, where the pilgrims accrued their first indulgences by sight, lies on the eastern wall of the city, to the north (right) of the Golden Gate. Reuwich elides the gate, perhaps reflecting the contemporary state of disrepair, and places the site of the saint's stoning (*locus vbi sanctus stephanus fuit lapidatus*) just in front of where the portal would pierce the wall (figure 99).[52] Fabri corroborates Breydenbach's report that the pilgrims could get a view of the Golden Gate from this location: "From there we came to Saint Stephen's gate. . . . Likewise, right there we were shown the Golden Gate. . . . No Christian may come near that same gate. But whoever sees it from this distance and prays toward it achieves the full forgiveness of all his sins."[53]

The indulgence attached to the view from the Mount of Olives lay in proximity to the vantage from which Reuwich's view was composed. Locating the artist's standpoint has been complicated by the construction of al-Makassed Hospital and other modern buildings in that area, to the north of al-Mansuriya road (an ancient route up the mountain from Jerusalem), near the top where it meets the ridgeline. From the closest position that affords unobstructed photography, the main landmarks of the city come almost into Reuwich's alignment (figures 18, 84). They match the configuration of the image more precisely from an obstructed vantage closer to the hospital, adjacent to the original site of the *palma mortis* (figure 100). The pilgrims' route uphill from Dominus Flevit took them past these spots, as they arrived at the top of the mount and turned left (north) to visit *palma mortis*, Galilea, and the outlook to receive indulgences. They then crossed to the other (south) side of the road to visit the Chapel of the Ascension and eventually make their way downhill. During construction of the hospital in the 1960s, the remains of a medieval church were found that seems to have been a sixth-century Byzantine foundation, destroyed in the late twelfth century. It fits accounts from as early as the sixth century of a church dedicated to the Virgin Mary in

honor of the *palma mortis* episode, and the site kept this association even without any commemorative structures. The current chapels were built by the Greek Orthodox Patriciate in the late nineteenth century.[54]

The Augsburger Jörg Mülich and the English pilgrim William Wey may be two of the first to express explicitly the connection between seeing the sites and gathering indulgences.[55] In his account of journeys in 1458 and 1462, Wey distilled the meaning of each locale into a short verbal unit, and then strung the units together in a hexameter verse to help readers remember the places to visit and their sequence. For example, in the second stanza of Jerusalem destinations, "Ascen." evokes the chapel where Christ ascended to heaven. For the "place where they are able to see the holy places in Jerusalem," the verbal unit is simply "Indulgens."[56] The order of sites in Wey's verse suggests that the pilgrims first visit the *palma mortis* as they come uphill toward Galilea, then take in the indulgenced view after Galilea, near there, before backtracking south past the *palma mortis* toward the Chapel of the Ascension. In the narrative portion of his account, Wey reiterates this location and specifies that the indulgences accrue from places that the pilgrims may not enter.[57] Mülich's account from a pilgrimage in 1449 follows

this same order, though implying that Galilea was on a height that allowed the view. After receiving indulgences for the places the heathens would not let them enter, they went uphill to a higher point, where they found the Chapel of the Ascension.[58]

Like Mülich, Felix Fabri places the indulgenced view near Galilea and, true to form, elaborates the details. According to his description, Galilea is marked by "heaps of stones" on the "brow of the mount," a "delightful" place, "suitable for a castle." First the pilgrims pray; then they obtain the "greatest indulgences because all those indulgences connected with these holy places which the Saracens will not allow pilgrims to visit are collected together at this spot." Directly after finishing their prayer and collecting their indulgences, the pilgrims "climbed over the heaps of stones and gazed far and wide over the land."[59] If the connection between viewing the sites and earning indulgences perhaps seems ambiguous in this passage, Fabri gives another explanation in a different text, *Die Sionpilger* (Sion pilgrims), the guide to spiritual pilgrimage that he wrote for Dominican nuns under his pastoral care:

> All the indulgences for places in the city of Jerusalem into which the real pilgrims may not enter are set by the pope on the peak of the Mount of Olives, because from that place one sees all the churches and houses of the city of Jerusalem. For that reason the real pilgrim stands on the peak. And as often he has forgiveness of all sins through his footsteps, so he looks on the Golden Gate and so receives † indulgence, so he looks on the Temple and so receives † indulgence, so he looks on the Church of Our Lady by the Temple where she was presented [Aqsa Mosque] and so receives † indulgence, so he looks on the Church of Our Lady's Nativity [House of Saint Anne, a.k.a. Salahiyya Madrasa] and so receives †

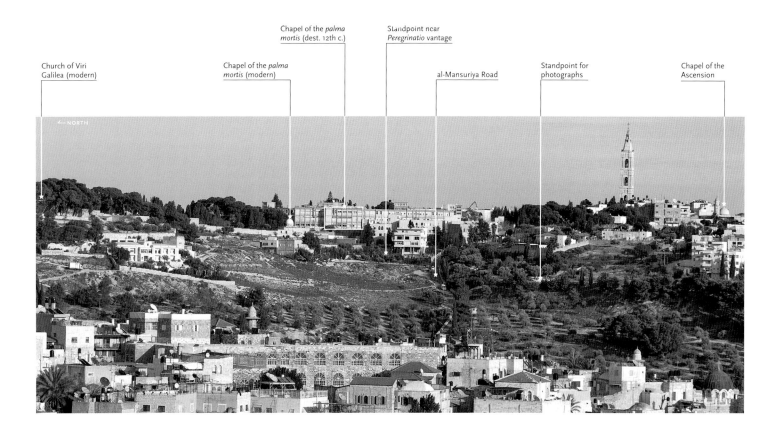

Church of Viri
Galilea (modern)

Chapel of the *palma
mortis* (modern)

Chapel of the *palma
mortis* (dest. 12th c.)

Standpoint near
Peregrinatio vantage

al-Mansuriya Road

Standpoint for
photographs

Chapel of the
Ascension

← NORTH

FIGURE 100
Diagram of pilgrimage
sites on the Mount of
Olives near vantage for
the *View of Jerusalem* in
Breydenbach's *Peregrina-
tio*. Photo: author.

indulgence; and so he looks on Pilate's house and so receives † indulgence, and Herod's house †, and other sites. At Galilea he also has † indulgence. The heathens do not let the real pilgrims enter the sites; therefore they take the indulgence there. But the Sion pilgrims go where they will, without hindrance from heathens.[60]

All the sites in Fabri's list are named or distinctly depicted in Reuwich's image.

The site and its indulgences were known to Breydenbach's party, as Fabri's testimony shows, but while the text of the *Peregrinatio* mentions Galilea, it does not note indulgences associated with the site or the view. However, as noted in chapters 2 and 3, the entire itinerary laid out for sightseeing in and around Jerusalem was a "tautened" adaptation of the circuit described by Hans Tucher in his pilgrimage account, rather than a fresh composition matched to Breydenbach's itinerary. Even though he failed to mention it, Tucher likely took in the indulgenced view, as his traveling companion Sebald Rieter Jr. describes the "big heap of stones" at Galilea and the indulgences obtained around there from the holy sites closed to Christians.[61] Tucher and Rieter exhibit the same discrepancy in their writing as Breydenbach and the person standing on the mount with him.

The idea of an indulgenced view provides a missing link between the practices of real and spiritual pilgrimage. Real pilgrims gained indulgences and other spiritual benefits by making a bodily journey,

"through their footsteps," as Fabri says. Spiritual pilgrims practiced a variety of devotional exercises or a structured program like that detailed in the *Sionpilger*, and images of sacred sites could substitute for the physical experience of traveling to them. The images could be panel paintings or miniatures, mental representations evoked by reading texts like *Sionpilger*, or boards cut to the length or breadth of buildings like the Holy Sepulcher. Spiritual pilgrims could use their vision to contemplate pictures or their footsteps to pace out key dimensions of sacred structures and the distances between them.[62] Religious advisors like Fabri promised practitioners all the benefits of real pilgrimage, including indulgences, if they followed a rigorous program with true faith. Fabri does draw a distinction between "legal" (*gesetzten*) indulgences instituted by prelates for real pilgrims and indulgences that come directly from God to spiritual pilgrims, but he suggests that the net reward for devoted spiritual pilgrims might be even greater than for real pilgrims.[63]

There is at least one instance of spiritual pilgrims who received, through a grant from Pope Innocent VIII in 1491, all the legal indulgences of visiting the sacred sites in Rome and the Holy Land. The privilege was bestowed on the Franciscan convent in Villingen, where the abbess Ursula Haider had erected stations around the buildings and grounds with panels describing biblical and hagiographical sites, including churches in Rome, and any indulgences associated with them. There were 210 sites, according to a seventeenth-century chronicler, who also tells us that Ursula had the text for the panels transcribed from a Latin book that sounds like a pilgrimage guide or account. The project was inspired and facilitated by the pilgrimage of the cloister's confessor, just as Fabri's *Sionpilger* responds to the requests of nuns under his spiritual care, aroused by tales of his travels.[64]

In the continuum of pilgrimage, the idea of the indulged view falls between real travel and the imagining of sites through visual, textual, or somatic simulations. With the indulged view, looking at sacred sites replaces walking in them. The ideal of physical contact is relaxed into the live view from a distance, and from there it is but one more step to looking at an image of Jerusalem, instead of the Holy City itself. The slip from visiting a site to viewing it from afar also echoes developments in the Eucharistic practice of the period, where seeing the elevated host had become more important and more common among the laity than taking communion.[65] Reuwich and his reader share in gaining the spiritual benefits of the sites depicted in his image of Jerusalem by viewing rather than visiting them.

Monastics like Ursula Haider were hardly the only group to transcribe their knowledge or imagination of sacred topography onto the terrain of their home community, and in this context it is interesting to consider that one of the most elaborate instances of this in northern Europe, a complex influenced by Reuwich's prints, also incorporates a view from the Mount of Olives. The three central monuments of the Passion park in the German town of Görlitz stand in for three sites within the Church of the Holy Sepulcher: the double-decker chapel of Golgotha above the grave of Adam; the Stone of Anointing where Jesus was prepared for burial; and the Holy Grave (figures 101, 102). First conceived in 1480, the chapel was finished by 1504, and the two other structures seemed to have followed in the years after that.[66] As an ensemble, their position within the park enclosure approximates the spatial relationship among the original sites within the Church of the Holy Sepulcher, though their individual architectural forms draw from secondary sources. For the Holy Grave, this source is generally agreed to have been Reuwich's rendering (figure 89).[67] Though the

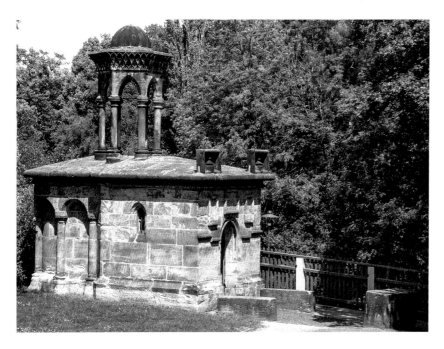

FIGURE 101
Holy Grave in Passion
Park, Görlitz, c. 1508.
Photo: author.

stream that runs through the Kidron Valley between the Mount of Olives and the Jerusalem walls.

In reality, Gethsemane stands near the foot of the Mount of Olives almost in the Kidron Valley, looking up at the city, not down at it. By opening a vista over a river valley, the placement of the Görlitz station exceeds the needs of the procession or topographical consonance with Gethsemane, incorporating the element of a view associated with other sites on the Mount of Olives. The origins of the procession and this wider conception of the landscape are poorly documented, but the historical record suggests that the town decided to modify rather than eliminate a prized local practice that predated the Reformation, as it would be highly unusual for a Reform polity to institute a new tradition that hews so closely to Catholic rituals.[69] Good Friday processions would become increasingly formalized and distinctive markers of Catholicism precisely because they flout the innovation and aniconism of Reform critique. Reform Passion theology may have inspired the addition of Gethsemane to the ritual, but even so, the station shows the strength of the conception of the Mount of Olives as a position for individual contemplation of Jesus's Passion, a conception already featured in one of the main sources for the architecture of the park—the *Peregrinatio*.[70]

Putting Islam at the Forefront of a Christian View

From their study desks or convents, the readers of the *Peregrinatio* could not gain physical access to any of the sites of the Holy City, not just those closed by the Muslims. Like pilgrims at Galilea on the Mount of Olives, they could aspire to the spiritual benefits of places they could not visit by substituting vision. They contemplated an image of the view rather

Görlitz grave differs from Reuwich's version in certain details, for example, its pointed instead of round arches supporting the ciborium, it follows idiosyncratic aspects of Reuwich's treatment, including the facade, quite closely.

A Holy Week procession traced out Jesus's journey east to west across the town, beginning with his condemnation at Pontius Pilate's house (the Church of Saint Peter), then traveling to more stations along the route to the park. Eventually, this mapping of Jerusalem's Via Dolorosa onto the Görlitz streetscape also included a Mount of Olives on a hill overlooking the park to the north, as visualized in an eighteenth-century engraving (figure 102). In the 1920s, this relationship was formalized with the creation of another park with signage that maps the elements of the view, even though summer foliage has since overgrown the line of sight (figure 103).[68] Between the hill and the park ran a small river, shown in the eighteenth-century illustration and read as the

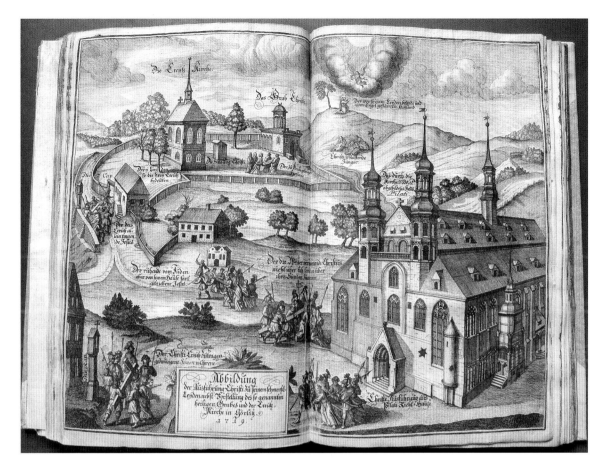

FIGURE 102
Illustration of Christ Carrying out His Grievous Passion with Picture of the So-Called Holy Grave and the Holy Cross Church in Görlitz, 1719, from *Ausführliche Beschreibung des Heil. Grabes zu Görlitz* (Bautzen: Richter, 1726), engraving. Oberlausitzische Bibliothek der Wissenschaften, Görlitz, Gph VI 34 b. Photo: author.

than the view itself. The indulgenced view from the Mount of Olives contains within it, however, the irony of offering a Christian view of the city that focuses on the sites most closely held by Muslims. Having ringed the Haram with loggias and other fenestration to capture the view from their colleges and monasteries, the Mamluk denizens of the city certainly did not then ignore the potential of this vista, as Mujir al-Din testifies: "Viewed from afar, [the city] is a marvel renowned for its luminosity, as seen from the east by a person standing on the Mount of Olives." By daylight, the source of this radiance is Jerusalem's signature white stone; but by night, it is the 750 lamps lit at the Aqsa Mosque together with the 540 that illuminated the Dome of the Rock, a number that rose to 20,000 on certain festivals.[71] Accordingly, this vantage also has drawbacks for a Christian artist, particularly if he is interested in providing a faithful record of the city in "its wretched state at the present day" (as Fabri put it at the beginning of this chapter). The Jews of Jerusalem recognized the loss for them at the heart of this view, when they ascended the mount to look out and mourn the First and Second Temples every year on the anniversary of their destruction, the fast day of Tisha B'Av.[72]

From the Mount of Olives, Reuwich confronts a view that foregrounds the Muslims' physical

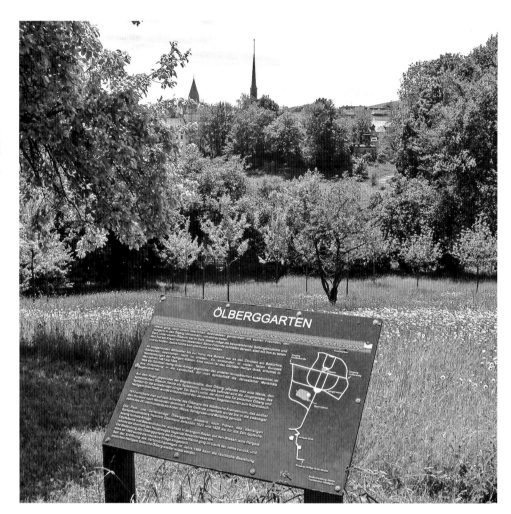

dominion, their sovereignty as signaled through their command of the built environment. For Christians, the view would have been less visually dominating, but also less politically charged from the Franciscan base on Mount Sion to the southwest, from the Citadel in the west, or as imagined from the hill of the Crucifixion. In the *Peregrinatio*'s handling of this situation lies the crux of the entire image: it embraces the irony of the indulgenced view, using a position of physical and symbolic exile to take visual mastery of the city. The artist does this by molding the observed space of Mamluk Jerusalem

into the space between two hills of Christian occupation, his own post on the Mount of Olives and the Church of the Holy Sepulcher on Calvary. Having assumed this position, he does not shirk from recording the topography and architecture of Jerusalem with unprecedented care and concern for detail. Like the text of the *Peregrinatio* itself, the visual presentation of Jerusalem pilgrimage is colored by the desire to draw attention to the Muslim occupation.

This is very much a contemporary vantage, not at all typical for depictions of the city in the period. The Islamic built environment used other means to

shape the city itself and to provide a distinct experience that is stable because centripetally consistent across many venues. And at the time of the publishing of the *Peregrinatio*, most Christian renderings of Jerusalem appeared in the background of scenes from the death and mourning of Christ, which took place on the hill of Golgotha on the opposite side of the city from the Mount of Olives. Taking a closer look at some Christian depictions of Jerusalem below is intended to defamiliarize the *Peregrinatio*'s format and viewpoint. In our own day, pictures of the view from the Mount of Olives may have become a customary way to encapsulate Jerusalem's unique potency as a sacred and contested site, but that is a legacy of Reuwich's widely disseminating the purpose and perspective of the Franciscan indulgenced view, his converting one moment in a long itinerary into an authoritative paradigm of the city.

By the fifteenth century, Golgotha and all the sites associated with the Crucifixion and Resurrection had been incorporated into the complex of the Church of the Holy Sepulcher, well within the city walls. Images of these events generally revert to the historical situation, placing Christ's death and subsequent events in the foreground of the picture, on a rise outside the western walls of an imagined ancient city that lies behind and below the main event. A group of works associated with Jan van Eyck (either by his hand, by an artist in his circle, or based on lost works by him) exemplify this type of composition, for example, *Three Marys at the Tomb* (circa 1425–35) in Rotterdam (figure 104); the *Crucifixion* miniature in the Turin-Milan Hours; *Crucifixion* panels in New York, Berlin, Padua, and Venice; and *Christ Carrying the Cross* in New York and Budapest. This Eyckian formulation strongly influenced painters in Utrecht, especially during the 1450s through 1470, the generation of Hillebrant van Rewyjk, the painter thought to be Reuwich's father.[73]

The narrative logic of the story presumes a vantage from Golgotha in the west, but these largely fictitious Jerusalems offer very little of the real topography of the ancient or contemporary city. A grand, round or polygonal domed structure, understood to represent the Jewish Temple, dominates the city from the middle or the back of the urban fill, and they assume their position of prominence through size and elaborate architecture, rather than topographical placement at the front (figures 77, 81).[74] In recognition of the importance of the Temple for biblical narrative and Christian typology, Reuwich labels his structure, which is clearly the Dome of the Rock, with the tag *Templum Solomonis* (Temple of Solomon), an incongruity between picture and descriptor that will be addressed below (figure 96). Before Reuwich, the building at center of the *Three Marys* came closest to rendering the Temple with the distinctive form of the Dome. Other compositions of the Van Eyck group as well as Memling's *Scenes from the Life of Christ and the Virgin* offer a fantasy of the grandeur of the destroyed Temple, and in Memling's case at least this is not done out of ignorance. Next door to the left he depicts the palace of Herod as an octagonal structure topped by a crescent moon (figure 81); he casts the center of power of the painting's evildoer, Jerusalem's potentate who persecutes the infant Jesus and murders innocent children, as a version of the Dome of the Rock.

The *Three Marys* comes from the circle around Philip the Good, as does a later Flemish miniature that treats the Temple in the same manner—and maintains the approach from the west—but for different purposes (figure 105).[75] Jan Le Tavernier illuminated a compilation of three pilgrimage texts for Philip after 1455, soon after the fall of Constantinople, at a height of the duke's interest in launching a new crusade. Over decades, Philip defrayed

FIGURE 104
Hubert or Jan van Eyck,
*Three Marys at the
Tomb*, c. 1425–35.
Photo: Museum
Boijmans Van Beu-
ningen, Rotterdam—
Photography Studio
John Tromp, Rotterdam.

the costs of pilgrims and collected reconnaissance on the Holy Land, often from courtiers who traveled with his crusader ambitions in mind. In the Le Tavernier volume, this is the case for one of the accounts, which was first composed by Bertrandon de la Brocquière and presented to Philip in 1433. The miniature of Jerusalem opens another text, however, a French translation of Burchard's *Descriptio Terrae Sanctae*, the same text that Reuwich's image is meant to illustrate.

The similarities between Le Tavernier's Temple and the one in the *Three Marys* belie the miniature's essential difference in reframing the view of Jerusalem as the view of a pilgrim's approach to the city. The Mediterranean Sea laps at the bottom of the miniature's frame near the dilapidated infrastructure of Jaffa, signaling the image's orientation. The triple arch entrance to a cave near the bottom of the frame recalls the cavities depicted behind the disembarking pilgrims in Reuwich's image (figure 98). Pilgrims, including Breydenbach and Bertrandon de la Brocquière, complained about the days they spent in holding pens at Jaffa waiting for a Muslim official to arrive from Jerusalem, collect their entrance tax,

FIGURE 105
Jan Le Tavernier, *View of Jerusalem* from Burchard of Mount Sion's *Description de la Terre Sainte*, after 1455. Bibliothèque nationale de France, Paris, ms. fr. 9087, fol. 85v.

and admit them to the Holy Land (43r, ll. 15–24).[76] Again a grand, domed structure dominates the Jerusalem skyline, but at the back of the city. Several elements of the Temple echo the architecture of the Dome of the Rock and its minarets: the polygonal shape, the tiered structure of the surrounding spires, and the spires' corbel-supported balconies and small domes. The position and shape of the basilica to the right of the Dome of the Rock presumably recall the Aqsa Mosque. At the far edge of the city stands the Holy Sepulcher, recognizable from the oculus in the dome above the Holy Grave.

A second Flemish miniature of "modern Jerusalem," contemporary with Reuwich's, remembers the Burgundian investment in crusade that resulted in the Le Tavernier image, but fuses a pilgrim's view of Jerusalem with the biblical view and local chauvinism (figure 106).[77] It, too, puts Golgotha and the west of the city at the front of the image. The manuscript, a Brabant chronicle with crusader texts, was illuminated for the Roocloster near Brussels in 1486–87 by an artist in the circle of Loyset Liédet. The image bears a striking resemblance to the *Peregrinatio*'s for the placement of an outsized Jerusalem in a maplike landscape, and the Roocloster illuminator identifies the sacred landmarks all over the city with clear labels. At first glance this "modern" city may seem to share many of the features of the fanciful biblical versions: the *Templum Domini* commanding the center is marked as an Old Testament structure by the statue of Moses holding the tablets of the Law. The adjacent moneychanger (*cambium monete*) remembers Christ's attack on the corruption of his day, and the artist has brought the twin hills of Golgotha (*golgota*) and Calvary (*mons calvarie*) within the city walls at the site of the Church of the Holy Sepulcher (*sepulchrum domini*).

A brief text, a "description of modern Jerusalem" (2r–2v), accompanies the image as a prelude to the rest of the book. This text draws attention to changes and continuity in the shape of the city, as the author understands them. He tells us, for example, that Mount Sion was in the middle of Jerusalem in the time of Christ, though now it rises outside the walls.[78] In the image, a chapel with tower on *mons syon* marks the Church of the Dormition. At the very front of the city walls, an angel crowns Godfrey de Bouillon, the first monarch of the Latin Kingdom and ancestor of the Dukes of Burgundy and Flanders. It is through Godfrey that the crusaders' occupation of Jerusalem, as recounted in the "Jerusalem history" (fol. 3r–98r), becomes an illustrious episode of Brabantine lore, and his presence links the manuscript's pictorial and verbal description of Jerusalem to its other interests in Brabant history and crusade. Maurits Smeyers has suggested that the image would have been used for spiritual pilgrimage.[79] Whether intended for that purpose or not, the miniature encourages both spiritual and political engagement with the modern topography of the city.

Whether representing sacred history, crusader history, or contemporary pilgrimage, none of these images stages the city from the east, as Reuwich does. One exception may be the woodcut fragments introduced in the last chapter that invite the viewer to enter the city in the lower right corner on the heels of a pilgrim, recognizable by his distinctive gear (figure 78). He passes through a gate with the sign of the Hospitallers after disembarking from a donkey that has transported him from a ship flying the flag of the same crusader order. "Here the heathens guard the temple," announces the city wall twice in the other fragment.[80] Together with the city's rough orientation, these may be clues that the woodcut was informed, directly or indirectly, by a visual record of pilgrimage, but the Holy Grave has been transported to the front and the Golden Gate pushed to the back, among other topographical rearrangements.

FIGURE 106
Circle of Loyset Liédet, *Jerusalem* from Johannes Gielemans's *Historiologium Brabantinorum*, c. 1486–87. © ÖNB Vienna, Cod. Ser. Nov. 12.710, fol. 2v.

Two other exceptions are images produced in Nuremberg for pilgrims, who, as we saw above, also stopped with their Franciscan guides to take in the indulgenced view of the city, so that they were oriented in this direction from their own experience. The manuscript plan associated with the pilgrimage account of Sebald Rieter Jr. (figure 107) was used as the basis for the view in the background of *Mourning the Dead Christ* by the Master of the Hersbrucker Hochaltar, now in the Nuremberg Museum Tucherschloss und Hirsvogelsaal. The painting was commissioned by Rieter's copilgrim Hans Tucher in 1483 as an epitaph for his sister-in-law, and in replacing the usual imaginary view of Jerusalem from Golgotha with a view developed from the pilgrim's record, the artist also commemorates the patron's journey. The numerous differences between the Nuremberg works and Reuwich's image preclude his having used the Nuremberg works as a direct model.[81]

As seen with the *Three Marys*, the *Peregrinatio* is not the first work to present the Temple in the guise of the Dome of the Rock, and the onion-shaped cupola is one glaring embellishment that it shares with its Nuremberg cousins. The origins and semantics of the onion domes are unclear, but they go back at least to a seal of the Knights Templar, on which their home base during the Latin Kingdom—the Dome of the Rock rebaptized as the Temple of the Lord—is crowned by an onion dome surmounted by a cross.[82] Reuwich was not the first to bring an onion dome to print: in the woodcut fragments, one tops the tower of the Aqsa Mosque (figure 78), and a pair of them also marks the towers of a city gate in a relatively simple 1481 woodcut of Christ approaching Jerusalem.[83] These onion domes could have been understood as neutral facts of the architecture; as markers of the East; or, after the Templars, as a reminder of the Muslim occupation.

Le Tavernier's miniature for Philip the Good and another illumination, made for René of Anjou, offer Flemish precedents for depicting the Dome as a polygon with an onion dome (figure 108).[84] In René's miniature, the Dome sits in the middle of a walled courtyard behind the Church of the Holy Sepulcher, and together the two structures and the Salahiyya minaret on the left form an architectural emblem of Jerusalem. René claimed the title of king of Jerusalem, and the image faced his arms across the opening of a book of hours. Both images were created for rulers with a particular interest in retaking the Holy Land, though there was a more specific connection. René's book of hours may have been illuminated while he was a hostage of Philip the Good in 1435–36, shortly after Bertrandon de La Brocquière returned to Philip's court with his Holy Land report.[85] More likely, it was executed in 1442–43 by an artist, Barthélemy d'Eyck, who brought a Flemish manner and motifs to René's domain when he emigrated from the bishopric of Liège, the home diocese of Jan van Eyck.[86]

Whatever the onion dome's meaning, it seems to have circulated as a Northern motif, German and Flemish, along with the second idiosyncratic detail from the circle of Philip the Good, the triple-arched cell at Jaffa. Reuwich's adoption of both may indicate that he drew upon a source or sources from this loose family of images. His model may not have needed to come directly from the Low Countries, however. Philip was an unusually active patron of the Franciscans in the Holy Land, providing them with an annual stipend, funds for rebuilding their chapel of the Holy Spirit on Mount Sion, a stained-glass window for it, and a prefabricated wooden chapel sent when Muslims demolished the Christian renovations in 1452.[87] With this ongoing exchange of monies and materials, it would not be surprising if an image of Jerusalem, available to inquisitive pilgrims at the Franciscan convent on Mount Sion, were an

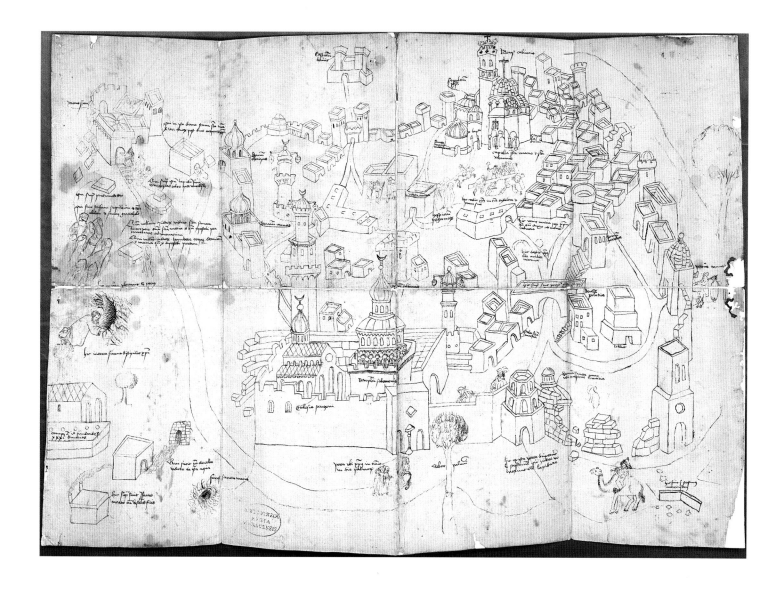

artifact of the Burgundian reconnaissance missions or, at least, supplied to Philip by the Franciscans.

Reuwich's rendering of the Dome of the Rock remains consistent with the perspective near the top of al-Mansuriya road in emphasizing the forward three walls, as if the front of a hexagon, with the hint of the extra walls where the front elevation turns away from the viewer on the right and left sides (figures 96, 97). He accurately records a blind arcade of recessed, full-length arches pierced by smaller windows along each face of the facade, though he miscounts the number of arches per face (five or six instead of seven). The shading of the arches on the leftmost face seems to suggest those are entirely open, but, instead, they may render the effect of shadow. The arcade along the parapet and the drum seem to simplify the original decorative mosaic along those areas (retiled in the sixteenth century and

FIGURE 107
View of Jerusalem associated with Sebald Rieter, after 1479. Bayerische Staatsbibliothek München, Cod. icon. 172.

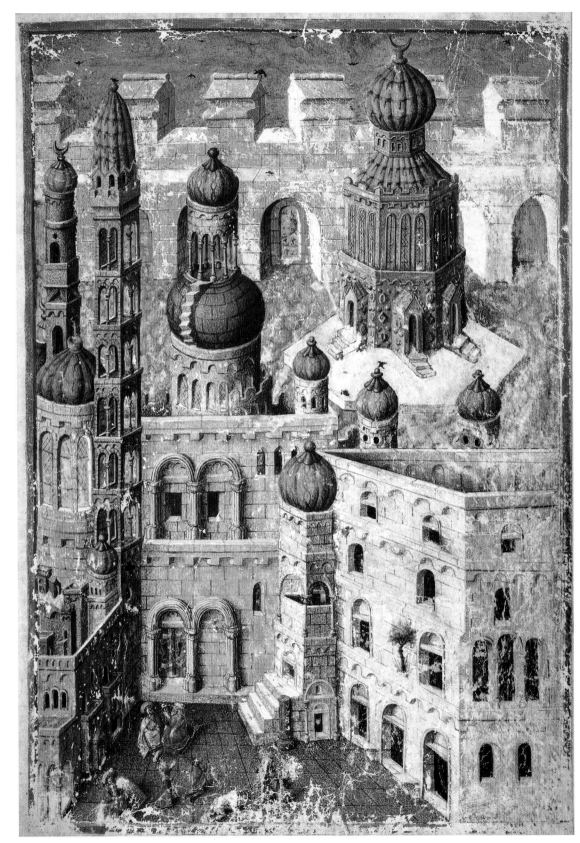

refurbished in the mid-twentieth), though arched windows partially camouflaged with screens did and do pierce the drum. The buttresses between pairs of panels on the drum depict real structural supports, if exaggerating their frequency, with the rhythm of two arched windows between each support recalling the drum of the *Peregrinatio*'s version of the dome over the entrance to the Church of the Holy Sepulcher (figure 12).

The Meaning of al-Haram al-Sharif for the Pilgrimage of 1483–84

When historians trace the genealogy of representations of the Jewish Temple at Jerusalem in Western art, they cite Reuwich's image as one of the first more or less architecturally accurate descriptions of the Haram complex.[88] With the possible exception of the onion-domed hexagons for Philip the Good and René of Anjou, the structure dominating the skyline in images of Jerusalem represents the Jewish Temple of ancient times, even when based on the Dome of the Rock. In this case, the acuity with which Reuwich observes the Muslim edifice and its supporting platform opens a gap between the visual and verbal signs, the image and its labels: Temple of Solomon (*Templum Solomonis*) for the Dome of the Rock and Temple of Simeon (*Templum Symeonis*) for al-Aqsa Mosque. It seems simple enough to assume that Reuwich ingenuously named these as he understood them, but this underestimates the complexity of the pilgrims' relationship to the site and their familiarity with the sweep of its architectural history.[89] Within this space between image and label, the *View of Jerusalem* oscillates between the viewpoint of Christian sacred history and a politicized view of the Islamic here-and-now to match the thematic doubling of the *Peregrinatio* as a whole.

A sense of a simultaneous past, present, and future governs Burchard's description of the pilgrims' view of Jerusalem from the Mount of Olives (discussed at the opening of this chapter), as well as the Jerusalem in the Roocloster miniature and the woodcut fragments. It is also legible in both of the *Peregrinatio*'s presentations of the Temple, once during the pilgrimage account and once in the supplemental material on Islam. The second passage begins by calling attention to the Muslim control and liturgical use of the structure, a point reinforced by the passage's context as part of the larger argument against the occupiers. The author then relates how the Temple was destroyed and restored under several other powers (Babylonian and Roman) before finally being rebuilt with a round plan by Christians (90r, ll. 19–27). Aside from the chauvinism of asserting a Christian role in the construction of the current building, the text is insouciant about the priority of any one structure over any other.

The description of the Temple in the *Peregrinatio*'s pilgrimage account maneuvers subtly to acknowledge the Temple Mount's Old Testament pedigree and contemporary importance for Muslims, while strongly recouping it as a Christian site. First, Breydenbach describes the appearance of the round structure and its "Greek" mosaic with emphasis on the crescent finial, an eclipsed moon, which marks it as a Muslim house of worship (50v, l. 39, through 51r, l. 5). After adding a description of the "long, beautiful church" (Aqsa Mosque) next door and the hundreds of lights in each building (a sign of wealth and magnificence in the financing of so much lamp oil), Breydenbach offers an image of Muslim pilgrimage: "The Saracens hold the Temple of Solomon in great reverence and suffer no uncleanliness within it. They enter barefoot and call it the holy rock and a temple of the lord and for such reason because in the middle of it is a small rock encircled

with an iron gate. . . . [Saracens and pagans] come from faraway lands in order to pray devoutly to the rock because one reads that many great miraculous signs happened on that very rock" (51r, ll. 23–31).

This discussion of the hallowed site's architectural and cultural envelope then recedes as Breydenbach reports on the rock's more sacred encrustation, stopping, though it seems he could go on, after revealing eight strata: the high priest Melchizedek offered his oblations there; Jacob had his dream of the ladder using it as a pillow; David saw an angel pose on it with drawn sword; the priests of the Temple burnt offerings on it; Jeremiah let it swallow the Tablets of the Law for safekeeping; Simeon reached across it and took the infant Jesus in his arms; the twelve-year-old Jesus sat on it to dispute with the doctors; and he returned there eighteen years later to begin his ministry. The stone altar where the priests of the Old Testament offered their sacrifice has become a center for the Muslim cult—but sheathed in Christian myth as a type of the Christians' own mensa. Nowhere does Breydenbach mention that Christians may not enter. What begins as an image of Muslim pilgrimage thus ends as another image of Christ for Western pilgrims to contemplate.

This understanding of the Temple of Solomon accounts for Reuwich's label, but it does not fully explain how he or his readers understood the visual record of the architecture of the Haram. Both of the *Peregrinatio*'s texts on the Temple of Solomon were taken from other sources; neither description reflects the eyewitness observations of Breydenbach himself.[90] Felix Fabri, in contrast, offers two detailed and pointed examinations of the Dome of the Rock, and their immediacy provides a better textual counterpart to Reuwich's visual scrutiny. Moreover, Fabri's testimony corrects the assumption that all pilgrims submerged the Muslim significance

of the building in favor of its Christian meaning. Indeed, Fabri emphasizes the role of the Dome of the Rock as an emblem of Islam and as the center of the Islamic cult precisely to draw readers' attention to Muslim domination of the Holy Land. His text expresses a wholly different model of the relationship between historical specificity and religious ideology, but his ideology nonetheless serves a purpose very familiar from other sections of the *Peregrinatio*.

This resonance between Fabri's concerns and the *Peregrinatio*'s program is not a mere coincidence or a symptom of the political climate of the times. After trekking with the Breydenbach party from Jerusalem through the Sinai to Egypt, Fabri sailed with them back to Venice on the same galley. Before they parted ways for their return to Germany, Breydenbach invited Fabri to come back to Mainz with him to compose their books together, and he speaks well of him in the list of pilgrims who made the trip to Mount Sinai, as outlined in chapter 1. One also has no difficulty imagining that the two aspiring authors did discuss their plans for a book, at least during the trip, and that their conversation reinforced each other's woe over the current state of the Holy Land. A preoccupation with calling readers to arms over Muslim domination in Jerusalem belongs to the particular culture of the pilgrimage of 1483–84, and Fabri uses the Dome of the Rock to this end.

In the *Evagatorium*, Fabri goes into great detail about the history of successive buildings on the site, but here, in contrast to the *Peregrinatio*, he draws attention to the discontinuity between the contemporary structure and the earlier Temples. He explicitly rejects erroneous speculation that the Dome was erected by Roman rulers and asserts that 'Umar ("Hamor"), the first Muslim conqueror of Jerusalem, cleared the abandoned site and rebuilt the Temple. According to his *Evagatorium*, Christians mounted resistance to this appropriation of the

Temple site, but not enough. Their prayers beneath a cross set up on the Mount of Olives "over and against the city" prevented the Dome's foundations from taking hold until 'Umar had the cross removed. Fabri laments that the Christians did not prevent the Dome's construction or demolish it when they had the chance during the crusaders' control of the city. It had become, he recognized, the sacred rallying point that inspired the Muslim dominion over Jerusalem.[91]

For Fabri, this particular structure, the Dome of the Rock, carries a meaning that the previous Temples on the site did not, and he makes use of it, as the Muslims do, as a symbol of infidel occupation. The symbol operates as synecdoche: the occupation of this multilayered, especially sacrosanct sector of Jerusalem stands for the subjugation of all of the Holy Land. In this sense, the Dome derives its meaning also for Fabri from its contact with the history of the site and with the Temples that have gone before it. Yet, where other Christian authors like Breydenbach immerse themselves in the abundance of meaning in the collapsed temporal layers of the site, Fabri treats the construction of the Dome as a significant break with the past.

His purpose in presenting the Dome this way becomes clearer in the *Sionpilger*. In that text the close attention paid to the Islamic nature of the edifice especially stands out, given that a Saracen-free experience is touted as one of the advantages of the genre. The opportunity for a pilgrimage cleansed of infidel obstacles is so fundamental to Fabri's conception of this type of devotional exercise that he counts it as number nineteen of the twenty principles of spiritual pilgrimage in the preface to the *Sionpilger*:

> The real pilgrim goes to Jerusalem as a pagan city, but the spiritual pilgrim comes to Jerusalem as a Christian city, as if Christendom possessed the Holy Grave and all the churches were open without hindrance from pagans. . . . [The real pilgrim] must . . . leave many holy sites unvisited. . . . All this does not afflict the spiritual pilgrim. He stands free of all the hardships of the Saracens, goes around where he will in the Holy Land without care, and stays as long as he wants in the Holy Grave, Bethlehem, Nazareth, and wherever he pleases in the Holy Land.[92]

Yet Fabri's lengthy excursus on the Muslim occupation of the Temple Mount ensures that the mosque will loom large in the mind of his spiritual pilgrim readers. Of the seventy-six lines dedicated to the buildings of the Haram in the modern edition of *Sionpilger*, only thirty-three remember the biblical history of the Jewish Temples or tell the nuns which prayers to offer. The rest bemoan the Muslim presence or rehearse the site's subsequent travails from the destruction of the Second Temple through the building of the Dome of the Rock, the brief Christianization of the Latin Kingdom, and the Muslim reconquest he deplores.[93] Fabri largely condenses his *Evagatorium* text, and in focusing the political lament, he sharpens the distinction between the site and the contemporary structure: "The spiritual pilgrim finds the Temple of Solomon in all holiness on that site. But, unfortunately, the real pilgrim finds on that site not the Temple of Solomon, but the Demon Temple where there is no God. But Muhammad, the devil's messenger, is praised. And there is nothing holy about the Temple except the place where it stands."[94]

In the context of spiritual pilgrimage, Fabri's lingering on the Islamic history of the building makes sense only if he finds value in the nuns' contemplation of the "wretched state" of present-day Jerusalem, as he describes the view from Dominus Flevit

in the *Evagatorium*. Principle 19 can be read in this light as well, as a deliberate reminder of the unfortunate reality the nuns do not have to face, rather than as a statement of a program to purge the spiritual pilgrimage of distracting elements.

This intent becomes clear at the end of the passage when Fabri leads his flock into "a new heathen church that is now being most sumptuously (*gar kostlich*) built."[95] This must be the royal Ashrafiyya Madrasa that Fabri describes in the *Evagatorium* as the spot from which his party got a closer look at the Haram. Neither this building nor this site has any salient Christian history or importance—except as an example of the Muslims' freedom to build and practice their faith. Where elsewhere Fabri notes the indulgences that pilgrims receive at a site, here there are none. His readers enter not to receive indulgences, but to "lament and weep the great misery of the Christian people," who do not have the power to construct a chapel or erect an image in Jerusalem.[96] This is a new stop for spiritual pilgrimage, and Fabri has included it solely as the proper culmination of the grief he has roused during the nuns' tour of the Haram.

Fabri ties his observations about the form of the Dome of the Rock to its Islamic character. He cites the form of the building as proof of its history: "Although I have often read in little books [for pilgrims] that it was built by Saint Helena [Emperor Constantine's mother, who found the True Cross], yet when I carefully examined this Temple, I did not see this because it is entirely built in the infidel manner, and has not the form of a Christian church, for its main door opens from the east, a thing which I have not seen in the churches of Christ."[97] In this passage, Fabri seems to be trying to identify the origin of the building by identifying its style. Nonetheless, it is difficult to specify to what extent the style of the building influenced Fabri's opinions about its

Islamic character and to what extent Fabri's sense of the building's Islamic character determined his perceptions of style. In the *Sionpilger*, he describes its shape as "round and formless," with the door where the altar should be, and in that text these are the only characteristics that he uses to express the building's foreignness. The remark about the misplaced altar provides a telling clue that, for Fabri, the shape or shapelessness of the building reflects its infidel function. Fabri is reading architectural difference as a marker of ritual difference and ritual difference as a marker of apostasy. In the *Evagatorium*, he indulges in a longer ekphrasis that includes a fairly detailed analysis of the construction of the building (inner rotunda encircled by single-story vaulted aisle) as well as admiration for the richness of materials and the Muslims' conscientious upkeep of the immaculate precinct. The idea of formlessness returns when Fabri notes the lack of figuration in the exterior decoration, according to the prohibitions of Islam. He develops this theme in his description of the interior, which he knows only through hearsay. Again, he locates the source of architectural difference in differences in ritual practice, though now the Muslims' foreign practices affect ornament and the qualities of interior space. They prefer an empty space "paved and paneled with marble of diverse colors, and lighted at night by many lamps" and with walls "decorated with Greek work" like the exterior, but where there are "no altars, no images, neither pictures nor sculpture" and no "wooden seats, neither benches nor chairs."[98] Aniconism, too, is a marker of difference.

Fabri's understanding, or at least his articulation, of an Islamic style is bounded by these few elements. Nonetheless, he approaches the Dome as an opportunity to draw attention to the Muslim occupation, and he uses description of the physical appearance of the Dome as a tool in expressing

Muslim difference. As explained below, readers of the *Peregrinatio* were free to shrug off the surplus of signification in Reuwich's detailed observations and to tour the sites of a Christian Jerusalem; in fact, the artist's manipulation of his image encourages this reading. But the program of the *Peregrinatio* also invites another reading, which interprets this excess as a sign of Muslim difference. Without direct testimony from Reuwich's pen, it is difficult to say which aspects of the Haram he thought served this purpose. But the artist of this *View of Jerusalem* peered at the Haram too long and too closely—just like Fabri and in Fabri's company—for his observations not to encode that aspect of the building's identity. This vacillation between depicting the Islamic city and recouping it as a site of Christian devotion characterizes the entirety of Reuwich's view of Jerusalem.

Reuwich has plucked out the main sites of a Christian itinerary while also embedding them within the urban landscape. At the center of the city, the artist carves a zone of deep space from the surrounding thicket of two-dimensional facades. Two types of space exist side-by-side in Reuwich's Jerusalem. The eye is fooled into overlooking the flat treatment of most of the architecture by the expansive recession from the city walls to the edges of the Temple platform and up a boulevard to the Holy Sepulcher. The effect is supported by the recession into depth behind the city, where Reuwich has strongly foreshortened the desert expanse leading to the Jordan River valley and the eastern mountains. In the first decade of the sixteenth century, Vittore Carpaccio will build the kernel of space at the front of Reuwich's view into expansive stage sets for his cycle of the *Life of Saint Stephen* (figure 109).[99]

The rest of the urban sprawl resembles the sketchy icons of less pictorial maps—with one systematic exception. Pockets of open space or solid architecture pop out from the urban fill to draw the reader's attention to the edifices of pilgrimage: the Cenacle on Mount Sion, hostel for the Last Supper; the House of Saint Anne; the so-called Palace of David (Citadel); the Church of the Holy Sepulcher; the Chapel of the Virgin; the Ecce Homo Arch; the House of Herod; the House of Pilate; and another House of Saint Anne. The last four are grouped around a single square in the south of the city where Christ assumed the burden of the Cross and pilgrims begin their recapitulation of his route to Calvary (figures 84, 85). The Ecce Homo episode (John 19:5) was tied to a triple Roman arch, a gate to a forum, erected in the second century as part of Emperor Hadrian's remodeling of the persistently rebellious city. Although the artist elides the two lateral archways, which were accessible though visually obstructed by other buildings, if Sebald Rieter's map is reliable (figure 107), he, like Rieter, captures the sense of a freestanding structure. This was lost when first the south and then the north side were incorporated into religious foundations on either side of the road in the sixteenth and nineteenth centuries. Reuwich gives Mount Sion volume as a hill by letting its slope carve out a bare mound among flat houses (figure 110). The placement of these sites in the map respects their relative location in the city itself, and this careful observation of topography joins with the illusion of an expansive urban fabric to suggest a reliable portrait. Yet Reuwich's coordination of design and space does more than weave the illusion of a lush, authentic view; it allows him to offer the pilgrims' view as the authentic view.

Looking closer, then, at the rest of Reuwich's Haram, we see that he has presented an existing, but relatively inaccessible, approach as the main entrance. Several of the city's scarce staffage start up these stairs to join the rest of their group milling outside the Dome of the Rock (figure 98). The map's only other figures disperse from the galley landed at Jaffa,

the pilgrims' port of entry. A sole pilgrim on the right looks up at Jerusalem as he sets out from Jaffa, and the direction of his gaze suggests that he is headed to join the figures climbing the stairs to the Dome of the Rock. Between the pilgrim and this stair stand, however, the bricked-up Golden Gate and its copious caption: "Golden Gate through which Christ, sitting on an ass, entered on Palm Sunday. Also one time when Emperor Heraclius approached with imperial pomp, it miraculously reclosed at first. After he humbled himself, it was opened. And today it remains miraculously closed to the Saracens, so that they are definitely not able to repair it by any

trick whatsoever. In attempting it they suddenly fall dead. From whence they have no use by means of this to go in or even out"[100] (figure 99).

It is by means of this gate, feeding into the featured approach to the Haram, that Reuwich and the viewer of the map gain entrance to the Temple precinct. Reuwich opens a gate forbidden to Muslims (according to the caption) so that visual pilgrims may follow in Christ's path. Just as the artist and the rest of his party had to rely on a view from afar to garner the indulgences associated with the Golden Gate, so does the viewer of Reuwich's image gain access to the spiritual benefits of Jerusalem through

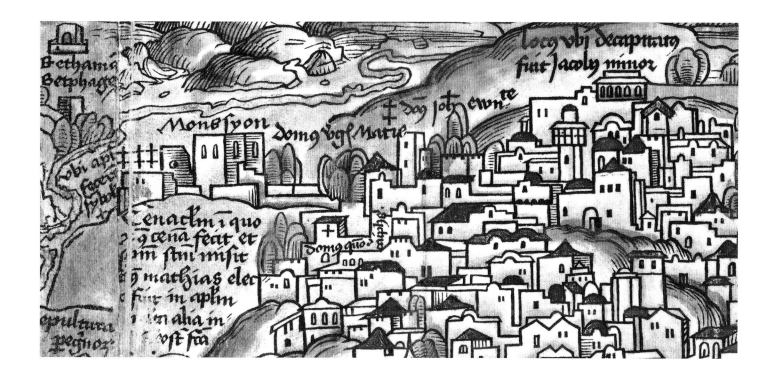

a view of the same. The view from the Mount of Olives reactivates the dormant portal of Christian miracle, inverting the actual situation that denies access to Christians and suggesting that it is Muslims who dare not try and gain admission. The image succeeds in this coup through the strategic use of verbal annotation (including the omission of the caption "Saracen graves") and, more subtly, by the ploy of realism. The image obscures its bias behind a screen of hyperfactity: here the bricks obstructing the Golden Gate and the particulars of the eastern stairs up to the Haram. In this context, the labels *Templum Salomonis* and *Templum Symeonis* do not merely indulge popular perception or draw out the Christian history of the site. They help enable a Christian reoccupation of the mount.

This maneuver works in concert with an even more significant manipulation of the image of the Church of the Holy Sepulcher. It has been rotated

90 degrees clockwise so that we recognize the signature south (not west) facade with the main entrance, and the scale of the structure has been exaggerated, including its height relative to one of the minarets that frame it (figures 90, 94). This is the entrance that Reuwich elaborates in a separate woodcut (figures 12, 95). In the end, the artist favors this facade over the elevation of any Islamic edifice. This manipulation may seem just another, more overt example of the formal means by which Reuwich emphasizes the city's Christian topography while respecting its urban context. Yet the simplicity of the maneuver, an easy twist, belies its significance. With this one stroke, Reuwich reconstructs the past moment in the history of the city when the Christian-Muslim rivalry ran along an axis from the front door of the Church of the Holy Sepulcher to the Dome of the Rock.

The Christians lost the battle over the built environment, so Reuwich shifts the contest to the

FIGURE 110
Erhard Reuwich, *Map of the Holy Land with View of Jerusalem* (detail: Mount Sion) from *Peregrinatio* Latin, hand-colored woodcut on vellum, fols. 143v–148r. Photo © The British Library Board, C.14.c.13. All rights reserved 2014.

printed page. With a simple change in the orientation of the Church of the Holy Sepulcher, Reuwich restores the architectural detente of an earlier era. He intuitively rediscovers the topographical terms by which Christian and Muslim had contended for control of the city and realigns the Church of the Holy Sepulcher according to Jerusalem's most privileged axis. In addition, while acknowledging the conspicuous addition of the two minarets over Calvary, he avoids conceding the symbolic reconfiguration of the airspace by rendering these twins asymmetrical in height, spacing, and appearance. He also neutralizes the barriers that mark the Haram as a Muslim preserve by emphasizing the encroachment of the surrounding urban environment and downplaying the arcaded perimeter that checks its advancement. He includes only a glimpse of the arcade in front of the House of Saint Anne and along the facade of the Temple of Simeon, while interpreting the rest of the border as an ambiguous fringe. In his moment of visual access, Reuwich but briefly notes the barriers that physically keep him off the Temple Mount.

It is the characteristic challenge of this map, however, that Reuwich does not go so far as to Christianize the landscape or submerge, wherever possible, the signs of Mamluk control; he refigures while recording. On the shores of Jaffa, a pilgrim just off the galley kneels in his monk's habit to receive blows from a man who can only be a local official about to herd the entire group into the waiting caves. Reuwich's choices reflect a tension inherent in the conception of the *Peregrinatio* project. On the one hand, Breydenbach aspires to encourage pilgrimage and provide readers with information to facilitate Christian study, devotion, and preaching. On the other hand, his desire to fire up interest in the Holy Land includes the goal of sparking knowledge and indignation about Muslim occupation of Palestine and their threat to push farther west. Together with

information for Christian religious practice, Breydenbach conveys the cold, hard facts of Middle East politics. Reuwich negotiates the same dual mission in his image of Jerusalem by scrupulously rendering, even foregrounding, the signs of Muslim rule while reworking them to allow Christian devotion. He reframes the view from the Mount of Olives as a Christian view, in a manner analogous to the architect who placed a figurative grille over the window of the modern Church of Dominus Flevit. This view allows readers to experience an image of the Holy Land that they themselves can occupy, rather than an ideal vision of a Palestine regained. Reuwich's manipulations make visible the Christian liberties that Fabri's spiritual pilgrims are free to imagine. Thus, two paths lead from the galley to the Temple Mount, one from abuse to occupation and one from freedom to spiritual fulfillment.

Coda: The View from the Jewish Quarter

During the reign of Qaytbay, the Jewish community of Jerusalem, comprising maybe 20 percent of the city's households, did not have much influence over the built environment, though they did successfully assert themselves in at least one matter. Their single synagogue stood next to a mosque in an area already known as the Jewish Quarter (though obviously not exclusively so), and the two houses of worship were separated by a structure that belonged to the synagogue and impeded direct access to the mosque from a main street. When the structure collapsed one day in 1473, Muslim neighbors attempted to appropriate the newly opened path. This resulted in a protracted lawsuit during which the synagogue was closed, destroyed, and then finally rebuilt, as the sultan tussled with legal councils in Jerusalem amidst insinuations that the Cairo authorities had

taken Jewish bribes. At least two of the legal proceedings took place in al-Tankiziyya Madrasa, one of the edifices depicted in the *Peregrinatio's* survey of the western boundary of the Haram.[101] Rebuilt again in the modern era, the synagogue, known by the name of its thirteenth-century founder, Ramban, an acronym for Rabbi Moses ben Nahman, still stands next to the mosque's Mamluk-era minaret, which is also duly recorded in the *Peregrinatio* (figure 84).

The pair have been joined in that immediate area by the reconstructed eighteenth-century Hurva Synagogue, whose large white dome now complements those of the Church of the Holy Sepulcher and Dome of the Rock in the view from the Mount of Olives (figure 18). And in a development reminiscent of Mamluk urbanism, the prime real estate at the front edge of the Jewish Quarter, at the border between the city and the sacred precincts, has been built up as a center for religious learning, the Aish HaTorah World Center, which includes a yeshiva, outreach programs, and a museum. Just as the madrasas and khanqahs of the fourteenth and fifteenth centuries, or the Palace of Lady Tunshuq, were built to frame a view of the Haram, so Aish HaTorah makes use of its privileged outlook. In 2009, a crane positioned a 1:60 scale model of the Second Temple on the roof, where it aligns

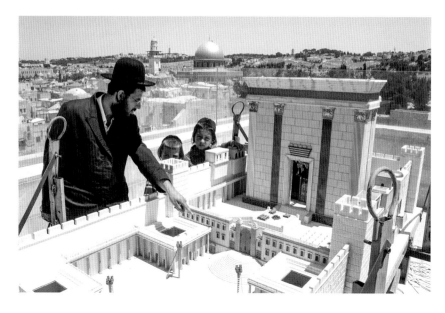

visually with the Temple Mount via its Western Wall and the plaza in front of the Wall, where Jews pray and mourn the destroyed Temples (figure 111). This construct from this particular vantage allows the re-creation of a lost ideal through the superimposing of near and far, the bringing of the past into the present, while yet embracing a visual reminder of the history of loss and its lament. This is the careful managing of parallax that is also at work in the *Peregrinatio's* view, and it is one thing that all three of Jerusalem's religious groups share.

FIGURE 111
Model of the Second Temple overlooking Temple Mount, Jerusalem, 2009. Photo: Gali Tibbon / AFP / Getty Images.

Chapter 1

1. Breydenbach, "Reiseinstruction."
2. Reuwich's three editions all share twenty-four woodcuts, but beyond that the woodcuts vary. *Peregrinatio* Latin with a total of twenty-six woodcuts adds initials on fols. 2r and 4v. The 1488 Dutch edition with twenty-five total includes one initial: Breydenbach, *Peregrinatio* [Dutch], a2r. Some examples of *Peregrinatio* German display the same initial (2v) as the Dutch edition, e.g., Bayerische Staatsbibliothek, 2 Inc.c.a. 1727, but some do not, e.g., British Library IB.335. *Peregrinatio* German is the only one to include the Armenian alphabet (111r), for a total of twenty-five or twenty-six.
3. See bibliography; *Fuchs*, 32; and *Davies*. After the three Reuwich editions, the following used the original blocks: Lyons: Gaspard Ortuin, 18 February 1489; Speyer: Peter Drach, 29 July 1490; and Zaragoza: P. Hurus, 16 January 1498. For the Reuwich editions, ISTC lists 183 of the Latin, 94 of the German, and 43 of the Dutch. GW counts 166, 84, and 39. Both accessed 11 July 2011. While print runs are difficult to estimate, this suggests half as many German copies as Latin with Dutch half that again.
4. One example of a large-scale print is Andrea Mantegna's *Battle of the Sea Gods*, spread across two plates, 28.3 x 82.6cm, and generally dated to before 1481. The *Peregrinatio* has been suggested as an influence, which would require a later date. Vickers, "The Palazzo Santacroce Sketchbook." For the sixteenth century, Silver and Wyckoff, *Grand Scale*.
5. Hamburg, Commerzbibliothek, 2/167b; Munich, Bayerische Staatsbibliothek, Rar. 324.
6. Breydenbach, *Peregrinatio*, ed. Mozer, xxxiii–xxxiv, 776–78. Mozer's image census is limited by her use of the blanket term "fragmentary," which may mean that one sheet of a foldout has fallen off or that most of the image has been purposefully removed. There are also discrepancies between her census and catalogue of missing text pages. That said, the *View of Venice* is missing from at least thirteen copies of the forty-four surveyed, the *Map of the Holy Land with View of Jerusalem* from at least sixteen.
7. Parshall, "Imago Contrafacta."
8. *Fuchs*, 52; also, Filedt Kok, *Livelier than Life*, 282; *Timm*, 118–19.
9. *Timm*, 263, identifies places near Utrecht with "raven" in their names and suggests the raven represents a place of origin for Reuwich.
10. The arms are all printed in reverse, including Archbishop Henneberg's arms in initials. *Fuchs*, 52.
11. To conform with the orthography of his place of origin, as seen on the frontispiece, Bernhard's name is often rendered Breidenbach. The salutation at the opening of the text uses Breydenbach, however, and this is the more usual form in English. Until recently, the most comprehensive biography of Breydenbach was *Fuchs*, 35–44. *Timm*, 53–66, adds much new information.
12. Diether von Isenburg, *Agenda Moguntinensis*.
13. Uhlhorn, "Geschichte," 108. For the portrait, Solms-Laubach, "Nachtrag," 113.
14. Uhlhorn, "Geschichte," 108–9; *Fuchs*, 37–38.
15. For the order, Gennes, *Chevaliers*, 1:263–353.
16. 158r, ll. 12–19 for the death; 137r, ll. 26–28 for the register. See also *FabriE*, 3:199–203; Ulhorn, "Geschichte," 110; Walther, *Itinerarium*, 244–46.
17. The inscription is Psalm 85:17. See *Fuchs*, 40; Solms-Laubach, "Hausbuchmeister," 56.

18. *FabriE*; *FabriS*; Fabri, *Pilgerfahrt*; and Fabri, *Pilgerbuchlein*.

19. Walther, *Itinerarium*, xi–xii, 114, 175–77, 181. This is an abridged edition. For his Arabic glossary, Bosslemann-Cyran, "Vokabular."

20. *FabriE*, 3:389.

21. For a contrast of the styles and approaches of Breydenbach and Fabri, *FabriS*, 20–22.

22. Front matter: *Peregrinatio* Latin, 7v, ll. 3–6; *Peregrinatio* German differs, calling him an unnamed "good painter," 10r, ll. 22–24. Colophon: *Peregrinatio* Latin, 163v, ll. 27–28; *Peregrinatio* German, 180r, ll. 29–30; Breydenbach, *Peregrinatio* [Dutch], 16v. Sinai travelers: *Peregrinatio* German, 137r, ll. 32–34; *Peregrinatio* Latin, 116v, ll. 2–4 differs in not mentioning Reuwich's role in the printing.

23. For payments to "hilbrandt, die maelre" in the accounts of the Buurkerk, Rappard, "Rekeningen," 155–56, 161–62, 164. For Hillebrant in the list of the deans of the Saddlers Guild, which included painters, and for a Cornelius van Rewyck, who was head of the guild in 1486 and 1492, as well as active in the accounts of the Saint Nicholas Church, Muller, *Schilders-Vereeningen te Utrecht*, 55, 56.

24. Uhlhorn, "Geschichte," 111.

25. Johannes Schnitzer, for example, signed the woodcut map of the world in the 1482 Ulm Ptolemy discussed in chapter 3. He did not draft the map, however. For *snytzer* as sculptor, Solms-Laubach, "Hausbuchmeister," 58.

26. Breydenbach arranged to have a little extra room, purchasing eight places for six people: 11r, ll. 38–39; corroborated in Breydenbach, "Reiseinstruction," 127.

27. *FabriE*, 1:353; *FabriW*, 1:436; without a name, also *FabriE* 1:329 and *FabriW*, 1:406.

28. "[Q]uidam socius armiger et servus comitis," *FabriE*, 2:107; cf. *FabriW*, 2:104. Fabri organizes his list by "societies," subgroups that managed provisions, cooking, and other logistics in common. Breydenbach's society had six members, presumably the same six together on the galley.

29. Walther, *Itinerarium*, 245. It is easiest to believe that he or his print editor simply errs with "Eckhart" in lieu of "Erhard." *Timm*, 53, supposes, however, that there were eight pilgrims in Breydenbach's party: the six listed by Fabri, plus Eckart (who is not Reuwich), and a never-mentioned eighth. Baumann and Baumann, *Mainzer Kräuterbuch-Inkunabeln*, 132–33, amplify this mistake.

30. For some less convincing proposals, Boon, "Utrechtse schilder"; Stange, "Anfänge des Hausbuchmeisters," 382–83.

31. *Fuchs*, 40, concludes that the trunk was made by Cristoforo Canzozzi of Lendinara, who provided intarsia for such patrons as the d'Este in Ferrara. Also, Arens, ed., *Inschriften der Stadt Mainz*, 138.

32. Hotz, "'Hausbuchmeitser' Nikolaus Nievergalt," 113 and 125n108. Hotz was the first to publish excerpts from documents and to make the connection with Erhard Reuwich. For the best recent discussion, Hess, *Meister*, 58–59, 151–53, with further literature. Also, *Fuchs*, 68–69; *Timm*, 292–300. Hess points out that most objections to the attribution of the glass are caught up in the debate over the identification of the Housebook Master with Erhard Reuwich. Scholars do not reject the attribution to Reuwich per se; they reject the attribution to the Master and to Reuwich only by association.

33. Husband, *Luminous Image*, 11.

34. Schneider, "Mainzer Drucker—Drucken in Mainz," 225.

35. For example, Fuchs chose to designate the printer as "(Peter Schöffer für) Erhard Reuwich," in his catalogue. *Fuchs*, 94, also 48–51 for a discussion and earlier literature.

36. Credit for the illustrations of the *Housebook* has been spread over several hands, and the contribution of a workshop and followers has been recognized in the production of paintings in the Housebook Master's style. For a history of the debate, Hutchinson, "Ex Ungue Leonem." Most recently, Husband, *Medieval Housebook*, esp. 53–74; König, "Der Hausbuchmeister / The Housebook Master" vol. 2. For complete literature, Hess, *Meister*; Stange, *Hausbuchmeister*. For the

drypoints, Lehrs, *Geschichte und kritischer Katalog*, vol. 8; Hutchinson, *Master of the Housbook*.

37. Pit, "Gravure dans les Pays-Bas," 494.

38. Gertrud Rudloff-Hille, "Doppelbildnis." Jane Campbell Hutchinson, "Housebook Master," 111–13, has also postulated that the 1505 panels of the *Life of the Virgin* were donated by Berthold von Henneberg.

39. For a lucid expression of this thinking, *Fuchs*, 63–64.

40. Hess, *Meister*, 36; Boon, "Master of the Amsterdam Cabinet," 20–21, also 282–83. Hutchinson, "Ex Ungue Leonem," 59, maintains that Reuwich's "consummate skill in the use of linear perspective" presents "a grave difficulty" to identifying him with the Master.

41. Boon, "Master of the Amsterdam Cabinet," 20–21.

42. Tietze and Tietze-Conrat, "Artist of the 1486 View of Venice"; Tietze and Tietze-Conrat, *Drawings of the Venetian Painters*, 63–65, 141–42, 146, 152–53, 156–57.

43. For example, *Fuchs*, 59.

44. Meyer zur Capellen, *Gentile Bellini*, 174–75.

45. *Timm*, 173–78.

46. Ibid., 120, 121–66, 196–99, 224–26, 257–58, and esp. 310–13.

Chapter 2

1. Gudenus, *Codex diplomaticus*, 2:477, quoting Mainz historian Georg Helwich (d. 1632).

2. Geldner, "Zum ältesten Missaldruck."

3. Eisermann, "Buchdruck und Herrschaftspraxis," esp. 497, 508.

4. Count based on ISTC, accessed 5 October 2009.

5. For the 22 March 1485 edict and 24 March letter to Frankfurt, Pallmann, "Censuredikt." For a reprint and good German translation, Gelhaus, *Streit um Luthers Bibelverdeutschung*, 2:1–6. Legible digital images of the 1 May 1485 Würzburg reprint (ISTC ir00349600) are available under the title "Censorship Edict of the Archbishop of Mainz, Würzburg

(1485)" at Bently and Kretschmer, Primary Sources, with a Latin transcription and partial English translation. For the 4 January 1486 edict, 10 January 1486 letter to the Mainz review board, and 1486 directive to suffragans, Gudenus, *Codex diplomaticus*, 4:469–75.

6. Pallman, "Censuredikt," 240.

7. Ibid., 239.

8. Ibid.

9. Ibid.

10. My summary of the text of the censorship edict is indebted to the cogent analysis of Weinmayer, *Studien*, 165–79, which is echoed in part by Schreiner, "Volkssprache als Element," 491–93. For the phrase "divine art of printing," Eisenstein, *Printing Press*, 1:317.

11. Pallman, "Censuredikt," 239.

12. Ibid., 239.

13. In the American literature, two scholars in particular have debated whether the effects of the introduction of print are driven by essential characteristics of the medium (Elizabeth Eisenstein), or whether they arise from the messy, unstable process of making, circulating, and reading books (Adrian Johns). Eisenstein, *Printing Press*, esp. 1:80–88 for standardization; Johns, *Nature of the Book*, esp. 10–14; Grafton, Eisenstein, and Johns, "How Revolutionary Was the Print Revolution?"

14. Friedemann Kawohl, "Commentary on the Privilege Granted by the Bishop of Würzburg (1479)," in Bently and Kretschmer, Primary Sources.

15. Henneberg's missal: ISTC im00674500, *Missale Moguntinum* (Mainz: Peter Schöffer, 3 April 1493); cf. also GW M24556, GW M24560.

16. For the evidence for this within the text, *Fuchs*, 48.

17. ISTC ib00502100, Berthold von Henneberg, *Decree on the enclosure of women* (Mainz: Peter Schöffer, 14 March 1485).

18. *Fuchs*, 43; Weinmayer, *Studien*, 175–76. This in contrast to *Timm*, 332–36, who argues that Breydenbach reworked his book to support Henneberg's domestic policy agenda as a strategy for making sure the book met approval.

19. *Peregrinatio* Latin, 7r, ll. 40–41; *Peregrinatio* German, 10r, ll. 17–20.

20. "Das buoch ist der frawen zuo gnadenzell wem sy es lyhent, der sol es fürderlich vnnd gelich wider überantworten." Stolz, *Überlinger Inkunabel-Katalog*, 27, L9*. The catalog places the convent in Offenbach, but it was in Offenhausen.

21. Stievermann, "Gründung, Reform und Reformation," 149–50, 168–70.

22. Suriano, *Treatise*, 20.

23. 2r, l. 31, through 2v, l. 12. The Latin (2r, ll. 21–36) reads a bit differently, though the argument is identical. The translation "to mutilate," for example, is inspired by "uniuersi praesumunt · lacerant · docentque antequam discant." Cf. Jerome, *Ep. 53*, in Migne, *Patrologiae latinae*, vol. 22, col. 544. For the dedication's relationship to the edict, *Fuchs*, 42–43; Weinmayer, *Studien*, 176–77.

24. *Peregrinatio* Latin, 7r, l. 43, through 7v, l. 4; *Peregrinatio* German, 10r, ll. 20–22. The phrase "sparing no expense" (*nec ullis parcendo expensis*) occurs only in the Latin, and the "clever and learned" (*ingeniosum et eruditum*) of the Latin is "good" in the German.

25. *FabriE*, 1:347, 353; 2:18; *FabriW*, 1:431, 438, 629; *Fuchs*, 47–48. In the modern editions of Fabri, this name is transcribed "Roth." *Fuchs* (47n505) notes that Fabri's text can be read as "Rath," which better matches the records in Mainz. *Timm* (95) adopts this. Fabri places Roth in Heidelberg, but Fuchs clarifies that he moved to Mainz in 1484.

26. For example, *Davies*, vii; *Fuchs*, 47.

27. For the concept of "author-function," see Foucault, "What Is an Author?," esp. 124–27.

28. Minnis, *Medieval Theory*. For Caxton and Chaucer, Gillespie, *Print Culture*, 10–12ff. For Dante, Ascoli, *Dante*, 38–41.

29. Minnis, *Medieval Theory*, 94–103.

30. Koerner, *Moment of Self-Portraiture*, 215–18; Landau and Parshall, *Renaissance Print*, 247–53, 399n228, for the presumed verdict; Parshall, "Imago Contrafacta," 567–70.

31. *Davies*, ix–xi, began the list of sources, which has been most extensively analyzed in one place by *Timm*, 80–95. This is repackaged as a list in Breydenbach, *Peregrinatio*, ed. Mozer, xxiv–xxvi. Tucher's role has been noted since the nineteenth century, and more recently, Tucher and Herz, *Reise*, xv, 23. On Walther von Guglingen as a source, Walther, *Itinerarium*, 303–4n1; Bosslemann-Cyran, "Vokabular," 153–82.

32. *FabriE*, 327–28; *FabriW*, 1:403–4, where Fabri credits Tucher's description of the Holy Grave.

33. For Wey's chapel, see chapter 4. Breydenbach and Bicken's relief now hangs in the cloister of Mainz Cathedral. The inscription below the frame is taken from Psalm 85:17 of the Vulgate. See *Fuchs*, 40; Solms-Laubach, "Hausbuchmeister," 56.

34. Margaret Smith characterizes the number of editions with just a figural woodcut on the first page as a "small group" and "relatively uncommon." See Smith, *Title-Page*, 78, 48, for her sampling method. This design did find a pocket of popularity in Augsburg in the 1470s. Kiessling, "Anfänge des Titelblattes," 17–18; Duntze, "Titelblatt in Augsburg." For the best overview of the incunabula title page, including illustrated ones, Rautenberg, "Buchtitelblatts in der Inkunabelzeit." However, her statistical analysis of pages with text does not explore the more idiosyncratic frontispiece without text. For example, her excursus (31–32) on Schöffer does not mention the *Gart der Gesundheit*.

35. Schedel, *Liber chronicarum*, Iv.

36. For examples of the *Peregrinatio*'s Candia, Rhodes, and Venice used as the Nuremberg Chronicle's Mainz (partial), Rhodes, and Venice, see Stephen Füssel in Schedel, *Chronicle of the World*, 29–31, 639, 641.

37. Da Lezze, *Historia turchesca*, 120; Luzio, "Disegni," 277. Published under the name of Donado da Lezze, the first source is commonly attributed to Giovanni Maria Angiolello, a Vicenzan who served in the Ottoman imperial retinue after having been captured and enslaved at the 1470 Battle of Negroponte.

38. Schulz, "Barbari's View of Venice," 430, 461–63, 464.

39. Pane, *Tavola Strozzi*, esp. 100–102, 132, 137.

40. Lillie, *Florentine Villas*, 140, 313n50–51 with further literature.

41. Friedman, "Fiorenza," 64–66.

42. For the villa decoration, Schulz, "Pinturicchio," 39–43. For the political program, Sandström, "Decoration," 39.

43. Schulz, "Barbari's View of Venice," 430, for his discussion of Reuwich's view as "unique."

44. For example, Clark, "View from Notre-Dame," esp. 60–66; Krauss, "Photography's Discursive Spaces," esp. 139–41.

45. The German is more precise on this point than the Latin: "Daz aber die rich und / mechtig statt Raguß . . . / . . . uns nit so sychtbar / ist worden daz sy hette mogen eygentlichen ab etworffen durch den ma / ler syn worden · " (4r, l. 32, through 4v, l. 7).

46. "Hec animalia sunt veraciter depicta sicut vidimus in terra sancta · "

47. *Timm*, 123–44 (Venice), 144–48, esp. 145–46 (Parenzo), and 155–60 (Modon).

48. *Timm*, 149–54, esp. 154 (Corfu), and 160–66, esp. 164 (Candia). She postulates a Venetian origin for Reuwich's models for Parenzo, Modon, and Candia, pointing out that these images emphasize the defensive fortifications of cities that were all Venetian dependencies (148, 174–76).

49. *Timm*, 231, also makes this connection.

50. Pilgrims also remark on goats' and sheep's great size, so perhaps the scale of the animals in Reuwich's picture reflects that. Leonardo Frescobaldi, as quoted in Niccolò da Poggibonsi, *Voyage beyond the Seas*, 92n2; Harff, *Pilgrimage*, 110–11; Walther, *Itinerarium*, 232, also quoting Joos van Ghistele.

51. *FabriE*, 2:441; *FabriW*, 2:534.

52. *FabriE*, 2:429; *FabriW*, 2:518–19.

53. *FabriE*, 2:429–30; *FabriW*, 2:519–20.

54. Murray, "Fabri's Pilgrimage," 338.

55. *FabriE*, 3:30–34. Fabri relates the name of the animal as "Seraph."

56. Ibid., 3:31. Also identified in Janson, *Apes and Ape Lore*, 334.

57. Schuster sorted the woodcuts by quality and his knowledge of mansucript models: copies from known manuscript traditions (95); "primitive" designs presumably copied from manuscrips; images that are true to nature but "pressed" without hatching; and images by Reuwich that are true to nature with hatching (65). Schuster, "Secreta Salernitana und Gart der Gesundheit," 218–20. The Baumanns identify 221 woodcuts as copies from a manuscript tradition and 17 as copies from the Codex Berleberg and then sort the rest into those copied from unknown, albeit often very high-quality, manuscripts (about 80) and those drawn from life (about 60). But they identify about 160 as "clearly recognizable," and of those, 74 plants as further "true to nature," such as the lavender illustrated here. Baumann and Baumann, *Mainzer Kräuterbuch-Inkunabeln*, 113, 117, 127–28, 130, 142, 324. For full literature on the *Gart*, Keil, "Gart der Gesundheit," cols. 1091–92.

58. Count from ISTC compared to GW, accessed 3 August 2012; Keil, "Gart der Gesundheit," col. 1081–90, esp. 1082–83.

59. Keil, "Gart der Gesundheit," cols. 1077–79. Macer is the pseudonym of the twelfth-century compiler of an herbal in Latin verse, which was translated into German prose as the text known today as *Älterer Deutscher Macer*.

60. Müller-Jahncke, "Deßhalben ich solichs angefangen werck," 1667; updated in Dressendörfer, Keil, and Müller-Jahncke, *Älterer deutscher "Macer,"* 80–81. Cf. Baumann and Baumann, *Mainzer Kräuterbuch-Inkunabeln*, 113, 122–27.

61. Keil, "Gart der Gesundheit," col. 1079; Schuster, "Secreta Salernitana und Gart der Gesundheit," 229.

62. Dressendörfer, Keil, and Müller-Jahncke, *Älterer deutscher "Macer,"* 35–37, 72–74; Keil, "Textual Transmission," 18, 23–24.

63. Cube, ed., *Gart der Gesundheit*, 2v, ll. 16–38. See Appendix. Or: "so that [through] my journey salvation would come not only to my soul, rather the whole world might come to [the] city. . . ."

64. For example, Schöffer could have started producing illustrations before Breydenbach's return. Keil, "Gart der Gesundheit," col. 1075. The drawings could have been lost. Dressendörfer, Keil, and Müller-Jahncke, *Älterer deutscher "Macer,"* 81–82. New drawings were only created in the absence of manuscript models. Baumann and Baumann, *Mainzer Kräuterbuch-Inkunabeln*, 129. The Baumanns err in their analysis of the documentation of Breydenbach's pilgrimage; see chapter 1.

65. For an elegant interpretation of this reference, Wood, *Forgery, Replica, Fiction*, 168–71.

66. Durling, "Ascent," 9–11, elucidates the juxtaposition between the corporeal and incorporeal ascent.

67. Francesco Petrarca, *Le familiari* [*Familiarium rerum libri*], vol. 1, Liber IV, 1, 153–61. Translation from Francesco Petrarca, "Ascent of Mount Ventoux," 44.

68. An observation inspired by the opening to "Petrarch's Pocket," chap. 3 of Gill, *Augustine in the Italian Renaissance*, 94–95.

69. Durling, "Ascent," 25–26n3.

70. For example, Greenblatt, *Renaissance Self-Fashioning*; Martin, "Inventing Sincerity."

71. Petrarca, *Le familiari*, IV, 1, 159. Durling, "Ascent," 16–17, points out that with this passage Petrarch himself introduces the suggestion that the text may be fiction.

72. Important foundations for this view were laid by Courcelle, "Pétrarque entre Saint Augustine et les Augustins," and Giuseppe Billanovich, "Petrarca e il Ventoso." For further literature, see Constable, "Petrarch and Monasticism," 96n199.

73. Similar interpretations are common since at least De Tolnay, *Le Maître de Flémalle*, 29. For fore- versus background and the alignment of the hand, Purtle, *Marian Paintings*, 82–83. Christ's hand was originally drawn differently. Asperen de Boer and Faries, "*Vierge au Chancellier Rolin.*" Many scholars attribute the change to the patron; for example, Belting and Kruse, *Erfindung des Gemäldes*, 160. But Van Eyck also had agency here.

74. For an elegant description of this phenomenon, Koerner, *Caspar David Friedrich*, 162–63.

75. Wood, *Forgery, Replica, Fiction*, 244.

76. Ibid., 51–53.

Chapter 3

1. 2v, ll. 42–43; 7r, ll. 12–16; 10r, ll. 17–20 (pilgrimage); 57r, ll. 30–32 (preaching); 10v, ll. 9–13; 80v, ll. 34, to 81r, ll. 11 (inspire love and crusade); 120r, l. 18, through 125r, l. 39 (spur leaders to crusade); 5r, ll. 9–10; 81r, ll. 23–26; 113v, ll. 11–14 (prophylactic against heresy).

2. Meserve, "News from Negroponte," esp. 463–65, where she describes ISTC ic00912000, Antonio Cornazzano's vernacular *Life of Christ* and appeal for action against the Turks paired with his Latin *carmen heroicum* in praise of Venice, a publication that harmonizes with the flow and tropes of the *Peregrinatio*; and 472, where she describes how the "Turkish problem . . . occupied Italians of every social station" through different forms of address; Helmrath, "German *Reichstage* and the Crusade." Also, Meserve, *Empires of Islam*; Bisaha, *Creating East and West*.

3. Setton, *Papacy and the Levant*, 2:388, 391.

4. Ibid., 2:398–99.

5. Lunt, *Papal Revenues*, 1:71–77, 2:82–91, 94–100, 111–13, 129–30, 131–33.

6. ISTC ir00349190, ISTC ir00349200, ISTC ir00349210, ISTC ir00349230, ISTC ir00349260, ISTC ir00349270, ISTC ir00349280; Falk Eisermann, "Buchdruck und Herrschaftspraxis," 499, 504, 506.

7. For the politics of the embassy, Seyboth, "Königserhebung," esp. 50–51.

8. Weiss, *Berthold von Henneberg*, 11.

9. Bauermeister, "Berthold von Henneberg," esp. 610, 614–15.

10. *Timm*, 336–51, argues that the *Peregrinatio*'s call for crusade was meant to promote the archbishop's domestic reform agenda. Effective action requires political unity, and such a threat from outside should compel the internal organization and

cooperation Henneberg pursued. If so, then it is ironic that papal taxes would be the foreign enemy to unite German clergy *against* crusade (or its funding). Henneberg's strategy often called for resisting the emperor, as may be the case with the Turks tithe, in order to gain leverage in advocating a greater role for the estates in the administration of the realm. The Frankfurt Reichstag contemporaneous with the *Peregrinatio*'s publication exemplifies this. The emperor's desire for military monies provided an opening for Henneberg and the other imperial princes to negotiate for items on their own agenda. The *Peregrinatio* supports conventional ideological aspirations without going against Henneberg in any way, but it does not facilitate his realpolitik. For the politics of 1486, Schröcker, "Unio atque concordia," 13–38; Seyboth, "Reichstage," esp. 523.

11. Paulus, *Geschichte des Ablasses*, 3:166–88; Setton, *Papacy and the Levant*, 2:158–60 for printing's role.

12. ISTC ic00422400; ISTC ic00422600; ISTC it00503500, "Eyn manūg d'cristēheit widd' die durkē"; Eisermann, "'Hinter Decken versteckt'"; Simon, "*Türkenkalender*," 5–23; Eisenstein, *Printing Press*, 178.

13. Lehmann-Haupt, *Peter Schöffer*, 61.

14. Eisenstein, *Printing Press*, 59–60, 178, 368, 375; Stallybrass, "'Little Jobs,'" 315–20.

15. Paulus, "Raimund Peraudi als Ablaßkommissar," 648–52; Paulus, *Geschichte des Ablasses*, 3:178–79, 323.

16. ISTC is0053860.

17. For example, the following bulls issued by Sixtus IV and printed by Schöffer: ISTC is00552000, 4 May 1480, extending an indulgence for defeating the Turks at Rhodes; ISTC is00552720, 1 September 1480, suspending all other indulgences in favor of renewing an indulgence to support the Hospitallers on Rhodes; ISTC is00553450, 4 December 1480, calling for driving back the Turks. Also, the letter to the papal indulgence commissioner in northern Europe, clarifying that the indulgence for defeating the Turks was still valid where it had already begun to be preached, 25 July 1482 (ISTC is00537780 and ISTC is00537781) and a related summarium (ISTC is00583700). See Paulus, *Geschichte des Ablasses*, 3:173–77.

18. Paulus, "Raimund Peraudi," 657; Paulus, *Geschichte des Ablasses*, 3:179.

19. Count based on ISTC and GW, accessed 15 August, 2012.

20. Paulus, *Geschichte des Ablasses*, 3:178–81, 323–29; Eisermann, "Indulgence as a Media Event," 326–28. The latter is a revised version of Eisermann, "Ablaß als Medienereignis."

21. Paulus, "Raimund Peraudi," 651–52; Paulus, *Geschichte des Ablasses*, 3:323–29. Instructions printed by Schöffer circa 1487 and 1489–90: ISTC ip00261100, ISTC ip00261075, ISTC ip00261050.

22. Eisermann, "Indulgence as a Media Event."

23. Röpcke, "Geld und Gewissen"; Vogtherr, "Peraudi als Ablassprediger"; Housley, "Indulgences for Crusading," 289–99.

24. "O chrestiens tant ieunes comme vieulx / Roys our bards / princes / marchās / bourgeois / . . . / Suyure la croix pour avoir paradis." Breydenbach, *Le grant voyage*, between p4 and q1.

25. Breydenbach, *Život Mohamedùv* and *Traktát o zemi svaté*. These have a single ISTC number, but they are two editions with separate introductory woodcuts and colophons.

26. Frankfurt, Universitätsbibliothek Johann Christian Senckenberg, Inc., fol. 132a on fol. 180r: "Ein Jungfrau auß der Dürrkeÿ / Quomodo turci veniunt / Ergo fuit igitur." As quoted in Breydenbach, *Peregrinatio*, ed. Mozer, xxxvii.

27. Solms-Laubach, "Hausbuchmeister," 83. Boon calls her "Lady Venice" in "Master of the Amsterdam Cabinet," 20. In Filedt Kok's catalog of the same volume, she is a "richly clad Venetian lady" (282).

28. Walther, *Itinerarium*, 51; *FabriE*, 3:433; Röhricht and Meisner, *Deutsche Pilgerreisen*, 171. For another example, Casola, *Viaggio a Gerusalemme*, 100–102. For visual evidence about costume, Newton, *Dress of the Venetians*, 47–55.

29. Two examples from the 1480s: the personification of Venice on the frontispiece in Vittore Cappello,

Oratio panegyrica ad Agostino Barbarigo, 4 May 1486, London, British Library, Add. ms. 21463, fol. 1r; *Timm*, 469, fig. 36.

30. For example, Kubinski, "Orientalizing Costume."

31. For Schongauer, Winzinger, *Zeichnungen*, 49–55, 87–91, 94–95, figs. 15–21, 53–54, 57–60, 68–70.

32. *Peregrinatio* German, 14r, l. 24, through 16v; *Peregrinatio* Latin, 10v, l. 36, through 12v.

33. Meserve, "News from Negroponte," esp. 463–65; Brown, *Venice and Antiquity*, 99–103, 163–64, and esp. 173–74 for a later description of Venice as "seawall of Christianity."

34. Gregory I, *Liber regulae pastoralis*, in Migne, *Patrologiae latinae*, vol. 77, col. 31. The roses on the left of the arbor are polysemous. Rose arbors are often associated with the Virgin in Rhenish art of this era, for example, Martin Schongauer's *Virgin of the Rose Bower* from 1473 in the Dominican church in Colmar. But they also have associations with martyrdom and the blood of Christ, and together with the red and juicy pomegranates, they could suggest Christian blood spilled for the faith. At the very center of the arbor, a bird attacking another bird injects a note of conflict consonant with that theme.

35. *Timm*, 171, 273–75, esp. 274. *Fuchs*, 58, attributes the damage to an earthquake.

36. 57r, ll. 22–23: "A short description of the holy land and all the places, especially those identified in the picture that follows at the end" (Eyn kurze beschreibung deß heyligen landes vnd aller stett yn sun- / derheyt die ym gemeld zů letzst nach volgend werden bezeychet ·); 57r, ll. 28–29: "In addition, this description is arranged in order to better elucidate the picture that comes after this" (dar zů besser erluterũg zů geben des ge- / melds hie nach gende · ist dise beschribung geordnet worden ·); *Peregrinatio* Latin, 49v, l. 43: "following picture" (sequens pictura ·). The Latin and the phrase "that comes after this" clarify the other phrase, "follows at the end [of this description]." Cf. Breydenbach, *Peregrinatio*, ed. Mozer, 183, which seems to misread "gemeld" (picture).

37. *Fuchs*, 43; *Timm*, 350.

38. A recent survey of medieval pilgrimage treats Latin pilgrims' response to Eastern Christians at this place: "The Church of the Holy Sepulcher: The Christian World in Miniature," chap. 7 of Chareyron, *Pilgrims to Jerusalem*, 91–101.

39. Suriano, *Treatise*, 19–20. For the original Italian, Suriano, *Trattato di Terra Santa e dell'Oriente*.

40. Suriano, *Treatise*, 52–76.

41. Ibid., 77–100.

42. Tucher and Herz, *Reise*, 340, ll. 8–14; 390, l. 12, through 391, l. 1.

43. Ibid., 391, ll. 4–8.

44. Ibid., 392, ll. 5–11.

45. Ibid., 404, l. 14, though 405, l. 2.

46. Haussherr, "Pfarrkind," 204. His analysis focuses largely on what the passage omits.

47. Tucher and Herz, *Reise*, 405–10.

48. *FabriE*, 1:281–82; *FabriW*, 1:340–42.

49. For an overview of Venetian costume books, see Mack, *Bazaar to Piazza*, 168–70.

50. Breydenbach, "Reiseinstruction," 142.

51. Deutsches Historisches Museums, Gr 92/1.

52. Tuğlaci, *Mehterhane'den Bando'ya*, 2–6, 33–48.

53. Gilsenbach, *Weltchronik der Zigeuner*, 1:103–4.

54. *Peregrinatio* German, 29r, ll. 10–15. *Peregrinatio* Latin varies, comparing the people to Ethiopians and naming their counterparts in Western Europe as Saracens, 25r, ll. 8–14. Also, Breydenbach, "Reiseinstruction," 135.

55. Mack, *Bazaar to Piazza*, 156–67; Raby, *Venice, Dürer*; Campbell and Chong, *Bellini and the East*; Carboni, *Venise et l'Orient*.

56. Meyer zur Capellen, *Gentile Bellini*, 94–96; *Timm*, 311–12.

57. Raby, *Venice, Dürer*, 41–53, 60–63. Also, Marshall, "Carpaccio," 610n5, for further literature that argues against such a journey. See also chapter 5, which establishes that the *Peregrinatio*'s *View of Jerusalem* must have been put together after the date proposed for Bellini's visit.

58. Raby, *Venice, Dürer*, 41–43, refuting Tietze and Tietze-Conrat, *Drawings of the Venetian Painters*,

63–65, 141–42, 146, 152–53, 156–57, and thereby also implicitly arguing against elements of *Timm*, esp. 173–78. Also, Carboni, *Venise et l'Orient*, 313–14, cat. 52.

59. Carpaccio's borrowings from the *Peregrinatio* have been recognized since the nineteenth century, for example: Molmenti and Ludvig, *Life and Works of Carpaccio*; Lauts, *Carpaccio*; Zampetti, "L'Oriente del Carpaccio"; Raby, *Venice, Dürer*, 66–69, esp. for male Saracen; Humfrey, *Carpaccio*, 98–99, 110; Colvin, "Zeichnungen des Carpaccio"; Marshall, "Carpaccio."

60. Forschungsbibliothek Gotha, Chart. A 541, fol. 93v.

61. *Fuchs*, 38, speculated that Ugelheimer would have been interested in the *Peregrinatio* project and would have shown the pilgrims his library; *Timm*, 309, also suggests the library would have been influential, but does not consider the known volumes.

62. Armstrong, "Hand-Illumination," 43–44, also 190–205 (cat. nos. 96–101).

63. For a complete list, Armstrong, "Il maestro di Pico," 20n53; supplemented by Armstrong, "Hand-Illumination," 47n53.

64. "Zu Venedigenn gut herberge zur fleytten, aber by madonna margaretha, so is sust keyne herberge, do selbst einer hatte dann sunder kentzschafft. Im kauffhusse aiber by Peter Igelnheimer vonn Franckfort." Breydenbach, "Reiseinstruction," 127. The inn recommended here was where Fabri's party stayed, and he names Margareta as one of the hoteliers. *FabriE*, 1:83; *FabriW*, 1:79.

65. For the account book, Uhlhorn, "Geschichte," 109–10.

66. ISTC id00022000, Dante Alighieri, *La Commedia* (Foligno: Johann Neumeister with Evangelista [Angelini?], 11 April 1472).

67. For the lintel as a source for Reuwich, White, *Peter Schoeffer*, 69. For the lintel, Prawer, "Lintels of the Holy Sepulcher." *Timm*, 119–20, sees their origin in Venetian illumination generally.

68. Armstrong, *Renaissance Miniature Painters*.

69. *FabriE*, 1:344; cf. *FabriW*, 1:427.

70. *Davies*, 3; Solms-Laubach, "Hausbuchmeister, 83; *Fuchs*, 52; Boon, "Master of the Amsterdam Cabinet," 20. Alfred Stange calls them putti without comment in "Anfänge des Hausbuchmeisters," 382. *Timm*, 116–17, identifies them as putti.

71. Vienna, Kunsthistorisches Museum, inv. 939, 943, 994; De Vos, *Hans Memling*, 212–16.

72. Ethan Matt Kavaler brought my attention to this connection.

73. For literature on the development of early frontispieces, see chapter 2.

74. Armstrong, "Hand-Illumination," 44, 192, 194, 200, 204–5.

75. Hobson, *Humanists and Bookbinders*, 51; Armstrong, "Hand-Illumination," 43, 190.

76. Jensen, *Last Will and Testament*, 8.

77. For a closer analysis, Wood, *Forgery, Replica, Fiction*, 287–89.

78. Hobson, *Humanists and Bookbinders*, 38–41, 51–57. Also, Mack, *Bazaar to Piazza*, 130–31; Grube, "La 'laque' vénitien et la reliure au XVIè siècle," 238.

79. Armstrong, "Hand-Illumination," 205.

80. Carboni, *Venice and the Orient*, 331–32, cat. 118; Morrison, "Note."

81. Rautenberg, "Buchtitelblatts in der Inkunabelzeit," 73–84.

82. Schmitt, "Aristotelianism," 109–10. For the sixteenth century, Schmitt, "Renaissance Averroism."

83. These include titles by Petrus de Abano and Aristotle with commentary by Averroës and others, and major works of law by Justinian, Gratian, Pope Gregory IX, and Pope Innocent IV. For Jenson and the university market, especially for legal texts, see Lowry, *Nicholas Jenson*, 137–72.

84. Barry, "Giorgione et les Maures," 164, 168; cf. Armstrong, "Hand-Illumination," 205.

85. Baumann and Baumann, *Mainzer Kräuterbuch-Inkunabeln*, 116, identify the nightshade and pronounce this Aristotle according to "prevailing opinion." It is unclear whose opinion they mean, as, for example, *Fuchs* (62) remains agnostic.

86. An example from the southern Netherlands, c. 1450–75, with a seated Aristotle flanked by two

others: Pseudo-Aristotle, *Le Livre des problèmes*,
The Hague, Koninklijke Bibliotheek, MS 133A31,
fol. 1r.

87. Barry, "Giorgione et les Maures," 168–69.

88. The extensive literature is summarized by Ferino-Pagden and Nepi Scirè, *Giorgione: Myth and Enigma*, 179–82. More recently, Barry, "Giorgione et les Maures," 161–68; Brown and Ferino-Pagden, eds., *Bellini, Giorgione, Titian*, 164–66. For the role of light and Plato, Meller, "I tre filosofi di Giorgione." For the three ages of man, Wilde, "Röntgenaufnahmen."

89. Ferriguto, *Attraverso i "misteri" di Giorgione*, 64–65.

90. Spinale, "Portrait Medals," esp. 1–43; Raby, "Mehmed the Conqueror's Greek Scriptorium," 18–19, 28.

91. Spinale, "Portrait Medals," 278–309. See also Bisaha, *Creating East and West*, 78–93.

92. Campbell and Chong, *Bellini and the East*, 72–77, condenses the findings of Spinale, "Portrait Medals," esp. 111–77; Raby, "Pride and Prejudice."

93. *Peregrinatio* [Spanish]; for sources for the additional prints, Pedro Tena Tena, "Martin Schongauer."

Chapter 4

1. For this entire passage, *FabriE*, 1:306–8; *FabriW*, 1:374–77. For another reading of this episode, Higgins, "Defining the Earth's Center," 38–39. For an assessment of pilgrims' geographical knowledge using Fabri as example, Delano-Smith, "Intelligent Pilgrim."

2. For an overview of *mappae mundi*, Woodward, "Medieval *Mappaemundi*." For portolan charts, Campbell, "Portolan Charts."

3. ISTC ic00760000, Christophorus Columbus, *Epistola de insulis nuper inventis* (Basel: Michael Furter or Jakob Wolff for Johann Bergmann, after 29 April 1493), fols. 1v and 4r. Reprinted in ISTC iv00125000, illustrated here. First noted by *Davies*, xxix; Deák, "New World Depicted."

4. Snyder, *Flattening the Earth*, 43–49.

5. For this problem in religious history, Van Engen, "Multiple Options."

6. Gautier Dalché, "Reception of Ptolemy's *Geography*," 285–87; updated in Gautier Dalché, *La Géographie de Ptolémée*, 7–11.

7. Monmonier, *Rhumb Lines and Map Wars*.

8. For *Geography* in the Middle Ages and its arrival in Florence, Gautier Dalché, "Reception of Ptolemy's *Geography*," 287–99; Gautier Dalché, *Géographie de Ptolémée*, 87–159.

9. Gautier Dalché, "Pour une histoire du regard géographique," esp. 89–98. For Gautier Dalché, this process brought about a "modern" awareness of the difficult relationship between reality and representation. He proposes (100–101) that its roots may lie further in the past. Also, Edson, *World Map, 1300–1492*, 114–40, esp. 132; Gautier Dalché, *Géographie de Ptolémée*, 195–98.

10. Gautier Dalché, "Reception of Ptolemy's *Geography*," 314–17; Dalché, *Géographie de Ptolémée*, 192–207, esp. 203–7.

11. Cattaneo, *Fra Mauro's Mappa Mundi*, 19–20, 38–46; Marcon, "Leonardo Bellini and Fra Mauro's World Map," 144–45.

12. Angelo Cattaneo established the priority of the extant Venetian map in "Fra Mauro," 29–30, 27 for Piero de Medici; Cattaneo, *Fra Mauro's Mappa Mundi*, 48–64.

13. For the text of Fra Mauro's map and its sources, Falchetta, *Fra Mauro's World Map*. Also, Cattaneo, "Fra Mauro," 14–48; Dalché, "Pour une histoire du regard géographique," 95–97; Iwanczak, "Entre l'espace Ptolémaïque et l'empire."

14. *FabriE*, 1:106; *FabriW*, 1:110. Falchetta, *Fra Mauro's World Map*, 24, confirms this is the map Fabri saw and says "a call to see the world map must have been standard practice among visitors to Venice."

15. For San Michele, Goy, *Building Renaissance Venice*, esp. 151–59.

16. Pon, "Document for Titian's *St. Roch*."

17. Ptolemy thought the Indian Ocean was a closed sea, so fifteenth-century maps often connect Africa

and Asia beneath it. Woodward, "Medieval *Map-paemundi*," 358; Campbell, *Earliest Printed Maps*, 23–26, fig. 41.

18. For more detailed analysis of the iconography of death, divine versus terrestrial vision, and the Wheel of Fortune, Kline, *Maps of Medieval Thought*, esp. 8–83; Edson, *Mapping Time and Space*; Kupfer, "Mappaemundi: Image, Artefact, Social Practice." For the content of the map, Westrem, *Hereford Map*.

19. For example, the Cloisters Apocalypse, made in Normandy circa 1330, Cloisters Collection 68.714, fol. 35v, where the globe is a T-in-O. Also, Trinity Apocalypse, made in England circa 1255–60, Cambridge, Trinity College R.16.2, fol. 25r.

20. Bailey, "*Mappa Mundi* Triptych." Updated: Bailey, "Discovery of the Lost Mappamundi Panel," esp. 88–89 for a summary of scholars' positions.

21. For its placement near the tomb, Terkla, "Original Placement of the Hereford *Mappa Mundi*." For the argument against its use as an altarpiece, Kupfer, "Medieval World Maps," 273–76; Kline, *Maps of Medieval Thought*, 78–81; Westrem, *Hereford Map*, xx. For its use as instructional aid, Terkla, "Informal Catechesis." Kupfer explains it in a context where the floor and the nave of the church represent the terrestrial realm and the choir and high altar the celestial realm.

22. For the whole inventory, Wey, *Itineraries of William Wey, Fellow of Eton College*, xxviii–xxx.

23. Sheingorn, *Easter Sepulchre in England*, 26–32, 43 for Wey's chapel and Easter rites.

24. For the relationship to Burchard's map, Röhricht, "Die Palästinakarte des William Wey," 191.

25. Woodward, Medieval *Mappaemundi*, 340–42; Baumgärtner, "Die Wahrnehmung Jerusalems auf Mittelalterlichen Weltkarten," 294–310; Brincken, "Jerusalem on Medieval Mappaemundi." For the outlines of an analogous history in texts, see also Higgins, "Defining the Earth's Center."

26. Different recensions of the map include different selections of toponyms and toponyms from other texts. Röhricht, "Marino Sanudo," esp. 109–10;

Röhricht, "Die Palästinakarte Bernhard von Breitenbach's," esp. 132; Röhricht, "Die Palästinakarte des William Wey"; Röhricht, "Karten und Pläne zur Palästinakunde," 8–11. For the letter, Burchard of Mount Sion, "Descriptio Terrae Sanctae," in Laurent, *Peregrinatores*, 10–11. Also Nebenzahl, *Maps of the Holy Land*, 43; Harvey, "Biblical Content"; Edson, "Reviving the Crusade," 145.

27. For the relationship to the *Rudimentum novitiorum*, Herkenhoff, *Darstellung außereuropäischer Welten*, 193–94; cf. *Timm*, 88–90.

28. 57r, ll. 22–23, 28–29, as discussed in chapter 3.

29. For example, on Marino Sanudo's map and those based on it (see below), the coast of the Mediterranean extends north only as far as Sidon. The Reuwich map adds an annotation there, "Sidon, city once great but today desolate" (*Sidon civitas olim maxima sed hodie desolata*), and then proceeds further to Beirut and Tripoli. The corresponding passage of the *Descriptio* reads, "sydon urbs olim ma- / gna phenicis · cuius magnitudinem adhuc ruine eius testantur" ("Sidon, once a great Phoenician city, whose ruins still attest to its great size"). *Peregrinatio* Latin, 51v, ll. 42–43. The sites directly above Sidon in the *Peregrinatio* map, including where Saint George slew the dragon (*Locus ubi Sanctus Georgius occidit draconem*), are also additions from the text. *Peregrinatio* Latin, 55v, ll. 23–24.

30. Melion, "Ad ductum itineris." For Burchard as a source, Broecke, *Ortelius Atlas Maps*, Ort170.8, 173.3, 174.10.

31. For the manuscript recensions and their circulation, Degenhart and Schmitt, "Marino Sanudo und Paolino Veneto," 3–20; Edson, "Reviving the Crusade."

32. For a catalogue of illustrated copies, Degenhart and Schmitt, "Marino Sanudo," 21–24, 105, and 16n17 for the text of Sanudo's testament. Also, Edson, "Reviving the Crusade," 151–52.

33. Sanudo Torsello, *Liber secretorum fidelium crucis*, 246, ll. 22–27.

34. Berggren and Jones, introduction to *Ptolemy's "Geography*," esp. 17–30.

35. Gautier Dalché, "L'œuvre géographique du cardinal Fillastre," 340–42.

36. *FabriE*, 1:307; *FabriW*, 1:376.

37. Böninger, *Deutsche Einwanderung*, 334–42; Dalché, *Géographie de Ptolémée*, 219–21.

38. Böninger, *Deutsche Einwanderung*, 332–34.

39. ISTC il00158000, Leonardus de Utino, *Sermones aurei de sanctis* (Ulm: Johann Zainer the Elder, 1475), Munich, Bayersiche Staatsbibliothek, 2 Inc.c.a. 421, fol. 2, 18. Handwritten notations name Fabri as the author of the index. ISTC il00146000, Leonardus de Utino, *Sermones quadragesimales de legibus* (Ulm: Johann Zainer the Elder, 1478): the text credits Fabri with the index and dedication. See Amelung, *Frühdruck*, 19–21, 89–90, 102.

40. ISTC ib00716000, ISTC ib00720000; Amelung, *Frühdruck*, 76–79.

41. ISTC ib00730000; Böninger, *Deutsche Einwanderung*, 325, citing a 1480 document that Donnus Nicolaus's estate owed Arigo money for the work.

42. Following Amelung, *Frühdruck*, 18, ISTC gives a date of about 1476, while GW dates it to "circa 1473, in fact 1476." Böninger, *Deutsche Einwanderung*, 325, suggests a new date of 1478.

43. Böninger, *Deutsche Einwanderung*, 325–48; Gautier Dalché, *Géographie de Ptolémée*, 245–46.

44. Beinecke Library, Yale University, *Map of the World of Christopher Columbus*, Art Storage 1980.57.

45. ISTC ip01084000, Ptolemaeus, *Cosmographia*. For Holle's career as a printer, Amelung, *Frühdruck*, 261–304, esp. 279–87 for *Geography*; Tedeschi, "Publish and Perish."

46. ISTC ip01085000, Ptolemaeus, *Cosmographia*. Amelung, *Frühdruck*, 269–71, for Holle's bankruptcy, 307–11, for Justus de Albano, 329–31, for the *Geography*.

47. Hoogvliet, "Medieval Texts," 9.

48. Fol. Ib, "in qua tabula sit posita mater nostra videlicet Ierusalem. . . . Primo quod auctor non intendit ostendere qualis nunc sit status religionis christiane : sed qualis fuerit : vt dolentes catholici : de suo damno penitentiam agentes : providere studeant : &que per victorias martirum & sanctimonialium : confessorum conquaesita erant his diebus perdita recuperare procurent."

49. For a register and description of the recensions of Germanus manuscripts, their contents, and variations, Babicz, "Donnus Nicolaus Germanus," 9–21.

50. For these manuscripts, Scaglia, "Archaeological Plan of Rome," 137–41, esp. note 4 for earlier bibliography; Ptolemaeus, *Géographie de Ptolémée*.

51. Marshall, "Carpaccio," 616–17.

52. One pilgrim who likely knew portolans was Joos van Ghistele, who encountered Breydenbach in Alexandria. He describes *Lesturjon* and *Desturion* or *Exturion* as a branch of the Nile and *Labrule* as a port near Rosetta. Zeebout, *Tvoyage*, 210, 213, 272. William Wey provides two gazetteers that include several Nile portolan toponyms also on the *Peregrinatio* map: *Vruth, Shericon, Damiata, Frascuri, Summit*. Wey, *Itineraries of William Wey, Fellow of Eton College*, 131–34, 137–38. On the *Peregrinatio* map, *frasturi* appears up the Nile from *summti*. These two likely came from portolans, but do not turn up on extant maps.

53. The role of the compass and method of compilation is debated. See Campbell, "Portolan Charts," 384–85, 387–88. For a subsequent study supporting the use of the compass and dead reckoning, Mesenberg, *Kartographie im Mittelalter*.

54. This is very clearly seen, for example, in the maps of the Cornado Atlas (British Library, Egerton ms. 73) from circa 1489.

55. For Vesconte's toponyms, Kamal, *Monumenta Cartographica*, 1471. The consistency between Vesconte's charts from the 1320s and the Abenzara portolan (figure 69) demonstrates the stability of the genre.

56. For Prester John in the fifteenth century, Knefelkamp, *Suche nach dem Reich des Priesterkönigs Johannes*, 87–121. For the history of the legend, Beckingham and Hamilton, *Prester John*. For Western reception of Ethiopia in this period, Cerulli, *Etiopi in Palestina*, 1:214–351.

57. Weill, *Presqu'île du Sinai*, 282–83.

58. *FabriE*, 2:539–42; *FabriW*, 2:665–70. Breydenbach mentions El Tur at 142v, ll. 25–28; 145v, l. 13; 146r,

ll. 4–9. For the death and entombment of Muhammad at Mecca, 84v, ll. 37–42.

59. *Suachym, Choos,* and *via ducens ad Ethiopiam* appear in Wey's gazetteers, *Itineraries of William Wey, Fellow of Eton College,* 131–33, 137–38. Joos van Ghistele was the rare pilgrim who traveled in search of Prester John. After El Tur, he sailed to Quseir, Suakin, and then Aden, where the local potentate forbade his continuing. Zeebout, *Tvoyage,* 252–54.

60. For portolans through 1439 with toponyms at the Red Sea, Kamal, *Monumenta Cartographica,* 1138, 1197, 1206, 1222, 1247–48, 1285, 1303, 1322, 1331, 1334, 1369, 1396, 1453, 1457, 1464, 1469–71, 1491.

61. For example, Kamal, *Monumenta Cartographica,* 1197, 1303, 1369, 1396, 1464. Cos can appear without Aidhab (1222, 1285, 1322, 1331, 1334, 1457) and vice versa (1138, 1206, 1247).

62. Bloss, "Story of Suakin," 279–85; Murray, "'Aidhab," 235–37; Couyat, "Routes d'Aidhab," 135–43. For itineraries to Ethiopia over these routes, Crawford, *Ethiopian Itineraries.*

63. Suakin does not appear in the examples in Kamal's *Monumenta Cartographica,* the Beinecke Library, the British Library, or the Österreichische Nationalbibliothek. Many of the remaining portolans were produced by the same cartographers as those, and most do not depict the Red Sea at all. For a catalog, Campbell, "Portolan Charts." For Abenzara, Dürst, *Seekarte.*

64. Breydenbach reports that the pilgrims saw eighteen places on the trip, if each church that houses multiple sacred spots is counted as a single place (53r, l. 23, through 54v, l. 19). Of these, Reuwich's map depicts nine: (1) *Monasterium · ad Sanctum Sabba dicitur ubi quondam · plurimi fuerunt monachi · ,* (2) *Bethleem,* (3) *locus vbi reapparuit stella magis,* (4) *Sepulchrum Rachelis · ,* (5) *locus vbi angelus Christo nato ait ad pastores Annuntio vobis etc.,* (6) *hic lignum illud creuit vnde crux Christi sumpta fuit,* (7) *hic quondam fuit domus zacharie,* (8) *Circa istum fontem maria salutauit elizabeth · ,* (9) *Mons in quo david goliam · funda et lapide prostrauit.* Of these nine, three are exclusive to the pilgrims'

itinerary and do not also appear in Burchard's text: 1, 3, and 6 (72r, l. 33, through 73r, l. 24).

65. *FabriE,* 1:2:20; *FabriW,* 1:631.

66. *De ista civitate itur ad sanctam katherinam · per desertum magnum et vastam solitudinem et venitur ut communiter illac spacio dierum x · cum labore magno.*

67. *Via per quam peregrini christiani redeundo de monte Synai · xii dierum interuallo · veniuntur in ciuitatem chayrum.*

68. *Per hanc viam itur ex gazera versus Chayrum per loca supra posita · que sunt oppida parua · et est tota via ista arenosa · .*

69. Murray, "Fabri's Pilgrimage," 335–42.

70. *Via · per quam filÿ Israhel venerunt de monte synaÿ in terram promissionis*

71. *Saraceni de longinquis partibus · peregrinatum ituri ad Mecham · primum veniunt In ciuitatem famosissimam Chayrum et Inde per viam istam longam et arenosam xxxviii dierum spacio perueniunt In Mecham ad suum pseudoprophetam.*

72. *FabriE,* 2:542; cf. *FabriW,* 2:670.

73. Murray, "Fabri's Pilgrimage," 338–39; *FabriE,* 2:434.

74. The three Memling works discussed here and the *Passion Altarpiece* in Lübeck, Sankt-Annen Museum, are often grouped as his *Simultanbilder.* Kluckert, "Methode der Erzählform," 150–51; Kluckert, "Simultanbilder"; Smeyers, "*Analecta Memlingiana,*" 176–94.

75. Scholars have not yet brought the woodcut into the Memling discussion. For the woodcut, Jammes and Saffrey, "Image xylographique." The most compelling painted example from Cologne is the *Calvary of the Wasservass Family,* circa 1420–30, in the Wallraf-Richartz-Museum. For the influence of Cologne on Memling, for example, Kluckert, "Simultanbilder," 288; De Vos, *Hans Memling,* 288; and Lane, *Hans Memling,* 53–59.

76. The Memling *Simultanbilder* have been extensively analyzed as "aids to spiritual pilgrimage," for example, Lane, *Hans Memling,* 147–73, with further literature.

77. For this work, Lane, *Hans Memling,* 164–69, 249, and 266, cat. 13 with recent literature; De Vos,

Hans Memling, 296–303, cat. 83 with further literature.

78. For this painting, Lane, *Hans Memling*, 155–62 and 291, cat. 45 with recent literature; De Vos, *Hans Memling*, 173–79, cat. 38 with further literature.

79. Gibson, "*Mirror of the Earth*."

80. For Van Eyck, chapter 2. For Rogier, Acres, "Luke, Rolin, and Seeing Relationships"; Acres, "Columba Altarpiece."

81. *FabriE*, 2:461, 463, 466; *FabriW*, 2:569, 571–72.

82. *FabriE*, 2:468; *FabriW*, 2:573.

83. *FabriE*, 2:469; *FabriW*, 2:574.

84. Certeau, *Practice of Everyday Life*, 118–22.

85. Jameson, "Cognitive Mapping."

Chapter 5

1. *Peregrinatio* German, 71v, l. 14; *Peregrinatio* Latin, 61v, l. 2.

2. *FabriE*, 1:384; *FabriW*, 1:480.

3. Works such as *Heavenly and Earthly Jerusalem* by Jochanan Ligtenberg at Blue and White Gallery, 1 Cardo Street.

4. Raymond, "Cairo's Area and Population." For Jerusalem, the earliest Ottoman records in 1525–26 list 616 Muslim, 199 Jewish, and 119 Christian households, with an estimate of six persons per household. Cohen and Lewis, *Population and Revenue*, 14–15, 23–25, 81–94.

5. Jarrar, "Two Islamic Construction Plans," 390–92.

6. Burgoyne, *Mamluk Jerusalem*, 78–84.

7. *FabriE*, 2:204; *FabriW*, 2:225. Also, Savage, "Pilgrimages," 61–62.

8. Burgoyne finds it "difficult to believe" that Mujir al-Din would not have known the origin of the minaret if it had been built so recently. *Mamluk Jerusalem*, 270, 272.

9. Ibid., 178–83, 415–18. Burgoyne concludes that the original Bab al-Asbat Minaret's shaft may also have been octagonal, largely because it is a more common form, but he does not consider the testimony of the *Peregrinatio* woodcut, a source he finds reliable elsewhere (194, 229).

10. As a result of the 1927 renovation, the Bab al-Asbat Minaret also has muqarnas corbeling based on that of the Ghawanima Minaret. Earlier photographs show continuous bands of molding. Burgoyne, *Mamluk Jerusalem*, 416. The original form before the Ottoman intervention is unknown, but the round minaret of al-Rumi Mosque in Aleppo, built within a year or two of the Bab al-Asbat Minaret, shows bold muqarnas corbeling beneath its muezzin gallery.

11. Hoppe and Fitner, "Frühe Studium," esp. 108–14, 110 for drum, 111 for church placement, 112 for church portal arches and Venetian sources (following *Timm*). As figure 97 demonstrates, they err in their assertion (110–11) that the three towers of the east wall of the Citadel are not visible from the Mount of Olives in the configuration shown in the *View of Jerusalem*.

12. Jerusalem and the Dome of the Rock are depicted on Forschungsbibliothek Gotha, Chart. A 541, fol. 56v–57r. For *Peregrinatio* German as source, see Grünemberg, *Konrad Grünembergs Pilgerreise*, esp. 93–101, 121–22.

13. Reuwich's ambiguities or inaccuracies stand out in comparison with depictions of the Holy Grave on Forschungsbibliothek Gotha, Chart. A 541, fol. 71r, or pilgrim-artist Jan van Scorel's 1527–30 painted group portrait of *The Knightly Brotherhood of the Holy Land in Haarlem*.

14. Hoppe and Fitner, "Frühe Studium," 114n29.

15. Burgoyne, *Mamluk Jerusalem*, 223–39, esp. 233, 237, fig. 18.5 (al-Tankiziyya); 249–57, esp. 255, fig. 21.5 (al-Aminiyya); 308–18, esp. 312, fig. 26.4 (al-Almalikiyya); 368–79, esp. 372, fig. 33.4 (al-Is'ardiyya); 384–98, esp. 390–91, fig. 35.5 (al-Manjakiyya); 519–25, esp. 523–24, fig. 53.3 (al-Basitiyya); 544–54, esp. 551, 553, fig. 57.5 (al-'Uthmaniyya); and 589–605, esp. 593–94, 596, 599–600, fig. 63.3, 63.4, 63.6 (al-Ashrafiyya).

16. Ibid., 485–504, esp. 498, fig. 48.13.

17. Ibid., 424–33, esp. 430, plate 40.19.

18. Walls, "Two Minarets."

19. For the minaret, Burgoyne, *Mamluk Jerusalem*, 517–18. For the khanqah, Hawari, *Ayyubid*

Jerusalem, 35–44, esp. 38. The date for the refurbishment is based on the testimony of Mujir al-Din. For Salah al-Din's strategy, see Frenkel, "Islamic Religious Endowments."

20. For the minaret, Burgoyne, *Mamluk Jerusalem*, 568–69. For the mosque, Hawari, *Ayyubid Jerusalem*, 49–50. Again the date comes from Mujir al-Din. The potent identification as the Mosque of 'Umar arose in the Ottoman period.

21. *FabriE*, 1:322; *FabriW*, 1:395–96.

22. Mujīr al-Dīn al-'Ulaymī, *Histoire*, 169.

23. Burgoyne, *Mamluk Jerusalem*, 85. The *Peregrinatio* caption reads, *Palacium quondam a christianis constructum et palacium david appellatum* (Palace once constructed by Christians and called the palace of David). Presumably, this refers to rebuilding in the crusader period, when it served as a residence for the kings of Jerusalem.

24. For the Umayyad Dome of the Rock, see Grabar, "Umayyad Dome of the Rock." Updated: "Meaning of the Dome of the Rock"; *Shape of the Holy*, 52–116; "Notes on the Dome of the Rock."

25. For the original exterior, Allen, "Observations." For the mosaic imagery as paradise, Rosen-Ayalon, *Early Islamic Monuments*, esp. 46–62. Raya Shani interprets the program of the building as glorifying the site of the throne of divine judgment: "Iconography of the Dome of the Rock," esp. 176ff. Carolanne Mekeel-Matteson interprets it as asserting Islam's correction of Jewish and Christian eschatology, while commemorating the future event of the resurrection of the dead and divine judgment: "Meaning of the Dome of the Rock."

26. Grabar, *Shape of the Holy*, uses computer imaging to simulate these relationships among monuments through the Fatimid period.

27. Creswell, *Early Muslim Architecture*, 1:74, 76.

28. When called to prayer during a tour of the church, the conquering Caliph 'Umar declined to pray inside, repairing instead to the front steps. 'Umar explained that had he prayed in the church, it would have been appropriated as a mosque. Coüasnon, *Church of the Holy Sepulchre*, 18. Among Christians, the caliph's restraint was legendary.

FabriE, 2:242; *FabriW*, 2:274–75. The Christian chronicler Eutychius understood the later establishment of a mosque where 'Umar made his obeisance as the pointed reversal of his policies. Berchem, *Jérusalem Ville*, 62–64. The mosque known as the Mosque of 'Umar today does not mark the spot of the original episode. It has migrated to follow the reorientation of the church.

29. An inscription, which survives, explicitly prohibits access to non-Muslims. Berchem, *Jérusalem Ville*, 64–65.

30. Hawari, *Ayyubid Jeruslaem*, 38. For Fabri on the custodians, see chapter 3.

31. *FabriE*, 2:123; *FabriW*, 2:125.

32. *FabriE*, 2:124; cf. *FabriW*, 2:125–26. Burgoyne, *Mamluk Jerusalem*, 35, 592.

33. For al-Ashrafiyya, including reconstruction of the original building, see Walls, *Geometry and Architecture*. Also, Mujīr al-Dīn al-'Ulaymī, *Histoire*, 143–44; Hillenbrand, *Islamic Architecture*, 204–6; Meinecke, *Mamlukische Architecture*, 194–96; Jarrar, "Two Islamic Construction Plans," 403–9.

34. Mujīr al-Dīn al-'Ulaymī, *Histoire*, 144.

35. For the siting, Walls, *Geometry and Architecture*, 11–17.

36. Yeomans, *The Architecture of Islamic Cairo*, 225.

37. Walls, *Geometry and Architecture*, 11, 129, uses Reuwich's rendering in reconstructing the Ashrafiyya. Burgoyne, *Mamluk Architecture*, 38n21, 194, 229, praises Reuwich's rendering of the southwest portico and the facades above it. The southwest qanatir, completed in 1472, should stand to the left of the Ashrafiyya in front of the Tankiziyya. Its absence could be taken as indicating Reuwich used an earlier image. However, from the distant vantage on the Mount of Olives, the qanatir arches can be read as the arches of the portico along the ground floor of the Tankiziyya, with the flat top of the qanatir appearing as a cornice across the facade, as depicted by Reuwich. The qanatir contains three arches, while Reuwich renders four, but he also depicts the northwest qanatir with five arches, for example, when it has four. *Timm*, esp. 311–13, suggests that Gentile Bellini drew the image on the

way home from Istanbul. This seems implausible. First, Bellini left Istanbul in January 1481. The pulling down of the old madrasa and the digging of foundations for the new began at the end of October 1480. In March 1481, the Cairene architects arrived, found the new ground-floor assembly hall too small, and ordered its partial demolition and expansion. Major construction was completed in August or September 1482. Therefore, Bellini would have visited at an early phase, when the frame of the ground floor was still in flux. For the construction timeline, Berchem, *Jérusalem Ville*, 358–67. For Bellini's return home, Campbell and Chong, *Bellini and the East*, 114–17. Second, there is no indication that Bellini ever visited the Holy Land. Istanbul and Jerusalem were the termini of different galley routes, so that traveling directly between them would have involved unorthodox arrangements. Had he made drawings in Mamluk lands, he and Carpaccio would have used his material, rather than Reuwich's and others', in populating later paintings with Mamluk figures and devices, as discussed in chapter 3.

38. Rudy, *Virtual Pilgrimages*, 58–90, 146–47, 425–46, for the role of the Franciscans and examples. Suriano, *Treatise*, is organized as a "treatise on the indulgences of the Holy Land."

39. The phrase "indulgence of seven years and seven quarantines" is rendered in Latin with a variety of orthography even on the same page, for example, *Peregrinatio* Latin, fol. 39v.

40. Sixten Ringbom, *Icon to Narrative*, 23–29.

41. *FabriE*, 1: 386; *FabriW*, 1:483.

42. *FabriE*, 1:368; *FabriW*, 1:459.

43. Konrad Grünemberg, *Pilgerfahrt ins Heilige Land*, Forshungsbibliothek Gotha, Chart. A 541, fol. 56v–57r.

44. Pringle, *Churches of the Crusader Kingdom*, 3:124–25.

45. Paulus, *Geschichte des Ablasses*, 3:237–38.

46. Suriano, *Treatise*, 139–40; Paulus, *Geschichte des Ablasses*, 3:237–38.

47. Paulus, *Geschichte des Ablasses*, 3:239–40.

48. Dansette, "Pèlerinages occidentaux," 108–10.

49. Paulus, *Geschichte des Ablasses*, 2:241–43.

50. Suriano, *Treatise*, 8, 166. Bishops also had authority to institute indulgences, though plenary indulgences should, in theory, only have been issued by the pope.

51. Dansette, "Pèlerinages occidentaux," 110–13, 115–22, describes the influence of Franciscan spirituality on pilgrims' devotional practices at Holy Land sites.

52. For Reuwich's depiction of these elements, Marshall, "Carpaccio," 615–19.

53. 51v, ll. 15–23; *FabriE*, 1:368; *FabriW*, 1:459.

54. Storme, *Le Mont des Oliviers*, 92.

55. Rudy, *Virtual Pilgrimages*, 146–50, 319, 430, gives three Dutch-language examples from spiritual pilgrimage texts dated 1450–1500, presumably based on pilgrimage accounts. She discusses the indulgenced view from "Mount Galilee" as an imaginative exercise of spiritual pilgrimage, without recognizing that these refer to a real pilgrimage stop on the Mount of Olives.

56. Wey, *Itineraries of William Wey, Fellow of Eton College*, 21.

57. Ibid., 36.

58. Mülich, *Beschreibung*, 38.

59. *FabriE*, 1:386; *FabriW*, 1:483.

60. *FabriS*, 139, ll. 4–16.

61. Rieter and Rieter, *Reisebuch der Familie Rieter*, 69, for Sebald Jr.

62. For a comprehensive exploration of spiritual pilgrimage, Rudy, *Virtual Pilgrimages*.

63. This is the third of twenty rules of spiritual pilgrimage that Fabri outlines at the beginning of his text. *FabriS*, 79, ll. 1–5.

64. Stegmaier-Breinlinger, "Hailigen Stett Rom und Jerusalem," 178–79, 182. The author suggests the *Peregrinatio* as a possible source, but more specific indulgence information could be found elsewhere, for example, the printed *Peregrinationes totius Terrae Sanctae*.

65. For this practice, see Caspers, "Western Church"; Duffy, *Stripping of the Altars*, 95–102.

66. Meinert, *Heilig-Grab-Anlage*, 118, 207–10, 391.

67. Anders and Winzeler, *Lausitzer Jerusalem*, 15–16; Meinert, *Heilig-Grab-Anlage*, 275–81, with complete bibliography.

68. For older photos, Anders and Winzeler, *Lausitzer Jerusalem*, 9, 20.

69. Meinert, *Heilig-Grab-Anlage*, 121–22, 354–57, assembles the evidence for dating the procession.

70. Ibid., 363–84, esp. 383–84.

71. Little, "Mujīr al-Dīn al-ʿUlaymī al-ʿUlaymī's Vision of Jerusalem," 242–43; Mujīr al-Dīn al-ʿUlaymī, *Histoire*, 183–84, 138–39.

72. From the 1481 account of Meshullam ben Menahem da Volterra in Adler, *Jewish Travellers*, 196.

73. For the *Crucifixions*, see Borchert, *Age of Van Eyck*, figs. 15, 18–21. For *Christ Carrying the Cross* and ties between Utrecht and Bruges, Trowbridge, "Jerusalem Transposed." Also, Boon, "Utrechtse schilder," 51–60; Ainsworth and Christiansen, *From Van Eyck to Bruegel*, 107–9.

74. Krinsky, "Representations," 13–14.

75. Krinksy, ibid., 14–15, argues that the Eyckian *Three Marys*, the Le Tavernier Jerusalem, and two other Le Tavernier miniatures all derive from a common source.

76. La Broquière, *Voyage d'Orient*, 45.

77. For the manuscript, Pächt and Thoss, *Flämische Schule II*, text volume, 116–17.

78. Vienna, Österreichische Nationalbibliothek, S. n. 12710, fol. 2r, ll. 26–27, 29–30.

79. Smeyers, *Flemish Miniatures*, 269–70, notes that the roots of the Windesheim canons of the Roocloster lay with the Modern Devotion, which discouraged real pilgrimage. This proscription led at least the women of the order to develop spiritual pilgrimage. Rudy, *Virtual Pilgrimages*, 23–24, 92–97.

80. Jammes and Saffrey, "Image xylographique," 16, 18–22, for a transcription of the inscriptions.

81. Haussherr, "Spätgotische Ansichten der Stadt Jerusalem," esp. 63–68.

82. Durrieu, "Vue de l'église," 207.

83. Schramm, *Bilderschmuck*, 19:702.

84. For a second Le Tavernier onion Dome of the Rock, dated 1458–60, Brussels, Bibliothèque royale de Belgique, ms. 9066, fol. 146v.

85. Durrieu, "Vue de l'église," 199–201; Pächt, "René d'Anjou."

86. Reynaud, "Barthélémy d'Eyck," esp. 32–35; Avril and Reynaud, *Manuscrits à peintures*, 224–27.

87. Paviot, *Ducs de Bourgogne*, 74, 80–81, 83, 88, 111–13, 318–19; Pringle, *Churches of the Crusader Kingdom*, 270–71.

88. Krinsky, "Representations," 14, 17.

89. For pilgrims who seem to have understood the building as the actual Temple, see Krinsky, "Representations," 5–6. Krinsky presents them this way, but they may have had a more complex relationship to the site, as Reuwich does.

90. The description of Solomon's Temple in the pilgrimage account follows Hans Tucher's version very closely. See Tucher and Herz, *Reise*, 417–20. The author of the *Peregrinatio* admits (100v, ll. 1–2) that he took the text on "the Saracens and their customs and errors" (89v–100r) from elsewhere.

91. *FabriE*, 2:216–18; *FabriW*, 2:240–42. The dome was built by ʿUmar's successor and finished in 691.

92. *FabriS*, 83, ll. 15–18, and 84, ll. 1–5, 8–12.

93. Ibid., l. 16, through 128, l. 23.

94. Ibid., 126, ll. 20–24.

95. Ibid., 128, ll. 13–15.

96. Ibid., 128, ll. 15–23.

97. *FabriE*, 2:218; cf. *FabriW*, 2:242.

98. *FabriE*, 2:221; cf. *FabriW*, 2:251.

99. Colvin, "Zeichnungen des Carpaccio"; Marshall, "Carpaccio," 610–11, 619–20.

100. *Porta aurea per quam Christus sedens in asino intrauit in die palmarum : quandoque etiam Eraclio imperatori venienti cum pompa imperiali · reclusa primum miraculose postea humilianti se aperta fuit et hodie clausa manet miraculose sarracenis ita quod nequaquam possunt eam reparare · quolibet ingenio quin id temptantes subito moriantur · Vnde nullum habent eis vsum ingrediendo uel egrediendo.*

101. Little, "Communal Strife," esp. 78–87, based largely on Mujir al-Din's account. For the mosque, also Burgoyne, *Mamluk Jerusalem*, 513.

BIBLIOGRAPHY

Abbreviations

Davies
Davies, Hugh. *Bernhard von Breydenbach and His Journey to the Holy Land, 1483–4: A Bibliography*. London: J. & J. Leighton, 1911.

FabriE
Fabri, Felix. *Fratris Felicis Fabri evagatorium in Terrae Sanctae, Arabiae et Egypti peregrinationem*. 3 vols. Edited by Konrad Dietrich Hassler. Stuttgart: Societas Literariae Stuttgardiensis, 1843–49.

FabriS
Fabri, Felix. *Die Sionpilger*. Edited by Weiland Carls. Berlin: Erich Schmidt, 1999.

FabriW
Fabri, Felix. *The Wanderings of Felix Fabri*. Translated by Aubrey Stewart. 4 vols. Library of the Palestine Pilgrims' Text Society 7–10. 1893. Reprint, New York: AMS Press, 1971.

Fuchs
Fuchs, R. W. "Die Mainzer Frühdrucke mit Buchholzschnitten, 1480–1500." *Archiv für Geschichte des Buchwesens* 2 (1960): 1–129.

GW
Datenbank Gesamtkatalog der Wiegendrucke. http://www.gesamtkatalogderwiegendrucke.de/. Online accompaniment to *Gesamtkatalog der Wiegendruck*. 11 vols. 1st ed., 1925–. 2nd ed., vols. 1–7. Stuttgart: Anton Hiersemann, 1968–.

ISTC
Incunabula Short Title Catalogue. http://www.bl.uk/catalogues/istc/.

Peregrinatio Latin
Breydenbach, Bernhard von. *Peregrinatio in terram sanctam*. Mainz: Erhard Reuwich, 11 February 1486. ISTC ib01189000; GW 05075.

Peregrinatio German
Breydenbach, Bernhard von. *Peregrinatio in terram sanctam* [German] *Die heyligen reyssen gen Jherusalem*. Mainz: Erhard Reuwich, 21 June 1486. ISTC ib01193000; GW 05077.

Timm
Frederike Timm, *Der Palästina-Pilgerbericht des Bernhard von Breidenbach und die Holzschnitte Erhard Reuwichs: Die Peregrinatio in terram sanctam (1486) als Propagandainstrument im Mantel der gelehrten Pilgerschrift*. Stuttgart: Hauswedell, 2006.

Select Incunabula and Early Editions

Breydenbach, Bernhard von. *Le grant voyage de Hierusalem*. Translated by Nicolas Le Huen. Paris: François Regnault, 20 March 1522.
———. *Le grant voyage de Jherusalem*. Translated by Nicolas Le Huen. Paris: Nicolas Higman for François Regnault, 12 October 1517.
———. *Peregrinatio in terram sanctam* [Czech, excerpts] *Traktát o zemi svaté; Život Mahomedův*. Pilsen: Mikuláš Bakalář, 1498. ISTC ib01190500; GW 0508210N and GW M2511410.
———. *Peregrinatio in terram sanctam* [Dutch] *Die heylighe beuarden tot dat heylighe grafft in Jherusalem*. Mainz: Erhard Reuwich, 24 May 1488. ISTC ib01191000; GW 05081.

———. *Peregrinatio in terram sanctam* [French] *Des sainctes peregrinationes de iherusalem.* Translated by Nicolas Le Huen. Lyons: Michel Topié and Jacques Heremberck, 28 November 1488. ISTC ib01192000; GW 05080.

———. *Peregrinatio in terram sanctam* [French] *Le saint voiage et pelerinage.* Translated by Jean de Hersin. Lyon: Gaspard Ortuin, 18 February 1489. ISTC ib01192500; GW 05079.

———. *Peregrinatio in terram sanctam* [German] *Die heyligen reyssen gen Jherusalem.* Augsburg: Anton Sorg, 22 April 1488. ISTC ib01194000; GW 05078.

———. *Peregrinatio in terram sanctam* [German] *Die heyligen reyssen gen Jherusalem.* Speyer: Peter Drach, after 1502. ISTC ib01195000; GW 4 Sp.656a.

———. *Peregrinatio in terram sanctam* [Spanish] *Viaje dela tierra sancta.* Translated with additions, including *Tratado de Roma*, by Martin Martinez de Ampies. Zaragoza: Paul Hurus, 16 January 1498. ISTC ib01196000; GW 05082.

———. *Peregrinatio in terram sanctam.* Speyer: Peter Drach, 29 July 1490. ISTC ib01190000; GW 05076.

———. *Peregrinatio in terram sanctam.* Speyer: Peter Drach, 24 November 1502.

———. *Peregrinatio in terram sanctam* [excerpt]. Wittenberg: Nicolaus Schirlentz, 1536.

Conrad von Megenberg. *Buch der Natur.* Augsburg: Johann Bämler, 19 August 1478. ISTC ic00843000; GW M16428.

Cube, Johann von, ed. *Gart der Gesundheit.* Introduction by Bernhard von Breydenbach. Mainz: Peter Schöffer, 28 March 1485. ISTC ig00097000; GW M09766.

Diether von Isenburg, ed. *Agenda Moguntinensis.* Mainz: Johann Numeister, 29 June 1480. ISTC ia00162000; GW 00468.

Ptolemaeus, Claudius. *Cosmographia.* Translated by Jacobus Angelus. Edited by Nicolaus Germanus. Ulm: Lienhart Holle, 16 July 1482. ISTC ip01084000; GW M36379.

———. *Cosmographia* [with additions *Registrum* and *De locis ac mirabilitus mundi*]. Translated by Jacobus Angelus. Edited by Nicolaus Germanus. Ulm: Johann Reger for Justus de Albano, 21 July 1486. ISTC ip01085000; GW M36374.

Rudimentum novitiorum. Lübeck: Lucas Brandis, 5 August 1475. ISTC ir00345000; GW M39062.

Schedel, Hartmann. *Liber chronicarum.* Nuremberg: Anton Koberger for Sebal Schreyer and Sebastian Kammermeister, 12 July 1943. ISTC is00307000; GW M40784.

Tucher, Hans. *Reise in das gelobte Land.* Augsburg: Johann Schönsperger, 1482. ISTC it00490000; GW M47728.

Facsimiles and Modern Editions of Primary Sources

Adler, Elkan Nathan, ed. *Jewish Travellers: A Treasury of Travelogues from Nine Centuries.* 2nd ed. New York: Hermon Press, 1966.

Arens, Fritz, ed. *Die Inschriften der Stadt Mainz von frühmittelalterlicher Zeit bis 1650.* Stuttgart: A. Druckenmüller, 1958.

Bently, L., and M. Kretschmer, eds. Primary Sources on Copyright (1450–1900). http://www.copyrighthistory.org.

Brasca, Santo, and Gabriele Capodilista. *Viaggio in Terrasanta di Santo Brasca, 1480, con l'Itinerario di Gabriele Capodilista, 1458.* Edited by Anna L. M. Lepschy. Milan: Longanesi, 1966.

Breydenbach, Bernhard von. *Peregrinatio in terram sanctam: Eine Pilgerreise ins Heilige Land; Frühneuhochdeutscher Text und Übersetzung.* Edited and translated by Isolde Mozer. Berlin: Walter de Gruyter, 2010.

———. *Peregrinatio in terram sanctam* [German] *Die heyligen reyssen gen Jherusalem.* Facsimile of Mainz 21 June 1486 edition, edited by Andreas Klußmann. Saarbrücken: Fines Mundi, 2008.

———. *Peregrinationes: Un viaggiatore del Quattrocento a Gerusalemme e in Egitto.* Translated by

Gabriella Bartolini and Giulio Caporali. Rome: Roma nel Rinascimento and Vecchiarelli, 1999.

———. *Die Reise ins Heilige Land: Ein Reisebericht aus dem Jahre 1483*. Edited and translated by Elisabeth Geck. Wiesbaden: Guido Pressler, 1977.

———. "Die Reiseinstruction des Bernhard von Breitenbach, 1483." In Röhricht and Meisner, *Deutsche Pilgerreisen nach dem Heiligen Lande*, 120–45. Berlin: Weidmannsche Buchhandlung, 1880.

———. *Les Saintes Pérégrinations de Bernard de Breydenbach, 1483: Extraits relatifs à l'Égypte suivant l'édition de 1490*. Edited and translated by Felix Larrivaz. Cairo: Imprimerie Nationale, 1904.

Burchard of Mount Sion. *Burchard of Mount Sion, A.D. 1280*. Translated by Aubrey Stewart. Library of the Palestine Pilgrims' Text Society 12, no. 1. 1896. Reprint, New York: AMS Press, 1971.

———. *Descriptio Terrae Sanctae*. In *Peregrinatores medii aevi quatuor: Burchardus de Monte Sion, Ricoldus de Monte Crucis, Odoricus de Foro Julii, Wilbrandus de Oldenborg*, edited by J. C. M. Laurent. Leipzig: J. C. Hinrichs, 1864.

Casola, Pietro. *Canon Pietro Casola's Pilgrimage to Jerusalem in the Year 1494*. Translated by M. Margaret Newett. Manchester: University Press, 1907.

———. *Viaggio a Gerusalemme di Pietro Casola*. Edited by Anna Paoletti. Alessandria: Edizioni dell'Orso, 2001.

Conrady, Ludwig. *Vier Rheinische Palaestina-Pilgerschriften des XIV., XV. und XVI. Jahrhunderts*. Wiesbaden: Feller and Gecks, 1882.

Da Lezze, Donado. *Historia turchesca, 1300–1514*. Edited by Ioan Ursu. Bucharest: Carol Göbl, 1909.

Dressendörfer, Werner, Gundolf Keil, and Wolf-Dieter Müller-Jahncke. *Älterer deutscher "Macer"—Ortolf von Baierland "Arzneibuch"—"Herbar" des Bernhard von Breidenbach—Färber- und Maler-Rezepte: Die oberrheinische medizinische Sammelhandschrift des Kodex Berleburg; Berleburg, Fürstlich Sayn-Wittgenstein'sche Bibliothek, Cod. RT 2/6*. Color microfiche facsimile edition. Munich: Edition Helga Lendenfelder, 1991.

Eusebius of Caesarea. *Eusebii Pamphili Episcopi Caesariensis onomasticon: Urbium et locorum Sacrae Scripturae; Graece cum latina Hieronymi interpretatione*. Edited by F. Larsow and G. Parthey. Berlin: In aedibus Friderici Nicolai, 1862.

Fabri, Felix. *Bruder Felix Fabers gereimtes Pilgerbüchlein*. Munich: E. A. Fleischmann, 1864.

———. *Die Pilgerfahrt des Bruders Felix Faber ins Heilige Land Anno 1483 nach der ersten deutschen Ausgabe 1556*. Berlin: Union, 1964.

Gregory I. *Liber regulae pastoralis*. In *Patrologiae cursus completus: Series latina*, edited by Jacques-Paul Migne, vol. 77, cols. 9–128. Paris: Migne, 1896.

Grünemberg, Konrad von. *Konrad Grünembergs Pilgerreise ins Heilige Land 1486: Untersuchung, Edition und Kommentar*. Edited by Andrea Denke. Cologne: Böhlau, 2011.

———. *Ritter Grünembergs Pilgerfahrt ins Heilige Land, 1486*. Edited and translated by Johann Goldfriedrich and Walter Fränzel. Leipzig: R. Voigtländer, 1912.

———. *The Story of Sir Konrad Grünemberg's Pilgrimage to the Holy Land in 1486*. Edited by Kristiaan Aercke. Moncalieri: Centro Interuniversitario di Ricerche sul "Viaggio in Italia," 2005.

Gudenus, Valentin F. von. *Codex diplomaticus . . . illustrantium*, vol. 2. Frankfurt and Leipzig: W. L. Springii and J. G. Garbe, 1747; vol. 4. Frankfurt and Leipzig: I. C. Stoehr, 1758.

Harff, Arnold von. *The Pilgrimage of Arnold von Harff, Knight, from Cologne through Italy, Syria, Egypt, Arabia, Ethiopia, Nubia, Palestine, Turkey, France, and Spain, Which He Accomplished in the Years 1496 to 1499*. Translated and edited by Malcolm Letts. Hakluyt Society, 2nd ser., 94. London: Hakluyt Society, 1946.

Jenson, Nicolas. *The Last Will and Testament of the Late Nicolas Jenson, Printer, Who Departed This Life at the City of Venice in the Month of September, A.D. 1480*. Translated by Pierce Butler. Chicago: Ludlow Typograph, 1928.

Jerome. *Epistola 53, Ad Paulinum de studio Scripturarum.* In *Patrologiae cursus completus: Series latina,* edited by Jacques-Paul Migne, vol. 22, col. 544. Paris: Migne, 1896.

La Broquière, Bertrandon de. *Le voyage d'Orient: Espion en Turquie.* Translated by Hélène Basso. Toulouse: Anacharsis, 2010.

Luzio, Alessandro. "Disegni topografici e pitture dei Bellini." *Archivio storico dell'arte* 1 (1888): 276–78.

Mülich, Jörg. *Beschreibung der heiligen Stätten zu Jerusalem und Pilgerreise nach Jerusalem.* Edited by Ulrich Seelbach. Göppingen: Kümmerle, 1993.

Niccolò, da Poggibonsi. *A Voyage beyond the Seas, 1346–1350.* Translated by T. Bellorini and E. Hoade. Jerusalem: Franciscan Press, 1945.

Pallmann, Heinrich. "Des Erzbischofs Berthold von Mainz ältestes Censuredikt." *Archiv für Geschichte des deutschen Buchhandels* 9 (1884): 238–41.

Petrarca, Francesco. "The Ascent of Mount Ventoux." In *The Renaissance Philosophy of Man,* edited by Ernst Cassirer, Oskar Kristeller, and John Herman Randall Jr., 36–46. Chicago: University of Chicago Press, 1948.

———. *Le familiari.* Edited by V. Rossi and U. Bosco. 4 vols. Florence: G. C. Sansoni, 1933–42.

Ptolemaeus, Claudius. *Géographie de Ptolémée: Traduction latine de Jacopo d'Angiolo de Florence; Reproduction réduite des cartes et plans du manuscrit latin 4802 de la Bibliothèque nationale.* Edited by Bibliothèque nationale (France), Département des manuscrits. Introduction by Henri Omont. Paris: Catala Frères, [1925?].

———. *Ptolemy's Almagest.* Translated and annotated by G. J. Toomer. 1984. Reprint, Princeton: Princeton University Press, 1998.

———. *Ptolemy's "Geography": An Annotated Translation of the Theoretical Chapters.* Translated and edited by J. Lennart Berggren and Alexander Jones. Princeton: Princeton University Press, 2000.

Rappard, F. A. L van. "De Rekeningen van de Kerkmeesters der Buurkerk te Utrecht in de 15ᵉ eeuw." *Bijdragen en Mededeelingen van het Historisch Genootschap, Gevestigd te Utrecht* 3 (1880): 25–224.

Rieter, Peter, Sebald Rieter Sr., and Sebald Rieter Jr. *Das Reisebuch der Familie Rieter.* Edited by Reinhold Röhricht and Heinrich Meisner. Tübingen: Litterarischer Verein in Stuttgart, 1884.

Röhricht, Reinhold, and Heinrich Meisner, eds. *Deutsche Pilgerreisen nach dem Heiligen Lande.* Berlin: Weidmannsche Buchhandlung, 1880.

Sanudo Torsello, Marino. *The Book of the Secrets of the Faithful of the Cross / Liber secretorum fidelium crucis.* Translated by Peter Lock. Farnham, UK: Ashgate, 2011.

———. *Liber secretorum fidelium crucis super Terrae Sanctae recuperatione et conservation.* Vol. 2 of *Gesta Dei per Francos,* edited by Jacques Bongars. Hanau: Typis Wechelianis apud heredes Ioannis Aubrii, 1611. Facsimile, with foreword by Joshua Prawer. Toronto: University of Toronto Press, 1972.

Schedel, Hartmann. *Chronicle of the World: The Complete and Annotated Nuremberg Chronicle of 1493.* Introduction and appendix by Stephan Füssel. Cologne: Taschen, 2001.

Somigli, Teodosio. *Etiopia Francescana nei documenti dei secoli XVII e XVIII preceduti da cenni storici sulle relazioni con l'Etiopia durante i sec. XIV e XV.* Vol. 1, *1633–1643.* Florence: Quaracchi, 1928.

Suriano, Francesco. *Il Trattato di Terra Santa e dell'Oriente di Frate Francesco Suriano, missionario e viaggiatore del secola XV (Siria, Palestina, Arabia, Egitto, Abissinia, ecc.).* Edited by Girolamo Golubovich. Milan: Tipografia Editrice Artigianelli, 1900.

———. *Treatise on the Holy Land.* Translated by Theophilus Bellorini and Eugene Hoade. Jerusalem: Franciscan Press, 1949.

Tucher, Hans, and Randall Herz. *Die "Reise ins Gelobte Land" Hans Tuchers des Älteren, 1479–1480: Untersuchungen zur Überlieferung und kritische Edition eines spätmittelalterlichen Reiseberichts.*

Edited by Randall Herz. Wiesbaden: Dr. Ludwig Reichert, 2002.

'Ulaymī, Mujīr al-Dīn 'Abd al-Raḥmān ibn Muḥammad. *Histoire de Jérusalem et d'Hébron depuis Abraham jusqu'à la fin du XVe siècle de J.-C., Fragments de la "Chronique" de Moudjir-ed-dyn*. Translated and abridged by Henri Sauvaire. Paris: Ernest Leroux, 1876.

Walther, Paulus, Guglingensis. *Fratris Pauli Waltheri Guglingensis Itinerarium in Terram Sanctam et ad Sanctam Catharinam*. Edited by M. Sollweck. Tübingen: Litterarischer Verein in Stuttgart, 1892.

Wey, William. *The Itineraries of William Wey*. Edited and translated by Francis Davey. Oxford: Bodleian Library, 2010.

———. *The Itineraries of William Wey, Fellow of Eton College: To Jerusalem, A.D. 1458 and A.D. 1462; and to Saint James of Compostella, A.D. 1456*. Roxburghe Club Books 76. London: J. B. Nichols and Sons, 1857.

———. *Map of the Holy Land: Illustrating the Itineraries of William Wey, Fellow of Eton College, in A.D. 1458 and 1462*. Roxburghe Club Books 88. London: J. B. Nichols and Sons, 1867.

Zeebout, Ambrosius, ed. *Tvoyage van Mher Joos van Ghistele*. Edited by R. J. G. A. A. Gaspar. Hilversum: Verloren, 1998.

Secondary Sources

Acres, Alfred. "The Columba Altarpiece and the Time of the World." *Art Bulletin* 80, no. 3 (1998): 422–51.

———. "Luke, Rolin, and Seeing Relationships." In *Rogier van der Weyden, St. Luke Drawing the Virgin: Selected Essays in Context*, edited by Carol Purtle, 23–37. Turnhout: Brepols, 1997.

Adler, Nikolaus. "Reuwichs Illustration zum Pilgerbericht des Mainzer Dom Dekans Bernhard von Breidenbach (1483/84)." *Das Heilige Land* 84 (1952): 1–4.

Ainsworth, Maryan, and Keith Christiansen, eds. *From Van Eyck to Bruegel: Early Netherlandish Painting in the Metropolitan Museum of Art*. New York: Metropolitan Museum of Art, 1998. Exhibition catalog.

Alexander, Jonathan J. G., ed. *The Painted Page: Italian Renaissance Book Illumination, 1450–1550*. London: Prestel, 1994. Exhibition catalog.

Allen, H. R. "Observations on the Original Appearance of the Dome of the Rock." In *Bayt al-Maqdis: Jerusalem and Early Islam*, edited by Jeremy Johns, 197–213. Oxford Studies in Islamic Art, vol. 9, pt. 2. Oxford: Oxford University Press, 1992.

Allen, Rosamund, ed. *Eastward Bound: Travel and Travellers, 1050–1550*. Manchester: Manchester University Press, 2004.

Almagià, Roberto. *Monumenta cartographica Vaticana*. 4 vols. Rome: Biblioteca Apostolica Vaticana, 1944–55.

Altman, Ursula. "Leserkreise zur Inkunabelzeit." In *Buch und Text im 15. Jahrhundert: Arbeitsgespräch in der Herzog August Bibliothek Wolfenbüttel vom 1. bis 3. März 1978 / Book and Text in the Fifteenth Century: Proceedings of a Conference Held in the Herzog August Bibliothek Wolfenbüttel*, edited by Lotte Hellinga and Helmar Härtel, 203–71. Hamburg: Dr. Ernst Hauswedell, 1981.

Amelung, Peter. *Der Frühdruck im deutschen Südwesten*. Vol. 1, *Ulm*. Stuttgart: Württembergische Landesbibliothek, 1979.

Anders, Ines, and Marius Winzeler, eds. *Lausitzer Jerusalem: 500 Jahre Heiliges Grab zu Görlitz*. Görlitz-Zittau: Gunter Oettel, 2005.

Andrews, Kevin. *Castles of Morea*. Amsterdam: Adolf M. Hakkert, 1978.

Anzelewsky, Fedja. "Das Gebetbuch der Pfalzgräfin Margarethe von Simmern." *Berliner Museen*, n.s., 8, no. 1 (1958): 30–34.

———. Review of *Der Hausbuchmeister: Gesamtdarstellung und Katalog seiner Gemälde, Kupferstiche und Zeichnungen*, by Alfred Stange. *Zeitschrift für Kunstgeschichte* 24, no. 1 (1961): 86–88.

Areford, David. *The Viewer and the Printed Image in Late Medieval Europe*. Farnham, UK: Ashgate, 2010.

Armstrong, Lilian. "The Hand-Illumination of Printed Books in Italy, 1465–1515." In Alexander, *Painted Page*, 35–47, 163–208.

———. "Il maestro di Pico: Un miniatore veneziano del tardo Quattrocento." *Saggi e memorie di storia dell'arte* 17 (1990): 7–39.

———. *Renaissance Miniature Painters and Classical Imagery: The Master of the Putti and His Venetian Workshop*. London: Harvey Miller, 1981.

Ascoli, Albert Russell. *Dante and the Making of a Modern Author*. Cambridge: Cambridge University Press, 2008.

Asperen de Boer, J. R. J. van, and Molly Faries. "La *Vierge au Chancelier Rolin* de van Eyck: Examen au moyen de la réflectographie à l'infrarouge." *La Revue du Louvre* 40, no. 1 (1990): 37–49.

Avril, François, and Nicole Reynaud. *Les manuscrits à peintures en France, 1440–1520*. Paris: Flammarion, 1993.

Babicz, Józef. "Donnus Nicolaus Germanus—Probleme seiner Biographie und sein Platz in der Rezeption der ptolemäischen Geographie." In *Land- und Seekarten im Mittelalter und in der frühen Neuzeit*, edited by Cornelis Koeman, 9–42. Munich: Kraus, 1980.

Bailey, Martin. "The Discovery of the Lost Mappamundi Panel: Hereford's Map in a Medieval Altarpiece?" In Harvey, *Hereford World Map*, 79–93.

———. "The *Mappa Mundi* Triptych: The Full Story of the Hereford Cathedral Panels." *Apollo* 137 (1993): 374–78.

Barry, Michael. "Giorgione et les Maures." In Carboni, *Venise et l'Orient*, 146–73.

Bauermeister, Karl. "Berthold von Henneberg und der Türkenzehnte von 1487." *Historisches Jahrbuch* 36 (1915): 609–21.

Baumann, Brigitte, and Helmut Baumann. *Die Mainzer Kräuterbuch-Inkunabeln: "Herbarius Moguntinus," "Gart der Gesundheit," and "Hortus Sanitatis"; Wissenschaftshistorische Untersuchung der drei Prototypen botanisch-medizinischer Literatur des Mittelalters*. Stuttgart: Anton Hiersemann, 2010.

Baumgärtner, Ingrid. "Die Wahrnehmung Jerusalems auf Mittelalterlichen Weltkarten." In *Jerusalem im Hoch- und Spätmittelalter: Konflikte und Konfliktbewältigung—Vorstellungen und Vergegenwärtigungen*, edited by Dieter Bauer, Klaus Herbers, and Nikolas Jaspert, 271–334. Frankfurt: Campus, 2001.

Beckingham, Charles, and Bernard Hamilton, eds. *Prester John, the Mongols, and the Ten Lost Tribes*. Aldershot: Variorum, 1996.

Behling, Lottlisa. "Der Hausbuchmeister Erhard Reuwich." *Zeitschrift für Kunstwissenschaft* 5 (1951): 179–90.

Behrens-Abouseif, Doris. *Cairo of the Mamluks: A History of the Architecture and Its Culture*. London: I. B. Tauris, 2007.

Belting, Hans, and Christiane Kruse. *Die Erfindung des Gemäldes: Das erste Jahrhundert der niederländischen Malerei*. Munich: Hirmer, 1994.

Berchem, Max van. *Matériaux pour un Corpus Inscriptionum Arabicarum II: Syrie du Sud*. Vol. 1, *Jérusalem Ville*. Cairo: Institut français d'archéologie orientale du Caire, 1922.

Billanovich, Giuseppe. "Il Petrarca e il Ventoso." *Italia medioevale e umanistica* 9 (1966): 389–401.

Bisaha, Nancy. *Creating East and West: Renaissance Humanism and the Ottoman Turks*. Philadelphia: University of Pennsylvania Press, 2004.

Bloss, J. F. E. "The Story of Suakin." *Sudan Notes and Records* 19, no. 2 (1936): 271–300.

Böninger, Lorenz. *Die deutsche Einwanderung nach Florenz im Spätmittelalter*. Leiden: Brill, 2006.

Boon, Karel. "The Master of the Amsterdam Cabinet or the Master of the Housebook and His Relationship to the Art of the Burgundian Netherlands." In Filedt Kok, *Livelier than Life*, 13–22.

———. "Een Utrechtse schilder uit de 15de eeuw, de Meester van de Boom van Jesse in de Buurkerk." *Oud Holland* 76 (1961): 51–60.

Borchert, Till-Holger, ed. *The Age of Van Eyck: The Mediterranean World and Early Netherlandish Painting, 1430–1520*. Ghent and Amsterdam: Ludion, 2002. Exhibition catalog.

Bosslemann-Cyran, Kristian. "Das arabische Vokabular des Paul Walther von Guglingen und seine Überlieferung im Reisebericht Bernhards von Breidenbach." *Würzburger medizinhistorische Mitteilungen* 12 (1994): 153–82.

Botvinick, Matthew. "The Painting as Pilgrimage: Traces of a Subtext in the Work of Campin and His Contemporaries." *Art History* 15 (1992): 1–18.

Bourne, Molly. "Francesco II Gonzaga and Maps as Palace Decoration in Renaissance Mantua." *Imago Mundi* 51 (1999): 51–82.

Brincken, Anna-Dorothee von den. "Jerusalem on Medieval Mappaemundi: A Site Both Historical and Eschatological." In Harvey, *Hereford World Map*, 355–79.

Broecke, M. P. R. van den. *Ortelius Atlas Maps: An Illustrated Guide*. 't Goy: HES, 1996.

Brown, David Alan, and Sylvia Ferino-Pagden, eds. *Bellini, Giorgione, Titian, and the Renaissance of Venetian Painting*. Washington, D.C.: National Gallery of Art, 2006. Exhibition catalog.

Brown, Patricia Fortini. *Venice and Antiquity: The Venetian Sense of the Past*. New Haven: Yale University Press, 1996.

Burger, E. "Die ältesten Belege für Giraffe im Deutschen." *Zeitschrift für Deutsche Wortforschung* 11, no. 4 (1909): 304–5.

Burgoyne, Michael. *Mamluk Jerusalem: An Architectural Study*. London: World of Islam Festival Trust, 1987.

Campbell, Caroline, and Alan Chong, eds. *Bellini and the East*. London: National Gallery, 2005. Exhibition catalog.

Campbell, Tony. "Census of Pre-Sixteenth-Century Portolan Charts." *Imago Mundi* 38 (1986): 67–94.

———. *The Earliest Printed Maps, 1472–1500*. London: British Library, 1987.

———. "Portolan Charts from the Late Thirteenth Century to 1500." In Harley and Woodward, *Cartography in Prehistoric, Ancient, and Medieval Europe and the Mediterranean*, 371–463.

Carboni, Stefano, ed. *Venise et l'Orient, 828–1797*. Paris: Institut du Monde Arabe, 2006.

Caspers, Charles. "The Western Church during the Late Middle Ages: *Augenkommunion* or Popular Mysticism?" In *Bread of Heaven: Customs and Practices Surrounding Holy Communion; Essays in the History of Liturgy and Culture*, edited by Charles Caspers, Gerard Lukken, and Gerard Rouwhorst, 83–97. Kampen: Kok Pharos, 1995.

Cattaneo, Angelo. "Fra Mauro *Cosmographus incomparabilis* and His *Mappamundi*: Documents, Sources, and Protocols for Mapping." In *La cartografia Europea tra primo rinascimento e fine dell'illuminismo: Atti del convegno internazionale / The Making of European Cartography*, edited by Diogo Ramada Curto, Angelo Cattaneo, and Andre Ferrand Alemeida, 19–48. Florence: Olschki, 2003.

———. *Fra Mauro's Mappa Mundi and Fifteenth-Century Venice*. Turnhout: Brepols, 2011.

Certeau, Michel de. *Practice of Everyday Life*. Translated by Steven Rendall. Berkeley: University of California Press, 1984.

Cerulli, Enrico. *Etiopi in Palestina: Storia della comunità etiopica de Gerusalemme*. Vol. 1. Rome: Libreria dello Stato, 1943.

Chareyron, Nicole. *Pilgrims to Jerusalem in the Middle Ages*. Translated by W. Donald Wilson. New York: Columbia University Press, 2005.

Clark, T. J. "The View from Notre-Dame." In *The Painting of Modern Life: Paris in the Art of Manet and His Followers*, 23–78. Princeton: Princeton University Press, 1984.

Cohen, Amnon, and Bernard Lewis. *Population and Revenue in the Towns of Palestine in the Sixteenth Century*. Princeton, Princeton University Press, 1978.

Colvin, Sidney. "Über einige Zeichnungen des Carpaccio in England." *Jahrbuch der Königlich*

Preussischen Kunstsammlungen 18 (1897): 193–204.

Conley, Tom. "Virtual Reality and the *Isolario.*" *Annali d'Italianistica* 14 (1996): 121–30.

Connolly, Daniel K. "Imagined Pilgrimage in the Itinerary Maps of Matthew Paris." *Art Bulletin* 81, no. 4 (1999): 598–622.

Constable, Giles. "Petrarch and Monasticism." First published in *Francesco Petrarca, Citizen of the World: Proceedings of the World Petrarch Congress, Washington D.C., April 6–13, 1974,* edited by Aldo S. Bernardo, 53–99. Albany: State University of New York Press, 1980. Reprinted in *Monks, Hermits, and Crusaders in Medieval Europe,* 53–99. London: Variorum Reprints, 1988.

Corbett, Margery. "The Architectural Title-page: An Attempt to Trace Its Development from Its Humanist Origins up to the Sixteenth and Seventeenth Centuries, the Heyday of the Complex Engraved Title-Page." *Motif* 12 (1964): 49–62.

Coüasnon, Charles. *The Church of the Holy Sepulchre in Jerusalem.* Translated by J.-P. B. Ross and Claude Ross. London: Oxford University Press, 1974.

Courcelle, Pierre. "Pétrarque entre Saint Augustine et les Augustins du XIVe siècle." *Studi petrarcheschi* 7 (1961): 51–71.

Couyat, Jules. "Les Routes d'Aidhab." *Bulletin de l'Institut Français d'Archéologie Orientale* 8 (1911): 135–43.

Crawford, O. G. S. *Ethiopian Itineraries, circa 1400–1524.* Hakluyt Society, 2nd ser., 109. Cambridge: University Press, 1958.

Creswell, K. A. C. *Early Muslim Architecture: Umayyads, Early ʿAbbāsids, and Ṭūlūnids.* 2 vols. Oxford: Clarendon Press, 1932.

Cuttler, Charles D. "Exotics in Post-Medieval European Art: Giraffes and Centaurs." *Artibus et historiae* 12, no. 23 (1991): 161–79.

Dackerman, Susan, et al. *Painted Prints: The Revelation of Color in Northern Renaissance and Baroque Engravings, Etchings, and Woodcuts.* University Park: Pennsylvania State University Press, 2002. Exhibition catalog.

Dalman, Gustaf. *Das Grab Christi in Deutschland.* Leipzig: Dieterich'schesbuchhandlung, 1922.

———. *Die Kapelle zum Heiligen Kreuz und das Heilige Grab in Görlitz und in Jerusalem.* Görlitz: Görlitzer Nachrichten und Anzeiger, 1916.

Damisch, Hubert. *The Origin of Perspective.* Translated by John Goodman. Cambridge, Mass.: MIT Press, 1994.

Dansette, Béatrice. "Les pèlerinages occidentaux en Terre Sainte: Une pratique de la 'Dévotion moderne' à la fin du Moyen Age? Relation inédite d'un pèlerinage effectué en 1486." *Archivum Franciscanum Historicum* 72 (1979): 106–33, 330–428.

Deák, Gloria. "The New World Depicted: Renaissance Woodcuts of 1493." *The Print Collector's Newsletter* 23, no. 4 (1992): 121–26.

Degenhart, Bernhard, and Annegrit Schmitt. "Marino Sanudo und Paolino Veneto: Zwei Literaten des 14. Jahrhunderts in ihrer Wirkung auf Buchillustrierung und Kartographie in Venedig, Avignon und Neapel." *Römishes Jahrbuch für Kunstgeschichte* 14 (1973): 1–137.

Delano-Smith, Catherine. "The Intelligent Pilgrim: Maps and Medieval Pilgrimage to the Holy Land." In Allen, *Eastward Bound,* 106–30.

Delano-Smith, Catherine, and Elizabeth Morley Ingram. *Maps in Bibles, 1500–1600: An Illustrated Catalogue.* Geneva: Librairie Droz, 1991.

De Seta, Cesare. "The Urban Structure of Naples: Utopia and Reality." In *The Renaissance from Brunelleschi to Michelangelo: The Representation of Architecture,* edited by Henry A. Millon and Vittorio Magnago Lampugnani, 348–71. Milan: Bompiani, 1994.

De Tolnay, Charles. *Le Maître de Flémalle et les frères van Eyck.* Brussels: Éditions de la Connaissance, 1939.

De Vos, Dirk. *Hans Memling: The Complete Works.* London: Thames and Hudson, 1994.

Dietz, Alexander. *Frankfurter Handelsgeschichte*. Vol. 1. Frankfurt: Hermann Minjon, 1910.

———. *Zur Geschichte der Frankfurter Büchermesse, 1462–1792*. Frankfurt: Hauser, 1922.

Dobras, Wolfgang, ed. *Gutenberg: Aventur und Kunst; Vom Geheimunternehmen zur ersten Medienrevolution*. Mainz: Hermann Schmidt, 2000. Exhibition catalog.

Duffy, Eamon. *The Stripping of the Altars: Traditional Religion in England, c. 1400–1580*. New Haven: Yale University Press, 1992.

Duntze, Oliver. "Das Titelblatt in Augsburg: Der Einleitungsholzschnitt als Vorstufe und Alternative des Titelblatts." *Archiv für Geschichte des Buchwesens* 63 (2008): 1–42.

Durling, Robert. "The Ascent of Mt. Ventoux and the Crisis of Allegory." *Italian Quarterly* 18 (1974): 7–28.

Durrieu, Paul. "Une vue de l'église du Saint-Sépulcre vers 1436, provenant du Bon Roi René." In *Florilegium ou Receuil de travaux d'érudition dédiés à M. le Marquis Melchior de Vogüe*, 197–207. Paris: Imprimerie Nationale, 1909.

Dürst, Arthur. *Seekarte des Iehuda ben Zara (Borgiano VII), 1497*. Zurich: Belser, 1983.

Dursteler, Eric R. *Venetians in Constantinople: Nation, Identity, and Coexistence in the Early Modern Mediterranean*. Baltimore: Johns Hopkins University Press, 2006.

Edson, Evelyn. *Mapping Time and Space: How Medieval Mapmakers Viewed Their World*. London: British Library, 1997.

———. "Reviving the Crusade: Sanudo's Schemes and Vesconte's Maps." In Allen, *Eastward Bound*, 131–55.

———. *The World Map, 1300–1492: The Persistence of Tradition and Transformation*. Baltimore: Johns Hopkins University Press, 2007.

Eisenstein, Elizabeth. *The Printing Press as Agent of Change: Communications and Cultural Transformations in Early Modern Europe*. 2 vols. Cambridge: Cambridge University Press, 1979.

Eisermann, Falk. "Der Ablaß als Medienereignis: Kommunikationswandel durch Einblattdrucke im 15. Jahrhundert." In *Tradition and Innovation in an Era of Change / Tradition und Innovation im Übergang zur Frühen Neuzeit*, edited by Rudolf Suntrup and Jan Veenstra, 99–128. Frankfurt: Peter Lang, 2001.

———. "Buchdruck und Herrschaftspraxis im 15. Jahrhundert: Der Würzburger Fürstbischof Rudolf von Scherenberg und sein Drucker Georg Reyser." In *Würzburg, der Große Löwenhof und die deutsche Literatur des Spätmittelalters*, edited by Horst Brunner, 495–513. Wiesbaden: Reichert, 2004.

———. "'Hinter Decken versteckt': Ein weiteres Exemplar des 31zeiligen Ablaßbriefs und andere Neufunde von Einblattdrucken des 15. Jahrhunderts." *Gutenberg-Jahrbuch* 74 (1999): 58–74.

———. "The Indulgence as a Media Event: Developments in Communication through Broadsides in the Fifteenth Century." In Swanson, *Promissory Notes*, 309–30.

Falchetta, Piero. *Fra Mauro's World Map: With a Commentary and Translations of the Inscriptions*. Turnhout: Brepols, 2006.

Feilke, Herbert. *Felix Fabris Evagatorium über seine Reise in das Heilige Land: Eine Untersuchung über die Pilgerliteratur des ausgehenden Mittelalters*. Frankfurt: Peter Lang, 1976.

Ferino-Pagden, Sylvia, and Giovanna Nepi Scirè, eds. *Giorgione: Myth and Enigma*. Vienna: Kunsthistorisches Museum, 2004. Exhibition catalog.

Ferriguto, Arnaldo. *Attraverso i "misteri" di Giorgione*. Castelfranco: Arti grafiche A. Trevisan, 1933.

Filedt Kok, J. P., ed. *Livelier than Life: The Master of the Amsterdam Cabinet or the Housebook Master*. Amsterdam: Rijksmuseum, 1985. Exhibition catalog.

Fischer, Hans. "Geschichte der Kartographie von Palästina." *Zeitschrift des deutschen Palästina-Vereins* 62 (1939): 169–89; 63 (1940): 1–21.

Foucault, Michel. "What Is an Author?" In *Language, Counter-Memory, Practice: Selected Essays and*

Interviews, translated by Donald F. Bouchard and Sherry Simon, 113–38. Ithaca: Cornell University Press, 1977. Originally published as "Qu'est-ce qu'un auteur?" *Bulletin de la société française de philosophie* 63, no. 3 (1969): 73–104.

Frenkel, Yehoshu'a. "Political and Social Aspects of Islamic Religious Endowments (*awqāf*): Saladin in Cairo (1169–73) and Jerusalem (1187–93)." *Bulletin of the School of Oriental and African Studies* 62, no. 1 (1999): 1–20.

Friedman, David. "'Fiorenza': Geography and Representation in a Fifteenth-Century City View." *Zeitschrift für Kunstgeschichte* 64, no. 1 (2001): 56–77.

Ganz-Blättler, Ursula. *Andacht und Abenteuer: Berichte europäischer Jerusalem- und Santiago-Pilger, 1320–1520*. Tübingen: Narr, 1990.

Gautier Dalché, Patrick. *La Géographie de Ptolémée en occident, IVe–XVIe siècle*. Turnhout: Brepols, 2009.

———. "L'œuvre géographique du cardinal Fillastre († 1428): Représentation du monde et perception de la carte à l'aube des découvertes." *Archives d'histoire doctrinale et littéraire du Moyen Âge* 59 (1992): 319–83.

———. "Pour une histoire du regard géographique: Conception et usage de la carte au XVe siècle." In *Il teatro della natura / The Theatre of Nature*, edited by Véronique Pasche, 77–103. Micrologus 4. Turnhout: Brepols, 1996.

———. "Un problem d'histoire culturelle: Perception et representation de l'espace au Moyen Âge." *Médiévales* 18 (1990): 5–15.

———. "The Reception of Ptolemy's *Geography* (End of the Fourteenth to Beginning of the Sixteenth Century)." In Woodward, *Cartography in the European Renaissance*, 285–310.

Geldner, Ferdinand. "Zum ältesten Missaldruck." *Gutenberg-Jahrbuch* 36 (1961): 101–6.

Gelhaus, Hermann. *Der Streit um Luthers Bibelverdeutschung im 16. und 17. Jahrhundert*. 2 vols. Tübingen: Niemeyer, 1989–90.

Gennes, Jean-Pierre de. *Les Chevaliers du Saint-Sépulcre de Jérusalem: Essai critique*. Vol. 1, *Origines et histoire générale de l'ordre*. Maulévrier: Editions Hérault, 1995.

Georgopoulou, Maria. *Venice's Mediterranean Colonies: Architecture and Urbanism*. Cambridge: Cambridge University Press, 2001.

Gerstel, Sharon E. J. "Medieval Messina" and "Focus: Venetian Methoni (Modon)." In *Sandy Pylos: An Archaeological History from Nestor to Navarino*, edited by Jack L. Davis, 211–28, 234–38. Austin: University of Texas Press, 1998.

Gibson, Walter. *"Mirror of the Earth": The World Landscape in Sixteenth-Century Flemish Painting*. Princeton: Princeton University Press, 1989.

Gill, Meredith J. *Augustine in the Italian Renaissance: Art and Philosophy from Petrarch to Michelangelo*. Cambridge: Cambridge University Press, 2005.

Gillespie, Alexandra. *Print Culture and the Medieval Author: Chaucer, Lydgate, and Their Books, 1473–1557*. Oxford: Oxford University Press, 2006.

Gilsenbach, Reimar. *Weltchronik der Zigeuner*. Vol. 1, *Von den Anfängen bis 1599*. Frankfurt: Peter Lang, 1994.

Gothic and Renaissance Art in Nuremberg, 1300–1550. Edited by Ellen Schultz. New York: Metropolitan Museum of Art, 1986. Exhibition catalog.

Goy, Richard. *Building Renaissance Venice*. New Haven: Yale University Press, 2006.

Grabar, Oleg. *The Dome of the Rock*. New York: Rizzoli, 1996.

———. "The Meaning of the Dome of the Rock in Jerusalem." *Medieval Studies at Minnesota* 3 (1988): 1–10.

———. "Notes on the Dome of the Rock." In *Jerusalem*, 217–29. Vol. 4 of *Constructing the Study of Islamic Art*. Aldershot: Ashgate, 2005.

———. *The Shape of the Holy: Early Islamic Jerusalem*. Princeton: Princeton University Press, 1996.

———. "Umayyad Dome of the Rock in Jerusalem." *Ars Orientalis* 3 (1959): 33–62.

Grabois, Aryeh. "Christian Pilgrims in the Thirteenth Century and the Latin Kingdom of Jerusalem:

Burchard of Mount Sion." In *Outremer: Studies in the History of the Crusading Kingdom of Jerusalem; Presented to Joshua Prawer*, edited by B. Z. Kedar, H. E. Mayer, and R. C. Smail, 285–96. Jerusalem: Yad Izhak Ben-Zvi Institute, 1982.

Grafton, Anthony, Elizabeth Eisenstein, and Adrian Johns. "AHR Forum: How Revolutionary Was the Print Revolution?" *American Historical Review* 107, no. 1 (2002): 84–128.

Greenblatt, Stephen. *Renaissance Self-Fashioning: From More to Shakespeare*. Chicago: University of Chicago Press, 1980.

Grube, Ernst J. "La 'laque' vénitien et la reliure au XVIè siècle." In Carboni, *Venise et l'Orient*, 230–43.

Harley, J. B., and David Woodward, eds. *Cartography in Prehistoric, Ancient, and Medieval Europe and the Mediterranean*. The History of Cartography 1. Chicago: University of Chicago Press, 1987.

Harvey, P. D. A. "The Biblical Content of Medieval Maps of the Holy Land." In *Geschichtsdeutung auf alten Karten: Archäologie und Geschichte*, edited by Dagma Unverhau, 56–63. Wiesbaden: Harrassowitz, 2003.

———, ed. *The Hereford World Map: Medieval World Maps and Their Context*. London: British Library, 2006.

Haussherr, Reiner. "Ein Pfarrkind des heiligen Hauptherren St. Sebald in der Grabeskirche." *Österreichische Zeitschrift für Kunst und Denkmalpflege* 40 (1986): 195–204.

———. "Spätgotische Ansichten der Stadt Jerusalem (Oder: War der Hausbuch Meister in Jerusalem?)." *Jahrbuch der Berliner Museen* 29–30 (1987–88): 47–70.

Hawari, Mahmoud K. *Ayyubid Jerusalem (1187–1250): An Architectural and Archaeological Study*. Oxford: Archaeopress, 2007.

Helmrath, Johannes. "The German *Reichstage* and the Crusade." In Housley, *Crusading in the Fifteenth Century*, 53–69.

Herkenhoff, Michael. *Die Darstellung außereuropäischer Welten in Drucken deutscher Offizinen des 15 Jahrhunderts*. Berlin: Akademie, 1996.

Herrigel, Hermann. "Bernhard von Breydenbach: Ein deutscher Reisender vom Ende des 15. Jahrhunderts." *Das Innere Reich* 6, no. 1 (1939): 68–89.

Herz, Randall. *Studien zur Drucküberlieferung der "Reise ins Gelobte Land" Hans Tuchers des Älteren: Bestandsaufnahme und historische Auswertung der Inkunabeln unter Berücksichtigung der späteren Drucküberlieferung*. Nuremburg: Selbstverlag des Stadtarchivs Nürnberg, 2005.

Hess, Daniel. *Meister um das "mittelalterliche Hausbuch": Studien zur Hausbuchmeisterfrage*. Mainz: Philipp von Zabern, 1994.

Higgins, Iain Macleod. "Defining the Earth's Center in a Medieval 'Multi-Text': Jerusalem in the *Book of John Mandeville*." In *Text and Territory: Geographical Imagination in the European Middle Ages*, edited by Sylvia Tomasch and Sealy Gilles, 29–53. Philadelphia: University of Pennsylvania Press, 1998.

Hillenbrand, Robert. *Islamic Architecture: Form, Function, and Meaning*. New York: Columbia University Press, 1994.

Hindman, Sandra, ed. *The Early Illustrated Book: Essays in Honor of Lessing J. Rosenwald*. Washington, D.C.: Library of Congress, 1982.

Hippler, Christiane. *Die Reise nach Jerusalem: Untersuchungen zu den Quellen, zum Inhalt und zur literarischen Struktur der Pilgerberichte des Spätmittelalters*. Frankfurt: Peter Lang, 1987.

Hobson, Anthony. *Humanists and Bookbinders: The Origins and Diffusion of Humanistic Bookbinding, 1459–1559*. Cambridge: Cambridge University Press, 1989.

Hoogvliet, Margriet. "*Mappa Mundi* and the Medieval Hermeneutics of Cartographical Space." In *Regions and Landscapes: Reality and Imagination in Late Medieval and Early Modern Europe*, edited by Peter Ainsworth and Tom Scott, 25–46. Oxford: Peter Lang, 2000.

———. "The Medieval Texts of the 1486 Ptolemy Edition by Johann Reger of Ulm." *Imago Mundi* 54 (2002): 7–18.

Hoppe, Stephan, and Sebastian Fitzner. "Das frühe Studium der Architektur Jerusalems: Zwei

unbekannte Zeichnungen im Zusammenhang mit Erhard Reuwichs Reise ins Heilige Land, 1483–1484." In *Reibungspunkte: Ordnung und Umbruch in Architektur und Kunst; Festschrift für Hubertus Günther*, edited by Hanns Hubach, Barbara van Orelli-Messerli, and Tadej Tassini, 103–14. Petersberg: Imhof, 2008.

Hotz, Walter. "Der 'Hausbuchmeister' Nikolaus Nievergalt und sein Kreis." *Der Wormsgau* 3, no. 3 (1953): 97–125.

Housley, Norman, ed. *Crusading in the Fifteenth Century: Message and Impact*. Houndmills, UK: Palgrave Macmillan, 2004.

———. "Indulgences for Crusading, 1417–1517." In *Promissory Notes on the Treasury of Merit: Indulgences in Late Medieval Europe*, 277–308. Leiden: Brill, 2006.

Humfrey, Peter. *Carpaccio*. London: Chaucer Press, 2005.

Husband, Timothy B. *The Luminous Image: Painted Glass Roundels in the Lowlands, 1480–1560*. New York: Metropolitan Museum of Art, 1995. Exhibition catalog.

———. *The Medieval Housebook and the Art of Illustration*. New York: Frick Collection, 1999. Exhibition catalog.

Huschenbett, Dietrich. "Die Literatur der deutschen Pilgerreisen nach Jerusalem im späten Mittelalter." *Deutsche Vierteljahrschrift für Literaturwissenschaft und Geistesgeschichte* 59, no. 1 (1985): 29–46.

———. "Spätmittelalterliche Berichte von Palästinafahrten und mittelalterliche Kartographie." In *Ein Weltbild vor Columbus: Die Ebstorfer Weltkarte, Interdisziplinäres Colloquium 1988*, edited by Hartmut Kugler, 367–79. Weinheim: VCH, 1991.

———. "Der tradierte und erfahrene Orient: Zur Frage der Traditionsgebundenheit sogenannter geistlicher und ausgeführter Pilgerreisen." In *Begegnung mit dem "Fremden": Grenzen—Traditionen—Vergleiche; Akten des VIII. Internationalen Germanisten-Kongresses, Tokyo 1990*, vol. 7, sec. 12, *Klassik—Konstruction und Rezeption*; sec. 13, *Orientalismus, Exotismus, koloniale Diskurse*, edited by Yoshinori Shichiji, 296–316. Munich: Iudicium, 1991.

Hutchinson, Jane Campbell. "Ex Ungue Leonem: The History of the 'Hausbuchmeisterfrage.'" In Filedt Kok, *Livelier than Life*, 41–64.

———. "The Housebook Master and the Mainz Marienleben." In "Tribute to Wolfgang Stechow," edited by Walter L. Strauss. Special issue, *Print Review* 5 (Spring 1976): 96–113.

———. *The Master of the Housebook*. New York: Collectors Editions, 1972.

Iwanczak, Wojciech. "Entre l'espace Ptolémaïque et l'empirie: Les cartes de Fra Mauro." *Médiévales* 18 (1990): 53–68.

Jameson, Fredric. "Cognitive Mapping." In *Marxism and the Interpretation of Culture*, edited by Cary Nelson and Lawrence Grossberg, 347–57. Urbana: University of Illinois Press, 1988.

Jammes, André, and Henri Saffrey. "Une image xylographique inconnue de la Passion de Jésus à Jérusalem." *Bulletin du bibliophile* 1 (1994): 3–23.

Janson, H. W. *Apes and Ape Lore in the Middle Ages and Renaissance*. London: Warburg Institute, 1952.

Jardine, Lisa, and Jerry Brotton. *Global Interests: Renaissance Art between East and West*. Ithaca: Cornell University Press, 2000.

Jarrar, Sabri. "Two Islamic Construction Plans for al-Haram al-Sharif." In Rosovsky, *City of the Great King*, 380–416.

Jennings, J. E. "Excavations on the Mount of Olives, 1965." *Annual of the Department of Antiquities of Jordan* 14 (1969): 11–22.

Johns, Adrian. *The Nature of the Book: Print and Knowledge in the Making*. Chicago: University of Chicago Press, 1998.

Kamal, Youssouf. *Monumenta Cartographica Africae et Aegypti*. 5 vols. 1926–51. Reprint, Frankfurt am

Main: Institut für Geschichte der Arabisch-Islamischen Wissenschaften an der Johann Wolfgang Goethe-Universität, 1987.

Kammerer, Albert. *La Mer Rouge, l'Abyssinie et l'Arabie depuis l'Antiquité*. 3 vols in 6. Cairo: Société royale de géographie d'Égypte, 1929–52.

Keil, Gundolf. "Gart der Gesundheit." In Ruh and Wachinger, *Die deutsche Literatur des Mittelalters*, vol. 2, ed. Kurt Ruh, cols. 1071–92. Berlin: Walter de Gruyter, 1980.

———. "Hortus Sanitatis, Gart der Gesundheit, Gaerde der Sunthede." In *Medieval Gardens*, edited by Elisabeth MacDougall, 55–68. Washington, D.C.: Dumbarton Oaks, 1986.

———. "The Textual Transmission of the *Codex Berleburg*." In *Manuscript Sources of Medieval Medicine: A Book of Essays*, edited by Margaret Schleissner, 17–33. New York: Garland, 1995.

Khattab, Aleya. *Das Ägyptenbild in den deutschsprachigen Reisebeschreibungen der Zeit von 1285–1500*. Frankfurt: Peter Lang, 1982.

Kiessling, Gerhard. "Die Anfänge des Titelblattes in der Blütezeit des deutschen Holzschnitts, 1470–1530." *Buch und Schrift* 3 (1929): 9–45.

Kline, Naomi Reed. *Maps of Medieval Thought: The Hereford Paradigm*. Woodbridge, Suffolk: Boydell Press, 2001.

Kluckert, E. "Die Simultanbilder Memlings, ihre Wurzeln und ihre Wirkungen." *Das Münster* 27 (1974): 284–95.

———. "Zur Methode der Erzählformen in der Malerei." *Das Münster* 26, no. 3 (1973): 150–51.

Knefelkamp, Ulrich. *Die Suche nach dem Reich des Priesterkönigs Johannes: Dargestellt anhand von Reiseberichten und anderen ethnographischen Quellen des 12. bis 17. Jahrhunderts*. Gelsenkirchen: Andreas Müller, 1986.

Koerner, Joseph Leo. *Caspar David Friedrich and the Subject of Landscape*. London: Reaktion Books, 1990.

———. *The Moment of Self-Portraiture in German Renaissance Art*. Chicago: University of Chicago Press, 1993.

König, Eberhard. "Der Hausbuchmeister / The Housebook Master." In Wolfegg, *Mittelalterliche Hausbuch / Medieval Housebook*, commentary volume, 163–219.

Krauss, Rosalind E. "Photography's Discursive Spaces." In *The Originality of the Avant-Garde and Other Modernist Myths*, 131–50. Cambridge, Mass.: MIT Press, 1985.

Kretschmer, Konrad. *Die italienischen Portolane des Mittelalters: Ein Beitrag zur Geschichte der Kartographie und Nautik*. Berlin: E. S. Mittler und Sohn, 1909.

Krinsky, Carol. "Representations of the Temple of Jerusalem before 1500." *Journal of the Warburg and Courtauld Institutes* 33 (1970): 1–19.

Kubinski, Joyce. "Orientalizing Costume in Early Fifteenth-Century French Manuscript Painting (*Cité des Dames* Master, Limbourg Brothers, Boucicaut Master, and Bedford Master)." *Gesta* 40 (2001): 161–80.

Kupfer, Marcia. "Mappaemundi: Image, Artefact, Social Practice." In Harvey, *Hereford World Map*, 253–67.

———. "Medieval World Maps: Embedded Images, Interpretive Frames." *Word & Image* 10, no. 3 (1994): 262–88.

Landau, David, and Peter Parshall. *The Renaissance Print, 1470–1550*. New Haven: Yale University Press, 1994.

Lane, Barbara. *Hans Memling: Master Painter in Fifteenth-Century Bruges*. London: Harvey Miller, 2009.

Lane, Frederic C. *Venice: A Maritime Republic*. Baltimore: Johns Hopkins University Press, 1973.

Laor, Eran. *Maps of the Holy Land: Cartobibliography of Printed Maps, 1475–1900*. New York: Alan R. Liss, 1986.

La Roncière, Charles de. *La dècouverte de l'Afrique au Moyen Âge: Cartographes et explorateurs*. 3 vols. Cairo: Société royale de géographie d'Égypte, 1924–27.

Lauts, Jan. *Carpaccio: Paintings and Drawings, Complete Edition*. New York: Phaidon, 1962.

Lefebvre, Henri. *The Production of Space*. Translated by Donald Nicholson-Smith. Oxford: Blackwell, 1991. Originally published as *La production de l'espace* (Paris: Éditions Anthropos, 1974).

Lehmann-Haupt, Hellmut. "Die Holzschnitte der Breydenbachschen Pilgerfahrt als Vorbilder gezeichneter Handschriftenillustration." *Gutenberg-Jahrbuch* 4 (1929): 152–63.

———. *Peter Schöffer aus Gernsheim und Mainz*. Wiesbaden: Reichert, 2002.

Lehrs, Max. *Geschichte und kritischer Katalog des deutschen, niederländischen und französischen Kupferstichs im XV. Jahrhundert*. 9 vols. Vienna: Gesellschaft für vervielfältigende Kunst, 1908–34.

Lemonnier, Henry. "Un pèlerinage en Terre Sainte au XVe siècle: Les *Pérégrinations* de Breydenbach." *Byblis* 9 (1930): 123–28.

Lemper, Ernst-Heinz. "Die Kapelle zum Heiligen Kreuz beim Heiligen Grab in Görlitz: Baugeschichte und Ikonologie." In *Kunst des Mittelalters in Sachsen: Festschrift Wolf Schubert, dargebracht zum sechzigsten Geburtstag am 28. Januar 1963*, edited by Elisabeth Hütter, Fritz Löffler, and Heinrich Magirius, 142–57. Weimar: Hermann Böhlaus Nachfolger, 1967.

Lievens-de Waegh, Marie Léopoldine. *Le Musée National d'Art Ancien et le Musée National des Carreaux de Faïence de Lisbonne*. Corpus de la peinture des anciens Pays-Bas méridonaux au quinzième siècle, 16. Brussels: Centre international de recherches "Primitifs Flamands," 1991.

Lillie, Amanda. *Florentine Villas in the Fifteenth Century: An Architectural and Social History*. Cambridge: Cambridge University Press, 2005.

Little, Donald. "Communal Strife in Late Mamlūk Jerusalem." *Islamic Law and Society* 6, no. 1 (1999): 69–96.

———. "Mujīr al-Dīn al-'Ulaymī's Vision of Jerusalem in the Ninth/Fifteenth Century." *Journal of the American Oriental Society* 115, no. 2 (1995): 237–47.

Lowry, Martin. *Nicholas Jenson and the Rise of Venetian Publishing in Renaissance Europe*. Oxford: Basil Blackwell, 1991.

Lunt, William. *Papal Revenues in the Middle Ages*. 2 vols. New York: Octagon Books, 1965.

Mack, Rosamond. *Bazaar to Piazza: Islamic Trade and Italian Art, 1300–1600*. Berkeley: University of California Press, 2001.

Manners, Ian R. "Constructing the Image of a City: The Representation of Constantinople in Christopher Buodelmonti's *Liber Insularum Archipelagi*." *Annals of the Association of American Geographers* 87, no. 1 (1997): 72–102.

Marcon, Susy. "Leonardo Bellini and Fra Mauro's World Map: The *Earthly Paradise*." In Falchetta, *Fra Mauro's World Map*, 135–69.

Marshall, David R. "Carpaccio, Saint Stephen, and the Topography of Jerusalem." *Art Bulletin* 66, no. 4 (1984): 610–20.

Martin, John. "Inventing Sincerity, Refashioning Prudence." *American Historical Review* 102 (1992): 1309–42.

McKitterick, David. *Print, Manuscript, and the Search for Order, 1450–1830*. Cambridge: Cambridge University Press, 2003.

Meinecke, Michael. *Die Mamlukische Architektur in Ägypten und Syrien, 648/1250 bis 923/1517*. Glückstadt: J. J. Augustin, 1992.

Meinert, Till. *Die Heilig-Grab-Anlage in Görlitz: Architektur und Geschichte eines spätmittelatlerlichen Bauensembles*. Esens: Edition Rust, 2004.

Mekeel-Matteson, Carolanne. "The Meaning of the Dome of the Rock." *Islamic Quarterly* 43, (1999): 149–85.

Melion, Walter. "*Ad ductum itineris et dispositionem mansionum ostendendam*: Meditation, Vocation, and Sacred History in Abraham Ortelius's *Parergon*." *Journal of the Walters Art Gallery* 57 (1999): 49–72.

Meller, Peter. "*I Tre Filosofi di Giorgione*." In *Giorgione e l'umanesimo veneziano*, edited by Rodolfo Pallucchini, 1: 227–47. 2 vols. Florence: Leo S. Olschki, 1981.

Mesenburg, Peter. *Kartographie im Mittelalter: Eine analytische Betrachtung zum Informationsgehalt der Portulankarte des Petrus Roselli aus dem Jahre 1449*. Karlsruhe: Fachhochschule Karlsruhe, Fachbereich Vermessungswesen und Kartographie, 1989.

Meserve, Margaret. *Empires of Islam in Renaissance Historical Thought*. Cambridge, MA: Harvard University Press, 2008.

———. "News from Negroponte: Politics, Popular Opinion, and Information Exchange in the First Decade of the Italian Press." *Renaissance Quarterly* 59, no. 2 (2006): 440–80.

Meyer, Hermann M. Z. "The Pictorial Presentation: Maps, Views, and Reconstructions of Jerusalem." In *Jerusalem: The Saga of the Holy City*, 59–72. Jerusalem: Universitas, 1954.

Meyer zur Capellen, Jürg. *Gentile Bellini*. Stuttgart: Steiner Wiesbaden, 1985.

Miedema, Nine. "Following in the Footsteps of Christ: Pilgrimage and Passion Devotion." In *The Broken Body: Passion Devotion in Late-Medieval Culture*, edited by A. A. MacDonald, H. N. B. Ridderbos, and R. M. Schlusemann, 73–92. Groningen: Egbert Forsten, 1998.

Minnis, Alastair J. *Medieval Theory of Authorship: Scholastic Literary Attitudes in the Later Middle Ages*. 2nd ed. 1984. Reprint, Philadelphia: University of Pennsylvania Press, 1988.

Molmenti, Pompeo, and Gustav Ludvig. *The Life and Works of Vittorio Carpaccio*. Translated by Robert H. Hobart Cust. London: J. Murray, 1907.

Monmonier, Mark. *Rhumb Lines and Map Wars: A Social History of the Mercator Projection*. Chicago: University of Chicago Press, 2004.

Morrison, Donald R. "Note on the Frontispiece: 'Aristotle and Alexander of Aphrodisias' by Ulocrino." In *Aristotle Transformed: The Ancient Commentators and Their Influence*, edited by Richard Sorabji, 481–84. London: Duckworth, 1990.

Moser, [Immanuel Gottlieb?]. "Beschreibung der drei ersten Ausgaben und der spanischen Uebersetzung der Reise des Bernhard von Breydenbach in den Orient, nebst einer mit den nöthigen Beweisstellen belegten Geschichte ihrer Abfassung." *Serapeum* 3, nos. 4–6 (1842): 56–84.

———. "Nachtrag zu dem Artikel über Bernhards von Breydenbach Reise in den Orient." *Serapeum* 4, no. 17 (1843): 270.

Muller, Samuel. *Schilders-Vereenigingen te Utrecht: Bescheiden uit het Gemeente-Archief*. Utrecht: J. L. Beijers, 1880.

Müller-Jahncke, Wolf-Dieter. "Deßhalben ich solichs angefangen werck vnfolkomen ließ: Das Herbar des *Codex Berleburg* als eine Vorlage des *Gart der Gesundheit*." *Deutsche Apotheker-Zeitung* 117, no. 41 (1977): 1663–71.

Murray, G. W. "'Aidhab." *Geographical Journal* 68, no. 3 (1926): 235–40.

———. "Felix Fabri's Pilgrimage from Gaza to Mount Sinai and Cairo, A.D. 1483." *Geographical Journal* 122, no. 3 (1956): 335–42.

Nagel, Alexander, and Christopher S. Wood. *Anachronic Renaissance*. New York: Zone Books, 2010.

Naredi-Rainer, Paul von. *Salomos Tempel und das Abendland: Monumentale Folgen historischer Irrtumer*. Cologne: Dumont, 1994.

Nebenzahl, Kenneth. *Maps of the Holy Land: Images of Terra Sancta through Two Millennia*. New York: Abbeville Press, 1986.

Newton, Stella Mary. *The Dress of the Venetians, 1495–1525*. Aldershot: Scolar Press, 1988.

O'Connell, Michael. "Authority and the Truth of Experience in Petrarch's 'Ascent of Mount Ventoux.'" *Philological Quarterly* 62, no. 4 (1983): 507–20.

Odermann, Erich. "Eine Seereise deutscher Pilger im 15. Jahrhundert." *Archiv für Buchgewerbe und Gebrauchsgraphik* 71, no. 12 (1934): 821–28.

Oehme, Ruthardt. "Die Palästinakarte aus Bernhard von Breitenbachs Reise in das Heilige Land, 1486." In *Aus der Welt des Buches: Festgabe zum 70. Geburtstag von Georg Leyh, dargebracht*

von Freunden und Fachgenossen, 70–83. Leipzig: Otto Harrassowitz, 1950.

Orbán, A. P. "Bernhard von Breydenbach, *Peregrinatio in terram sanctam*." *Ons Geestelijk Erf* 57 (1983): 180–90.

Ousterhout, Robert. "Rebuilding the Temple: Constantine Monomachus and the Holy Sepulchre." *Journal of the Society of Architectural Historians* 48 (1989): 66–78.

Paatz, Walther von. "Das Aufkommen des Astwerkbaldachins in der deutschen spätgotischen Skulptur und Erhard Reuwichs Titelholzschnitt in Breidenbachs 'Peregrinationes in Terram Sanctam.'" In *Bibliotheca Docet: Festgabe für Carl Wehmer*, edited by Siegfried Joost, 355–67. Amsterdam: Der Erasmus Buchhandlung, 1963.

Pächt, Otto. "René d'Anjou—Studien I." *Jahrbuch der kunsthistorischen Sammlungen in Wien* 69 (1973): 85–126.

Pächt, Otto, and Dagmar Thoss. *Flämische Schule II.* 2 vols. Vienna: Österreichische Akademie der Wissenschaft, 1990.

Pane, Giulio. *La Tavola Strozzi tra Napoli e Firenze: Un'immagine della città nel Quattrocento.* Naples: Grimaldi and C. Editori, 2009.

Paravicini, Werner, ed. *Europäische Reiseberichte des späten Mittelalters: Eine analytische Bibliographie.* Frankfurt: Peter Lang, 2000.

Parshall, Peter. "Imago Contrafacta: Images and Facts in the Northern Renaissance." *Art History* 16, no. 4 (1993): 554–79.

———, ed. *The Woodcut in Fifteenth-Century Europe.* Studies in the History of Art 75. Washington, D.C.: National Gallery of Art, 2009.

Parshall, Peter, and Rainer Schoch. *Origins of European Printmaking: Fifteenth-Century Woodcuts and Their Public.* Washington, D.C.: National Gallery of Art, 2005. Exhibition catalog.

Paulus, Nikolaus. "Die Ablässe der Kreuzwegandacht." *Theologie und Glaube* 5 (1913): 1–15.

———. *Geschichte des Ablasses im Mittelalter.* 3 vols. 1922–23. Reprinted with introduction and bibliography by Thomas Lentz. Darmstadt: Wissenschaftliche Buchgesellschaft, 2000.

———. "Raimund Peraudi als Ablaßkommissar." *Historisches Jahrbuch* 21, no. 4 (1900): 645–82.

Paviot, Jacques. *Les Ducs de Bourgogne, la croisade et l'Orient, fin XIVe siècle–XVe siècle.* Paris: Presses de l'Université de Paris-Sorbonne, 2003.

Pieper, Jan. "Der Garten des Heiligen Grabes zu Görlitz/The Garden of the Holy Sepulchre in Görlitz." *Daidalos* 58 (1995): 38–43.

———. "Jerusalemkirchen: Mittelalterliche Kleinarchitekturen nach dem Modell des Heiligen Grabes." *Bauwelt* 80, no. 3 (1989): 82–101.

Pit, Adriaan. "La gravure dans les Pays-Bas au XVe siècle et ses influences sur la gravure en Allemagne, en Italie et en France." *Revue de l'art chrétien* 34, no. 6 (1891): 486–97.

Pon, Lisa. "A Document for Titian's *St. Roch*." *Print Quarterly* 19, no. 3 (2002): 275–77.

Prawer, Joshua. "The Lintels of the Holy Sepulcher." In *Jerusalem Revealed: Archaeology in the Holy City, 1968–1974*, edited by Yigael Yadin, 111–13. New Haven: Yale University Press; Jerusalem: Israel Exploration Society, 1976.

Pringle, Denys. *The Churches of the Crusader Kingdom of Jerusalem: A Corpus.* Vol. 3, *The City of Jerusalem.* Cambridge: Cambridge University Press, 2007.

Purtle, Carol J. *The Marian Paintings of Jan van Eyck.* Princeton: Princeton University Press, 1982.

Quillen, Carol. *Rereading the Renaissance: Petrarch, Augustine, and the Language of Humanism.* Ann Arbor: University of Michigan Press, 1998.

Rabbat, Nasser. *Mamluk History through Architecture: Monuments, Culture, and Politics in Medieval Egypt and Syria.* London: I. B. Tauris, 2010.

Raby, Julian. "Mehmed the Conqueror's Greek Scriptorium." *Dumbarton Oaks Papers* 37 (1983): 15–34.

———. "Pride and Prejudice: Mehmed the Conqueror and the Italian Portrait Medal." In *Italian Medals*, edited by J. Graham Pollard, 171–94.

Studies in the History of Art 21. Washington, D.C.: National Gallery of Art, 1987.

———. *Venice, Dürer, and the Oriental Mode*. London: Islamic Art Publications, 1982.

Rappard, F. A. L. Ridder van. "De rekeningen van de kerkmeesters der Buurkerk te Utrecht in de 15e eeuw." *Bijdragen en mededeelingen van het Historisch Genootschap (gevestigd te Utrecht)* 3 (1880): 25–224.

Rautenberg, Ursula. "Die Entstehung und Entwicklung des Buchtitelblatts in der Inkunabelzeit in Deutschland, den Niederlanden und Venedig—Quantitative und qualitative Studien." *Archiv für Geschichte des Buchwesens* 62 (2008): 1–105.

Raymond, André. "Cairo's Area and Population in the Early Fifteenth Century." *Muqarnas* 2 (1984): 21–31.

Reynaud, Nicole. "Barthélémy d'Eyck avant 1450." *Revue de l'Art* 84 (1989): 22–43.

Ringbom, Sixten. *Icon to Narrative: The Rise of the Dramatic Close-up in Fifteenth-Century Devotional Painting*. 2nd ed. Doornspijk: Davaco, 1984. First published 1965.

Rohrbacher, Heinrich. "Bernhard von Breydenbach und sein Werk 'Peregrinatio in terram sanctam' (1486)." *Philobiblon* 33, no. 2 (1989): 89–113.

Röhricht, Reinhold. *Deutsche Pilgerreisen nach dem Heiligen Lande*. Innsbruck: Wagner'sche Universitäts-Buchhandlung, 1900.

———. "Karten und Pläne zur Palästinakunde aus dem 7. bis 16. Jahrhundert." *Zeitschrift des deutschen Palästina-Vereins* 14 (1891): 8–11, 87–92, 137–41; 15 (1892): 34–39, 183–88.

———. "Marino Sanudo sen. als Kartograph Palästinas." *Zeitschrift des deutschen Palästina-Vereins* 21 (1898): 84–126.

———. "Die Palästinakarte Bernhard von Breitenbach's." *Zeitschrift des deutschen Palästina-Vereins* 24 (1901): 129–35.

———. "Die Palästinakarte des William Wey." *Zeitschrift des deutschen Palästina-Vereins* 27 (1904): 188–93.

———. "Zur Bibliotheca geographica Palaestinae." *Zeitschrift des deutschen Palästina-Vereins* 16 (1893): 269–96.

Röpcke, Andreas. "Geld und Gewissen: Raimund Peraudi und die Ablaßverkündung in Norddeutschland am Ausgang des Mittelalter." *Bremisches Jahrbuch* 71 (1992): 43–80.

Rosen-Ayalon, Myriam. *The Early Islamic Monuments of al-Haram al-Sharif: An Iconographic Study*. Jerusalem: Institute of Archaeology, Hebrew University, 1989.

Rosovsky, Nitza, ed. *City of the Great King: Jerusalem from David to the Present*. Cambridge, Mass.: Harvard University Press, 1996.

Ross, Elizabeth. "Mainz at the Crossroads of Utrecht and Venice: Erhard Reuwich and the *Peregrinatio in terram sanctam (1486)*." In *Cultural Exchange between the Netherlands and Italy, 1400–1600*, edited by Ingrid Alexander-Skipnes, 123–44. Turnhout: Brepols, 2007.

———. "The Reception of Islamic Culture in the Book Collection of Peter Ugelheimer." In *The Books of Venice / Il libro veneziano*, edited by Lisa Pon and Craig Kallendorf, 127–51. Miscellanea Marciana 20. Venice: Biblioteca Nazionale Marciana; Venice: La Musa Talia; New Castle, Del.: Oak Knoll Press, 2008.

Rubin, Rehav. "Ideology and Landscape in Early Printed Maps of Jerusalem." In *Ideology and Landscape in Historical Perspective: Essays on the Meanings of Some Places in the Past*, edited by Alan R. H. Baker and Gideon Biger, 15–30. Cambridge: Cambridge University Press, 1992.

Rudloff-Hille, Gertrud. "Das Doppelbildnis eines Liebespaares unter dem Hanauischen Wappen im Schlossmuseum in Gotha." *Bildende Kunst* 16 (1968): 19–23.

Rudy, Kathryn. *Virtual Pilgrimages in the Convent: Imagining Jerusalem in the Late Middle Ages*. Turnhout: Brepols, 2011.

Ruh, Kurt, and Burghart Wachinger, eds. *Die deutsche Literatur des Mittelalters: Verfasserlexikon*. 14 vols. Berlin: Walter de Gruyter, 1978–2008.

Sandström, Sven. "The Decoration of the Belvedere of Innocent VIII." *Konsthistorisk tidskrift* 29 (1960): 35–75.

Savage, Henry. "Pilgrimages and Pilgrim Shrines in Palestine and Syria after 1095." In *A History of the Crusades*, vol. 4, *The Art and Architecture of the Crusader States*, edited by Harry Hazard, 36–68. Madison: University of Wisconsin Press, 1977.

Scaglia, Gustina. "The Origin of an Archaeological Plan of Rome by Alessandro Strozzi." *Journal of the Warburg and Courtauld Institutes* 27 (1964): 137–63.

Schmidt, Peter. *Gedruckte Bilder in Handgeschriebenen Büchern: Zum Gebrauch von Druckgraphik im 15. Jahrhundert*. Cologne: Böhlau, 2003.

Schmitt, Charles. "Aristotelianism in the Veneto and the Origins of Modern Science: Some Considerations on the Problem of Continuity." In *Aristotelismo veneto e scienza moderna: Atti del 250 anno accademico del Centro per la storia della tradizione aristotelica nel Veneto*, edited by Luigi Olivieri, 1:104–23. 2 vols. Padua: Antenore, 1983.

———. "Renaissance Averroism Studied through the Venetian Editions of Aristotle-Averroës (with Particular Reference to the Giunta Edition of 1550–2)." *Convegno internazionale: L'Averroismo in Italia (Roma, 18–20 aprile 1977)*, 121–42. Rome: Accademia Nazionale dei Lincei, 1979.

Schneider, Cornelia. *Peter Schöffer: Bücher für Europa*. Mainz: Gutenberg-Museum, 2003.

———, ed. *Die Reise nach Jerusalem: Bernhard von Breydenbachs Wallfahrt ins Heilige Land*. Mainz: Gutenberg-Museum, 1992. Exhibition catalog.

Schramm, Albert. *Der Bilderschmuck der Frühdrucke*. 23 vols. Leipzig: Deutsche Museum für Buch und Schrift; K. W. Hiersemann, 1920–43.

Schreiner, Klaus. "Volkssprache als Element gesellschaftlicher Integration und Ursache sozialer Konflikte: Formen und Funktionen volkssprachlicher Wissensverbreitung um 1500." In *Europa 1500: Integrationsprozesse im Widerstreit; Staaten, Regionen, Personenverbände, Christenheit*, edited by Ferdinand Seibt and Winfried Eberhard, 468–95. Stuttgart: Klett-Cotta, 1987.

Schröcker, Alfred. "Unio atque concordia: Reichspolitik Bertholds von Henneberg, 1484 bis 1504." Ph.D. diss., Julius-Maximilians-Universität zu Wurzburg, 1970.

Schulz, Juergen. "Jacopo de' Barbari's View of Venice: Map Making, City Views, and Moralized Geography before the Year 1500." *Art Bulletin* 60, no. 3 (1978): 425–74.

———. "Pinturicchio and the Revival of Antiquity." *Journal of the Warburg and Courtauld Institutes* 25, no. 1/2 (1962): 35–55.

———. "The Printed Plans and Panoramic Views of Venice, 1486–1797." *Saggi e memorie di storia dell'arte* 7 (1970): 1–182.

Schuster, Julius. "Secreta Salernitana und Gart der Gesundheit: Eine Studie zur Geschichte der Naturwissenschaften und Medizin des Mittelalers." In *Mittelalterliche Handschriften: Paläographische, kunsthistorische, literarische und bibliotheksgeschichtliche Untersuchungen; Festgabe zum 60. Geburtstage von Hermann Degering*, 203–37. Leipzig: Karl W. Hiersemann, 1926.

Schwoebel, Robert. *The Shadow of the Crescent: The Renaissance Image of the Turk, 1453–1517*. New York: St. Martin's Press, 1967.

Setton, Kenneth. *Papacy and the Levant, 1204–1571*. 4 vols. Philadelphia: American Philosophical Society, 1976–84.

Seyboth, Reinhard. "Die Königserhebung Maximilians I. und die Stellungnahme der Kurie im Licht der Reichstage von 1486 und 1487." In *Reichstage und Kirche: Kolloquium der Historischen Kommission bei der Bayerischen Akademie der Wissenschaften, München, 9. März 1990*, edited by Erich Meuthen, 41–54. Göttingen: Vandenhoeck and Ruprecht, 1991.

———. "Die Reichstage der 1480er Jahre." In *Deutscher Königshof, Hoftag und Reichstag im späteren*

Mittelalter, edited by Peter Moraw, 519–45. Stuttgart: Jan Thorbecke, 2002.

Shalev, Zur, and Charles Burnett. *Ptolemy's "Geography" in the Renaissance.* London: Warburg Institute, 2011.

Shani, Raya. "The Iconography of the Dome of the Rock." *Jerusalem Studies in Arabic and Islam* 23 (1999): 158–207.

Sheingorn, Pamela. *The Easter Sepulchre in England.* Kalamazoo, Mich.: Medieval Institute, 1987.

Shoemaker, Stephen. *Ancient Traditions of the Virgin Mary's Dormition and Assumption.* Oxford: Oxford University Press, 2002.

Silver, Larry, and Elizabeth Wyckoff, eds. *Grand Scale: Monumental Prints in the Age of Dürer and Titian.* Wellesley, Mass.: Davis Museum and Cultural Center, 2008. Exhibition catalog.

Simon, Eckehard. *The "Türkenkalender" (1454) Attributed to Gutenberg and the Strasbourg Lunation Tracts.* Cambridge, Mass.: Medieval Academy of America, 1988.

Simon, Karl. "Mittelrheinische Scheiben in Amorbach." *Der Cicerone* 17, no. 3 (1925): 137–41.

Smeyers, Maurits. "*Analecta Memlingiana*: From Hemling to Memling—From Panoramic View to Compartmented Representation." *Memling Studies: Proceedings of the International Colloquium (Bruges, 10–12 November 1994)*, edited by Hélène Verougstraete, Roger van Schoute, and Maurits Smeyers, 171–94. Leuven: Peeters, 1997.

———. *Flemish Miniatures from the 8th to the Mid-16th Century: The Medieval World on Parchment.* Turnhout: Brepols, 1999.

Smith, Margaret. *The Title-Page: Its Early Development, 1460–1510.* London: British Library, 2000.

Snyder, John. *Flattening the Earth: Two Thousand Years of Map Projections.* Chicago: University of Chicago Press, 1993.

Solms-Laubach, Ernstotto Graf zu. "Der Hausbuchmeister." *Städel-Jahrbuch* 9 (1935–36): 13–96.

———. "Nachtrag zur Hausbuchmeisterfrage." In *Beiträge für Georg Swarzenski zum 11. Januar 1951,*

edited by Oswald Goetz, 111–13. Berlin: Gebr. Mann, 1951.

Spinale, Susan. "The Portrait Medals of Ottoman Sultan Mehmed II (r. 1451–81)." Ph.D. diss., Harvard University, 2003.

Stallybrass, Peter. "'Little Jobs': Broadsides and the Printing Revolution." In *Agent of Change: Print Culture Studies after Elizabeth L. Eisenstein,* edited by Sabrina Baron, Eric N. Lindquist, and Eleanor F. Shevlin, 315–41. Amherst: University of Massachusetts Press, 2007.

Stange, Alfred. *Deutsche Malerei der Gotik.* Vol. 7, *Oberrhein, Bodensee, Schweiz und Mittelrhein in der Zeit von 1450 bis 1500.* Munich: Deutscher Kunstverlag, 1955.

———. *Der Hausbuchmeister: Gesamtdarstellung und Katalog seiner Gemälde, Kupferstiche und Zeichnungen.* Baden-Baden: Heitz, 1958.

———. "Untersuchungen über die Anfänge des Hausbuchmeisters." *Das Münster* 9, nos. 11/12 (1956): 381–92.

Stegmaier-Breinlinger, Renate. "'Die hailigen Stett Rom und Jerusalem': Reste einer Ablaßsammlung im Bickenkloster in Villingen." *Freiburger Diözesan-Archiv* 91 (1971): 176–201.

Stievermann, Dieter. "Gründung, Reform und Reformation des Frauenklosters zu Offenhausen: Der Dominikanerinnenkonvent Gnadenzell im Spannungsfeld zwischen Stifterfamilie und Landesherrschaft." *Zeitschrift für Württembergische Landesgeschichte* 47 (1988): 149–202.

Stolz, D. H. *Überlinger Inkunabel-Katalog: Katalog der Inkunabeln der Leopold-Sophien-Bibliothek, Überlingen.* Constance: Seekreis, 1970.

Storme, Albert. *Le Mont des Oliviers.* 3rd ed. Jerusalem: Franciscan Printing Press, 1993.

Swanson, R. N., ed. *Promissory Notes on the Treasury of Merit: Indulgences in Late Medieval Europe.* Leiden: Brill, 2006.

Talbot, Charles. "Prints and the Definite Image." In *Print and Culture in the Renaissance: Essays in the Advent of Printing in Europe,* edited by

Gerald P. Tyson and Sylvia S. Wagonheim, 189–207. Newark: University of Delaware Press; London: Associated University Presses, 1986.

Tedeschi, Martha. "Publish and Perish: The Career of Lienhart Holle in Ulm." In *Printing the Written Word: The Social History of Books, circa 1450–1520*, edited by Sandra Hindman, 41–67. Ithaca: Cornell University Press, 1991.

Tena Tena, Pedro. "Martin Schongauer y el *Viaje de la Tierra Santa* de Bernardo de Breidenbach (Zaragoza, 1498)." *Archivo Español de Arte* 68, no. 272 (1995): 400–404.

Terkla, Dan. "Informal Catechesis and the Hereford *Mappa Mundi*." In *The Art, Science, and Technology of Medieval Travel*, edited by Robert Bork and Andrea Kann, 127–41. Aldershot: Ashgate, 2008.

———. "The Original Placement of the Hereford *Mappa Mundi*." *Imago Mundi* 56, no. 2 (2004): 131–51.

Tietze, Hans, and Erica Tietze-Conrat. "The Artist of the 1486 View of Venice." *Gazette des Beaux-Arts*, 6th ser., 23 (1943): 83–88.

———. *The Drawings of the Venetian Painters*. New York: J. J. Augustin, 1944.

Tishby, Ariel. *Holy Land in Maps*. Jerusalem: Israel Museum, 2001.

Trowbridge, Mark. "Jerusalem Transposed: A Fifteenth-Century Panel for the Bruges Market." *Journal of Historians of Netherlandish Art* 1, no. 1 (2009). doi:10.5092/jhna.2009.1.1.4.

Tuğlacı, Pars. *Mehterhane'den Bando'ya / Turkish Bands of Past and Present*. Istanbul: Cem Yayınevi, 1986.

Uhlhorn, Friedrich. "Zur Geschichte der Breidenbachschen Pilgerfahrt." *Gutenberg-Jahrbuch* 9 (1934): 107–11.

Untermann, Matthias. *Der Zentralbau im Mittelalter: Form, Funktion, Verbreitung*. Darmstadt: Wissenschaftliche Buchgesellschaft, 1989.

Van Engen, John. "Multiple Options: The World of the Fifteenth-Century Church." *Church History* 77, no. 2 (2008): 257–84.

Vickers, Michael. "The 'Palazzo Santacroce Sketchbook': A New Source for Andrea Mantegna's 'Triumph of Caesar,' 'Bacchanals,' and 'Battle of the Sea Gods.'" *Burlington Magazine* 118, no. 885 (1976): 824–35.

Vogtherr, Thomas. "Kardinal Raimund Peraudi als Ablassprediger in Braunschweig, 1488–1503." *Braunschweigisches Jahrbuch für Landesgeschichte* 77 (1996): 151–80.

Vooys, C. G. N. de. "Heeft de Utrechtse kunstenaar Erhard Reeuwich ook letterkundige verdiensten?" In *Opstellen bij zijn afscheid van de Bibliotheek der Rijksuniversiteit to Utrecht op 31 mei 1940 aangeboden aan G. A. Evers*, 284–88. Utrecht: Oosthoek, 1940.

Walls, Archibald. *Geometry and Architecture in Islamic Jerusalem: A Study of the Ashrafiyya*. Buckhurst Hill, UK: Scorpion, 1990.

———. "Two Minarets Flanking the Church of the Holy Sepulcher." *Levant* 8 (1976): 159–61.

Weill, Raymond. *La presqu'île du Sinai: Étude de géographie et d'histoire*. Paris: Honoré Champion, 1908.

Weinmayer, Barbara. *Studien zur Gebrauchssituation früher deutscher Druckprosa: Literarische Öffentlichkeit in Vorreden zu Augsburger Frühdrucken*. Munich: Artemis, 1982.

Weiss, Joseph. *Berthold von Henneberg, Erzbischof von Mainz, 1484–1504: Seine kirchenpolitische und kirchliche Stellung*. Freiburg: Herdersche Verlagshandlung, 1889.

Westrem, Scott. *The Hereford Map: A Transcription of the Legends with Commentary*. Turnhout: Brepols, 2001.

Wharton, Annabel Jane. *Selling Jerusalem: Relics, Replicas, Theme Parks*. Chicago: University of Chicago Press, 2006.

White, Eric. *Peter Schoeffer: Printer of Mainz; A Quincentenary Exhibition at Bridwell Library, 8 September–8 December, 2003*. Dallas: Bridwell Library, 2003.

Wilde, Johannes. "Röntgenaufnahmen der *Drei Philosophen* Giorgiones und der *Zigeunermadonna*

Tizians." *Jahrbuch der Kunsthistorischen Samm-lungen in Wien* 6 (1932): 141–54.

Winter, Heinrich. "The Fra Mauro Portolan Chart in the Vatican." *Imago Mundi* 16 (1962): 17–28.

Winzinger, Franz. *Die Zeichnungen Martin Schongauers.* Berlin: Deutscher Verein für Kunstwissen-schaft, 1962.

Wolfegg, Christoph Waldburg Graf zu, ed. *Das Mittel-alterliche Hausbuch / The Medieval Housebook.* 2 vols. Munich: Prestel, 1997.

Wood, Christopher S. *Forgery, Replica, Fiction: Tempo-ralities of German Renaissance Art.* Chicago: University of Chicago Press, 2008.

Woodward, David, ed. *Cartography in the European Renaissance.* The History of Cartography 3. Chicago: University of Chicago Press, 2007.

———. "Medieval *Mappaemundi*." In Harley and Woodward, *Cartography in Prehistoric, Ancient, and Medieval Europe and the Mediter-ranean,* 286–370.

Yeomans, Richard. *The Architecture of Islamic Cairo.* Reading, UK: Garnet, 2006.

Yerasimos, Stéphane. *Les voyageurs dans l'Empire Otto-man (XIVe–XVIe siècles): Bibliographie, itiné-raires et inventaire des lieux habités.* Ankara: Imprimerie de la Société Turque d'Histoire, 1991.

Zampetti, Pietro. "L'Oriente del Carpaccio." In *Venezia e l'Oriente fra tardo medioevo e rinascimento,* edited by Augustino Pertusi, 511–26. Florence: Sansoni, 1966.

Zrenner, Claudia. *Die Berichte der europäischen Jerusa-lempilger, 1475–1500: Ein literarischer Vergleich im historischen Kontext.* Frankfurt: Peter Lang, 1981.

Zülch, Walter Karl, and Gustav Mori, eds. *Frank-furter Urkundenbuch zur Frühgeschichte des Buchdrucks: Aus dem Aktem des Frankfurter Stadtarchivs.* Frankfurt: Joseph Baer, 1920.

San Michele detail, 105–6, *106*

vantage for, 38

'views'

credibility through, 4–5, 29–39, 47–52, 80–81

history of, 35–37, 47–50

perspective and, 33, 36–38

use of term, 4

Virgin and Child with Chancellor Rolin (van Eyck), 49–50, *51*, 137

Votive relief of Bernhard von Breydenbach and Philipp von Bicken, 10, *11*, 28, 89

vruli, 121–23

Walther von Guglingen, Paul, 11, 13, 26, 28, 61

Weil, Raymond, 124

Wey, William, 110–11, 161, 196n52

Whore of Babylon (Dürer), 63, *65*, 80

Wolgemut, Michael, 30

women

as audience for *Peregrinatio*, 23–25

as audience for *Sionpilger* (Fabri), 25

as audience for *Treatise on the Holy Land* (Suriano), 72

in censorship edict, 21

clothing of Venetian, 61–65

and spiritual pilgrimage in Villingen convent, 163

Wood, Christopher S., 50

Wurzburg, bishop of, 19, 20–21, 57–58

Zacharias, 128

Zainer, Johann, 88, 116